E. V.

 St. Louis Community College

Forest Park
Florissant Valley
Meramec

Instructional Resources
St. Louis, Missouri

GAYLORD

THE
TALKING
CURE

THE
TALKING
CURE

TV Talk Shows
and Women

Jane M. Shattuc

ROUTLEDGE

New York London

Published in 1997 by

Routledge
29 West 35th Street
New York, NY 10001

Published in Great Britain by

Routledge
11 New Fetter Lane
London EC4P 4EE

Library of Congress Cataloging-in-Publication Data

Shattuc, Jane
 The talking cure: TV talk shows and women / Jane M. Shattuc
 p. cm.
 Includes bibliographical references and index.
 ISBN 0-415-91087-0 (hc). — ISBN 0-415-91088-9 (pbk.)
 1. Talk shows—United States. 2. Television and women—United States
 3. Television History—United States. I. Title.
 PN1992.8 T3S52 1996
 791.45'6—dc20 96-2879
 CIP

CONTENTS

❖

ACKNOWLEDGMENTS

❖

For the last four years whenever I said the magic words "talk show," I got a response immediately. As a result I have had nonstop debates, conversations, and interactions about these shows with academics, industry executives, friends, and, most of all, viewers in the Boston area. As a result *The Talking Cure* is not the initial book I set out to write; it has grown more multifarious. These people made me rethink my simple assumptions about TV, sensationalism, and viewers. I can only hope that the resulting book does justice to the complexity of the conversations and the diversity of participants who are too numerous to list here.

Nevertheless, there are individuals who were essential to the completion of this book. Foremost, I must thank my graduate assistants, Luke Frasier, Jacqueline Joyce, and Sara Beechner, whose intelligence, hard work, and humor cataloging 240 hours of talk shows, 500 advertisements, and over a hundred questionnaires made the process a pleasure. They also offered insight into the generational differences in the reception of talk shows.

A number of friends and colleagues commented on portions of the manuscript: Siouxie Bird, Ken Feil, Tom Kingdon, Lynn Layton, and Robyn Warhol. I thank Jan Roberts-Breslin for her great photography. As always I must single out Henry Jenkins for his thorough and tireless reading of various versions. I am lucky to have such a great collaborative friendship. I owe a debt to my family, Helen Bloch and Rick Shattuc, whose friendly skepticism about talk shows kept me from using any simple populist rhetoric about the genre. The intelligence and emotional support of Will Shattuc made it all worth it.

This book also would not have had the depth of detail had not several people in the television industry had the wherewithal to respect an academic project. Bert Dubrow, vice president of program development at Multimedia, was the first talk show executive to respond to my entreaties. He paved the way for me to get unparalleled interviews in an industry that is notoriously suspicious of "academic" thinking. Liz Cheng, director of programming at WCVB (the Boston ABC affiliate), opened up the station's personnel to me. The interviews allowed me to see the complex economics and politics of the local broadcast of national talk shows. Last, I owe a solid debt to Martin Berman, the executive producer of *Geraldo*, for his

candor and trust. Not only did he allow me to sit in on the inner sanctum of talk show production, he broke many of my negative assumptions about TV executives.

A number of institutions aided in the research of this book. Emerson College supported the project through a generous faculty grant. The librarians and archivists of the Association of Moving Image Archives, the Schlesinger Library at Harvard University, and the Museum of Television and Radio in New York were generous in their time and advice. In particular, I thank the staff at the Emerson College Library—Liz Bezera, Bob Fleming, and Arlene Rodda—for their investigative zeal for television history.

Last, I want to dedicate this book to my foster sister, Mary. She transcribed the hundreds of hours of the book's interviews while out of work. To help the book she went on an *Oprah Winfrey Show* program on home hair care as a guest. She fried her hair with cheap dye, listened patiently to experts "diss" her looks on air, and kept her wit. But like many of the women viewers, she has lived from job to job without security and health care. Yet she has not been passive or duped by TV. Her spirit and sense of irony have always kept her going. Was Oprah's designer haircut and dye job worth it, Mary?

INTRODUCTION
The Terms of the Debate about Talk Shows

Talk shows (and we are one of them) and self-help books have been blamed for turning this country into a nation of crybabies. There are a lot of critics that say that we have made it easy for weak people to come up with 101 excuses from poverty to abuse to explain why they can't take charge of their lives. . . . It is my hope that all of us will take the pain that life has dealt us and use it to get to the other side.

> Oprah Winfrey, *Oprah Winfrey Show*, February 22, 1994

Sure, a lot of the stuff we discuss is really tasteless. Some guy's infidelities can be hard to watch, embarrassing and even considered trashy. There's a line we don't cross. We won't put someone on a stage to laugh at them, belittle them, make fun of them, and basically destroy their life.

> Ricki Lake, quoted in "Star Talker," *Broadcasting and Cable*, December 12, 1996.

Ricki—You have the most entertaining talk show on television. Oprah looks like Lawrence Welk compared to you.

> Viewer, *Ricki Lake* Message Board, America Online, July 29, 1995

❖

Talking Cure chronicles the cultural history of the rise and fall of a participatory form of TV devoted to the public debate of everyday issues by women: the daytime television talk show. By 1995 an average of fifteen such shows were being aired in the major U.S. TV markets. The new genre had ended the near-fifty-year reign of soap operas as the most popular daytime "dramatic" form. More important, talk had become the most

watched for-women TV genre. In May 1993 the *Oprah Winfrey Show* attracted a greater number of women viewers than network news programs, nighttime talk shows, morning network programs, and any single daytime soap opera. More than fifteen million people were tuning in daily to watch Oprah Winfrey and her female studio audience debate personal issues with as much fury as an old-time revival meeting or the balanced-budget deliberations in the 1990s Congress.[1]

By 1996 the major proponents of this kind of talk—*Oprah*, *Geraldo*, and the *Phil Donahue Show*—had abandoned the flourishing format because it had hit a nerve: it had produced a national controversy regarding the nature of politics, the role of tabloid culture in the U.S., the rise of a victim culture, and the exploitation of the disadvantaged for commercial gain. What was it about the format that so deeply affected Americans? Externally, the programs appeared to be throwaway mass culture as hour after repetitive hour were devoted to transsexuals, adultery, child abuse, and the like. They could make almost any sensational topic (for example, "Serial Killers Who Want To Have a Sex Change") seem commonplace. And many Americans felt that the programs trivialized traditional politics by being staged in the style of town meetings.

In this book I argue that the public outrage emanated from the identity politics of the 1960s through the 1980s, a battle over who would define American culture and politics. New movements—civil rights, black power, feminism, gay, and lesbian—looked to the psychology of oppression as the source of inequality. They rewrote what constituted the private and public spheres of life to include consideration of how education, language, lifestyle, and representation were imbued with social consequences. In particular, feminism, through its slogan "the personal is political," had pried open what was previously off-limits for social debate: private life. No longer was politics something to be carried on in Congress or through the electoral system. It was about what happened in the everyday experience of Americans. The Right reacted to identity politics not only by scapegoating it as "politically correct" authoritarianism but by dismantling the initiatives that had characterized post-1960s politics: affirmative action, environmental protections, and equal rights legislation. And into the fray rushed commercial TV ready to publicize this latest controversy for "the people" and exploit its potential for sensationalism by presenting private acts as socially relevant. Each daytime talk show had its own version of the politics of everyday culture, and their clash played out in the living rooms across the country.

From 1967 to 1993, TV produced some of the most radical populist moments in its history as women (and men) rarely seen on national

television (lesbian, black, bisexual, working-class) stood up, spoke about, and even screamed for their beliefs about what is culturally significant. They redefined politics to reflect a practice of power in which average Americans had a measure of influence. The debate—its history, construction, psychology, and politics—is the focus of this book.

Defining the Genre

This book also addresses genre theory by analyzing how cultural history affects the conventions of an industrial entertainment form. The talk show is much more complex than its reputation as "simple" pop culture, and the daytime talk show is a subgenre of the form. The talk show is as old as American broadcasting and borrows its basic characteristics from those of nineteenth century popular culture, such as tabloids, women's advice columns, and melodrama. Today the term *talk show* encompasses offerings as diverse as *Larry King Live*, the *Oprah Winfrey Show*, the *700 Club*, the *Tonight Show*, *Rush Limbaugh: The Television Show*, *Ricki Lake*, talk radio, *Good Morning America*, and a host of local shows that are united by their emphasis on informal or nonscripted conversation rather than the scripted delivery of the news.

Nevertheless, the issue-oriented daytime talk show—the subject of this book—is what a majority of Americans mean when they speak of pre-1994 talk shows; that year the form started to change direction. It is distinguished from other types of talk shows by five characteristics. One, it is issue-oriented; content derives from social problems or personal matters that have a social currency such as rape, drug use, or sex change. Two, active audience participation is central. Three, it is structured around the moral authority and educated knowledge of a host and an expert, who mediate between guests and audience. Four, it is constructed for a female audience. Five, it is produced by nonnetwork companies for broadcast on network-affiliated stations. The four shows top rated by A. C. Nielsen in the 1980s, the first generation of daytime talk shows, fit these generic traits: *Geraldo*, the *Oprah Winfrey Show*, the *Phil Donahue Show*, and *Sally Jessy Raphaël*. Their similarity allows their treatment as a cultural group.

Issue-oriented content differentiates daytime talk shows from other interactive TV forms, such as game shows and other talk shows. Daytime talk shows are not the news, but even at their most personal and emotional, their topics emanate from current social problems or issues. The shows can be considered as the fleshing out of the personal ramifications of a news story: the human-interest component. There needs to be a cultural conflict. Subjects are culled from current newspaper and magazine

articles, and from viewer mail and call-ins. The producer decides whether a subject has opposing sides and is socially broad enough to appeal to a large audience. (In fact, local stations categorized the shows as "informational" programs on applications for license renewals in the 1980s.) At one end of the daytime talk show spectrum are programs featuring classic social policy or public sphere debates such as "Mystery Disease of the Persian Gulf War," with army personnel (*Donahue*, March 23, 1994); "Press Actions on Whitewater," with reporters (*Donahue*, March 16, 1994); "Strip Searching in Schools," with school administrators (*Sally Jessy Raphaël*, March 14, 1994); and even "Do Talk Shows and Self-Help Movements Provide Excuses?" with lawyers and cultural critics (*Oprah*, February 22, 1994).

More typically, the social issue is placed in a domestic and/or personal context, such as "Arranged Marriages" (*Oprah*, March 10, 1994); "When Mothers Sell Babies for Drugs" (*Geraldo*, March 17, 1994); "Custody Battles with Your In-Laws" (*Sally*, April 22, 1994); and "Domestic Violence" (*Donahue*, February 1, 1994). Domestic social issues are often further broadened to deal with perennial behavior problems, for example, "You Are Not the Man I Married" (*Geraldo*, February 14, 1994); "Broken Engagements" (*Oprah*, January 31, 1994); "Ministers Who Seduce Ladies" (*Sally*, April 19, 1994); and "Jealousy" (*Donahue*, March 3, 1994). All such programs involve the breaking of a cultural taboo (for instance, infidelity, murder, seduction, nonprocreative sex).

Formally, the convention of audience participation also differentiates daytime talk shows from other talk shows. Spectacles are traditionally defined by separation between an active presentation on a stage and a passive viewing audience, as in Aristotelian theater, classical Hollywood films, and network drama.[2] The fiction is maintained through the fourth-wall convention (the imaginary wall over which we peep as a seemingly "real" drama unfolds). The role of the viewing public is effaced. Within fictional TV, sitcoms are the only genre that offers the audience a role; it is configured as the laugh track ("canned laughter") or with the declaration "taped before a live audience." Both function as an attempt to signal and encourage the correct viewer reaction to the fiction.

However, conventional drama is only a part of TV. As a whole TV is different from film and theater in that it is marked by what Robert Allen calls a "rhetorical mode," wherein the viewer's presence is often simulated through direct address.[3] Advertisements and news anchors speak directly to the audience through use of the pronouns "you" or "we" as a means of cutting through the impersonal nature of TV's mass address, as well as of creating a hierarchy address and authority. The "you" is subjected to the

words and ideas of the "I" or an anonymous announcer: "It's time for *you* to buy right now!"

Talk shows are marked by the active inclusion of the audience in the spectacle. The celebrity talk shows such as the *Tonight Show* (1954–), *Late Night with David Letterman* (1982–), and the old *Mike Douglas Show* (1962–1982) are conversations among entertainment elites about the entertainment industry. Yet audience members are frequently called by name and asked to interact with the host. Although the studio audience is seen and called upon, it still functions somewhat like a laugh track (although less predictably): as passive "inscribed viewers" whose main role is to represent the at-home viewer by following the program's rules of good viewership. Audience members embody the immediate "you" to whom the host refers as he or she addresses the camera. They laugh and applaud— to a degree voluntarily—out of appreciation for the entertainment, but the producers attempt to bring about the sought-after emotional tenor through prompts: flashing signs or gesturing personnel.

Even when the host interacts with audience members, their response is usually limited in that they are on the receiving end of highly contrived situations. Consider *Letterman* and its often-repeated jape of putting an off-color title under the on-screen face of an unsuspecting person in the audience. The joke is the incongruity of the label and the resulting public embarrassment of the person. This audience interaction is only a minor warm-up to the main event: conversation between luminaries who perform and/or talk. After its brief moments of being in the limelight, the studio audience returns to its classic role as spectator.

Even with the more interactive public-affairs programs such as *Larry King Live!* (1985–), *700 Club* (1976–), and *Rush Limbaugh: The Television Show* (1992–), the studio audience is a secondary element and often off-screen. Limbaugh's audience is represented through "viewer mail." We have no idea how edited viewer mail is or if it is from actual viewers. *Larry King Live!*, defined as a call-in show, offers home viewers access by telephone to the debate of the issues of the hour. They are disembodied voices; the focus remains on King and his guest authority. Each caller is allowed to make a short statement or, preferably, to direct a question to the authority.

Robert Allen argues that the daytime talk show studio audience has a stronger similarity to the game show audience than to those of other genres.[4] *Commonweal* magazine calls it a "sibling" relationship.[5] Both genres acknowledge the audience directly by equal lighting of stage and audience. The audience becomes part of the performance, just "on the other side of the screen."[6] It is represented as an "ideal audience" that listens

respectfully and asks the questions (or guesses the answers) for the viewer at home. For all their look of spontaneity greater than those given on celebrity talk shows, the responses are still highly regulated through the host's selections, prior coaching, and the general production process of camerawork, miking, and segmentation.

More specifically, both daytime talk shows (hereafter the definition of "talk shows") and game shows blur the line between audience and performance. They allow the audience member to shift from characterized viewer to performer. Allen believes that many game shows depend on this change for their entertainment. He cites the example of Johnny Olsen's famous "Come on down!" on *The Price Is Right* (1956–1974) as marking the audience member's switch to participant.[7]

Perhaps no other game show comes closer to the combination of the interactive audience and emotional narratives of the talk show than *Queen for a Day* (1956–1962).[8] Begun as a radio show, its TV version chose four or five women from the studio audience to appear on the stage. One by one each would state what she needed most and why. The winner, or "queen for the day," was picked based on audience applause. Usually, the woman who told the most tearjerking story received the most applause. *Queen for a Day* has become emblematic of TV's early ability to offer the common American a chance at temporary stardom or what Andy Warhol glibly proclaimed everyone's "fifteen minutes of fame." A number of critics are of the opinion that this social empowerment, albeit brief, is what causes the guests and audience members of talk shows to become less fearful and to disclose their personal lives on national TV.[9] The best and most emotionally told stories on talk shows continue to win the greatest attention and audience respect.

Talk shows bring about the change from audience member to performer more subtly than game shows do. Although the initial focus is the guests on stage and their topical problems, an audience member can confess similarity or differ with the presentation at any moment that the focus moves to the studio audience. The shows intentionally do not make a clear distinction between guests and audience members. Producers often ask guests with similar problems and entire groups with a vested interest in the issue to be part of the studio audience. Consider a program on drag queens on *Geraldo*. The audience is full of invited friends of the "queens" on stage and some who are not in sympathy with them. A physical fight breaks out in the audience because of one man's anger at men "masquerading" as women. By taping a characterized viewer's becoming a participant, the program hopes to create greater vicarious involvement on the part of the at-home viewer. In like fashion, the at-home viewer sides with

audience members in the debate, thinking what he or she would want to ask or say to the guest. For all their supposed dependence on lurid description and unhealthy voyeurism, the talk show genre breaks through the anonymity of the audience that such peep-show comparisons necessitate. Consider how often viewers address talk shows being screened in, say, bars, waiting rooms, launderettes, or at home. The talk show is a genre predicated on active audience response, not silent and anonymous voyeurism.

Talk radio offers a set of traits similar to those of the TV talk show in that the format combines call-in shows on social issues, interview shows, and psychological advice shows that provide the range of topics found on the latter. Talk radio also stages controversy to create dramatic appeal. Additionally, talk radio is wholly dependent on audience participation by means of listener call-ins. For example, Toni Grant's show on the ABC talk network provides psychological advice to call-ins, much like Dr. Joyce Brothers provides advice to guests and audience members on *Geraldo*. However, talk radio tends to keep psychological advice shows separate from its call-in shows on social issues; TV talk shows tend to move more easily between the psychological and the social dimensions.

Further, audience participation on the radio is often censored through the technology of the cut-off button. TV talk shows as a practice do not often edit out material from audience members, who tend to self-censor. As a result, the disembodied and often anonymous radio caller does not carry the burden of responsibility for participation that the TV talk show participant does. Television visually identifies the speaker, ideally forcing her or him to be more conscious of the consequences of utterances.

Yet the audience participation of talk shows is held in check by the subgenre's third characteristic, which is similar to a characteristic of talk radio: the moral authority of the host and experts who regulate the discussion. Oprah, Phil, Sally, Dr. Joyce Brothers, U.S. Senator Donald Riegle, or Rabbi Richard Simon—these people represent the educated middle class (or bourgeois public sphere). The hosts use their own experience of many programs on a particular topic to establish authority. Oprah Winfrey will often begin: "What I have gotten from doing a number of shows on the subject. . . . " The expert's status derives from advanced education and/or a specialized occupation, often within the health-care industries. Consider the continual tagging of "Ph.D." after the expert's name in an attempt to deflect questions of credibility away from someone who possesses "knowledge" on a subject of which we know little or nothing. Through their advice and mediation of the conflict, host and expert communicate

the "established" position or "culturally acceptable" course of action regarding the issues at hand. Even hairstylists and dressing consultants on makeover programs communicate the socially acceptable or middle-class fashion look to a lower class as a $300 haircut and Armani clothing are paraded as socially normative. The host and the expert provide the ballast that keeps the daytime talk show's conflict in check. Their authority distinguishes this first generation from the 1990s generation, such as the *Ricki Lake Show* (1993–), the *Richard Bey Show* (1993–), *Gordon Elliott* (1994–), and *Jenny Jones* (1991–), that depends more on a free-for-all style, often in the absence of expertise (see chapter 7).

Daytime talk shows are constructed primarily for a female audience; women constitute 80 percent of their audience, according to the A. C. Nielsen Company, as opposed to talk radio, where they constitute 42 percent (see chapter 3).[10] Whether this gendering has to do simply with the fact that the shows tend to be scheduled during daytime hours, when many women are at home, or whether it is the shows' "feminine" focus on emotion and interpersonal behavior is discussed later. However, much like the soap operas (their fictional cousins), the daytime talk shows not only appeal to women at home but have women as the majority in their studio audiences and populate their production staffs with women. These features set the shows apart from issue-oriented radio talk shows, whose audiences are predominantly male.

The fifth distinguishing characteristic of the talk shows is that it comprises hourlong first-run programs financed and distributed by syndicators and put together by independent producers. The shows are sold to local network affiliates and independent stations to fill the fringe schedule not dominated by the network feed. In these respects they differ from more prestigious network productions, such as *Today*, *Good Morning America*, the *Tonight Show*, and *Late Night with David Letterman*, as well as soap operas and news. The shows are an ancillary form of programming. Their independence from the networks, high profits, low production costs, and daytime placement allow them a latitude in content that normally would be censored on network television. As a "degraded" form, they can bring to the fore politically and socially controversial issues rarely seen on network television.

Talk shows have other characteristics as well. They tend to be scheduled during midmorning and late afternoon as a transition from news programming to soap operas in the afternoon, and then from the soap operas to the evening news. Many are rerun late at night, when the newer talk shows also air. They tend to run five days a week, in dependable daily "strips" in industry parlance. In other countries, such as Great Britain,

they can be seen only once or twice a week.

A number of similar talk shows began in the 1990s, but it was the volatile 1960s and 1970s that left their stamp on the talk show's content and structure. *Donahue, Sally, Oprah,* and *Geraldo* all began before 1990. The form originated in Dayton, Ohio, in November 1967, when Donahue presented a program devoted to atheism and featuring the activist Madalyn Murray O'Hair. The other three shows began in the mid-1980s. All four mix sensationalism with a liberal political agenda that champions the rights of the disenfranchised. The coherence of this group became clearer with the rise of the "youth" talk shows of the 1990s, which shifted the genre away from identity politics toward a more apolitical and ironic treatment of social issues.

This Book: Structure, Theory, and Assumptions

Because of the unique participation of the audience on talk shows, this book enters the debate about the "active" audience—the ideal viewers who enjoy but challenge the form and content of TV—that cultural studies has come to champion. Reacting against the academic (and the media's) conception of these viewers as passive, controlled, and inactive, critics as diverse as Henry Jenkins, Ellen Seiter, John Fiske, and colleagues have offered ethnographic evidence of the complexity of active audience participation for *Star Trek,* soap operas, and Madonna.[11] In fact, I argue that talk shows are self-conceived as 1960s-style "activated texts" that openly encouraged response in the audience and at home through the use of a vociferous studio audience.

My thinking is marked by a critical populist sensibility derived from my upbringing in the Midwest, where the politics of the farmer-labor movement deeply affected my view of the inherent intelligence of ordinary people. Theoretically, this position is supported by the rise of cultural studies, which argue for the centrality of everyday culture in political change. Hence, my analysis owes much to the populist roots of Raymond Williams[12] and Stuart Hall[13] (and the Birmingham Centre for Contemporary Cultural Studies), who have combined their populism with a Marxist awareness of economic and social determinisms.

This book breaks with any idealized account of the viewer of television as a completely critical and self-determining individual. I look at how the active audience is "produced" as a result of industrial needs, psychological theory, and the conservative agenda in the 1980s and 1990s. Yes, "real" women do speak, but for whom—themselves or a bourgeois notion of the underclass as victims or an uncontrolled mass? Here, Michel

Foucault's cautionary notion of how power and knowledge are intertwined becomes central for feminist analysis. How do talk shows and the popular debate about them categorize certain female behaviors as "normal" and others as "abnormal?" Talk shows construct a hierarchy of good female behaviors for American culture.

We should question whether the topic of sexual freedom on talk shows—a choice fought for by women in the 1960s and 1970s—is indeed really about freedom. Jana Sawicki declares that we should look to Foucault's theory of the productive nature of power and of the body as a target of modern disciplinary practices against women. Foucaultian theory involves understanding the complex relations of power and knowledge and forces political activists and intellectuals to consider the more subtle forms of power inherent in theory, language, and professional expertise.[14] From this perspective, the self-help ethos of talk shows may be teaching women more about how to monitor their behavior within the prescribed norms of American culture than about how to empower themselves. The skepticism of Foucault's theories about the relative nature of emancipation complements "developing feminist insights about the politics of personal life, the ambiguous nature of the so-called 'sexual revolution' in the sixties, the power of internalized oppression, and seeming intractability of gender as a key to personal identity."[15] What looks on talk shows to be about self-actualization could be as much about self-regulation. In attempting to negotiate the maze of talk show reception, I move cautiously between my belief as an activist in the capacity of women to assert their ideas and effect change and my caution as an intellectual conscious of how power works elusively to create inequality.

This book bridges theory and practice by going into the talk industry, interviewing women fans, and analyzing 240 hours of talk shows. To understand talk show history, content, and reception, I have identified five distinct elements in the debate about talk shows. Chapter 2 chronicles the rise of talk shows, looking to the nineteenth century tabloid newspaper as their predecessor. I isolate the problem of the tabloid "stereotype" for women and analyze its political role. Chapter 3 analyzes how the industry produces "the female viewer"; in other words how it creates programs to attract her and, ultimately, expose her to commercials. The programs, scheduling, and advertising are predicated on specific notions having to do with women and feminine desires—all of which are reflective of dominant notions of femininity in the late twentieth century.

The second half of the book moves on to the influence of feminism and the other identity politics movements on talk shows. Chapter 4 looks at how talk shows reflect the larger values of the identity-politics

movements of the past three decades. The movements shifted political discussion to personal issues and the psychology of oppression. It granted average women and oppressed groups greater authority to debate politics based on personal experience. Chapter 5 describes how the women's movement and feminist therapy have affected the therapeutic environment of talk shows as hundreds of female experts and therapists translate Freud's and other theoretical psychologists' ideas into suggestions for millions of women at home. Does such a therapeutic sensibility empower women or make them dependent on psychiatric formulations? Chapter 6 looks at the *Ricki Lake* phenomenon as both a generic shift and a backlash against the "social do-good" righteousness of the first generation shows. The post-1993 shows represent a new outlaw culture that has both the Right and Left up in arms.

The last chapter asks how might we "know" this audience of average women that has been constructed by the discourse of the talk industry, therapy, the Right's paranoia, and academic theory. According to the industry's research (the Nielsen ratings), it is an audience of lower-income housewives. Is that indeed the audience? How might I as a fan and as an academic writing about talk shows find that audience and bridge the cultural gap between it and middle-class me? Is there a way to discuss our shared community of talk show watching?

I have written this book (often in first person) as a fan and an academic. I have chosen to do so for several reasons. First, I like talk shows. I have watched them on and off for twenty years, since *Donahue* premiered in the Chicago area where I grew up. The rebellious energy of his female audience attracted me. I began to argue with my mother, a therapist, about the normalizing role that psychology played in defining the sexuality of women. These programs still engage me emotionally, intellectually, and politically. I am part of a community of talk show watchers and am often addressed as one: "Girl, you like OPRAH!?! Oh, my!" I want to express the energy and pleasure of this talk show experience.

Second, I believe that I offer knowledge of the history, criticism, and practices of daytime talk shows and the viewer far beyond that of most critics, who generalize from a few programs. But that knowledge is based on my own experience of them. Here, I want to make a claim for academic research that is steeped in the everyday intimate experience of the subject. Therefore, much of my information and understanding has to do with the Boston area,where I live and teach. Many of the questions that emerge are from my training as a media historian, but more are from my sense of identity with talk show viewers. However, I do not assert that I am a "typical" viewer. I am a middle-class, educated white woman writing

about a community that is racially diverse and seemingly composed of primarily working-class, if not underclass, women with little or no higher education.

The last reason for my choice of subject: I want to question the concept of academic distance as the only means to a true or honest version of talk shows. If I were to make a claim to detachment and objectivity, I would be offering this book as "truth." Cultural anthropologists such as James Clifford and Renato Rosaldo have critiqued the notion of distance as integral, a notion widespread in traditional social science research. I believe there is no one vantage point from which to view talk shows correctly. I acknowledge that I am laying claim to a specific historical understanding of talk shows, and hence want to forefront the element of subjectivity and "personal" perspective involved. I situate my knowledge as a feminist academic coming of age during the history of these programs. The book is not conclusive; it extends the debate over American culture—another reason I am drawn to talk shows.

I do not want to disallow the importance of my work and my ability as an academic to be critical of the subject. First, I believe that talk shows are a historical phenomenon and that the facts and details of their history matter. Therefore, I provide extensive and highly detailed data. I also test the data from several theoretical perspectives to reveal the generative mechanisms that have led to what we call a "talk show." I have attempted to write in a manner that will engage a larger, nonacademic audience and some talk show viewers in the debate over talk shows. Renato Rosaldo warns, "Social analysis must now grapple with the realization that its objects of analysis are also analyzing subjects who critically interrogate ethnographers—their writings, their ethics, and their politics."[16] I await that test.

SOBBING SISTERS

The Evolution of Talk Shows

Carol Bundy (accomplice): He [serial killer Douglas Clark] said that he had shot these two young women. Dropped one body near NBC Studios in Burbank and the other one he had taken to a Sizzler Restaurant where he decapitated her and left the body by a dumpster and brought the head home and put in the refrigerator . . . I mean the freezer.

Sally Jessy Raphaël: What was he going to do with the head?

Louise Farr (author of *Sunset Murders*): Douglas Clark took the head out of the freezer and into the shower to masturbate with.

Studio Audience: eeeeeeeeeeeeew!!!

> *Sally*, February 3, 1994

To-day this little hamlet has been horrified and thrown into the most intense excitement by the exposure of a crime which has caused the death of a beautiful girl, the arrest of her lover for complicity and the disappearance of a physician who performed the operation which brought the girl to an untimely grave.

> *New York World*, June 29, 1884, 1, quoted in George Juergen, *Joseph Pulitzer and the New York World*

❖

The *Sally* program on a serial-killer couple in California (February 3, 1994) contained all the stereotypical characteristics of a daytime talk show: graphic discussion of sex, violence, and emotions by seemingly ordinary people whose stories of extremes engage a responsive audience. With twenty or so such nationally syndicated shows on the air in 1996, the genre rules television's daytime hours. *Talk show* is now part of the popular vernacular, and the term always gets an immediate reaction—usually rolling eyes, a smile, or an exclamation like "Oh my god!"

Are daytime talk shows emblematic of what Fredric Jameson describes as "the whole 'degraded' landscape of schlock" of a country in decline?[1] The characterization is of a United States that has become a commercial nightmare populated by network TV, fast food, and sick people who no longer have a moral perspective. The shows are often categorized as "sleaze TV," "tabloid TV," and "trash TV," and the print press reviles them as the death of political debate, lurid sensationalism, or a new dumbness. But are they new, bad, or dumb?

There is no pure understanding of talk shows. Over the past quarter century they have been weighed down with so many cultural accretions and become so much a part of our lives that to achieve objectivity about their role in American culture is hard to do. The shows always come "encrusted" with previous meanings from viewings and popular discourses about them. Robert Allen believes that we should acknowledge "our position as experienced or tainted readers and our object of study as 'always-already-read'" to grasp the complexity of the layers of meaning of a TV genre.[2]

Historians offer a more temperate description of talk shows as classical popular culture.[3] As this chapter's epigraphs illustrate, the daytime talk show throws into the limelight the very kinds of popular drama that depend on gossip, sensation, and the excitement of testing limits and that captured newspaper readers a century ago. Our understanding of the *Sallys*, the *Oprahs*, and the *Phils* is an amalgam of previous forms and discourses that are read onto them. To begin to separate out how our perception of the form is always already "tainted," this chapter looks at the historical encrustation of daytime talk shows.

Tabloid Talk: Television's Debt to the Nineteenth-Century Popular Culture

The year 1987 is often branded the year "tabloid TV" began because it was then that the talk shows *Geraldo* and the *Morton Downey Jr. Show* and the news magazine *Current Affair* premiered. Their format was described as "confrontainment"—"discussing inflammatory topics at a high decibel level."[4] Spurred by the notoriety of his daytime talk show, Geraldo Rivera gained additional fame through a series of prime time specials. He went to the "jaws of death" on "Murder: Live from Death Row." In "The Mystery of Al Capone's Vault" (the highest-rated syndicated special in history), he opened the gangster's vault with all the fanfare of finding the lost ark, but there was nothing in it. These empty spectacles gave Rivera a reputation for prime time tabloid sensationalism, but his daytime show was the

archetype of the tabloid culture of talk shows.

In 1988 *Geraldo* created the now-famous confrontation between a group of white supremacists and Roy Innis, a black activist. The program placed the participants in close proximity to one another to enhance tension as they debated racism. Not surprisingly, a melee broke out between the two sides, resulting in a broken nose for Rivera. His black-and-blue face and prominently bandaged nose appeared on TV news and in newspapers across the country, confirming talk shows as a tabloid form. In the aftermath *Variety* proclaimed talk show hosts "shockjocks," citing not only *Geraldo* but also a lawsuit against *Donahue* by a Galveston woman whose mother had revealed familial incest on one of his programs.[5] Invoking *Geraldo* as the most nefarious, *Vogue* magazine characterized all talk shows, including *Donahue* and *Oprah*, as "nuts and sluts."[6] David Halberstam declared their content "wildly demagogic and dangerous. One of these hosts gets a Nazi on the air, another then gets two Nazis."[7] In 1989 Albert Scardino commented, "After years of dancing around the edge of sensationalism, television leapt enthusiastically into the pit last year with the kind of journalism many newspapers have practiced for a hundred years or more."[8]

Scardino is right: the tabloid nature of talk shows is not new; it has always been part of American journalism, as it is now of talk shows.[10] A tabloid is traditionally defined as a "paper whose stock in trade is the human-interest, graphically told story, heavy on pictures, and short, pithy, highly stereotyped prose."[10] Talk shows are carrying on the printerly tradition for television. The epigraph's extract from a *Sally* program clearly fits the tabloid definition: the human interest story of a mother who went astray. It is narrated by the "serial-killer mom," who vividly lays out the details in the NBC studios and Sizzler Steakhouses while photographs of killers and victims are superimposed on the screen. The host and expert guide the narrative with sober clipped reportage of the lurid events. Even though we associate *tabloid* with a half-broadsheet newspaper—such as today's *National Enquirer*, *New York Post*, and the British *Sun*—talk shows such as *Sally* owe much more to turn-of-the-century tabloids for their mixture of sensationalism, populist politics, and consumerism for a popular audience than current tabloids. It is this combination that motivates Donahue to proclaim in a *TV Guide* interview: "We are tabloid—I'm happy to wear the label."[11]

One can trace the origins of tabloids to the seventeenth century, when ballads and newssheets vividly told of lurid and wondrous occurrences (murder, strange births, omens). The newssheets were descendants of such oral traditions as the town crier, gossip, and folk tales. The penny

press came of age in the nineteenth century. In the 1830s James Gordon Bennett founded the *New York Herald* and Benjamin Day founded the *Sun*, perhaps the first mass-market newspapers targeted at a growing urban population that was poor and semiliterate. The *Sun* sold for one cent; as opposed to the established papers for six. Its language was the language of the common man, not of the politician and merchant: "Plain talk that was athletically lean and representative of realistic human conditions."[12] Its motto, "The Sun Shines for All."

The nineteenth-century tabloids offer an illuminating series of parallel traits with daytime talk shows. By the last quarter of the century they were an established component in the cultural and economic class divisions, as are the shows. They were cheap, as are the shows. They were born out of the new inexpensive technologies (printing, photography, illustration), as are the shows (broadcasting for television). The tabloids' audience materialized because of changes in the lower classes, waves of immigrants and a newly arrived urban working class; the shows are consumed by a growing underclass.

Charles Dana bought the *Sun* in 1868 and within a few years turned it into what Joseph Pulitzer called "the most piquant, entertaining, and without exception, the best newspaper in the world."[13] In 1883 Pulitzer, a *Sun* editor, acquired his own newspaper, the *New York World,* and embarked on the crusading for social justice that marks the yellow journalism of the turn of the century and is the model for today's daytime talk show.

As does the "teaser" advertising for daytime talk shows ("In bed with the mob! Mafia Women—next *Geraldo!*"), Pulitzer used provocative headlines about murder, sex, crime, and disasters ("A Septuagenarian's Body Stolen" and "Nursing a Cold Corpse") as bait leading readers on to straightforward stories of Victorian politics. But, it was Pulitzer's crusades in the name of workers that drew the largest readership. Following in the footsteps of the *Sun's* class-conscious populism, Pulitzer espoused greater working-class rights within a democratic tradition. "When the editor called for reform and social justice, he appealed to widely held fears of concentrated powers and authority."[14] He referred to his readers as "the people," and the *World* sought with inflammatory editorials to protect them from the growing industrial giants. The efforts, such as the campaign against J. P. Morgan and the manipulations of his bond syndicate, sprang as much from the desire to boost circulation as from social concern.[15] Daytime talk shows may have tipped the balance away from sensational public news toward sensational human interest, but the first generation of programs still crusades for the rights of the lower class using

a commercial venue such as network television as a platform.

Pulitzer began mixing sensation with commercialism in the 1880s, much as the daytime talk shows intersperse their dramas with commercials today. As "one of the creators of American consumer culture,"[16] he was distinguished from the other yellow journalists, such as Dana, who disdained advertising and whose crusades were against the evils of industrial capitalism. Whereas Dana saw his readers as producers (workers and unionists), Pulitzer saw his readers as pleasure-seeking consumers. The World's owner was cognizant of the role of the expanding consumer culture in the life of the average worker. With the growth of leisure time and surplus capital, there proliferated activities such as movies, vaudeville, sports, and amusement parks, and consumer goods such as ready-to-wear clothing, cameras, and dime novels.

Pulitzer marked the shift away from the Victorian virtues of denial, hard work, and self-sufficiency toward more immediate gratification.[17] He made the World a prime venue for advertising the new pleasures. Like the daytime talk shows of the 1980s, the World's people-centered stories with their vivid, excessive language offered a perfect vehicle for informing readers about consumerism as well as a frame for advertisements that staged a parallel world of spectacle and exciting human needs. The quotation that appears in this chapter's epigraph from a World article on a botched abortion is a typical example of the prose. The newspaper developed the sports section, the women's page, and, most portentous for talk shows, the advice column. Pulitzer innovated photographs, illustrations, bold headlines, and attractive advertisements—the devices that are the hallmark of tabloids—to attract the common reader.

When one compares daytime talk shows to the supermarket tabloids of today, Pulitzer's yellow journalism offers the more obvious historical precedent. The weekly supermarket tabloid evolved into its present form in the early 1960s with Generoso Pope's National Enquirer. Elizabeth Bird writes that from the start the newspaper eschewed politics and sexual topics for a "family-oriented" tabloid based on gore, mysterious events, celebrity gossip and cute animal or child photographs.[18] At their most populist, the supermarket tabloids are skeptical of conventional knowledge, evinced by their constant stories of UFOs, strange medical occurrences, and assassinations that contradict "official" (governmental or scientific) findings. Although the shows share some of the same topics (the desks of the producers are littered with copies of National Enquirer, Star, Globe, and People magazine), the programs are more graphic, more respectful of educated knowledge, and openly socially conscious than the weekly tabloids. Like the yellow journalism tradition, daytime talk shows

combine a populist emphasis on the injustices done to the "average" American with the allure of the extremes of vividly told stories.

A comparison of daytime talk show subjects in 1994 and Pulitzer headlines in 1884—ninety years apart—reveals the parallel interest in news of crime and the uncommon.

The New York World, March 3–10, 1884[19]	Television Daytime Talk Shows, March 4–11, 1994
• "A Child Flayed Alive"	• "Cross-Dressing: Flamboyant Drag Queens"
• "A Quintuple Tragedy—An Entire Family Annihilated by Its Murderous Head"	• "Vidor, Texas: A Town That Banned a Race of People"
• "An Assassination Foretold"	• "The Con Man, the Boyfriend, and the Fiancee"
• "Strangled by Robbers: A Wealthy Stockraiser Murdered for His Money"	• "Passion and Cover Up: President Clinton's Accusers"
• "Died a Desperado's Death: The Outlaw Rande Hangs Himself to the Door of His Cell"	• "Sexual Harassment among Teens"
• "Our Militia 'Bosses'"	• "Jealousy Rears Its Ugly Head"
• "A Lady Gagged in a Flat"	• "Teen Gang Members Confronted by Their Parents"
	• "Strange Self-Phobias"
	• "Identical Twins: What Makes One Person Rich and Another Poor"
	• "Wife Slavery: Women Mutilated by Men"

Because the class structure prevents their audiences from attaining the education associated with the content of the established press, tabloid newspapers and daytime talk shows present stories of ageless fascination: sex, violence, crime, and tragedy. The style of presentation (as Pulitzer urged) is "simple vocabulary and uncomplicated sentence structure."[20] The World's sensationalism emphasized crime and tragedy; the shows are more explicit, with more sexual topics in a post-Freudian era. Both forms blow up the trivial to assume the proportions of major social issues. Daytime talk show producers comb today's tabloids and the back pages of established newspapers for human interest dramas to stage as emotional debates, which often take on operatic proportions with their conflict and passion.

Like tabloids, the shows' unflagging sensationalism leads the established press to call them a "low" or "tabloid" form. *Sensationalism* is derived from the Latin verb *sentire*, which means "to feel, perceive." Today *sensationalism* means, broadly, "the use of subject matter, style, language, or artistic expression that is intended to shock, startle, excite or arouse intense interest; addiction to what is sensational in literature, art, public speaking, etc."[21] To return to the description of the serial killing on *Sally*, it stimulates a frisson in the law-abiding viewer through a stirring of the senses, sensationalism. The pejorative use of the term springs from the fear that exposing the lower class to nonnormative behavior in such fashion leads to irrational and asocial behavior. From this perspective, sensationalism must be controlled. The fear of sensationalism does speak to a central cultural pleasure furnished by daytime talk show and tabloid content to people who feel repressed by day-to-day conformity and economic limitations: examining at a safe remove another, less confining side of life.

Ideologically, the liberatory appeal is furthered through the daytime talk shows' populism or championing of rights and values of the common people. Consider how they advance Pulitzer's political agenda:

1. Tax luxuries.
2. Tax inheritance.
3. Tax large incomes.
4. Tax monopolies.
5. Tax the privileged corporations.
6. A tariff for revenue.
7. Reform the civil service.
8. Punish vote buying.
9. Punish employers who coerce their employees in elections.[22]

Although the shows tend not to focus on specific corporations, laws, or individuals, they crusade against concentrated forms of power. An interesting parallel exists in *Geraldo*'s "The Tax Man Cometh" (April 15, 1994). The program consists of average citizens' horror stories about the excesses of the Internal Revenue Service. Instead of Pulitzer's focus on taxes as a means to remedy class inequities, the program concentrates on taxes as harassment of the weak individual. Rivera announces that its focus "is winning against the tax man," a point that reveals its populist sentiments. There are also citizens' rights, advocates such as IRS whistleblowers and Congressman Billy Tauzin, who advocates legal reform through "a progressively driven consumer tax." The "voice of the people" is heard

through a poll of the "representative" studio audience concerning prefer-
ence for a consumer tax over an income tax. The program caps its people's
logic by closing with a list of hints on how to avoid trouble with the IRS.
Other daytime talk shows repeat the emphasis on class inequities:
"Lawyers Who Are Crooks" (*Donahue*, February 2, 1994), "Kids Who Get
Strip Searched at School" (*Sally*, March 14, 1994), "High Profile Attor-
neys" (*Geraldo*, April 4, 1994), "Getting Fired When You Least Expect It"
(*Sally*, April 13, 1994), and "The Working Homeless" (*Oprah*, April 14,
1994). Given that the shows' programs are interwoven with commercials
for personal-injury lawyers, cleaning products, and weight-loss clinics
that tell us to "fight back," their debt to the combination of consumerism
and populism in Pulitzer's *World* becomes clear. Since the turn of the cen-
tury the crusading tabloids and talk shows have perpetuated a self-serving
contradiction: they actively promote commercial consumption as a
panacea for the pains of inequality imposed by the capitalism on which
these institutions rely.

Nevertheless, the populism of talk shows is still complex and contra-
dictory. Usage of the term *populism* is slippery in American culture. Is it a
movement or an ideology? The term has its origins in the short-lived Pop-
ulist Party (1877–1898) that united midwestern farmers ("plain people"
in the language of the platform) against monopolies and New York fi-
nance.[23] Such politicking against the concentration of power was a preoc-
cupation of the turn-of-the-century tabloids; the *World*, *Sun*, and *Herald*
espoused the rights of the worker. *Populism* has since come to be broadly
defined as "a sense of commitment to 'the people' and their struggles"[24]
and is descriptive of a politics that seeks economic equity for all classes,
be they industrial (unionism), geographical (farm movements), or politi-
cal (third-worldism).

The populism of talk shows is defined in its broadest sense as defend-
ing "the people," "the little guy," or "underdog" against the reigning power,
whatever it is construed to be. The conflicts are defined not in clear class
or economic terms but, rather, through a narrative of inequality, David-
versus-Goliath scenarios: a seventy-year-old housewife sues her dishonest
lawyer, a teenager reports her principal for sexual discrimination, a rene-
gade lawyer fights back against the IRS.

Yet populism also lurks behind the seemingly asocial theme of scan-
dal, the principal topic category. Daytime talk is a test of the American
tolerance of difference and democratic freedom. On one hand, the shows
trade on tabloid sensationalism and the titillating but conservative threat
of social decay. Programs such as "People Obsessed with Serial Killers"
(*Sally*, February 1, 1994), "In Search of the Big 'O': Enhancing Marital

Sex" (*Geraldo*, February 22, 1994), "People Who Live Double Lives" (*Oprah,* March 7, 1994), "When Your Husband Is a Cross-dresser" (*Geraldo,* April 4, 1994) and "Post-Menopausal Sexpots" (*Donahue*, April 13, 1994) demonstrate that the breaking of social taboos (familial, sexual, or legal) is a central theme. Here, the guests represent social deviants or freaks put on the circuslike display typical of tabloids. On a program about transsexuals, "From Girly to Burly: Women Who Become Men" (*Geraldo*, April 18, 1994), Geraldo dwells on the difference between the men he sees before him and the photographs of them as young girls. He is incredulous: "I can't believe it." The camera parallels the host's obsession with the difference as it zooms in on them in close up or elaborately tracks back and forth across their faces as Geraldo exclaims, "Listen to them speak! Look at them! Can you believe it . . . they were born women?! Look at Jon and Jake. Look at Devon. And Ben. And Morgen. And BJ." To add to the self-consciousness of their aberrant nature, Geraldo has each give his former name as a woman in quick secession. And the audience questions the problems that the change has caused their families, especially their children. The underlying fear is the destruction of the nuclear family and the consequences for social conformity.

This brand of programming evokes what Stuart Hall calls authoritarian populism,[25] a term which comes from his analysis of the surprising triumph of Thatcherism among working-class Britons as Margaret Thatcher dismantled the very programs that support the working class. Thatcher, as well as Ronald Reagan (her ideological soulmate), tapped into the rhetoric of the commoner by addressing the popular aspirations that consumer capitalism offers ordinary people. Underlying this new populism was an appeal to competition, possessive individualism, and a them-against-us ideology. This ideology surfaces in Britain's leading tabloid, the *Sun*, a Thatcherite daily, where "[p]opulist interests in individuals, personalities, sex, scandal, violence, sport and amusement are presented in a lively, identifiable language and format which ideologically layers a heterosexual, male, white, conservative, capitalist world view."[27] Daytime talk shows speak to this political conservatism and social conformity with their sensational titles and topics whose attraction lies in the violating of "normal" behavior.

Geraldo Rivera invokes the same claim to an ordinary point of view when he gawks at the transsexuals as freaks and exclaims, "I can't believe it " (an odd assertion in that he has done programs on the topic many times). The topics of the shows play on the bogey of the loss of social order and on the need for authority as much as they titillate through the possibility of transgression. However, the *Morton Downey Jr. Show*

(1988–1989) most consistently exemplifies this reactionary populism. His audience was primarily angry young white men (atypical, given the female audiences of daytime talk). His populism entailed, for example, Downey's wrapping his bottom with a U.S. flag and telling his Iranian guest to kiss it. One program also staged a fight between black activists Roy Innis (who was involved in the *Geraldo* fracas) and the Reverend Al Sharpton. Nevertheless, the show revealed the commercial limits of the social antagonisms on which such shows depend; it was so combative that national advertisers boycotted it, forcing cancellation after fourteen months.[27]

On the other hand, daytime talk shows also stage a liberal cultural populism that sees "ordinary people as active pleasure seekers and still trusts in their good judgment."[28] Here, the shows recognize the subversive pleasure that the average person experiences when exposed to the transgressions of the guests. The programs rely on the audience to provide a sense of perspective through a spectrum of opinion. Similar to Pulitzer's *World*, the producers often beguile viewers with hyperbolic titles and openings that promise more sensationalism than the programs deliver. An archetypal *Geraldo* program is "Passion and Cover-ups: Clinton's Accusers" (March 3, 1994), with two Arkansas state troopers who have accused the president of extramarital relations while governor. Geraldo begins:

> These two men made the most scathing allegation against their boss saying he was a philanderer, a wild and crazy uncontrollable sort of guy who put sex ahead of duty and fidelity. . . . Their former boss is of course the forty-second President William Jefferson Clinton.

After quizzing the troopers about Clinton's affairs, Geraldo asks about their reputations for adultery, insurance fraud, wife beating, and drunk driving. Then he turns the questioning over to the audience:

> Audience Member #1: How can you sit there and pass judgment on the President when they both sit there like they're proud? And they both also . . . you cheated on your wife as well.

> Audience Member #2: If Hillary doesn't care, why should we? (Resounding applause) And as far as Clinton's sex life, who gives a damn?! And our constitution, where is it written that we should

have a puritan for a president? . . . What is critical is what the man is doing for the country.

Audience Member #3: What does sex have to do with running this country? This happened before we elected him. Why didn't you [speak up] then? Who cares now?

Audience Member #4: Can't we judge Bill Clinton's ethics, morals, performance by his actions on the job, by his presidency and leave his love life out of it?

The audience takes on the guest accusers as well as an expert, cross-examining them from a commonsense understanding of the difference between the public and the private, and of fair play and a live-and-let-live philosophy. The program slowly shifts from its somewhat prurient opening to a succession of rather staid testimonials and reprimands.

One can see a comparable outlook on *Donahue's* "Postmenopausal Sexpots" (April 13, 1994). Donahue begins by setting up a titillating debate on the morality of older women's having sex. He brings on a daughter who is upset by her mother's lack of propriety. Prompted by Donahue's soft joshing, audience members slowly rise to announce support for the older women. The concern is still moralistic (Is it for love or sex?) and fear of the destruction of the family unit still underlies the discussion, but a spirited permissiveness ("No one is hurt") wins out in the end. As the final credits roll, an audience member sums up the collective ethos: "As a younger woman, it gives us a lot to look forward to. And I am glad to know." Like Pulitzer's populist ideology for the *World's* diverse immigrant readership, this leniency of the daytime talk show audience comes from the values of the big city. New York and Chicago studio audiences live the heteroglossia of American culture daily, unlike rural American's more conservative and homogeneous milieu.

Finally, daytime talk shows—more than other present media institution—have mined the journalistic traditions of "the sob sisters" of the early tabloids (1900s–1920s) for their style and content. Women writers who worked for Hearst, Pulitzer, and the other yellow journalism czars produced the most sensational and emotionally manipulative accounts of crime and scandal in the early twentieth century. Reputed to be the best at interviewing and colorful reporting, they were assigned the human interest side of trials, executions, and disasters. Like Rivera's opening of Capone's vault or Winfrey's taping of a show in a racist Georgia town, they

were known for their investigative stunts, such as using disguises to gain entry to forbidden places. Consider the comparable ambiguity of Donahue's campaign in 1993 to tape an execution for his program. Was it a muckraker's attempt to uncover the horror of capital punishment? Or was it a pandering to the voyeuristic impulse?

The sob sisters often manipulated the subjects of their stories by gaining their confidence in order to elicit information, and then relayed the intimate discussions to a considerable audience. Daytime talk show hosts are quite likely to engage in a similar practice. TV producers' lack of concern for the "authenticity" of their guests and the guests' stories parallels the women reporters' often exaggerated or even fabricated accounts. In 1897 Ada Patterson of the *St. Louis Republican* interviewed Dr. Arthur Duestrow, son of a St. Louis millionaire, on death row for the murders of his wife and daughter. She wrote expansively: "He seized [one of the women] by the ankles and dashed out her brains against the wall." Hearst reporter Winifred Black, masquerading as a boy, got through police lines to report the Galveston, Texas, tidal wave flood in 1900. Dorothy Dix followed the rather dull Carrie Nation as she closed down Kansas saloons in 1901. Dix's descriptions, not the facts, made the story memorable; In her colorful phrase, Nation became "a queer, flowzy, fat unromantic Joan of Arc." It was the kind of overblown rhetoric that is the hallmark of daytime talk shows eighty years later as the shows labor to turn the prosaic into the epic. Consider a program opening for hangovers (April 7, 1994): "Now often the horrifying . . . the embarrassing realization of what exactly we did the night before leads to some awful hangover horror stories!!!" The hyperbole is an attempt to enliven what turns out to be a failed program of unimaginative and banal narratives recounted by average people.

However, it is the human interest story behind social injustice that most connects the sob sisters with the talk daytime talk shows. The event through which they became most well known was the 1907 murder trial of Harry K. Thaw (a wealthy Broadway celebrity), at which they occupied the front row. The focus of their lurid, torrid, and sentimental reporting was the testimony of Evelyn Nesbit Thaw, the defendant's wife, who had been raped by the murder victim. Daily articles under their bylines blew open newspapers' Victorian traditions of modesty. In the 1960s sob-sister descendants Adela Rogers St. John and Dorothy Kilgallen covered the Dr. Sam Shepard trial, and in the mid-1990s the daytime talk show coverage of the O. J. Simpson trial was of the same cloth.

Although *Geraldo* hews closest to the yellow journalism tradition, all the daytime talk shows depend on the play between social injustice and human interest. Rivera, Donahue, Raphaël, and Winfrey began as

television journalists who had a professional stake in social topics as opposed to the newest generation of hosts in the 1990s out of the entertainment industry, such as Ricki Lake (actress), Jenny Jones (comic), and Susan Powter (exercise guru). For example, Rivera began his career as the crusading left-leaning journalist/lawyer Jerry Rivers in the 1970s. As a Puerto Rican and Jew, he (like Donahue, who is white Irish, and Winfrey, who is black) uses his ethnic affiliation to stage his anger as an underdog. With the Hispanic name change to Geraldo Rivera, he advertises his affinity with the disenfranchised or "the people."

Rivera was hired to "fill an ethnic niche" on a local New York station.[29] As a TV reporter in 1972 he sneaked into Willowbrook State School, a mental institution, and reported, while sobbing, on its deplorable conditions: "It smelled of filth, it smelled of disease, and it smelled of death." He gained part of his populist reputation as a reporter by following Cesar Chavez into the fields as Chavez tried to organize migrant workers. Later he reported for *Good Morning America* and *20/20*, quitting over the network's squashing of a story about Kennedy and Marilyn Monroe—now a common type of topic for daytime talk shows. The title of *Geraldo's* production company, Investigative News Group, astutely advertises its muckraking affinities. Like Pulitzer, who innovated the use of nonofficial "street" sources for news, *Geraldo* has a production unit that combs the back streets of New York City and develops programs out of its contacts with the drug users, pimps, prostitutes, and criminals who often function as sources and guests.

The opening of a *Sally* program also demonstrates how daytime talk shows continue the sob sister sensibility. A murderer describes in intimate detail the particulars of her crime to the host who is cast as her friend (whom she calls "Sally"), as they sit in a private, albeit televised, living room. Comparable discussions took place on "Fugitive Women: The Kitty Dodd Story" (*Oprah*, April 13, 1994), "The Caning of Michael Fay" (*Donahue*, April 18, 1994), "The Ruth Finley Case" (*Oprah*, April 25, 1994), "Homicidal Drama: The Norman Larzaler Family" (*Geraldo*, February 9, 1994), "Who Killed Janet Myer" (*Sally*, February 17, 1995), "Shooting Victims Confront Their Shooter" (*Sally*, February 28, 1994), and "Lyle Menendez: How the Jury Got So Deadlocked" (*Donahue*, February 2, 1994).

But as a whole, instead of these larger-than-life news stories of crime and scandal, the shows have taken everyday intimacies and turned them into larger-than-life dramas by reenacting them through confrontation. Like the Ada Pattersons of the turn of century, the hosts (continuing the feminine tradition) trade on their girl (or boy)-next-door interview skills to create a friendly familiarity and to deflect awareness of the inequities of

corporate control of and gain from the situation. Consider the frequent "I like you . . ." trope of Winfrey when she parallels her emotional reaction and experience to the guest's and thereby wins her or his confidence. Through such verbal juggling, imbalances can be effaced. Oprah's weight problem can be made oddly comparable to that of a hugely obese woman.

The programs also trade on the social importance of the confession for other viewers who might be in "similar" situations. Like the killer who acknowledges guilt to journalists, the daytime talk show guest is often urged to leave a social legacy whereby the public can somehow profit. "What do you want America to learn from your situation?" prompts Raphaël of serial killer Carol Bundy. What has changed in the decades since the sob sisters is the means of distribution. The daily televised Simpson trial has replaced the daily newspaper reportage of the Thaw trial as the sensationalized "trial of the century." The ever-present TV cameras' footage goes instantly across the country and the world and into the home. Today we televise the event and news—seeing has supplanted reading as credible evidence. Talk shows re-create and intensify the human drama, using the same language as sob sister journalism which has been described as "exciting, sentimental, prurient, mawkish, soppy—and tear-jerking."[30]

Advice to Women:
The Voice of Authority in Daytime Talk Shows

If the daytime talk show host's function is derived from that of the tabloid news reporter, the expert descends from the early tabloid's women's page and advice columns. Today's expert is usually a woman with an advanced degree in psychology or a health-related field. Dr. Joyce Brothers is the prototypical expert, but it was Dorothy Dix, a leading sob-sister reporter, who innovated the women's advice column as a staple of twentieth century tabloid newspapers. Her columns consisted of intimate letters from readers and her counsels, which were replete with middle-class morals. By the 1920s women giving advice on behavior was standard fare in the newspaper, radio, and publishing industries. However, programs devoted to psychological or even general behavioral advice were a rarity on TV for its first two decades. Only with the daytime talk show in 1980s did television establish a generic forum for the moral and behavioral training of women.

From the 1870s to 1917 American interest in manners generated a near industry devoted to advice. Every woman's magazine took on the burden of upgrading morals and deportment. *Harper's Bazaar* turned out

a manual, *The Bazaar Book of Decorum* (1870), *American Queen* compiled its writings into *The American Code of Manners* (1880), and *Delineator* published *Social Life* (1889).[31] The surge emanated in part from the influx of immigrants; the gentility wanted to exert social control and impose class distinctions. "As etiquette authorities now saw their mission, it was to instill a more aristocratic style of behavior, one consonant with the improving fortunes of the middle class."[32]

Pulitzer innovated the women's advice column in newspapers in the 1880s as an extension of women's pages and the advertising of consumer products. Articles reflected the traditional conception of the domestic interests of women: etiquette, fashion, beauty, recipes, and interior design. Concurrently, *Ladies' Home Journal* hired Isabel A. Mallon ("Ruth Ashmont") to conduct a department on "social propriety and heartaches" for the women's magazine.[33]

Articles that dictated correct behavior were the overall favorite of women readers.[34] In 1883 the *World* built a column around letters from Edith to her country cousin Bessie, instructing the rustic who was planning to move to the city. The conceit allowed the transmission of New York's social conventions, such as calling cards, male escorts, and proper attire. Daytime talk shows often stage this big city sophisticate and rube scenario when middle-class experts from New York and Chicago lecture audiences from middle America and the rural lower class on acceptable behavior. Even though the majority of most audiences are from metropolitan areas, the age-old stereotype of the rural hick as an innocent or an ignoramus continues to appear in higher-brow humor and cartooning, from *David Letterman* to the *New Yorker* to major newspapers. The image of the trailer park is continually evoked as the source for the guests on talk shows.

The early advice columns depended on domestic topics similar to those on the daytime talk shows—ones often suggested by the public. An 1880s column, "Jennie June's Melange"—styled as breakfast table chatter—discussed topics ranging from dieting to women's equality. It was followed by "The World of Women," "Doings of Women Folk," and "Grandma's Wise Advice;" whose content spanned descriptions of the wealthy and famous such as the First Ladies, to "castigating the most traditional of all villains, the husband."[35] For example, "Ruth Ashmont's Side Talks with Girls" in *Ladies' Home Journal* generated more than 158,000 letters in sixteen years.[36] The outpouring of letters to the columnists revealed the popularity and profitability of advice in the late nineteenth century, and was a harbinger of the thousands of letters that *Geraldo*, *Oprah*, and *Donahue* receive and use as sources of material and guests.

As time passed the advice column became the province of famed genteel women, models for the daytime talk show host. Dorothy Dix (the nom de plume of Elizabeth M. Gilmer)—the woman most closely associated with this tradition—began her column in New Orleans in 1896 and it ran nationally through the 1950s. In 1898 Beatrice Fairfax (the nom de plume of Marie Manning) began her column in the *New York Journal*. (These columns begot the Ann Landers and "Ask Beth" columns for post-1950s readerships.) These columnists functioned to promote women's rights as well as to control women. Dix is described by her biographer as one of "the greatest of American counselors."[37] The column was first called "Dorothy Dix Talks of Women We Know" but was later changed to simply "Dorothy Dix Talks" in an attempt to appeal to men. It was a conglomeration of etiquette, commonsense advice on the day-to-day trials of marriage, and a tracking of the women's suffrage movement. These columns continued the social reformism of the nineteenth century tabloid on a personal level; they were a means to elevate the manners, morals, and behavior of the commoner. Barbara Ehrenreich and Deirdre English also suggest that the rise of scientific expertise in the late nineteenth century coincided with the rise of women's suffrage and independence from paternal control. Advice (even from leading women) regulated the parameters of this newfound freedom.[38]

In the 1920s radio carried the advice industry forward in the form of daytime programming for women at home. Beginning with the first season of network programming in 1926, the subjects roughly paralleled those of the metropolitan newspaper women's pages. "Betty Crocker: Food Talk" sponsored by General Mills premiered in that year, and by the end of the decade numerous other sponsored shows had appeared (for example, Heinz's "Josephine Gibson," Libby Packaging's "Libby Program," Multi's "Mrs. Julian Health," and General Mills's "National Home Hour"). Shows on beauty were rivals for the homemaker's ear: Wildroot sponsored "Elisabeth May's Wildroot Beauty Chat," and half-hour talks were given by Barbara Gould, Edna Hopper, Frances Ingraham, and Nell Vinnick. The female audience was also the object of with advice on child rearing (for example, "Your Child: Grace Abbott") and etiquette ("Emily Post"), and of inspirational talks ("Cheerio").

The CBS program *Voice of Experience* (1933–1940) is a possible prototype for the TV daytime talk show of the 1980s: social worker Marion Sayle Taylor offered advice on a range of domestic issues having to do with behavior, particularly child rearing. At-home members of the audience participated by donating to Taylor's fund for the less fortunate.

Helping the marginal was motivated by profit. As Wayne Munson points out in his book *All Talk*: "The host worked with people, such as prostitutes, whose lives and experience prefigured the sensationalized, difference-based subject matters of many talkshows today."[39]

What held the daytime radio show together was the voice of a single female authority who served as host and expert, direct descendants of the women who had dispensed advice in print. They addressed the audience at home through viewer mail and seemingly nonscripted responses. Their authority was based not so much on experience as on commercial sponsorship, a credibility that speaks to the power that consumer capitalism had attained by 1920s. Whereas the newspapers separated advertising from other content, early radio and television collapsed the clear distinction. The host was expert and saleswoman, often recommending the sponsor's product as a solution.

What in the nineteenth century had been guidance on correct behavior slowly evolved into psychological advice as the ideas of Sigmund Freud gained currently in the United States in the 1940s through 1960s. Janet Walker has documented how popular culture used these ideas in the 1950s as a means to translate social problems into personal issues for women.[40] Dr. Benjamin Spock and Margaret Mead popularized Freudian psychology and a generalized permissiveness as a tool for women to deal with emotional and behavioral problems in the family.

By 1963 Mead was writing regularly for *Redbook* (a popular monthly with a circulation of 4.5 million). In a column that ran back to back with Spock's, she addressed a range of issues from the fluorination of water to overeating and school prayer. In regard to human behavior, she dwelled on upbringing as the source of adult problems, and often suggested psychoanalysis for a child. A sampling of her articles : "What Does a Man Expect of a Wife? (May 1962), "Double Talk about Divorce" (May 1968), and "Can the American Family Survive?" (February 1977). Consider how Mead approached a classic etiquette question in "What is a Lady?" (April 1963). For her, ladyhood is a matter of social control and personal limitations. She begins by describing how the term "lady" historically was associated with class breeding and how etiquette maintained the class and gender hierarchy to keep women in their assigned place. "Permissive parents" need not worry about such outmoded traditions of gentility; they should allow their daughters freedom and educate them to have "values" and "take responsibility for others," qualities present in a "lady."[41]

It was still radio more than television that was the site for advice for women in the 1960s and 1970s. With the rise of all-news talk radio as a

rival to the "Top 40" in the early 1960s, radio's audience became more fragmented and specialized. News and talk radio were geared to an older audience, and talk stations often subdivided their offerings further, based on gender. Psychological or relationship advice programs were being scheduled for the midday by the 1970s. A format known as "female only, two-way talk" took hold in the late 1960s. Typical was the KGBS (Los Angeles) "Feminine Forum," light, humorous conversations about relationships between women and men, and unrestricted conversations about sex with young women callers, with host Bill Ballance offering advice. The show's success led to imitation throughout the 1970s on radio and later on TV, with the "intense interpersonal focus" of issue-oriented talk shows.[42]

Dr. Joyce Brothers brought together Mead's and Spock's permissive psychology and the interpersonal focus of radio to television. *Current Biography* describes her as "a smooth blend of Dorothy Dix and Sigmund Freud."[43] Even with a doctorate in psychology from Columbia University, she never has been a practicing clinical psychologist. It was TV that constructed an identity for her in that regard. Her earliest renown came as an "honest" participant and winner on the *$64,000 Question*. In 1955 she began appearing on celebrity talk shows, dispensing quirky intellectual knowledge and lively talk. In 1958 NBC offered her an afternoon show, the *Dr. Joyce Brothers Show* (perhaps the first of the genre), during which she counseled and advised on love, sex, and child rearing.[44] She received more than a thousand letters a week from listeners. Considered a pioneer, she broke taboos by discussing frigidity, impotence, sexual satisfaction, and menopause on a broadcast medium. She became a syndicated counselor with *Consult Dr. Joyce Brothers* (1961) and *Tell Me, Dr. Brothers* (1964), as well as a call-in radio show host (WMCA, New York) and a monthly columnist for *Good Housekeeping* (1964–). She also coauthored *Ten Days to a Successful Memory* (1957), a self-help guide, and has been a consultant for Magee Carpet Company, Greyhound Bus Lines, and Sperry Hutchinson Company, advising on feminine taste.[45] A frequent guest expert on 1980 talk shows, Brothers is emblematic of talk show experts because of the several applications of her specialty.

In my survey of three months of daytime talk shows in the spring of 1994, Brothers appeared only twice. A *Sally* program (March 3, 1994), "When Husbands Are a Bad Influence on Their Kids," exemplifies her style. Introduced as "a friend of the show," a matronly Brothers discusses quietly and slowly how a fathers' disparaging treatment of a daughter leads to low self-esteem in the child. This program and discussion of sexism and female self-esteem are paralleled in another *Sally* program

(March 29, 1994) with a different psychologist (see chapter 3). Such replication speaks to the limits of educated communication within the constraints of mass-consumed therapy. The expert evokes a socially current trope or discourse (for example, self-esteem, twelve steps, multiculturalism) as shorthand for a wider sensibility or practice. This part for the whole leads to the fragmented nature of discussion on the shows as commercial breaks rule the structure and dominate the time. And Brothers is a master of media-pleasing homilies as she gamely alludes to men's having a "period," or a monthly emotional cycle (to the glee of the audience), just as the program cuts to commercial.

Yet a makeover show on *Geraldo* (February 4, 1994) dedicated to "Peg Bundy Moms" represents Brothers' iconic symbolism. She is presented as a guest and her daughter describes her appearance as "too conservative." To audience hoots and whistles, an "improved" Brothers appears highly made up and wearing a low-cut, studded leather dress à la a "motorcycle mama." This bit of theater (a dressing-down reminiscent of a drag show) reveals the degree to which Brothers is so associated with the matronly advice tradition that she has become a self-conscious or ironic figure.

Brothers has been replaced by a generation of new and "serious" experts on daytime talk shows. The field is dominated by psychologists, psychiatrists, psychotherapists, social workers, and relationship counselors. The next level of frequency is occupied by writers of self-help books (for example, Ruth Jacobvitz's *150 Most Asked Questions about Menopause*). After them are bureaucrats who manage social welfare and health agencies (for example, Dr. Eric Hollander of the Mount Sinai School of Medicine), elected officials (for example, U.S. Senator Orrin Hatch, Utah), academics (for example, Dr. Sherwin Nuland, Yale University), religious leaders (for example, Rabbi Marvin Hier, Simon Wiesenthal Center), lawyers (for example, Alan Dershowitz), and journalists (for example, local investigative reporters). They distill their social knowledge into uncomplicated explanations, formulas, and advice for a feminine viewership that is defined by family, relationships, and faith. Janice Peck suggests that these experts function as the "application of social scientific knowledge for the purposes of bureaucratic control." The power balance between such experts and the "ordinary" guests is grossly distorted. Typically, the advice addressed to women is based on relational issues and women's ascribed deficiencies in communicating. Here, experts who are trained in the skill tell guests that they need professional help to learn to communicate "normally," like the expert does. Such circular reasoning ensures the centrality of bureaucratic control and discourse.[46]

TV Antecedents of Issue-Oriented Talk Shows

Several 1950s TV genres presaged the ingredients that became the mixture of women's topics, advice, and audience interaction of talk shows in the 1980s. Since network TV's debut in 1949, prime time has been its focus and daytime programming has been secondary. In the early days of TV, daytime public affairs programming was the province of radio because of its limited visual appeal. The network daytime schedule was mainly filled with drama—specifically the soap operas that had formerly been in radio.

Of the small percentage of daytime talk shows devoted to women that did get aired in the 1950s, the majority were ephemeral, lasting under a year. Maxine Barratt hosted *And Everything Nice* (1949–1950), a Dumont network show for women. *The Kathi Norris Show* (1950–1951) ran on NBC for seventeen months. *The Lili Palmer Show* (1951) a talk show for women, ran Thursdays on CBS for less than half a year. CBS's *Meet Betty Furness* (1953) aired for six months on Friday mornings for fifteen minutes of interviews with celebrities and discussion of domestic issues. More ambitious informational and less gender-specific programming in daytime scheduling arrived in 1952 with the debut of *Today*, a morning show of news summaries every half hour interspersed with features, interviews, and the weather.

NBC's *Home* (1954–1959), a "woman's magazine of the air," was the first major attempt at broadly informational programming geared to women. Created as a logical extension of *Today*, it was modeled on early women's magazines and hosted by Arlene Francis as "editor-in-chief." Several editors organized segments and appeared as experts within them. In 1955 Natalie Cole was the fashion and beauty editor; Katherine Kinne, the food editor; and Dr. Ashley Montagu and Dr. Leona Franzblau, the family affairs editors. *Home* was organized somewhat like the women's page of a newspaper; radio's various talk shows were condensed, combined, and organized into an "umbrella" program. The psychological or behavioral advice that would characterize daytime talk shows in the 1980s was labeled "family affairs" and guided by professionals who doled out their expertise in advice about children and family relations to the woman at home. The authority was top down; there was no studio audience participation.

TV news, public affairs, and informational programming of the 1950s did not see the advantage in active audience participation. However, the studio audience was an important element in early variety, musical programming, and game shows inherited from radio and vaudeville, such as

the *Tonight Show* (1954–) and *You Bet Your Life* (1950–1961). Even so, the major early-days predecessor for the discussion of social or personal issues by a studio audience was ABC's *America's Town Meeting* (1948–1952). Begun on radio in 1935, the TV version featured public affairs discussion in which a guest speaker and the audience would debate the issue of the day. George V. Denny and John Daly hosted this prime time attempt at televised participatory democracy.

The history of *Town Meeting* reveals that public service programming has never come easily to the networks. The original radio show had been conceived as a way to mollify the academics, religious leaders, and politicians who, displeased by the growing commercialization of the medium in the late 1940s, had attempted unavailingly to amend the Federal Trade Commission Act of 1934 such that 25 percent of the broadcast spectrum would be redistributed to public service organizations.[47] Seemingly, *Town Meeting* satisfied many people's notion of public affairs programming, but the show was an anomaly; when it ended in 1952 no regularly scheduled show that combined social issues and audience debate appeared until the *Phil Donahue Show* went national in November 1977.

A major reason that issue-oriented talk shows did not materialize until the late 1970s is the undue power that network news departments exerted in the first two decades of television in defining public affairs programming. Daniel C. Hallin offers a cogent analysis of the rise and decline of the high modernist period of TV journalism. The news department was a "privileged and insulated place in the networks for a relatively brief period from about 1963 until the mid-1980s," when traditional journalism suffered from the decline in national consensus.[48] During that time Americans lost a sense of unity in regard to the Cold War, domestic strife surrounded the civil rights and antiwar movements, and the dismantling of the New Deal began. In general Americans grew distrustful of government. Politics became more fragmented, individualized, and adversarial. Hallin argues that the shift resulted in "journalists becoming bolder about challenging political authority as they did most dramatically with the Pentagon Papers. And more profoundly, the old model of 'objective journalism' was giving way to a more active, mediated, journalist-centered form of reporting."[49]

As the Vietnam War became unpopular, TV journalists became more jaded, seeing themselves as vested antagonists of the state, the president, and elected officials. They shed their allegiance to objectivity in favor of more editorializing as political advocates. The "high" period of network news organizations, of Edward R. Murrow and Walter Cronkite as symbolic of the noble Fourth Estate, was over.[50] By the mid-1980s network

news was no longer a bastion of distanced reporting of political institutions; rather it was taking on the language of "outrage and pathos" of tabloid journalism and its practice of "dropping neutrality and presenting the journalist as a 'regular person' who shares and champions the emotions of the audience"—a stance often mimicked by the hosts of talk shows.[51]

According to Hallin, the change was also fueled by network economics; the spiral of cable and the deregulation of broadcasting in the early 1980s had brought a drop in profits and in audience share (from 90 percent to 60 percent). Conglomerate takeovers left the parent companies with huge debts. Network news was forced finally to be competitive and profitable. Following the lead of lucrative local news and the tabloids, network news began to mix news and entertainment. The diminishment spilled over into political reporting, an egregious example of which is the one-sided reporting of the Gulf War. The result is what Hallin calls "pseudo-populism":

> Often the temptation of TV news is to push a political story into the sphere of public consensus; so war becomes not a story of political decisions but of individual heroism and the journalist, like the politician, can ride the crest of emotions that pour into such a story.

Hallin warns that the change is dangerous for political reporting for several reasons: "it heightens emotion, makes black and white what is far more ambiguous, and undercuts dialogue in the rush to create consensus."[52]

Considered in light of this history, the issue-oriented daytime talk shows do not represent a sudden tabloidization of the "serious" traditions of network news and public affairs. Rather they are part of a continuum of general changes in news and public affairs programming toward greater profit by creating a broader audience in the 1980s. Talk shows such as *Geraldo* represent an updating of a genre born in 1950s and 1960s that investigated the private or personal side of the news: Edward R. Murrow's *Person to Person* (1953–1961), Mike Wallace's *Nightbeat* (1956–1961), and CBS's *60 Minutes* (1968–). To illustrate, *Person to Person* followed a celebrity around her or his home as Murrow's questions and the camera explored the private life and belongings of the individual. The networks constructed news magazines such as *60 Minutes* with "eyes through which 'ordinary' people see and judge the world."[53] When *60 Minutes* premiered, its three stories in one hour were seen as a vulgar attempt at popular appeal and "an affront to the traditional hour long documentaries."[54]

In any event, daytime talk shows were one result of the breakdown in political and journalistic consensus by the 1980s. The appearance of the *Phil Donahue Show* in Dayton in 1967 can be directly related to the rise of identity politics within the civil rights and women's movements (see chapter 5). No longer was the audience to be deemed an undifferentiated mass. Americans began to define themselves by social differences such as race, gender, class, generation, and politics. The civil rights movement crystallized in the late 1960s into the black power movement, student anger coalesced around the Students for Democratic Society, and women began the early consciousness-raising groups of the feminist movement. With his early on-air support of the women's movement, Donahue directed his appeal openly to women who were newly conscious of their social role. Sensing the new audience identities, television responded to this new potential market. So, for example, the *Pamela Mason* celebrity talk show for women (1965) resurfaced in 1968 with the more socially conscious title *The Weaker? Sex.*

Nor was it now acceptable for citizens within the protest culture of the 1960s to acquiesce in the unquestioned authority of the dominant discourses of news anchors and public officials. Communication ("Let's rap") was the buzzword. Participatory talk shows were where common people could express frustration with the impersonal state and society. It is not surprising that *Donahue's* first program in Dayton was on the relation of church and state, with atheist Madalyn O'Hair. It was emblematic of the growing divisions in the foundations of American culture—no longer did women represent a genteel or submissive class who accepted the dictates of church, state, and televised expertise.

Economically, daytime talk shows came about as TV stations redefined their public affairs programming in light of competition from cable in the early 1980s. Nighttime talk shows were to be flagship programming for the networks; the daytime talk shows were cheaper and produced by nonnetwork syndicators. Their emphasis on socio-psychological issues gave them a broader appeal than network news, although news itself was taking on an entertainment-orientation and increasingly being narrativized around character identification through a focus on individual circumstances. Shows such as *Donahue* filled those needs.

A second major influence on daytime talk shows was the celebrity talk show, specifically the *Tonight Show* (1954–). A direct descendent of nineteenth century vaudeville, the celebrity talk show evolved from radio variety shows, on which former stage performers (musicians, comics, and novelty actors) would do short one-acts and a dominant host would organize the show for the listening audience. Although *Broadway Open House*

(1950–1951) was the first late-night talk show, the *Tonight Show* became the most successful. NBC shifted the format away from the slapstick vaudevillian of the earlier show toward the more relaxed conversational tone of the later. Through the periods of Steve Allen, Jack Paar, Johnny Carson, and now Jay Leno, the format has remained the same. After the host's introduction and a warm-up of stand-up comedy, come celebrity appearances consisting of interviews and performances. *Donahue* and other daytime shows have somewhat the same structure, but their guests are representatives not of the entertainment industry but of a social or emotional problem. The performance of music has been replaced with a series of emotional conflicts as a show adds new guests and the potential for a new lively performance.

Daytime talk shows are different, however, in their nonnetwork status; they are second-class, or "degraded," as syndicated programming and hence are allowed a degree of tawdriness or a moral latitude not found on prime time. The first wave of daytime talk was ninety-minute syndicated celebrity shows, for example, the *Gypsy Rose Lee Show* (1965), the *Mike Douglas Show* (1963–1982), *Merv Griffin* (1972–1982), and *Dinah!* (1974–1980).[55] They mixed interviews with entertainment celebrities, political figures, and domestic experts—all touching on topics that can be the focus of *one* issue-oriented talk show episode. For example, *Girl Talk* (1963–1970), the longest-running talk show devoted to women, featured Virginia Graham discussing a variety of women's issues with female celebrities and authors. The strategy of the show was to place female celebrities who were "known" antagonists on the same program, hoping for a clash or a "cat fight"—presaging the interpersonal conflicts on *Geraldo* and *Oprah Winfrey*.[56] Such staged confrontation was rare on network talk shows.

Two important exceptions existed within the celebrity talk show model in the late 1960s: the *David Susskind Show* (1958–1987) and the *Dick Cavett Show* (1968–1975). *Susskind* was a New York–based, issue-oriented show where the format of one topic and three to seven guests dominated. The guests—important figures from political, intellectual, and entertainment circles—debated a current news issue for an hour and a half. The show was syndicated on local big-city educational stations. *Susskind* presaged PBS's *Firing Line* (1966–) with William F. Buckley, Jr., an example of today's political discussion show.

Cavett was more typical of the networks' response to the changing political climate of the late 1960s. It was conceived as ABC's celebrity talk show to rival the *Tonight Show* and began in March 1968. Although the content mimicked the competition's, the show brought on more politically

topical guests. It exploited the confrontational mood of the period, often putting prominent figures against known or potential antagonists. As a result, there were famed blowups in the late 1960s and early 1970s, such as Lester Maddox's walking off the set, angry at Cavett's pointed questioning; the sparring between Norman Mailer and Gore Vidal; and Lily Tomlin's departure from the program in response to Chad Everett's sexist references.

As the celebrity talk shows grayed and American culture became more open, network affiliates relinquished their moral guardianship of daytime programming in favor of immediate profits in the early 1980s. *Variety* proclaimed that talk shows were "trying to ride with the new youth wave," when syndicated discussions of sex, crime, and politics replaced celebrities and chatter."[57] New talk shows cashed in on countercultural values—social issues, sexual liberation, and confrontation. *Oprah, Sally,* and *Geraldo* were off and running.

Even though daytime talk shows are considered a form of national programming, issue-oriented talk shows started as a local phenomenon in the Midwest. (Only *Geraldo,* which began late in 1987, has its origins in New York City, accounting for its more open muckraking tabloid character.) Dayton, Ohio is the generally acknowledged birthplace. It was there that, while coanchoring the local news, Donahue produced and hosted a phone-in radio talk show, *Conversation Piece,* that offered advice on issues ranging from the domestic to the social. A local VHF TV station (WLWD, owned by Avco Broadcasting, a midwestern chain of stations) was losing its popular singer/variety host and hired Donahue to do his radio show as a TV show.

The issue-oriented talk show format materialized not because of a political agenda of the creators of *Phil Donahue,* but, rather, from economic expediency. A local television talk show could not lure the "names" who were the main attractions of variety and celebrity talk shows. Instead, *Donohue* put controversial issues center stage, with single or multiple representatives of the issues, allowing the studio audience to develop the show's volatile potential. *Donahue* made the everyday controversial. His autobiography gives an example of the format in a program concerning a woman whose daughter was on a fast in Greene County Jail to protest the Vietnam War:

Audience Member: What if she dies?
Mother: If she dies, she dies.
Audience Member: You might have an obligation to her.
Mother: You have an obligation to the men coming home dead
 from Vietnam.[58]

The format was a ratings success and Avco stations in Detroit, Cleveland, Cincinnati, and Columbus picked up the show. Growth stalled at thirty eight cities because guests and subject matter were limited in a medium-market city.

In 1973 *Donahue* moved to Chicago—where it had a seven-market reach—and was produced by the independent mega station WGN. It then began its present scheduling of issue-oriented programs interspersed with celebrity interview programs. A series of programs brought about boycotts by local stations that carried the show: the on-camera birth of a baby (Cleveland, "too graphic"); footage of an abortion (10 percent of stations, "too graphic"); footage of a reverse vasectomy and tubal ligation (WGN, "too educational for women . . . and too bloody"); the appearance of parents of gays (Springfield, Mass., "a touchy subject"); guest sex researchers William Masters and Virginia Johnson (Medford, Ore., "tantalized the audience by talking about homosexuality"); lesbian mothers (Seattle, because of "fathers' legal suit"); and mistresses of married men (Springfield, Mass., no explanation).[59]

"Censorship" intensified when the NBC affiliate WNBC in New York began carrying the show in 1977. The network imposed a strict paternalistic censorship policy in the New York market. According to Donahue, "WNBC felt a need to protect women from material it decided was too sexual or too visually explicit, like the film of hip-reduction surgery that showed the bare buttocks."[60] But during this time the show aired heated debates between Phyllis Schlafly (anti-ERA activist) and Eleanor Smeal (head of the National Organization for Women); Edward Cole (retired president of General Motors) and Ralph Nader (consumer rights advocate); and Eldridge Cleaver (self-confessed rapist and author) and Susan Brownmiller (feminist and academic).

Donahue also participated in the inflammatory tabloid culture by putting David Duke (grand wizard of the Ku Klux Klan) and Frank Collins (head of the American Nazi Party, in storm-trooper regalia) on stage together in July 1979. The show even went so far as to do a program on an eight-foot-tall woman and seven-hundred-pound twins to promote the book *Freaks*. By 1979 *Donahue* was reaching 9 million viewers through a 178 stations, which made it more popular than the *Today Show* and *Good Morning America*, but more important, it had a rating slightly higher than the *Tonight Show*.[61] *Donahue* was hitting a new nerve by giving prominence to a marginal culture. The fears of the dominant culture were unwittingly portrayed by a *Newsweek* writer when he fretted: "One sometimes suspects that Donahue's idea of the perfect guest is an interracial lesbian couple who have a child by artificial insemination. Sure enough, that couple

appeared last March."[62]

Sally Jessy Raphaël got her start in broadcasting in Puerto Rico as a radio talk show host, went national with a radio advice show on NBC's *Talknet* in 1982, and began hosting a local TV celebrity talk show in St. Louis in 1983. She describes her radio roles as "the Dear Abby of the air waves," responding to call-ins with matronly advice based on her own experience.[63] After she successfully substituted as a host for the TV talk show *Braun & Company* in Cincinnati, the show's parent company, Multimedia, capitalized on her radio following by creating the low-budget St. Louis TV show *In Touch with Sally Jessy Raphaël*. Aware of *Donahue's* success with more news-oriented personal issues, the show differentiated itself by focusing on purely personal issues, or what Raphaël describes as "ordinary people caught in extraordinary circumstances of danger or tragedy or crisis such as rape and incest victims."[64] But it was her continuing radio show that gained her a national reputation: it was heard on 130 stations in 1987. In that year the TV show moved to New Haven, where proximity to New York and a large major market meant greater prominence.

Oprah Winfrey also began as a local talk show host. Unsuccessful as a TV news feature reporter and news coanchor for a Baltimore ABC affiliate, Winfrey was demoted to hosting a morning talk show, whereupon its ratings rose considerably. She was offered the host slot on *A.M. Chicago*, a half-hour morning talk show in 1984, and immediately gained the highest ratings for that time period, beating out *Donahue*. In 1986 the show was renamed the *Oprah Winfrey Show*, made hourlong, and syndicated nationally. *Oprah* combined *Donahue's* public-sphere orientation with a much more intimate style: the host breaks through the traditional distanced-adviser role and becomes as much adviser as guest-in-need. In its first five months *Oprah* became the third-highest-rated syndicated show behind *Wheel of Fortune* and *Jeopardy!*, and the leading daytime talk show. It reached between 9 and 10 million viewers daily in 192 cities. In 1986 Winfrey was nominated for an Academy Award for her portrayal of Sophie in Steven Spielberg's *The Color Purple*. The film not only increased her name recognition but elevated her credentials as a committed and serious celebrity due to the film's portrayal of the racial plight of black women. No longer was Oprah Winfrey simply a TV personality; she had the multidimensionality of a "star."

Winfrey's salary (estimated to be $8 million) and 25 percent of the show's gross profit allowed her to buy the production rights of *Oprah* from the ABC affiliate in Chicago in 1988. She created HARPO Productions, Inc.—the first black-owned film and television production studio. During the 1988–1989 season the show's profit was $50 million; Winfrey herself

earned $40 million. By 1990 her daytime ratings were calculated to be higher than those of many prime time programs. It is *Oprah's* popularity and profitability that are responsible for the cultural currency of the daytime talk show in the 1990s.

Talk, Tabloids, and Stereotypes:
"Women Transsexuals: You're Not the Man I Married"
(*Geraldo*, February 14, 1994)

The success of *Oprah* and other daytime talk shows is frequently indicted because it hinges on the manipulative use of guests and audience to create a sensationalized and unhealthy image of human interaction. There is no question that these shows depend for the most part on social stereotypes—the "black-and-white" reductions that Hallin warns are the problematic character of tabloid culture. In fact, stereotyping is one of the most-often-lodged criticisms of the shows.

Deborah Lupton argues that the shows manufacture a clear split between normal and abnormal behavior by dividing the audience and the guests, "marking the guests out as 'strange' and 'unusual,' forced to justify their choice of lifestyle to an audience positioned as uncomprehending, hostile, confused, viewing the guests' narrative with suspicion as abnormal and inexplicable."[65] What is left unexamined by Lupton and by other such critics is the hazy line between the acceptable or "realistic" portrayal of a social type and a stereotype, a representation based on prejudice and fear. To reveal this all-important tension in popular representation, I want to examine a *Geraldo* program on women transsexuals—a topic that typifies what faultfinders condemn as the "freak show" aspect of daytime talk. Here, we can begin to understand the problematic concept of the tabloid stereotype.

The *Geraldo* program presents the conflict between Bobby and Donya, former husband and wife. Donya maintains that Bobby deceived her during courtship and marriage by maintaining he was a hermaphrodite (an animal or plant having both female and male reproductive organs). Donya is tormented because she realized after several years into the marriage that Bobby was not a man but "a woman." She wants revenge by publicly denouncing him on national television. According to Bobby, Donya's anger has turned into an obsession. She is stalking and harassing him and his new wife. All Bobby wants is for Donya to stop. Donya is joined by her mother. And Bobby is accompanied on stage by his new wife, Alice. Rivera set up the story:

Wait til you hear this all-too-real story that comes out of Alaska. This is Donya. Donya claims to have met, fallen in love with and married Bobby, the man of her dreams. Bobby said things to Donya that every woman wants to hear from a man. Bobby is backstage. I will be bringing him out shortly. Donya, why don't you read that letter. Why don't you tell us some of the things he said to you, this *manly* man.

Donya [reading the letter]: "My sweet beautiful lady, I just wanted you to know that I love you with all my heart. And I cannot wait until we become one. The beauty you have is only surpassed by the beauty you have inside. I will always keep you safe. I love you . . . [sob] and want you to be my wife, my friend, my mate. Love Bobby." [sobbing]

As Richard Dyer reminds us, all societies depend on stereotyping as an "ordering process" to make sense of the massive and chaotic information received.[66] We organize representation through generalities, patternings, and typifications. *Geraldo*, like any social representation (but especially one constrained by the limits of one hour) must construct a shorthand to deliver a story and a host of complex connotations. Here, we have Donya, "the woman." Not only is she constructed as the "misled innocent" but we are "telegraphed" that she is a traditional woman ("out of Alaska"). She is further represented as typical of *all* women in her romantic desires: to be with a man, to be sheltered, and to be objectified as "beautiful." At the least, this is a problematic typing of womanhood on a program that purports to be an objective discussion of female transsexuality. Nevertheless, the program constructs her as a sympathetic figure or what Dyer sees as an acceptable "social type."

Television and talk shows in specific are not arenas for subtle representations of individuals. What we normally associate with "realistic" portrayals are novelistic characters, figures defined by a number of developing traits across the narrative. The novel is based on the growth of a complex character or the protagonist. It centers on understanding her or his unique individuality rather than on how the individual functions within society. When a particular character becomes a social representative, the story returns to the individual as a unique figure through personal or psychological solutions. The character loses connectedness to society by virtue of her or his uniqueness. If the character remains in the social world, she or he is known as a type.[67] Social types are people we

think of as in our society; stereotypes are people who do not belong—outsiders. The movement between social type and stereotype is subtle in society. Talk shows depend on a game manipulating the ambiguous difference between the social type and the stereotype.

As children of the advice industry, the shows are ideological debates about acceptable social behavior. Guests and audience members are representatives of social behaviors; they are initially deemed social types. Consider how Rivera introduces Bobby:

> Bobby, when we shook hands in the Green Room prior to the program, you had a firm shake. You have a pretty hairy hand there . . . your facial hair . . . certainly make it seem that you are a man. Are you, sir, are you living lie? Are you in fact a woman?"

As in the depiction of Donya, the program depends on people as types. In fact, it is making a claim for the ability to calculate the most basic form of social typing: man or woman. But what is also at issue here is whether these two people are indeed socially representative of the established concerns involved in transsexuality or simply "freaks" or stereotypes living outside socially acceptable norms. However, it is the defining of what is socially acceptable and what is freakish behavior that begins the movement toward their being seen as "beyond the pale" of acceptability. If there is not an established social label for the behavior, then it becomes an unacceptable stereotype.

The program attempts to solve Bobby's gender ambiguity through empirical proof and biological difference, not through social lifestyle. Bobby allows himself to be completely objectified as he responds to questions about his formerly female body. Rivera begins the cross-examination directly: "Do you, Bobby, have a male sex organ? Do you have a penis?" As Bobby replies that the answer is complex, the host interrupts: "That's a yes/no!" As Bobby stutters out, "Yes, yes . . . very underdeveloped," Rivera, ever the investigative journalist, asks, "Is it a penis that looks like a female sex organ?" Donya and Alice jump in and attempt to establish the basic characteristics of a "real" penis and vagina. Donya states that "it's pretty swollen because of the testosterone she takes. But there is nothing penis about it." Alice interrupts, "Bobby doesn't look anything like I do."

Given the indeterminacy of Bobby's sex (talk shows have yet to ask people to expose themselves physically), a second line of proof surfaces: legal or governmental verification. An audience member asks what sex appears on Bobby's birth certificate, and upon hearing "female," responds: "If the government states you are a female then you are a female

(Applause)." Donya chimes in that "she" (Bobby) enlisted in the military as a "female." Bobby and Donya dispute whether he gave a legal deposition stating his sex was female. Given the participants' acceptance of the power of the legal and medical establishment to define Bobby's sexuality, the program is a classical example of what Michel Foucault sees as the monitoring of sexuality in late capitalism. Due to the growing field of sexology where sexuality is medicalized, investigated, and categorized, the state, the medical field, and the media have been accorded exceptional power to define acceptable sexual behavior and ultimately control it.[68]

The uncertainty of Bobby's sex poses the real crisis of the program, not the domestic dispute of two angry former lovers. Even a scientific declaration that Bobby is a hermaphrodite is preferable to not knowing. Within this frame, Bobby would be seen as the sick individual who, as a transsexual, cannot fit in—a classic daytime talk show stereotype.

However, daytime talk shows are much more contradictory than a simple disciplinarian device that controls acceptable behavior through stereotyping. As much as the shows are full of stereotypical moments of asocial confrontations and emotions, they depend on narrative development wherein guests/characters (or at least our understanding of them) often change. *Talk Soup*, the E Network's humorous digest of outrageous moments on talk shows during the week, depends on these moments. Many critics base their negative understanding on a similar generalizing of the part for the whole. Additionally, many viewers experience talk shows in this manner; they watch distractedly and are drawn in mainly by the moments. Yet as anyone who watches regularly can attest, the story and its tenor can change quickly.

The *Geraldo* program on transsexuals is no exception. Across the hour, Bobby goes from a stereotype of sexual deviant to a normative figure of the beset-upon family man. In the beginning Donya is set up as a social type: the strong woman who has been wronged by her "man." The first fifteen minutes are spent developing her character and her side of the story. Bobby sits silent as the camera cuts to him for a visual reaction as a tearful Donya makes her allegations. She is the more complexly developed figure and therefore the more socially acceptable figure. Donya oversteps the bounds of acceptability, however, when she moves from complexity to excessiveness in becoming more confrontational. Bobby's appearance and demeanor as the strong silent "male" (an acceptable social type) increases his credibility. He is bearded, paunchy, and deep-voiced, and wears a suit jacket and tie. He is "all male"; there are no remaining physical signs of his female past. In contrast to Donya, he is a family man as he holds hands with his wife, a classically feminine woman he met at a religious function.

As the intensity and shrillness of Donya's accusations mount ("What he has between [his] legs is what I have between my legs"; "This prosthesis was nothing but a dildo"; "My world went black. I was looking at my own death"; "It was the most vile disgusting filthy degrading thing that has ever happened to me in my life. I'd rather be raped by a herd of donkeys"), so does her lack of credibility. The audience laughter increases with each ever-more dramatic statement. Bobby tells of Donya's various forms of harassment of his "family," causing one audience member to congratulate him on his perseverance. Rivera underlines Bobby's growing believability: "But Bobby I ask you, man to man, have you, sir, ever been dishonest to Donya, your former wife?" Bobby's "no" is not remarked upon by the host; Bobby has withstood the challenge and given a "manly" answer.

In the last five minutes the therapist, that accepted arbiter of behavior, resolves any ambiguity about the program's position on transsexuality. Dr. Sharna Striar, Ph.D. ("relationship therapist"), responds to Rivera's request for the "headlines" of the situation: "It does not really matter whether you are a hermaphrodite or a transsexual. [Looking at Bobby] It seems like your life has moved on. [Turning to Donya] But yours hasn't." Even as Donya interrupts ("I have been raped") and some in the audience applaud her anger, the therapist maintains that the issue is to move beyond this conflict. Friends of Donya testify that she needs help. Rivera closes by telling Donya that he sees her hurt but she needs to get past Bobby; he offers her paid therapy. He also offers to pay for a physical for Bobby to resolve his sexual status. But in each case there is a rider: a return appearance to share the results.

Commercial profit from the creation of stereotypes is as old as industrial capitalism and the mass-produced tabloid culture. The obvious economic and class inequalities of a multimillion-dollar show turning the lives of working-class people into commercial fodder rankles viewers and critics. But all of society depends on stereotypes. On January 15, 1884, the World reported that a thirty-eight-year-old woman had just realized that she had been a man all her life and was now engaged to be married to a woman. According to George Juergens, the story garnered such public interest that the newspaper ran a follow-up, "How She Got Her Boots On," which described the appearance of, and difficulties of male attire for, Mr. Calhoun (a.k.a. Elizabeth Rebecca).[69] To speak of a forerunner is not to excuse the excesses of talk shows but, rather, to place their stereotypes within their social context of the ongoing attempt of tabloids to make sense of difference.

The tabloid stereotypes of daytime talk shows are more complicated,

of course, than surface description illuminates. The *Geraldo* program exchanges the image of a transsexual as a deviant for a transsexual as acceptable family man—a conservative or socially permissive twist on a radical decision unlike the nineteenth-century newspaper, which dwelled on the abnormality of the situation. The treatment by the show disengages the threat of the sexually indefinable, and gives it an aspect that puts it into conformity with the nuclear family. In the end, the shows depend on the nuclear family as their mainstay, contrary to their reputation as a spectacle of deviants. Almost every show plays upon the fear of loss and the triumph of the return of the nuclear family. They make difference familiar. They take deviance and attempt to find a social type to integrate it into the family. At their worst, they ostracize difference as antithetical to the morals of the familial structure. And at their best, they make difference permissible as the nation attempts to redefine the family in the late twentieth century.

TALK IS CHEAP

How the Industrial Production
Process Constructs Femininity

"Do It with Gusto"

Studio Audience Instructions
Phil Donahue Show, March 9, 1994

◈

The *Geraldo* studio audience had grown excited and tense during its two-hour wait for the taping to begin, partly because the topic had been withheld. There was a teasing hint; a flurry of drag queens rushed out, modeled on the stage, and disappeared. We were told how to clap properly, and not to chew gum, wave to our friends at home, wear hats, or mouth the teleprompter along with Rivera. A twenty-five-year-old male producer warmed us up by joking about our sex lives and calling the women "sluts." The audience, primarily women, seemed both angry about and complicit in the program's snowballing production. The tension mounted to near-explosion as Geraldo was about to walk on. Hot lights flashed on and the camera whirled. Then, all of a sudden, the production manager menacingly screamed, "When Geraldo comes out, go BER-SERK!!!" And we *did* as we were told: we all went BERSERK!!!

This was my first experience with a daytime talk show: I was and still am one of those "ubiquitous" women who populate the talk show audience. The television industry argues that the audience is more than eighty percent women, a percentage reflected that day and at all talk shows I have since visited. A studio audience of several hundred people is a far cry, however, from an audience of what is said to be many millions at home who watch daily. Yet, industry researchers maintain that they "know" the typical viewer. As a former *Oprah* publicist put it, the "Roseanne Connor" TV character typifies the viewer of the talk show as a housewife with about a ninth-grade education in a lower socio-economic bracket.[1]

But the industry *does not know* the women who largely constitute the audience. First, TV viewing is a private experience. Through Nielsen's "black box," the TV industry might know if television is on, but it cannot know who is watching and how. Do they "surf" channels, skipping commercials? Do they sit attentively in front of the television set taking in every issue, nuance, and emotion? Or do they walk in and out of the room with the barest of attention, carrying on their household labors? Even with the help of viewer "diaries" and focus groups the industry cannot know its female audience. Statistical research yields only an estimate of who is watching. Nielsen samples 4,000 households to assess the behavior of 240 million people or 92 million households. Audience researcher Karen Buzzard suggests the method's shortfalls:

> There is little doubt that the system is imperfect, that samples should be larger and more perfectly random, that data collection method leaves room for error, that ratings firms make claims for their wares that are unjustified, and that the people who use ratings, programmers and advertisers, do not use always use them with concern for their limitations.[2]

The concept of a knowable audience of women is ultimately a fiction used by producers and advertisers to support their self-ascribed ability to attract specific audiences for specific products and to charge the advertisers of those products accordingly. As Ien Ang argues that "the television audience is not an ontological given, but a socially constituted and institutionally produced category."[3] James Ettema and Charles Whitney point out: "The measured audience is *produced* by research companies, *sold* to the media channels and *bought* by the advertisers."[4] From this perspective, the female audience is a self-perpetuating industry construct that really needs no real women.

More abstractly, the female audience is a discourse, a way of speaking about viewers. Ang reminds us that "the 'television audience' refers first of all to a structural position in a network of institutionalized communicative relationships: a position located at the receiving end of a chain of practices of productions and transmissions of audiovisual material through TV channels."[5] The production of a talk show is a multimillion-dollar enterprise of syndication firms, network affiliates, and major corporate advertisers who do not passively accept that audience viewing is a fiction or even a capricious activity. Audience research produces a form of knowledge undergirding how the producers attempt to weave actual women viewers into their commercial process. The talk show aspires to

produce a certain woman viewer/consumer.

How do the industry and, specifically, the producers build the chain of "practices" called the talk show and its female audience. The process establishes what Julie D'Acci calls the relationship between the terms "woman, women, and femininity."[6] She argues:

> Television depictions, in other words, may have a real correlation to our conceptions of what "woman" (as a notion produced in language and discourse) and "women" (as historical human beings) are and can be. They may take an active part in fashioning our social, sexual, and gendered possibilities and positions, as well as our behaviors and our very bodies.[7]

A range of elements come into play in the attempt to attract women. Some are intentional, such as program topic, scheduling, advertised products, and guest choice. Others are less intentional (ideas about women that are naturalized or unquestioned): scripting, set design, and hiring policies. Nevertheless, the elements create part of the discourse of femininity, which is part of the dominant ideology of television. They create the traits, values, and ideas that a woman understands as "feminine" when she is told that talk shows are for "women."

Precedent exists for the discursive analysis of feminine television, but the usual focus has been the narrative, visual style, or the reception of fictional programming.[8] The notable exception and the model for this chapter is D'Acci's book on the historical, institutional, and textual construction of femininity in *Cagney and Lacey*.[9] This chapter breaks from the textual and reception analyses in cultural studies to look at how the industrial structure or the economic base of a nonfiction television genre broadly defines its audience and therefore its product. Ultimately, the genre's address to women is a by-product of larger institutional practices.

Although Louis Althusser's economic determinism theory has become less popular as cultural studies has searched for a less teleological and more human-centered model of ideology under capitalism, we cannot dispute that commercial TV is unified by an incentive: the profitability to be had in attracting an audience of consumers. Certain practices, activities, and values inevitably result.[10] At this level, talk shows are powerful capitalist institutions that ultimately attempt to convince their viewers of the logic of liberal capitalism and the desirablilty of consumption.

Yet, as many neo-marxists admit, the relationship of the economic base and the institutions that ideologically support the base is dynamic and ever-changing.[11] The production of a talk show—a cultural product—

also cannot be reduced to the equivalent of manufacturing a steel girder— a highly standardized product. No two talk shows are alike. And at times the industry's aims are not without contradictions: talk shows produce some of the most controversial and politically radical moments on TV. But that should not keep us from looking at how the industrial structure and economic imperatives of commercial TV's attempt to control and create female tastes instead of mirroring them. The appeal of talk shows is polysemic—their meaning is read in a variety of ways—but institutional logic is defined by profitability. Nevertheless, we need to look at how feminist values can be taken up by talk shows to produce a large audience and corresponding profits.

One basic reason that such an industry analysis of femininity has not been done is the lack of data. The industry does not publish its assumptions, intentions, or ideas; producers of talk shows are not paid to be self-reflective. For example, when I asked Bert Dubrow, *Sally's* creator and its executive producer for ten years, how he knows what topics interest women he offered a typical response: "I just sense it. I think that I know women. I am married to one."[12] Todd Gitlin suggests the problems of research in the television industry: "Anecdote is the style of industry speech, dialogue is its body, and narrative its structure."[13]

To draw out the complex and unwritten assumptions about women in the making of talk shows, this chapter maps the broad institutional process and hones in on how structures and decisions are affected by the assumptions. The research has five sources: talk show programs; on-location observation (studio audience, control room, the green room, and production meetings); interviews with production and administrative personnel; trade papers and popular newspapers and magazines, and corporate publicity; and commercial audience research (Nielsen, Simmons, and in-house).

Talk Show Economics:
Television, Corporate Capitalism, and Female Culture

Talk shows are part of what Ernest Mandel argues is a general expansion of "the service sector, the 'consumer society' and the realization of surplus-value" in late capitalism.[14] Women dominate this area of the U.S. economy and also the production of talk shows. Talk shows are a nonessential product; they are entertainment and advertising. They also manufacture a social product—advice—that was once provided by the family and by secular and even state agencies but is now the dominion of

professional and lay women. However, even though the shows provide advice in a commodified form, profits do not come directly from the product itself but from the advertising carried. They are a vehicle for the display for consumer products aimed at women as consumers.

Here, talk shows are part of what Mandel sees as the larger "tendency towards an enormous expansion both of selling costs (advertising, marketing, to some extent expensive packaging and similar unproductive expenses) and of consumer credit" in the later half of the century.[15] Talk shows and TV in general represent an elaborate mechanism to reach the woman consumer in a sphere normally separate from retailing: the home. For example, the fashion makeover is one of the most popular talk show programs. An expert advises about makeup, clothing, and hairstyling—all with product tie-ins. In fact, the format for infomercials (a television genre in which advertising and advice are collapsed) so parallels that of the talk show that *Forbes* outlined the subtle differences in an article between the "sell" on a genuine talk show and the "huckster" version.[16]

Ideologically, the talk show between the 1970s and 1990 was indirect in its manufacture of consumer desires. The interchange between the expert and the consumer (the guests, studio audience, and home audience) served as a vehicle to turn women into expert consumers; they weighed and argued over the problem and solution offered by a program. Here, this active consumerism differed from the consumer activism of Ralph Nader or Common Cause. On talk shows women did not need to be protected by law; the programs addressed them as "knowing" or "thinking" individuals. The programs created problems and hence "needs" (for therapy, self-help, emotional support, family). Advertising breaks offered more concrete and immediate responses to the needs: product consumption.

Only the most naive would dispute that in commercial TV, talk shows exist mainly to sell to the woman viewer. They define her in terms of buying potential and, in turn, of profits for advertisers. The profits for talk shows come through distribution fees and the advertising revenues garnered from hundreds of TV stations and advertising companies across the United States. Robert Allen states that as a result of being provided with programming, the viewer becomes a "commodity" sold in lots of a thousand to advertisers.[17] In the talk show business, it is the syndicator or the distributor who reaps the greatest direct gains. For the exhibiting station, talk shows are only a small, albeit important, part of the daytime offering—the honey, so to speak, that attracts women. And for the production company or the producer, profits depend on the popularity of the show or shows and the the syndicator's sales ability.

First Run Syndication

The four most popular daytime talk shows on network TV in 1994—*Geraldo, Sally, Donahue*, and *Oprah*—were distributed by large corporations that syndicate first-run, nonnetwork-produced programs in exchange for licensing fees and bartering advertising. (The right to sell a portion of advertising time through the local station—the majority case.) They ran primarily during fringe nonnetwork periods—periods in which women viewers dominate. According to the Federal Communications Commission (FCC), syndicated programs "are sold, licensed, distributed, or offered to television licensees (usually network affiliates) in more than one market within the United States for noninterconnected (i.e., nonnetwork) television broadcast exhibition."[18] Unlike the syndicated network reruns (*Cheers, Seinfeld, Murder She Wrote*) the four syndicated shows were original (or first-run) shows produced by a syndication company (Multimedia for *Donahue* and *Sally*) or a production company formed by the host (Investigative News Group for *Geraldo*, HARPO Productions for *Oprah*). There were other types of first-run syndicated programs in the mid-1980s, such as *Entertainment Tonight, Newlywed Game*, and *People's Court*. The rights to first-run programs continued to be owned by the syndication companies, not the network, the host, or production company. Because of their nonnetwork status, syndicated talk shows have had a secondary status as inexpensive filler for women between network programming.

In the 1980s the syndication companies did not operate under the assumption that they produce culture for women. They were medium-size divisions of vertically integrated media corporations (Multimedia, Tribune Entertainment, and Viacom) in a highly competitive industry. Each differed in its corporate interests but media remained the focus and talk shows stand as a central product. For example, Multimedia Inc., the corporate parent of *Sally* and *Donahue* (as well as *Rush Limbaugh: The Television Show*, the *Jerry Springer Show*, and *Susan Powter*) comprised five operating divisions as of 1993. The shows are produced and syndicated by Multimedia Entertainment, but the corporation (located in Greenville, South Carolina) also owned 11 daily and 49 nondaily newspapers (Multimedia Newspaper Company); 5 network-affiliated television stations and 5 radio stations (Multimedia Broadcasting Company); 125 cable television franchises (Multimedia Cablevision); and a home-security-alarm system (Multimedia Security Service). In 1993 Multimedia, Inc., made nearly $100 million in profits and had revenues of $634.6 million. The Multimedia Entertainment division brought profits of $63.3 million, virtually all of

which were due to *Donahue* and *Sally*.[19]

Geraldo was a minor, albeit important, element in the media revenues of its syndicator, the Tribune Company. By 1994 the corporate portfolio of the Chicago company was a combination of big-city newspapers (for example, the *Chicago Tribune*) and radio and television stations (superstations WGN and WPIX). Its syndication of prime first-run programs was limited to *Geraldo*, *Soul Train*, and *Can We Shop Starring Joan Rivers* (an infomercial masquerading as a talk show).[20] Again, the logic is to create a diverse portfolio, not a certain type of consumer to whom to sell, such as women.

King World Productions, the distributor of *Oprah*, is a classic syndication company. Unlike Multimedia and Tribune, its revenues came primarily from fees for the licensing of syndicated television shows and series. The leading distributor of first-run syndicated programming, in 1994, it also syndicated *Wheel of Fortune, Jeopardy!*, and *Inside Edition*. In that same year it launched *Rolonda*, a show on the *Oprah* model, self-consciously dubbing it: "Your Next Favorite Talk Show." King World that year owned a library of 68 feature films and 210 television programs. Through its barter subsidiary, Camelott Entertainment Sales, it sold national advertising time in King World programming. In 1993 King World made a profit of $101.9 million on $474.3 million in revenues.[21]

In 1994 *Oprah* represented about half of King World's profits; the show had captured an unprecedented number of women eighteen to forty-eight years old[22] and generated $180 million in revenues. The income came from two sources: cash license agreements with stations ($144 million), and barter agreements whereby King World traded the programs for station time—advertisers and station split spot availability within an *Oprah* program, about two minutes per episode ($36 million). King World charged a fee of approximately 43 percent, or $77 million of the show's revenues for distribution.[23]

To understand the economic importance of these talk shows and their women audiences to their syndication company, one can look at the contract-renewal dispute between *Oprah* and King World in spring 1994. At the time, *Oprah* was seen in 10.1 percent of households; *Sally* had a 5.1 percent rating and *Donahue* 4.9 percent. King World's 1993 Annual Corporate Report had touted *Oprah* as "the number one rated television talk show for 27 consecutive sweep periods [five years]. The show's ratings outranked the nearest competitor by 95 percent."[24]

HARPO Productions maintained that King World's distribution fee was too high, that the syndicator had used the money to build itself by launching other talk shows. The loss of *Oprah* might have led to a drop in

King World's stock of 30% in one day. The negotiations made the front page of the *Wall St. Journal* and of major metropolitan newspapers' business sections. The syndicator negotiated set five-to-seven-year contracts, with the show's having the option to stop production after two years. *Oprah's* 1994 contract jumped King World stock by 2 ⅛ points, 5.8 percent; more than 950,000 shares changed hands on March 18, 1994, five times the stock's daily turnover.[25]

The large syndicators are guided by a strict economic imperative: sell a product to network affiliates, who in turn sell to advertisers desirous of access to women. They maintain their distance from a talk show's production company, letting its ratings serve as a barometer of its success.[26] Their awareness of the ideological role of this cultural product in women's lives surface only when a talk show jeopardizes the relationship with advertisers through topics with which the advertisers did not want to be associated. According to Liz Cheng (director of programming at WCBV, the ABC Boston affiliate), talk shows such as *Geraldo* have been "hit listed" when certain advertisers, such as Proctor and Gamble, Kellogg's, General Foods, and Campbell's Soup fear being tainted by a show's values.[27] The *Morton Downy Jr. Show* was canceled by MCA because of advertisers' refusal to place their ads on aggressive tabloid-style television.[28] But here the issue for the syndicators was not the general or even antiwomen values the program represented but, rather, the loss of advertising potential due to content (that is, values became an issue only when someone objected).

Host As Product Differentiation

King World sold *Oprah* to advertisers and stations based on Oprah, the host—an overweight black woman who often discloses bits of her personal history. The female or a "sensitive" feminized male host connects herself or himself to feminine culture. The problem for talk show competition is that the shows being sold are not highly differentiated. According to Richard Caves, "[U]sually a product has some distinguishing marks which make the brand sold by one producer not quite the same as a competitor's."[29] The topics, production process, and guests are often similar if not the same. In fact, the popular press enjoys chronicling talk show sameness. Sara Welles told of a well-known example of "copy-catting": "a 44-year-old who married the 14-year-old boy (her son's friend), abandoning her other children and husband. She went from Sally to Donahue to Springer."[30]

In the three months of my study, the talk shows often duplicated generalized topics—obesity, HIV+, rape, parent/child conflict—but varied a topic by an individualized spin: ministers who rape versus cops who rape,

or father-daughter conflicts versus mother-daughter conflicts. As a whole, the topics were rather standardized, yet each show produced idiosyncratic or signature topics, such as *Oprah's* emphasis on race (for example, "How Did Black Men Get to Be So Feared?" [March 22, 1994]). Exact topic duplication was rare; I found only two examples in three months. The topic "fathers and daughters who are too close" with the same expert and book was featured on *Donahue* (March 9, 1994) and *Oprah* (March 29, 1994). Second, *Sally* presented the same topic, "fathers who teach their sons to be sexist," with different guests, studio audience, and experts yet similar program structure on March and March 29, 1994. Even though limited, program similarity speaks to the problems of innovation in a mass-production system, much as genre films did within the Hollywood film system during the 1930s and 1940s. The complexity of these topics is limited by their social currency for issues affecting women.

Therefore in the 1970s through the 1980s, talk shows were distinguished by their hosts, their major form of product differentiation. Publicity produced their subtle differences. They cohered around cultural associations with women, such as informal friendship, intimacy, and unmediated openness. The most obvious sign of the hosts' centrality was that not only their names but their first names serve as the shows' shorthand titles. The friendly first-name basis invited belief in an intimate access to host and her or his personality. A common technique was to have the opening logo appear as the host's signature. Rivera's signature, written on a dynamic diagonal, was underlined with a zigzag like the mark of Zorro. The logo signaled *Geraldo's* contradictory style: intimacy with swagger. The *Sally* logo was also a signature on a diagonal, emphasizing the host's vibrancy; the script was in red, but the letters were more rounded than those on *Geraldo*. With pale crayon-like red squiggles in the background, the logo hinted at Raphaël's persona: a soft modern feminine presence in red glasses.

Oprah, too, offered the friendly first name of the host as the initial title but the subtitle, in bolder letters, was more formal: *The Oprah Winfrey Show*. Admittedly, *Donahue* broke completely from this friendly intimacy not only with its use of only the host's last name in the title, but the bold block lettering, indicating an unusually formal and serious sensibility. Nevertheless, the last-name basis also signified a certain familiarity; there must be only one "Donahue." The implied formality was undercut by topsy-turvy images of Donahue laughing and smiling behind the logo as the opening credits rolled. On the whole these personal inscriptions were too "produced" to indicate actual authorship, such as a signature on a painting or a name below the title of a play. Rather, they were meant to convey the

intimacy of a friend who takes her or his signature seriously and also to evoke the feminine tradition of informal and personal communication.

From an economic standpoint, Winfrey and the others were not just specific women or men or stars—paragon listeners—but, more important each represented a monopoly on a persona possessed by the syndicator. Each was "handled" by a set of publicists who tightly control the image of and information about the host. When millions of dollars in profits are at stake in rating points, all we know and see of the host is subject to corporate decision making. Economically, television personalities function similarly to film stars.

Richard Dyer points out that stars represent four categories: capital ("each star is to some extent the holder of a monopoly, and the owner of contracts for a service of a star is the owner of a monopoly product"; investment ("a guarantee, or a promise, against loss on investment or even profit"); outlay ("a major portion of a film's budget"); and market ("used to sell films, to organize the market").[31]

A regular reading of what appears in the popular press about daytime talk show hosts impresses one with how tightly the same images were maintained across the years, of those famed for their so-called confessional style. Raphaël, Winfrey, and Donahue (with the help of ghostwriters) have written autobiographies, entitled, not surprisingly, Sally, Oprah, and Donahue.[32] The relevations in the books did not affect their images as open and emotional women and a "new" man. Raphaël was a wacky mother and wife who now must deal with her professional ambitions and family. Donahue is a serious and often preachy "new" man concerned with career, family, and political issues. Each book solidified the constructed persona as "real" through first-person narratives, confiding that the host, too, was subject to the everyday trials of the "average" viewer. Winfrey pulled her autobiography from publisher Alfred A. Knopf in 1993 minutes before it was to be shown to the press—a move revealing of the control that is involved in the image of a host.

In general, we should question the role of the confessional discourse in creating talk show drama, increasing ratings and stereotypes about women's culture. The entertainment news industry survives on the constant turnover of late-breaking dramatic events to increase viewership. When a cover story in People magazine can boost interest in and ratings of a talk show, a well-timed confession or event on a talk show can be a very effective business tool. It was not surprising, then, that Winfrey's "spontaneous" confession of cocaine addiction on her show in late January 1995 came just before a sweep period (when the most important ratings are

calculated from which advertising charges are set). Nor was it a coincidence that Winfrey gave a highly revelatory cover-story interview to *People* ("Oprah Gets Personal") in September 1994 after the show's ratings had dropped for the first time.[33] Such "personal" disclosures in mass media are part of a skillful balancing act: creating an aura of spontaneity and truth while also maintaining a highly managed image at the heart of a $50 million enterprise. There was no authentic Winfrey; there was the image of Winfrey's authenticity.

In regard to general publicity, only a few repeatedly mentioned traits separated the hosts and, it was hoped, swayed public interests in the shows. Consider how certain physical attributes of the hosts were central in the promotion of their shows: Winfrey's weight, Raphaël's glasses, Donahue's shock of white hair, and Rivera's mustache and broken nose. The hosts were also distinguished along gender, race, ethnicity lines. Further certain emotional traits had come to typify them—Winfrey's confessionalism, Donahue's intellectualism, Raphaël's maternal maturity, Rivera's bravado—the popular press singled out and reinforced. Winfrey was "everywoman—laughs and cries with guests."[34] Phil was "the white male intellectual feminist."[35] Highlighting her lack of a strong persona, Raphaël's was "something between the two with big red glasses."[36] And Rivera had a "swashbuckling style" of bravado and emotion.[37] Slowly, the press constructed the terms of what we have come to think of as the femininity of daytime talk shows: open feelings and talk.

Consider a *National Enquirer* special issue (fall 1994) entitled "Oprah, This Your Life" and subtitled "*Everything* you wanted to know about TV's BILLION DOLLAR WOMAN." Again, it was not surprising that this issue was coincidental with the new season after the first ratings decline. Given the popularity of the hosts, publications are eager to do cover stories on the them; Oprah sold copy. The *Enquirer* articles were variations on the same old themes of tabloid journalism, this time with Winfrey as the central figure:[38]

> "How She Toppled King Donahue Pages"
> "Shock Shows: From Nudes to Satan"
> "The Letters She Keeps in Her Bedroom"
> "Men Who Almost Drove Her to Suicide"
> "Her Battle of the Bulge"
> "Oprah's Sex Show Killed My Son"
> "The Wealth That Fame Brought Her"
> "Will She Be a Mom? Will She Wed?"

The same elements—Winfrey's climb up the corporate talk ladder; the sensational hits of her talk shows; her personal appeal through a range of intense emotions; her history of abuse; her weight; her wealth; and her love life with Steadman Graham—were also repeated without much deviation in an unofficial biography, *Oprah! Up Close and Down Home* by Nellie Bly.[39]

Compare Winfrey's steady persona as the conflicted woman wavering between career and marriage with the image of Raphaël as a plucky survivor of unemployment and family misfortune. An interview appeared as a 1993 cover story in *Ladies' Home Journal*: "My Toughest Year." The writer opens with: "In this exclusive interview, she talks about her family tragedies and tells how she learned to live with heartbreak."[40] The main tragedy is the death of her daughter, an account of which had been given three years earlier in the autobiography.[41] I am not suggesting that the events did not take place but that the timing, amount, and style of information released were well thought out to give the impression of a spontaneous and intimate confessional mode. The interview was another recycling of a limited set of calculated disclosures. Such information can be found in her press releases and her well-oiled relationships with the major tabloids and popular magazines that her publicists create. The reader was not privy to Raphaël's personal life, only the corporate construction of her life. Such "public intimacies" (a central oxymoron of talk show culture) of a host serve more as advertisements for the discursive logic of the talk show as confessionals for unhappy women.

At the economic level, Winfrey and the other hosts were like brand names on labels, devices to attract women buyers. In turn, their shows' viewers represented numbers to be sold to individual network-affiliated and independent stations or markets across the country, which in turn sold the numbers—potential buyers—to local advertisers. It is clear that the various traits of the hosts—which would be unremarkable were they attached to ordinary persons—could exercise considerable influence on tastes and on the marketplace. For a show to be considered popular or successful, it has to be seen in a hundred markets or areas defined by the broadcasts' reach. In 1993 *Donahue* reached 189 markets (97 percent of the country) and 50 foreign countries; *Sally* reached 186 markets (also 97 percent) and 30 foreign countries; *Geraldo* reached 142 markets (95 percent), Canada, and several countries in Latin America and Europe; and *Oprah* reached 204 markets (98 percent) and 64 foreign countries. The image of the American woman as a confessor had international currency.

Boston Stations: The Scheduling, Broadcasting, and Selling of Talk Shows

The local stations' belief that the intended audience of talk shows is female was operative in their scheduling and in their selling of time to advertisers. Talk shows ran during the day, when women dominate television viewing, and the stations sold local advertising time on and around the shows, based on the perceived buying habits of women from the ages of 18 to 48. However, much of the advertising was sold in bulk (for example, that for personal injury lawyers) without specifying the time of day it would air. The advertisers were directing their pitch at a broadly defined notion of a lower economic female: the daytime viewer.[42]

Before 1971 the networks and their affiliated stations filled their daytime schedules with their own programming, such as soap operas, but since the mid-1970s first-run syndicated programming, especially talk shows and game shows, have taken over the lucrative morning and early fringe times—9:00 A.M. to noon and 4:00 P.M. to 6:00 P.M.—when revenue potential is double and so is viewership.[43]

The affiliated stations vied for the woman viewer primarily through scheduling; timing was as central to a show's popularity as content. Women were at home, although decreasingly so, and in control of daytime television in the 1980s and early 1990s. In Boston, the fifth-ranking major market, where this study took place in spring 1994, *Geraldo* (at 10:00 A.M. on WHDH, a CBS affiliate) and *Sally* (11:00 A.M. on WCVB, an ABC affiliate) constituted the morning block; *Donahue* (at 4:00 P.M.) and *Oprah* (at 5:00 P.M.) both on WCVB, led into the evening news. Late afternoon, because of its audience share, was the most-sought-after slot for the shows.

A pattern emerged in Boston. The ABC affiliate aired the top three talk shows, placing them within the two traditional blocks of the daytime

Daytime Talk Show Schedule, Boston, Spring 1994

Morning		Afternoon	
9:00	*Bertice Berry* (WBZ, NBC)	2:00	*Ricki Lake* (WBZ, NBC)
10:00	*Geraldo* (WHDH, CBS)	3:00	*Les Brown* (WBZ, NBC)
	Jerry Springer (WCVB, ABC)		*Rolonda* (WBZ, NBC)
	Vicki! (WBZ, NBC)	4:00	*Donahue* (WCVB, ABC)
11:00	*Sally* (WCVB, ABC)		*Povich* (WBZ, NBC)
	Montel Williams (WBZ, NBC)	5:00	*Oprah* (WCVB, ABC)

schedule. The NBC affiliate aired the "up-and-coming" talk shows as a form of soft or "hipper" counterprogramming, either against the dominant or established talk shows or, as in the case of NBC's *Ricki Lake*, against soap operas—ABC's *One Life to Live* and CBS's *As the World Turns* at 2:00 P.M. Against *Oprah*, the CBS affiliate aired local news and the NBC affiliate aired *American Journal*, a relatively new half-hour newsmagazine (syndicated by King World) and a half-hour local news program.

The talk shows were a hybrid form: part narrative melodrama and part public affairs. The counterprogramming strategy allowed them to erode the popularity of soap operas. They fit more easily into the fragmented American lifestyle, with their cycles of repetition within an hour format—three (sometimes up to five) parallel cases with similar guests are presented. As much as they, too, telegraph meaning through melodramatic gesture, soap operas construct their complexity through years of changing familial relationships and intricate story patterns. In contrast, the talk show host repeats the basic situation upon each return from the commercial break. Additionally, the ebb and flow of crises and conflicts allow for comfortable entry and departure, of viewer attention and in consequence a potentially large potential viewership. To miss a particular program because of the contingencies of domestic chores does not affect the viewer's overall apprehension of the show's logic (see final section of this chapter).

As public affairs programming, daytime talk shows are affected by their placement around news programming. For example, *Oprah's* early lead in the ratings had to do with an arrangement made with a number of ABC affiliates when it was first produced by WLS, the ABC affiliate in Chicago. Their arrangement was fortified later, when a group of ABC-owned and -operated stations negotiated a package of *Jeopardy!*, *Wheel of Fortune*, and *Oprah*, King World's top-rated programs. The agreement placed *Oprah* in a powerful position—lead-in to the local news—and guaranteed the show automatically higher ratings and revenues based on the late afternoon's larger, higher-income audience.[44] Late afternoon is the crossover period when soap operas and talk shows give way to the more masculine traditions of hard news. King World used this fact to sell the show: viewership would boost the audience of the news. King World's annual report quoted a former NBC News president: "A lot of people watch your news show because they watch Oprah Winfrey." This was the discursive strategy that has led many to type the viewers of both *Donahue* and *Oprah* (often paired in the late afternoon) as more "serious" and less "sensation-seeking" women than the morning viewers.[45]

Advertising, Ratings, and Demographics: "Women" as a Rationalized Category

Although ratings or audience size drove many of the decisions on the form, content, and scheduling of daytime talk shows in the 1980s and 1990s, audience demographics or female composition of the audience had a more powerful influence. Margaret Morse argues that what propels talk shows is the ratings, the commodification of culture: "US commercial television employs a rating system which measures viewership and demographics that divide the public according to the amount of buying power and the kind of goods likely to be bought." Ratings "tie the symbolic exchange of discourse to the economic exchange of commodities."[46]

Bert Dubrow, the originator of numerous talk shows, stated that almost every producer began the day by checking the "overnights," the daily Nielsen ratings that sample twenty-nine cities. She or he would watch the slow trend over four weeks to see significant viewer pattern changes. They looked at the overnights to rate the performance of a specific topic and show.[47] Rivera declares: "Ratings are reality, and to deny that is to be very unrealistic."[48] Yet there is a conservative counterweight to the ratings: maintaining established audience. According to Rivera: "What you try not to do is pander to them [the ratings]—that's an easy trap to fall into. . . . Do a topic designed strictly for the ratings, and people will see through and not watch."[49] Producing completely ratings-driven programs (for example, on proven topics) reduces innovation and ultimately leads to loss in viewer interest.

Daytime talk shows became a cultural debate because of two ratings-related factors: the phenomenal success of *Oprah* in 1993 and the resulting proliferation of new talk shows in the winter of 1993/1994 (see table on next page). Ratings allow the local stations and national syndication companies to set the advertisement rate card. Also they serve as an inexact and broad barometer of a show's popular success.

It is the demographics of the audience that brings advertisers. Overall ratings are broken down for men, women, teenagers (ages 12 to 17), and children. The men and women categories are broken down by age: 18–24, 25–34, 35–49, and 50–64.[50] For example, Adrienne Lotoski, director of research for WCVB, the Boston ABC affiliate, states that the demographic breakdown of the daytime talk show audience revealed a higher proportion of working women than other major market cities and that therefore the sex of the show's viewers was more mixed and was not as easy to characterize as female.[51]

Yet King World touted *Oprah* as "number one daily program for all women demographics."[52] "Women demographics" was the single most important category of viewers for daytime programmers. According to Marilyn Matelski, "[D]espite the fact that a lucrative advertising revenue can be obtained from appealing to any demographic viewing group, many broadcasting executives still prefer to target most of their programming to 18–49-year-old women." She argues that the reason is twofold. First, research tells us that women in this age bracket constitute the largest percentage of habitual viewers. Second, buying household items is still primarily a woman's responsibility in the 1990s.[53] Not only were women the main viewers of television, they reached their highest concentration during the daytime because they still represent the highest percentage of Americans at home then. As Paul DeCamera, general manager of WCVB, points out, the demographics are slowly changing as more women go into the workplace and the audience becomes younger and of mixed gender.[54] Yet given the numbers of women at home during the day, Boston daytime

Daytime Television Shows' Nielsen Ratings, Winter 1993–1994

RANK	SHOW	STD/NTI HH RATING	STD FALL 1992	PERCENT CHANGE
1	Oprah	0.1	10.1	+1.0
2	Sally	5.1	5.2	-2.0
3	Donahue	4.9	5.6	-12.5.0
4	Geraldo	3.8	4.3	-11.7
6	Maury Povich	3.8	4.1	-7.4
7	Montel Williams	2.8	2.4	+16.6
8	Vicki	2.5	2.0	+25.0
9	Jenny Jones	2.3	1.6	+43.7
10	Bertice Berry*	2.2	—	—
11	Ricki Lake*	2.2	—	—
12	Les Brown*	2.1	—	—
13	Jerry Springer	2.0	1.6	+25.0
14	Jane Witney*	1.8	—	—

Source: Nielsen Syndication Service Ranking Report, August 30–November, 14 periods, 1994.

Note: STD = season to date; NTI = Nielsen Television Index; HH = Households

*First-season shows; no previous record.

programmers gear their efforts toward reaching adult women—still defined as household consumers.[55]

To tie down the specific characteristics of the elusive female viewer, the syndication companies and local affiliates airing daytime talk shows consulted focus groups and lifestyle survey research companies. The syndicators probed the female viewer to give feedback to the production company as well as to assure national advertisers as to viewer taste.

A research firm, Research Communications, in Dedham, Massachusetts, created focus groups of women in six to eight cities, segmenting them by favorite daytime talk show and viewing frequency. For specific talk shows, a group of "average" women viewers of two shows a week was shown a single program of, say, *Sally*. According to Debra Hackenberry, vice president of research at Multimedia, each woman fills in a mark-sensitive form as she watches; a number is occasionally called out and the woman fills in whether she would continue to watch.[56]

The researchers held later, parallel sessions of *Sally*'s rivals. In chats with the women subsequently about what works and does not work they asked, for example: "What do you dislike about *Sally* and why? What are your comments on how *Sally* listens to and interacts with guests? What suggestions do you have for the producers that would get more people to watch the show?" The results were fed to the executive producers of the shows who had commissioned the research and they conveyed it to the producers. This kind of information rarely causes a major change in production, but, rather, affects the subtle nuances, such as the host's questions, gestures and demeanor, as well as topic choice.

Another kind of research into female viewer tastes concerns lifestyle. The syndication firms often consult general research on trends such as that reported upon in the newsletter *Public Pulse*, self-described as "Roper's authoritative report on what Americans are thinking, doing, and buying." The spring 1994 issue (which was consulted by Multimedia's audience research people) highlighted the article "Populist Backlash Against Elites."[57] Trust in the entertainment industry, sports figures, and most millionaires was steady because the public believed their wealth derived from "talent," but trust in politicians, doctors, lawyers, and journalists had dropped because of "instances in which elites gained at the expense of the public."[58] The issue also dealt with survey research into such matters as the erosion in trust in the established press; the vitality of the American family in the 1990s; time as the scarcest resource after money for consumers; the movement toward more comfortable fashions; the decline of the work ethic; and the shifting interest in a return to homemaking among working women. Such trends all relate to daytime talk show

concepts about women and are undoubtedly taken note of by production companies.

More commonly, national (Simmons) and local (Marshall in Boston) research firms are commissioned to survey the buying habits of women viewers of daytime talk shows. The marketing director of a Boston affiliate would use such research to convince advertisers that its talk show viewership is composed of potential consumers whose taste and habits are compatible with their particular products. According to Adrienne Lotoski, WCVB's research director, you need to know "who your consumer is so that you can produce the right commercials to sell your product."[59] Hackenberry suggests that Simmons lifestyle findings could be used to persuade, say, a cosmetics company launching a new line to buy advertising time on a talk show because a high percentage of women viewers spend a good portion of their incomes on personal care. Audience and product match up.[60]

Leading Advertisers and Number of Advertisements, Four Top-Rated Daytime Talk Shows, Boston Market, February–April 1994

1. Jenny Craig (national weight-loss-clinics chain): 80
2. Feinstein and Forlizzi (personal-injury lawyers): 69
3. Jim Sokolove (personal-injury lawyer): 68
4. Furniture City (Boston discount furniture chain): 66
5. Fretter (Boston-based appliance chain): 65
6. Injury Helpline (personal-injury lawyers): 61
7. Sylvania (lightbulbs): 53
8. Ford (national car company): 50
9. Home Furniture (local furniture store): 46
10. Sears (national department store chain): 44
11. 1-800-DENTIST (national dentistry franchise): 37
12. Fleet Bank (Boston-based interstate bank): 34
13. Dove (soap sold nationally): 32
14. Brookside Hospital (alcoholism rehab): 29
15. Cybergenics (weight-loss clinics): 29
16. Lipton (Recipe Secrets/Tea): 28
17. Facelifters (kitchen remodeling): 24
18. Ponds (anti-age face cream sold nationally): 24
19. ADT (home security systems): 21
20. General Nutrition Systems (national health store chain): 19

Any attempt to understand TV's construction of the female viewer of a daytime talk show from the list below is fraught with difficulties. Given the degree to which opponents of the shows stereotype, they would say that the advertising is directed at a fat, addictive, lower-class woman who shops at cheap department stores, sues at the drop of a hat, searches out the newest fads, and is never satisfied, even as she buys more and more. Many of these products, however, are also sold during network news as well, which is believed to have a quite different kind of viewership. Reasoning for placement of advertising is inexact and highly generalized; a number of elements are factored in, such as time of day of program, type of sale (bulk, local, national), and city and/or region. But on the whole we can conclude that the advertising points to an image of a weight-conscious woman who buys large and small consumer goods from discount and mass-market department stores, and who may be moved to sue to undergo dentistry at a discount.

Leading Advertisers, Four Talk Shows, Boston Market, February–April 1994

Geraldo
1. Injury Helpline (personal-injury lawyers): 52x
2. Feinstein and Forlizzi (personal-injury lawyers): 44x
3. Jim Sokolove (personal-injury lawyer): 39x
4. Fretter (Boston-based appliance chain): 28x

Sally
1. Furniture City (Boston-based discount furniture chain): 29x
2. Jim Sokolove (personal-injury lawyer): 29x
3. Home Furniture (local furniture store): 28x
4. Feinstein and Forlizzi (personal-injury lawyers): 25x

Donahue
1. Fretter (Boston-based appliance chain): 30x
2. Dove (soap sold nationally): 22x
3. Ford (national car company): 18x
4. Furniture City (Boston-based discount furniture chain): 18x

Oprah
1. Sears (national department store): 34x
2. Ford (national car company): 32x
3. General Nutrition Center (national health-food chain): 19x
4. Jenny Craig (national weight-loss-clinic chain): 18x

The Talk Show's Mode of Production

Daytime talk shows are conscious of the broad demographics of a lower-income homemaker in her late twenties to fifties as their central consumer and product buyer when constructing their offerings. Their production companies, like modern factories, are run as highly rationalized systems. Bordwell, Thompson, and Staiger describe the classic Hollywood mode of film production as "a characteristic ensemble of economic aims, a specific division of labor, and particular ways of conceiving and executing the work of filmmaking."[61] Like the big studios that had to fill a heavy schedule imposed by the regular turnover of double bills, the daytime talk shows have to fill a strip of five one-hour programs a week (roughly 220 a year, with repeats primarily in summer); prime time shows each typically produce a half to a full hour program a week. To ensure the popularity of daytime talk shows with women, their producers populate their staffs, shows, and studio audiences with women, select topics that they believe are feminine, and, most important, create programs based on a women's favored fiction genre: melodrama.

For all of the look of spontaneity in the daytime talk show, its production process is rather exacting. Much like romance novels and soap operas, it is a mass-produced product meant to be repeatedly "bought" by women in a mass disposable culture. Dubrow (the originator of *Sally, Jerry Springer,* and *Susan Powter*) calls it "controlled anarchy," or "planned spontaneity."[62] It has to be predictable and time-efficient. It involves an assembly-line system of codified rules of production, specialized labor, and aesthetic norms and thereby turns out one of the least expensive forms of televisioning to produce—$25,000 to $50,000 each half hour, a fraction of the cost of a unit in a network drama. In fact, it is the revenues from the daytime talk show that offset the high cost of prime time production. Because it is a product that non-network syndicators can make "on the cheap" but that is nevertheless highly profitable the show is allowed an ideological latitude or a certain open political bias toward women's social issues not permitted in prime time. As a result, a fascinatingly contradictory discourse of femininity is woven into its productions.

Much as in in soap operas—a related daytime production process—the production staff of the daytime talk show is highly categorized. With the exception of *Geraldo,* the production staffs of the top four shows at the time of this study were dominated by women; the staff of *Sally* stated that the show attempts to hire women primarily. The technical jobs (cameramen, switchers, and director), were held by men; and women were in charge of the creative work (executive, senior, associate, and line

producers)—all in all, a clear gender division. However, unlike most dramatic programming, daytime talk shows in general do not separate conception from execution. The creative process depends on the taping process. As a result, much of the originality and content of a show comes from the guests and audience, overwhelmingly women.

Unlike the soap operas whose head writer leaves an authorial stamp, the daytime talk show does not have an authorial voice or aesthetic signature. It is driven by the host's personality and program topic. Yet the host is rarely involved in program conception; he or she acts as talent—an actor whose personality leaves an aura-like stamp in the execution of the programming and the publicity generated by the industry.

Traditionally, the executive producer or producer for prime time is like a film director in that she or he comes up with a string of successful, similar offerings (for example, Norman Lear's *Archie Bunker*, *Jeffersons*, and *Maude*; Steven Bochco's *Hill Street Blues*, *L.A. Law*, *NYPD Blues*, and *Murder One*; and Grant Tinker's *Mary Tyler Moore*, *Lou Grant*, and *Rhoda*) in which a personal signature or influence can be seen. Their counterparts in the daytime talk show field cannot achieve that kind of oeuvre because neither revenues nor time constraints permit the required artistic freedoms. Nor is the field taken as seriously as an object of aesthetic consideration as emotion-filled daytime programming for lower-class women as the more masculine and restrained world of nighttime drama.

The host and the executive producer vied for dominant influence in the production of the daytime talk shows under study for this book. The most successful shows were those where the two have a close long-term relationship. Up until spring 1994, each executive producer had been with her or his show since its origination; an executive producer is primarily the business agent for a show. In the spring of 1994 the position was filled by three women and one man (Rose Mary Henri, *Sally*; Pat McMillan, *Donahue*; Debra DaMaio, *Oprah*; and Martin Berman, *Geraldo*), all of whom tended toward a day-to-day micromanagment style. They made decisions on such matters as set design, airing controversial topics, and expenditures on live remotes. Each was the conduit with the parent syndication companies regarding production costs and content. And each, along with the host, represented the program at the annual NATPE (National Association of Television Program Executives) convention, when shows are sold to affiliated and independent stations.

The four executive producers often supervised the immediate production process of programs, even though individual associate producers were responsible for the creation of a specific program. Henri consulted with Raphaël between segments, much like a ringside coach. Berman and

McMillan each produced from the control room. For example, during the highly charged and complex taping of the two-part "Trial of Tonya Harding" (March 21–22, 1994; at which I was present), Berman often went on the set to make suggestions to Rivera about how to handle the "trial." Berman even consulted with a Tribune representative, who sat in the control room—one of few instances of the possibility of syndicator influence on the production process.

The origination and production of programs were the purview of the four shows' associate producers, however, overwhelmingly women. Often at their beginnings, the shows had been driven by outside publicists, who booked clients on programs. But as the shows gained in reputation and following, the associate producers of each became "connected" and established a "rolodex" (a term in the trade) and could generate its own programs and guests. The requirement for contacts and constant change in experts and sources for topics is why the shows are located in New York and Chicago and not Los Angeles, where the entertainment industry competes for the same talent. Instead of contract players, the shows depend on what Mandel describes as the publicity industry grown large in the past century. Vast numbers of people are willing to appear on TV and "act" for no fee or personal publicity (or public recognition).

The associate producers (bookers) of the four shows studied had to create one program a week and therefore settle upon its topic. About one to three weeks before a program was to be taped, its topic was chosen at an idea meeting. Topics were limited by their social currency for women and were culled from current newspapers, women's magazines, and other talk shows. Often one associate producer was assigned just to clip potential stories from the print media. An associate producer would have started with a highly generalized topic idea or a social problem, such as stalking, and called a social agency involved with or related to the issue. The decision to do a topic hinged on several considerations: frequency of use; timeliness or newsworthiness for women; and the potential for conflictual sides to be represented.

The associate producer would solicit names of people with some association with the topic from an agency or would have an agency "put out word" that the show was looking for guests. Or in the case of a specific news story as a topic source, the booker would track down the participants, hear their stories, and ask them onto the program. Most often, viewer mail—sometimes written in revealing intimate detail—served as the central inspiration for program material. Each show keeps a data bank or inventory of the mail categorized by topic: incest victims, cross-dressers, domestic abuse, and so on. The process functions to classify

women's social experiences into industrial categories. Another way to discover a likely topic is to poll a studio audience for potential guests. These people—letter writers and audience members—do not need to be persuaded to go on a show. As regular viewers, they see it as a vehicle of conflict resolution as well as public support of a position in a dispute.

A central method of *Geraldo* and *Sally* is on-air solicitations for calls to the show about a specific topic. These promos came usually toward the end of a program, after a commercial break. In the words of one *Geraldo* voice-over:

> Speak up America! We want to hear your comments and show ideas. Give us a call at 1-900-SPEAK-UP. Let us know what you are thinking. We will record your message to play in a future broadcast. We may even call you to be a guest on a show. So call 1-900-SPEAK-OUT. Don't forget: the call costs $1.00.

Here, *Geraldo*—a show with more male viewers than the other three in this study—solicited responses on the basis of the democratic freedom of speech, or the right of a citizen to "speak out," even though the right came at a monetary cost.

Sally solicited primarily mothers at home for program ideas. Typical was a short prerecorded promo (April 14, 1994) featuring a softly focused Sally in white: "Is your child just a spoiled brat and you really can't take it anymore? If so, call us and tell us your story." Then a graphic flew onto the screen, accompanied by this voice over: "1-800-93-SALLY. IS YOUR CHILD A SPOILED BRAT AND YOU CAN'T TAKE IT ANYMORE?" In contrast to *Geraldo*'s address to the public sphere of the viewer, *Sally* hailed viewers as private people who should go public. The hoped-for caller was a harried mother on the verge of emotional collapse. Just by calling "SALLY" and telling her story, she would begin the process of confession and resolution. The elements of a good melodramatic story are in place: a woman seeking surcease of a domestic or familial crisis. The answer would become the *telling* of the story to the benevolent white knight, Sally, who would come to the rescue. The fact that the melodrama would take place on national TV in front of millions was at best a sidelight. The virtue of the process was that it was immediate, uncomplicated, and free.

Even though daytime talk shows are a form of nonfictional programming involving "real" people with "real" stories (a concept derived from the news genre), they are closer in construction to fictional programming. Whereas news emphasizes the event and broad social experience, the shows look at the individual experience and stories of social experience.

Putting a program together is akin to creating a narrative. Producers phone people named in an article and people who have called in, looking for a "good story." The test of a suitable topic is whether it has conflict within it. Most common in the four shows during the study period were sexual, marital, generational, and racial conflicts. There were also unusual conflicts between guests and institutions: the Internal Revenue Service (*Geraldo*, April 15, 1994), the National Rifle Association (*Donahue*, March 18, 1994), and Martha Stewart, Inc. (*Oprah*, February 2, 1994). Even on *Donahue*, the show that aired the most news story topics (Michael Fay's caining, exile Cubans, and affirmative action), the conflict could have been presented as a tension between an individual and a large institution. In fact, when a show did a celebrity topic, the program's value was marked by the ability of the celebrity to tell a life story of clear conflict and resolution (for example, Roseanne's battle with child abuse).

When any of the four shows' producers began to create a program, the test was of her or his ability to draw out a story from a potential guest. This is described as "building the program" within the talk show world, looking for the "elements of a story." According to Henri (*Sally*), a good story is a situation in which there is a "solid opposition" between sides and, more specifically, between people.[63] The conflict model favors guests who are dead set against each other, not, for example, couples who made peace after battling over an unusual issue, such as the woman's making more money than the man. The program's narrative must construct the resolution—not the guests.

The second test of a topic's worthiness is its characters, how they fill their roles is ascertained in preinterviews. Associate producers of the four shows questioned the story participants by telephone to see whether they were good guests—talkative, passionate, emotional. Dubrow says that guests should not "talk"; they should "argue." The emphasis should be emotional, not intellectual. Guests have to rely on their personal experience of a topic/issue; it is up to the expert to provide a more dispassionate view. If an associate producer felt that she or he had a lively participant, the person was invited onto the show and promised not money but a trip to New York (flight, hotel, and meals). Ultimately, the producer would suggest that the individual "go public" on national television to help others.

Guests are the basic material in the manufacture of the daytime talk programs, but they cannnot be regulated the way, say, that iron ore shipments can be for the steel industry. To ensure a steady mass-production stream, the four shows' producers overproduced or booked too many guests; often guests dropped out at the last moment and the program fell apart. The overproduction was due to the time constraints of television

production. A program often might have been in the making up to its taping. Studios and crews had to be utilized for the production time that had been set or a show might have suffered extra production costs. Usually, another preprepared topic with a set of guests was in the wings—a mark of how standardized the system is. When extended family or guests were a part of the audience, they had been booked as potential back-up guests for center stage—they were interchangeable parts.

Each of the four shows kept a standby list of regular experts whom it "discovered" and called upon to adjudicate the conflict and resolve the narrative on one specific program or another. In an attempt to regularize the industry in the 1990s, talk shows that trade on changing or unusual situations began to use the Los Angeles–based National Talk Show Registry. It charges $75 to $100 to find, through its database, guests and experts who fit a topic, searching key phrases such as "call-girl/actress," "likes to wear his other mother's underwear," and "strange disappearances." The registry also lists people who want to be guests and packages groups of guests by theme.[64]

Once an associate producer on one of the four shows studied had constructed a program, she or he took it into a production meeting, at which the executive and coordinating associate producers assess its viability on the show. For example, at a March 6, 1995, production meeting a *Geraldo* associate producer pitched a program on the New York sex industry to Berman and senior or managing producer Jose Pretlow. The central point at issue was how intensity was to be maintained throughout the hour. Pretlow outlined the program on a chalkboard, laying out the pros and cons. The program set up the initial line positioning "Angela, the screamer," who had taken herself out of the industry (con) as the first guest. She was described as "over the top" by the associate producer, which means that she was unusually intense and vociferous—an excellent catalyst for conflict. Next came "Dan of *Dan and the Sex Kitten* cable access porn show," and Maya, a stripper, and Gigi and Tina, "hookers who are pro for the sex industry."

Berman pointed out that the ideal would be that there would be a "direct counterpart for each guest." A second tier was added to the board: "Cindy, dancer who wants out," "Carolyn, a prostitute," "Robert, a stripper," and "Robin, owns strip service." The discussion centered around possible combinations of participants to maximize constant viewer interest and not let "the bottom fall out of the show." The final lineup depended on a fleshing out of the story as each participant added something new to this "unmasking." The producers also attempted to balance the race and gender of the guests to avoid "stereotyping"; two-thirds were women and half were

people of color. A writer from a *Hard Copy* program who had done a hidden-camera exposé on the sex industry was added to give the show "form" and "voice."

The producers were against the sex industry, decrying it earnestly as "exploitative." They traded horror stories (much as the program would) and shook their heads in disbelief (just as the audience would) without showing the least self-consciousness of their planned manipulation of the sex workers. They hoped that the *Hard Copy* expert would tip the balance against belief in the glamour or profits asserted by participants.

Many of the producers on the four shows were hired because of the expertise in certain topic areas. Women produced the more melodramatic family programs; gay men produced the gender-bending and fashion programs; former lawyers produced the more investigative programs; and blacks and Hispanics created the urban-street programs.

The assembly-line system of the shows was regulated by a tight production schedule. In general, they weekly taped two programs a day Tuesday through Thursday; Monday and Friday were reserved for program preparation, long-range-decision meetings, and budgeting. A day of taping started with a production meeting at 8:00 A.M. to go over the projected tapings. Ideally, the host would be briefed an hour before taping; but was most often briefed at taping. This lack of preparation attests that the host role is that of performer, not that of promoter of a rigorous discussion. She or he was provided a synopsis of the program's issues and relevant information. During taping, hosts (with the exception of Donahue, who performed extemporaneously) were aided by a teleprompter with introductions, guest names, and bumpers (statements setting up issues and guests).

Guest preparation on the four shows was equally simple and quick, establishing the preconceived archetypes (for example, "the bitch," "the angry mother," or "the wronged woman") in the drama. The guests arrived an hour before the taping. The associate producer who originated the specific program briefed the guests about a show's expectations. Producers preferred to say that they "focus" the guests instead of "coach" them. They went over the story a guest told on the telephone and made sure that it was still the same: conflictual and emotion-filled. The producer encouraged the guests to jump into the discussion, to be passionate, and to argue. With less than ten minutes of "focusing," the guests were whisked onto the set. Most guests rely on their extensive at-home viewership of the show to cue their performance; the silent, confused, or outraged guests tended not to be regular viewers and became disturbed by the conventions of conflict, interrogation, and self-disclosure.

The prebroadcast taping allowed for some measure of control over unpredictability in a genre that is defined by "real" or documentary drama. With the exception of *Donahue*, which aired live in many markets for years, the programs were taped two to four weeks ahead. But as demonstrated by *Donahue*'s success at live broadcasting, the production process was so well scripted that there was not much need to censor. The shows depended on the unwritten belief in the predictability and conventionality of most human behaviors. Moreover, they sensed that the power and speed of TV production, with its technological and industrial imperatives, would force guests into compliance with the necessities of the genre.

With a few exceptions, the taping that the studio audience saw was almost what the home audience saw. Between segments the taping process stopped the length of time allotted for advertisements (approximately two minutes); the audience chatted, the guests talked to the expert, and the host consulted with the associate and/or senior producer.[65] But for all these attempts at control, whether structure or process, the draw of the shows was still their potential for surprise and spontaneity. They capitalized on the ultimately uncontrollable: real people without scripts.

As previously mentioned, talk shows are characterized by the active participation of the studio audience, 80 percent of which was women before 1993. In the 1980s and early '90s they depended on the audience member to engage actively in the program issue at hand using her or his intellect, experience, and emotions to flesh out the conflict presented on the stage. On an economic level, the audience functioned as an free source of material to fill the hour. The programmers positioned the studio audience as part of a greater audience; the hosts continually referred to "you viewers at home and in our studio audience." But it was also a source of additional "characters" as the drama moved from the stage to the auditorium, serving as a combined source of spontaneity and control.

Yet there were distinct divisions in the studio audiences for the four major talk shows. The programs were rationalized products and had to control audience selection, so they set up barriers that only the tenacious could overcome. All programs advertised their accessibility through ticket giveaways sent by mail. First, *Donahue* and *Oprah* were much more selective because of their higher ratings. Audience members were chosen a month in advance and allowed only one ticket every three months. An interested person had to call or write the talk show; had to be able to predict his or her life a month or two ahead; and most important, had to be in a position to take a weekday off from work or home duties. A self-selected middle-class studio audience was the result. (NBC pages told me that on some occasions they had been instructed to go out into the streets of New

York and hand out tickets for *Donahue* to tourists, especially women, who look middle-class.)

All the shows encouraged and solicited institutional groups to attend, particularly women's groups and those related to the day's topic. The production staff of the *Oprah* program on "teachers who quit" (April 7, 1994) contacted teacher organizations and local inner-city schools, soliciting teacher attendance. Here, the audience became a selected cross-section of America. Conventional wisdom within the industry has it that women dominate the studio audience because they are less likely to work outside the home during the day. Left unremarked upon is that economic divisions lead to a particular class representation in the audience.

What immediately struck anyone who visited *Sally* and *Geraldo* was the random and democratic selection process for the audience. These shows could not always fill their auditoriums (*Geraldo*, 200 seats; *Sally*, 100–120). Any passerby on West 57th Street in New York City—when both shows taped—could have gotten in line and be watching within an hour. Because both wanted their audiences to represent average Americans, it was ironic that they often had to resort to pulling in pedestrians to fill up seats, including workers on lunchtime breaks, lucid street people, and unsuspecting tourists. On this level, those studio audiences did represent "the people," but the difference in access between the more tasteful and politically and socially conscious *Oprah* and *Donahue* as opposed to the more lurid and emotional *Sally* and *Geraldo* spoke to a subtle class divide: the former solicited a more restrained and educated class; the latter allowed more democratic access.

Nevertheless, all four shows exerted control on the studio audience. The audience coordinator policed the audience. She/he herded the members into their seats, keeping an eye out to create the appearance of social diversity by mixing gender, race, age, and even clothing color across the brightly lighted space. In fact, the *Oprah* ticket office told ticket holders in advance not to wear beige or white. The request may have been dictated by video technology, yet the result symbolized the "colorfulness" of the women in the *Oprah* audience.

But for all the look of spontaneity of audience behavior, the show's producers attempted to control audience activities, questions, and performance during taping. The parameters came in a set of quick stages. In preparing the audience for the program, the audience coordinator lectured the audience about the basic rules: season-specific apparel should not be within camera range (syndication and reruns); the teleprompter should not be read along with host (seamlessness of the host's performance); chewing gum should be removed (class standards);

and applause should be loud (maintenance of program's highly charged tempo). The commands were often reiterated when the executive or a senior producer came to do the warm-up.

The audience warm-up is common to all talk shows that depend on live audience reaction. It is usually an interactive comedic routine designed to loosen and energize the audience and evoke the appropriately boisterous responses to the program. As a whole the four issue-oriented talk shows all did a similar warm-up: the producer joked with the audience, asking where they were from, why they were in town, and what did they think of the show. The routine was often somewhat aggressive in that it made fun of the audience, building a bit of antagonism. Jokes were usually about regional difference (New Jersey versus New York) or audience lack of enthusiasm. But the humor could be anti-feminist about body size and sexual proclivities, as in my introductory example of the *Geraldo* show; here the producer wanted to excite or even anger the women in the audience to "egg" them on to be more active, assertive and loud during taping.

The last stage of audience warm-up is a general attempt to coach the audience response, which replaces the music of traditional dramatic TV. The producer often asked the audience to respond "emotionally"; they were to applaud when the guests said something important and, by all means, ask questions. (They also could be told to hold off on their questions because of the complexity of telling a specific story.) Announcing the topic at the last minute (a universal talk show convention), was a tactic to arouse audience curiosity and tension. It was also done because attendance cannot be a matter of viewer taste; a central imperative of a program is a large and diverse pool of audience questions and responses. Moreover, the announcing of the topic allows a producer to put a specific spin on the topic: the preferred interpretation.

An instance of the foregoing occurred on *Donahue*, known as one of the more restrained and serious talk shows. On March 9, 1994, executive producer Pat McMillan warmed up the audience after a few jokes from the audience coordinator. Stating that she really wanted audience participation, she exclaimed, "Do what is in your head and heart." Aware of allegations that producers control audience questions, she continued, "We don't screen questions. . . . We want a 'natural' response. . . . Do what you want to do." And then smilingly, added, "We want you to look better than on *Geraldo*." She encouraged: "Do it with gusto." She urged: "The later [you ask questions], the more you wait." She cast the audience as part of a team: "Can I count on your help?" She gave the guest lineup and topic: father and daughters who have an "unusually close relationship." She closed

by inviting the audience to read the subject as "a women's issue."

The process of setting up the preferred interpretation continued during tapings. First, the associate producer and/or floor manager signaled when to applaud. Not only did the signaling come with the opening, the commercial breaks, and the close but often when a guest made a particularly direct or emotional declaration (for example, "I left the cult at that moment and never returned"). During the breaks between segments some hosts screened audience questions and later called for the question deemed pertinent—a well-known practice subject to the expression of much pretaping anger from the audience.

On the whole, the studio audiences were acquiescent; they enjoyed the theatrics of participation. Yet, audience as well as guests' response could never be entirely controlled. Each taping became a game of roulette: the ultimate preferred reading of a program derived from who chose, and were chosen to talk, who had the greater performative skills, and who had the most dramatic story. The programs offered small gifts to audience members: *Donahue*, a soft drink; *Sally*, a mass-produced signed photo of Raphaël; and *Geraldo*, key rings with Rivera's photo. Both Donahue and Winfrey undercut the economics of their relationship to the audience by staying on as "hosts" to say good-bye to the individual audience members, who had functioned as "guests." Here the audience member is positioned more as a warmly welcomed visitor to a home than as an unpaid performer.

Because talk shows cannot write the guests', experts', or even the host's dialogue, the four shows could not exert the control that characterizes fiction programming. The Hollywood film industry was able to standardize its product through the continuity script: a highly detailed blueprint of scenes, shots, and dialogue.[66] In the daytime world of soap opera, the producer has the head writer's finished script, from which there is no deviation during production.[67] The four talk shows did nevertheless attempt to control the process through segment/cue cards or notes. These were 5x8 cards or sheets of paper that the host carried and through which she/he maintained program's episodic movement or narrative progression; each outlined a segment (defined by commercial breaks) of the program. The talk shows were divided into seven segments (*Oprah* had eight).

Almost any regular viewer of daytime talk shows has some sense of this streamlined model of the normative structure of a program. Much like reading a romance novel or watching a soap opera the pleasure of regular viewing lies in the continual variations on the model and how particular programs manipulate the various elements of program construction based on the necessities of a "good story" and the contingencies

Program Model

Segment One,
13–17 min. Exposition: Introduction of subject, the prob-
lem/conflict, the guests/characters (usually
three parallel examples/narrative). Set up of ar-
chetypical structure. Host functions as perfect
listener. The longest segment because of the
amount of narrative detail.

Segment Two,
6–9 min. Establishment of Conflict: The audience begins
asking questions, fleshing out the conflict. They
move from listeners to characters in the narra-
tive by paralleling their experiences.

Segment Three,
4–6 min. Further Complication: Divisions between guests
and/or audience members grow. Expert is intro-
duced. She/he complicates narrative by adding
a new level of conflict/understanding.

Segment Four,
3–6 min. Questioning the Expert: The audience begins to
question the expert's interpretation. Often new
guests are introduced on stage or in audience,
complicating the range of resolutions. The host
may move from perfect listener to narrator/
character by offering personal experiences.

Segment Five,
2–5 min. Beginning of Resolution: The expert begins to
offer a resolution. The guests/characters ques-
tion and discuss the viability of expert's resolu-
tion. The host begins to support the expert's
resolution. The audience begins to side or
break with the expert's resolution.

Segment Six,
2–5 min. Resolution Development: The resolution is dis-
cussed more and moves toward affirmation.

Segment Seven,
$\frac{1}{2}$–2 min. Coda: Short speech by expert on answer to
conflict or short statements by guests and/or
audience members affirming their personal res-
olutions.

of production. David Thorburn argues for this interpretation of the complexity of this pleasure when he suggests:

> We ought to learn to see such texts from the standpoint of the audience, whose pleasures in witnessing these spectacles of excess and grandiloquence may be deeper than we know and whose intimate familiarity with such texts may lead them to perceive as complex aesthetic conventions what the traditional high culture sees only as simple stereotypes.[68]

From Formula to Genre: The Melodrama in Talk

Melodrama is the central precedential genre that television and film has utilized as the blueprint for the production of feminine narratives.[69] The industrial-production process of talk shows conceives of the talk show viewer as a woman who is a mother, a homemaker, and consumer of emotion-filled narratives about socially current domestic issues. Therefore melodrama makes the consummate vehicle for the expression of the home, the family, and motherhood as the central sources for solving the social ills of the United States.

I return to this nineteenth-century precedent to look at how daytime talk shows' predecessor's structure parallels the construction of femininity on talk shows. Tabloid newspapers and their sob-sister reporters in particular employed the narrative elements of melodrama—the leading literary genre at the time—in their lurid accounts. Scriptwriting critics point to the centrality of melodrama in television and film writing.[70] Made-for-TV films, soap operas, and now talk shows return to the form to shape the hierarchy of female morality implicit in their plebeian scripts.

To understand how TV as an industrial medium uses genres, we need to realize, as Jane Feuer points out, that unlimited originality in programming would be a "disaster" for the industry. Therefore "television takes to an extreme the film industry's reliance upon formulas in order to predict audience popularity."[71] A formula is a pattern and prescribed set of rules that the industry employs every time to produce a standardized program. Each talk show program becomes a variation on the basic formula. Such a system ensures a steady viewership for a talk show through a tension between standardization and innovation. Genre represents the larger cultural context that the industry and viewers draw on to ensure interpretability of the formula. And the clear social types in melodrama—victim, victimizer, and hero—serve as a neat resource; producers can pattern an hour's drama around an age-old social or personal issue while

telegraphing a message to the audience.

Donahue's program "Crooked Attorneys" (February 9, 1994), about the ethics of the legal profession, does not externally exhibit the characteristics of melodrama. The genre usually takes place in the domestic realm, where social conflicts are internalized as highly explosive emotional crises within the family. In fact, in my study *Donahue* was the show that came closest to being the opposite of melodrama, a rational discussion of personal, social, and public matters and public-sphere debates (for example, "Rodney King-like Beatings" [March 11, 1994], a two-part program on Whitewater [March 15–16, 1994], and "Haiti Turmoil" [April 14, 1994]).

Donahue's news orientation serves as a test of the viability of melodrama fiction as a model for daytime talk shows. How can social debates be narratives? Stuart Hall maintains that "we make an absolutely too simple and false distinction between narratives about the real and the narratives of fiction. And you can find that in the news: the news is full of little stories which are very similar to war romances."[72] David Bordwell and Kristin Thompson hold that narrative is "a fundamental way that humans make sense of the world."[73] Nonfiction TV forms such as the news, documentaries, and talk shows are organized around stories within stories. John Hartley has analyzed how the BBC news (the ideal of "objective" news reporting) constructs "narrative point-of-view" to set up identification with British authority through "we" and "they" pronouns.[74] A talk show follows the pattern of news with its six-segment model, which organizes the program as a whole through the inherent social conflict of the topic, such as legal injustice, unfair taxation, or dishonest advisers. Within the model are a series of personal narratives that function to repeat and test the overall validity of the social-issue-of-the-day format.

The *Donahue* program on attorneys uses the conventions of melodrama to explain the problem of ethics in the legal profession by individualizing the problem. It presents the first-person accounts of four "victims" of lawyers. We begin with Doris O'Donnell, a formerly wealthy woman who has been reduced to near poverty in pursuit of a divorce from her cheating husband. She has gone through fifteen lawyers and $200,000 in legal fees. Then comes Sylvia DiPietro, who wanted to sue her husband, one of John Gotti's lawyers, for divorce, but no lawyer would take on the case. Anthony and Arlene Lucante, an Italian-American working-class couple, were "shafted" out of their dream house because their lawyer did not closely examine their building contracts and the house is unfinished. There is the quick story of a construction worker who did not receive just compensation for an on-the-job injury because of lawyer negligence. And last, a family of recent emigrés who were misled by their lawyer into

buying land on a flood plane to build a home.

Such individual stories are usually held together by a hero theme: the put-upon are rescued. Typically, a therapist and/or an expert functions in this role. She or he narrates the overall story of victimization in the culture, the master narrative of the program's drama, but moves beyond just narration (a function shared by the host) to become an active participant in the drama, performing therapy or offering solutions. In the *Donahue* program, the show is organized around Hilton Stein (an attorney who sues attorneys). Because most of the "victims" onstage are his clients, he is able to add details to their stories and make clear narrative parallels based on the legal process. But he also positions himself as the active agent who rescues them from the exploitation of social inequality. Hilton's action took place outside the program whereas therapists are called on to intercede during the interpersonal drama created by the program's and host's confrontational logic.

But what differentiates the melodramatic narrative from a classic action-oriented narrative is that the protagonist (Doris and the others) is a passive figure who is rescued by a secondary active figure of the middle-class professional (Hilton Stein). Implicit is the assumption that this type of people or characters (typically working or lower-class women) do not have the emotional, physical, or social power to solve their problems. A further differentiation in the postfeminist environment of self-actualization and empowerment is that the hero not only rescues the victim but teaches her the secrets of her or his magic agent (to borrow from Vladmir Propp's morphology).[75] Here self-help formulas empower the victim to become a hero. "Tips on lawyer-proofing your case" flash on the screen as a summary of Stein's advice. Therapists advise people with psychological formulas on how to work through their interpersonal dramas.

Daytime talk show programs stage a highly standardized drama of the disenfranchised. The *Donahue* program sets up veiled class, education, and gender distinctions as the image, primarily of women, the working class, and ethnic people exploited by powerful male lawyers. The power polarities are usually not so clearly portrayed as in this program (Doris's husband is a local power broker), but talk shows always build a sense of a victim (someone who has been cheated, emotionally hurt, physically beaten, or otherwise mistreated) and a perpetrator (boss, parent, husband, lover) into the conflict. Rarely did these talk shows play against established notions about social inequality; white middle-class men were not seen as victims, nor were poor black women depicted as aggressors. These scenerios were played out only when there was someone with even more power than a particular white man or when a particular black

woman misused what little power she had, for example, to hurt a child. On this level, the four daytime talk shows came the closest of any TV program to being plebeian morality plays.

Peter Brooks argues in *The Melodramatic Imagination* that melodrama is where "the social must be expressed as the personal."[76] Each story on the *Donahue* program takes place in the domestic realm as the guests chronicle the loss of a "home"—the psychic location of melodrama. The program begins with a slide of a New England–style snow-covered residence. Doris sadly acknowledges, "Yeah, that was my house." Donahue emphasizes the loss: "Very Nice." Doris responds: "Built in 1692." When Donahue rejoins, "So it's a landmark," the program acknowledges the centrality of home in the American experience. These are not idiosyncratic stories of social misfits, freaks, or even simple victims. Talk shows almost always posit a victim who turns into a heroine during the course of the program when she learns to challenge or remedy a social or emotional injustice. The *Donahue* program is predicated on the threat that the legal profession poses to the average American's right to a "home"; women in particular must fight for the right.

The ideal of "home"—one of the most emotionally charged and ideologically loaded terms in the American vocabulary—looms in the background of almost all daytime talk shows. Most often home translates into family and emotional relationships as "havens from a heartless world." Mr. Lucante laments his failed home in the *Donahue* program: "Well, they started to build a house which the builder, at the time, did an excellent job for us. We put in a lot of extras. You know, we came from a family, a big family, that didn't have a built house." Lucante sees the building of the house as a way of redressing familial inadequacy. Like melodrama, talk shows are not about what "is" but, rather, "should be"—nostalgia for an idealized notion of family and the past. Even a transsexual can yearn for the quiet domestic life of a family man (see chapter 2). As Christine Gledhill declares: "The Edenic home and family, centering on the heroine as 'angel in the house' and the rural community of an earlier generation, animate images of past psychic and social well-being as 'moral touchstones'."[77]

Most important, the "angel in the house" of nineteenth-century melodrama resurfaces in daytime talk shows as women once again become the moral guardians of the nation. From Harriet Beecher Stowe's Little Nell to Louisa May Alcott's Jo to the afternoon matriarchs of "matinée weepies" and soap operas, the melodramatic form has been associated with the suffering of women and their emotional and moral strength to bear it. In the *Donahue* program of the five stories, three are narrated by women and two by working-class men.

Prior to the nineteenth century, emotional display was associated with men as a sign of virtue; crying was evidence of a refined demeanor.[78] However, the tradition produced contradictions in the ideology of masculine emotions where men could be both strong and emotionally sensitive; the world of feeling was given over to women: "The heroine, idealized as 'Angel in the House' and the focus of the 'Cult of True Womanhood' was often of more significance to the drama than the hero in her capacity to evoke and legitimize emotion."[79] Daytime talk shows still depend on this fascination with the sight of women suffering as part of their powerful spectacle. It is Mrs. Hadam, not Mr. Hadam, who tells the immigrant story of innocence and loss in the land of promise on the *Donahue* program.

Daytime talk shows, like their cousin soap operas, construct what Annette Kuhn calls "woman-centered narratives and identifications."[80] Programs are usually built around a woman who is initially a victim. Although the *Donahue* program on dishonest lawyers draws on a series of victims, it is Doris O'Donnell who receives the most attention; her story sets the symbolic parameters for the others. The exposition of her story takes the first third of the hour and becomes the moral and expository touchstone for the others. She is depicted as a classic victim of forces that lie beyond her control and understanding—the "old-boys network" of the male professionals in her hometown.

But as Martha Vicinus points out, "melodramatic pathos could be turned to assertion: the victimized heroine proves 'weakness is strength' as the assaults of the villain draw out 'hidden talents and unrecognized virtues.'"[81] Daytime talk shows are not the melodramas in which women suffer passively under the sway of emotional weakness, nihilistic fate, or male control. Women learn to act. Doris O'Donnell fights back through her "helper" lawyer. Ultimately, the shows are not purely fictional dramas. They step outside the fiction to teach how these interpersonal and social dramas are created and resolved. They bestow active agency on individuals and groups—women and the lower classes—who are perennially seen as weak and subservient to other persons. Women learn that interpersonal dramas are made and how to unmake them. The Donahue program on lawyers ends with a display:

"If You Want To Sue a Lawyer" available from:
Americans for Legal Reform
1319 F Street N.W., Suite 200
Washington, DC 20004

The melodrama format of daytime talk shows does not mean that they have a progressive or feminist ideology. Their self-help formulas fall within the dominant ethos of the American belief in self-determination, individualism, and personal success. They are a mechanism that assures advertisers a "can-buy" audience while reproducing the dominant ideology of a capitalist system. The logic is to activate a woman as a capable and thinking consumer but not as a political activist. Remember: we are here to sue the lawyer, not to change the legal system. Even so, the shows break through the convention of passive consumption of melodramatic spectacle; they ask for women's animated participation in a medium condemned for engendering only emotionalism and passivity.

THE "OPRAHFICATION" OF AMERICA?

Identity Politics and Public Sphere Debate

> Today I am sitting between two people who have never been this close face to face since one very unforgettable night two years ago. Debbie says that the man sitting across from her locked her in a closed room, held a gun to her, and violently raped her. Jawad says Debbie is lying.
>
> Oprah Winfrey, *Oprah*, May 3, 1994

❖

Are daytime TV talk shows simply sensational commercialism or could they be a new form of political debate? The visceral description by Winfrey of an *Oprah* program on May 3, 1994, seemingly relegates the social issues involved in rape to the realm of cheap thrills. But on another level, the program's dramatic and individualized account allows ordinary citizens—in the studio and at home—to enter into a debate about sexual power in their everyday lives, a rare moment on network television.

Traditionally, democratic thought assumes that there must be an independent public arena where political opinion can be formed freely. The arena should be entirely free of the taint of government control as well as that of corporate capitalism. For many Americans, the town meeting is the ideal of participatory democracy: the citizen takes part in the politics of the local community by standing up and speaking up. But such direct communication is becoming less tenable in the age of information technology and global communication.

If TV has become the central communicator of information, no other public forum replicates the town-meeting democratic sensibility better than the first generation of daytime TV talk shows, born in the 1970s through the 1980s: the *Oprah Winfrey Show*, *Sally Jesse Raphaël*, the *Phil*

Donahue Show, and even *Geraldo.* Here, "average" Americans debate important, albeit sensationalized, issues that are central to their political lives: racism, sexuality, welfare rights, and religious freedom. Would Jürgen Habermas, one of the leading theoreticians of the public sphere, have included such shows as part of the public sphere, which he defined it as "the realm of our social life in which something approaching public opinion can be formed. . . . A portion of the public sphere comes into being in every conversation in which private individuals assemble to form a public body"?[1] The answer depends on whose definition of politics one invokes.

The concept of the public sphere—the place where public opinion can be formed—looms over all analyses of talk shows. From "The Talk Show Report" in *Ladies' Home Journal*[2] to think pieces about tabloid culture in the *New York Times,*[3] to a Marxist collective analysis of the genre in *Sociotext,*[4] to an article on talk and female empowerment in *Genders,*[5] our culture is hyperconscious that daytime TV talk shows are involved in the political arena. They are a rare breed: highly popular programs that depend on social topics and the participation of average citizens. However, there is the fear that the shows may be trivializing "real" politics by promoting irrational, victimized, and anomalous individuals as representative of the citizenry. The print press has pejoratively alluded to the "oprahfication" of America. Yet the popularity of the shows continually begs two questions: Can the content of the shows be defined as "political"? And, more important, can the shows—the children of corporate media interests—be considered public arenas where "the people" form opinion freely?

Even though the women's movement has shown that politics in the late twentieth century includes the personal, American culture still is uncomfortable in describing the content of daytime talk shows as political. The term *political* is derived from the Latin *politicus,* which means relating to a citizen.[6] A citizen is defined by his or her allegiance to a state and protection by it. Obviously, the shows, with their dependence on spectacle, individualism, and sensation, deviate radically from the traditional political discussions about social policy that define citizenship, such as Oxford debates, congressional deliberations, union-hall meetings, and even network news, with its emphasis on established political institutions. Although debate has shifted from the Aristotelian model of speaker and listener to the coordinated discussion of the twentieth century, the shows are more personal and emotional in their content and vertiginous in structure than traditional forms of political discussion. Still, Rivera asserts continually on air: "Our studio is a representation of the country at large." And Ron Rosenbaum argues that the shows "have become the American

equivalent of the Athenian agora, where citizens, sophists and philoso-
phers bat around questions of behavior. They can be barometers of public
feeling on questions of good and evil."[7]

No other TV genre—not news, prime time drama, or soap opera—
generates more ongoing social controversy than daytime talk shows. Be-
yond the headline-grabbing *Jenny Jones* murder[8] or Winfrey's cocaine
confession,[9] the shows evoke endless debates about everyday experience.
Not only does viewer give-and-take take place as part of the show but dis-
cussions continue on the news, in the workplace, and at home: the popu-
larization of current political, social, and theoretical topics. The shows raise
questions of fact versus fiction as the audience tests the credibility of the
stories presented. (In the common vernacular: "Are those people for real?")
They test the demarcation between entertainment and news as they mix
political issues and personal drama. Further, they use ordinary people to
stage social issues that are infrequently discussed elsewhere on television:
homosexuality, familial conflict, sexual relations, and racial divisions.

As the 1990s bring into the political arena an angry African-American
underclass, gay activists, and employed women, might *Oprah's* audience
and those of other daytime talk shows be the newest incarnation of the
public sphere? This chapter looks at the concept of the active audience in
media studies and the political change brought on by identity politics.

The Social Sphere: Democracy, Debate, and Public Participation

Historically, open debate has been a fundamental ideal of capitalist
democracies. The public sphere, as articulated by Habermas, exists in op-
position to the sphere of the nuclear family and domestic activity, which is
governed not by public discussion but by privacy. The concept of the
public sphere emanates from the agora of democratic ancient Greece, part
marketplace and public forum. Its modern manifestation arose in Britain
in the seventeenth and eighteenth centuries out of the development of
competitive capitalism and the corresponding rise of liberal democratic
thought. A new political class, the bourgeoisie, emerged to formulate
these economic and political theories and initiate their implementation.
These people became the intellectuals and technicians who articulated the
ideas of civil society separate from its dominant institutions.

A series of institutions also developed, such as debating societies, cof-
feehouses, salons, the press, libraries, and universities, where public opin-
ion was fashioned. The bourgeois public sphere came to be demarcated by
its separation from the interests of the church and the state; its activities

were carried out by citizens who had independent sources of income. All members of the civil society were equal. Rational discourse defined the debate; arguments were won not on power but evidence. The public sphere's authority was derived from the fact that the ideas therein generated had to do not with private interests but with the public good.

Ultimately, for Habermas, the advent of monopoly capitalism in the twentieth century has destroyed the independence of the public sphere as a universalist institution. The new economy has led to an uneven distribution of wealth and rising entry costs to the social sphere and, accordingly, unequal access to it and control over it. Instead of public opinion, private-interest advertising and public relations have taken over. What was the free press has become the mass media. Instead of fostering a free flow of rational debate, these public-sphere institutions manipulate the populace. Government emerged as the welfare state: a giant with its own bureaucratic self-interests, one of which is sustaining capitalism. The independent public sphere as the generator of "critical" information has been slowly squeezed by late capitalism and the state.

For Habermas, as well as recent media critics,[10] the change has become more obvious. The mammoth, corporate mass media serve as a "tranquilizing substitute for action" for the "uncritical masses."[11] The former divisions between the public sphere, capitalism, and the state have collapsed as the mass media increasingly substitute for independent public thought. As fewer and fewer citizens vote, the media "produce" the concept of the "public." U.S. journalism—now "a mouthpiece for officialdom"—engineers consensus by manipulating public opinion; in the case of the Gulf War, for example, the news could not be distinguished from the official state's line.[12]

Even though Habermas concedes that the public sphere has been more an ideal than fact down through history, the concept still serves as a powerful element in the assumptions of capitalist democracy. Hopes of a public sphere are evoked whenever a writer bemoans the passing of considered discussion of public issues is where the commercial pressures for "entertainment" have destroyed objectivity and truth.[13] The *New York Times* often stands as the principal defender of "real" news. Janet Maslin commented in its pages, "In the world of daytime talk shows, only one topic is truly off limits: America's fascination with escapist trivia as a means of avoiding real discourse."[14] John J. O'Connor, the paper's TV critic warns: "There's a battle being waged in television these days and broadly speaking, it's taking place along lines of 'us versus them' cultural lines. Depending on your vantage point, the results so far could be interpreted as either democracy taking the offensive or the barbarians." He

maintains that the tabloid-style TV shows "are in the business of inventing emotional 'wallops' and are openly contemptuous of what they like to refer to as 'pointy-headed' journalists, meaning for the most part the college-educated kind that works in non-tabloid print."[15] Here, a newspaperman writing a column for a traditional news medium suppresses questions about the objectivity in all news reporting in favor of charges that tabloids or talk shows are manipulative or that they are promoting what another New York Times writer calls "the new kind of dumbness."[16] This nostalgia for the loss of the bourgeois public sphere is deeply intertwined with a kind of politics where clear categories of power are maintained: a class, culture, and gender hierarchy based on the centrality of the educated white bourgeois male.[17] Not surprisingly, Donahue is often nominated by the press as the most "responsible" or "trusted" daytime host.[18]

At issue is whether a popular audience can enjoy but be critical of TV. Or whether TV is a commercial Moloch swallowing up the minds of viewers and creating passive consumers. The public sphere tradition calls for a liberal or educated elite to lead the uneducated masses for their own good by steering media content and the social agenda toward democratic values. This patrician style of leadership or public service assumes ordinary people do not have the ability to comprehend the mass media's power and control.

Indeed, the concept of "the people speaking"—what the daytime talk show industry self-consciously trades on—has been criticized as a naive, unattainable ideal.[19] For example, Richard Rorty exemplifies the fear of the loss of the bourgeois public sphere or the "elites" for democratic values:

> The epithet [elites] simply ignores the success of the elites in the widening human freedom—defying mass opinion by fighting against capital punishment, against racial hatred, and in favor of religious tolerance. There are worse things than liberal condescension, and one of them is the self-righteous fury to which demagogues like Pat Robertson, Vladimir Zhirinovsky, and Louis Farrakhan can still move the masses.[20]

Within this critique, the problem is twofold. The talk show audience is a passive mass ready to be led by commercial interests and self-promoting hosts, or the shows have the potential to become a forum for social control in which the audience taunts, shouts down, and demands conformity of the "guest deviants." Yet also consider how a series of binary oppositions surface in all the discussions of the liberal news tradition and the exploitive talk show genre: democratic versus bias, independent versus

profit-oriented, serious versus trivial, educated versus uneducated, and ultimately, masculine versus feminine.

The Rise of Identity Politics and the Counter Public Sphere

The feminist movement has launched the most thoroughgoing critique of the public sphere and the concept of serious/trivial split in political issues that underpins the discussion about daytime talk shows.[21] From a feminist point of view, the problem lies in the fact that the public sphere is set in opposition to the private sphere and therefore produces a not-so-subtle division between masculine and feminine realms: men participate in the serious realm of politics and rational debate: women, the emotional realm of the domestic arena. Nancy Fraser cautions:

> Consider, first, the relations between (official) private economy and private family as mediated by the roles of worker and consumer. These roles, I submit, are gendered roles. And the links they forge between family and (official) economy are effected as much in the medium of gender identity as in the medium of money.[22]

For Fraser, the public sphere is understood as a realm that the male worker or breadwinner enters to support his family and home. This separation has historically denigrated women's labor and legitimized their lower wages. If a woman works within the public sphere, she is treated differently, as a secondary form of labor. And if she works within the home or private sphere, her work is not even considered labor.

The woman at home, then, is not a domestic laborer but, rather, a consumer: an individual to be manipulated by the media. The consequence of envisioning the private sphere in opposition to the public sphere is to devalue women, their labor, and the political role of domestic activity. Therefore, the daytime talk shows, whose audience is predominantly women at home, are easy to denigrate as well, as a non-culture. The shows are feminine in that they are experienced as sites of emotion and consumerist values by domestic labor within the home.

Such distinctions allow Walter Goodman of the *New York Times* to brand the shows as "the nation's picture window onto domestic dysfunction." He decries: "No week passes that Oprah or Phil or Sally Jessy or Geraldo or Montel or one of the lesser practitioners does not conduct a public examination of private abominations like wife beating, husband slashing and, most relevant to the Menendez case, child abuse."[23] The

division between what is public and what is private is much more complex and historically controversial than Goodman's dichotomy connotes.

Feminist questions about culture and the social relevance of the personal and psychological realms emanate from a larger shift brought on by identity politics in the second half of the twentieth century. Identity politics asserts the centrality of identity in carrying out radical change. Although related to nineteenth century movements of suffrage, abolitionism, and unionism, with their interest in governmental and institutional reform, identity politics places equal if not greater emphasis on an understanding of the psychology of repression, or social subjectivity, in political activism. That is, political change must begin with a labor on how we learn racism, sexism, and classism by challenging previously nonpolitical issues, such as lifestyle, sexual relations, and everyday culture.

L. A. Kauffman traces the emphasis on identity back to the civil rights movement, which offered a "markedly distinct way of thinking about the nature and purpose of politics."[24] Although guided by the need to change the institutionalized barriers of racism, the Student Nonviolent Coordinating Committee (SNCC) understood racism as a nexus between the personal and political. Kaufmann describes the sources of civil rights politics as an "eclectic mix" of the individual action of European existentialism, Gandhian civil disobedience, and spiritual growth based on the individual and collective redemption of the southern black church. Civil rights leaders not only fought for the right of blacks to vote but wanted to improve the black self-image. Stokely Carmichael called for "psychological equality." "Black Power" moved beyond economic and political power of the public sphere; in the language of the 1970s, it was about "black consciousness."

The feminist movement grew out of and learned from the civil rights movement. The title of Kate Millett's feminist manifesto *Sexual Politics* attests the continued interest in the psychology of power. Politics could no longer be confined to notions of citizenry and institutional representation: rather, "politics" was also personal in the female domain. Millett wrote:

> In introducing the term "sexual politics" one must first answer the inevitable question "Can the relationship between the sexes be viewed in a political light at all?" The answer depends on how one defines politics. This essay does not define political as that relatively narrow and exclusive world of meetings, chairmen, and parties. The term "politics" shall refer to power-structured relationships, arrangements whereby one group of persons are controlled by another.[25]

With the women's movement, power and domination came to been seen as pervading of life. Liberation slowly moved from the national to the institutional to the personal arena where the study and understanding of political oppression surrounded the relationship of the "individually experienced and the collectively organized" sense of politics.[26] Everyday culture became the new battlefield; the politics of the daily experience became the language of the 1970s and 1980s.

Feminism has questioned the public-sphere distinction between serious news and daytime TV talk shows and asked whether access to the all-powerful political arena or "serious" news is gender neutral. If the public sphere is where political participation, debate, and formation take place, then the theory walls off the private sphere and the family from political practice. This sensibility can no longer be maintained in view of the welfare state, which actively intervenes in the private lives of its citizens in the name of its citizens, the emphasis on the social construction of power since the arrival of identity politics.

Nancy Fraser considers how the concept of citizen is one associated with men:

As Habermas understands it, the citizen is centrally a participant in political debate and public opinion formation. This means that citizenship, in his view, depends crucially on the capacities for consent and speech, the ability to participate on a par with others in dialogue. But these are capacities connected with masculinity in a male-dominated, classical capitalism; they are in ways denied women and deemed at odds with femininity."

As further evidence, she cites studies on the inequalities in male/female dialogues and the lack of respect shown to women in matters concerning marital rape. She concludes by quoting Carole Pateman: ". . . [I]f women's words about consent are consistently reinterpreted, how can they participate in the debate among citizens?"[27]

Gloria-Jean Masciarotte captures this public condemnation of women who speak out on the daytime talk shows: "Well, the critical comments are usually off-the-cuff condemnatory remarks aimed at the sight of women talking, woman taking pleasure in talking, even when it is about painful subjects." She argues that the attitude toward women's speaking out misses the pleasure and aims of the women: "Sad women? Silly women? Manipulated women? Victimized by the evil empire of television and mass culture? Hmmmm. . . . perhaps it is more than just a cliched observation to prattling women. Perhaps it is the fact that the women are

talking, taking pleasure in talking, and talking about painful experiences, on-going and ill-defined struggles."[28] Here, the shows are taken to offer a subversive yet gratifying venue for the rare public portrayal of women's struggles.

Many feminists have come to champion daytime talk shows as a new public sphere or counter public sphere. The shows not only promote conversation and debate but do away with the distance between audience and stage. They do not depend on the power of expertise or bourgeois education. They elicit common sense and everyday experience as the mark of truth. They confound the distinction between the public and the private. The shows are about average women as citizens talking about and debating issues and experience. As a lesbian transsexual who has been on *Geraldo*, *Donahue*, and *Jane Whitney*, Kate Bornstein states that she sees the appearances as a battle to establish how her cultural identity is to be represented. She likens the shows to the nineteenth-century freak-show circuses but declares: "What's different now is that we, as freaks, are doing the speaking. It isn't the barker telling our story for us."[29]

Talk Shows: Women in a Counter Public Sphere

One of the most politically creative discussions about daytime TV talk shows as a new counter public sphere is "Chatter in the Age of Electronic Reproduction: Talk, Television and the 'Public Mind.'" Authors Paolo Carpignano, Robin Andersen, Stanley Aronowitz, and William Difazio champion the shows for breaking down the clear lines between truth and fiction. The shows demonstrate that public debate is "no longer civilized nor following the dictates of general interest."[30] They are created to produce controversy, and are repetitious, inconclusive, and fragmentary. Because they refuse to speak of "truth," they reveal the subjective nature of politics.

What is important is that shows such as *Morton Downey Jr.* "reject the arrogance of a discourse that defines itself on the basis of its difference from common sense."[31] For example, a *Downey* program on the massacre of Chinese students in Tiananmen Square allows an expert from the conservative Heritage Foundation to be shouted down by an anarchist squatter group. Carpignano and colleagues argue that Downey provided "a forum for the disenfranchised, especially young white men (working and lower middle class) who are not represented in the current knowledge-based commodity culture."[32] Ultimately, even Downey was the child of the women's movement not only because feminism changed the American "political agenda" but because it challenged the relationship between the

public and the private. The authors label the change the "politicization of the private,"[33] which allows even lower-class white men a forum in which to speak about their lives and thought.

Masciarotte agrees with Carpignano and his associates' populist position but places its populist tradition within the feminist movement. She sees *Donahue* as more closely aligned with the traditional public sphere, whereas *Oprah* promotes "the politics of identity and voice."[34] For her, daytime TV is a genre based on a "citizen strategy" whereby the accounts produce an "irritated middle" that turns aside from simple conclusions and answers.[35] *Donahue* depends on a much more classical debate format that works toward national harmony, a format that produces a sense of "the social good" and a belief in answers. Ultimately, *Donahue* masks the role of white male privilege by positing "union within diversity": for all our social differences, we citizens are the same behind the facade of class, racial, and sexual difference. That is why, according to Masciarotte, Donahue (much like Rivera on transsexuals) can in all seriousness assert that under their women's apparel, transvestites are *ordinary* family men.[36]

Lisa McLaughlin disparages the idea of daytime talk shows as a "counter public sphere." Her analysis of a *Donahue* program on safe-sex prostitution reveals the limits of talk's liberal ideology: it rejects "radical structural change and desires to work within existing structures."[37] She describes how *Donahue* sets up controversy through guest choice. The program establishes a binary opposition between several seductively clad prostitutes and Helen, a woman who has repeatedly written Donahue to complain that talk shows glorify prostitution. With the announced purpose of giving representation to the silent women who never voice their displeasure with prostitution, the program allows Helen to lash out at the prostitutes. The (not-so-silent) audience joins in on the vituperation, turning the program into a morality play. McLaughlin concludes that the confrontational style of *Donahue* and similar shows leads to "resistive binaries such as male/female, madonnas/whores, good/bad—and [limits] the terms of the debate to the acceptability of lifestyles and sexual practices."[38]

Of course, the daytime talk shows are not simply progressive or regressive. They do not represent the death of the public sphere. Although they do not often discuss specific governmental or social institutions, they are clear debates about the public sphere's growing intercession into the family, the home, and regulation of the individual's body. Further, the genre most explicitly enters the public sphere debate through its gesture toward participatory democracy: its town-meeting structure. Further, it maintains the organization of the social debate by always placing the private issue within a social matrix. As a result, the talk show participates

in a debate arena comparable to Habermas's public sphere. However, the evidence of social injustice has shifted from rational and distant forms to an intersection that collapses personal experience, physical evidence, and emotion.

Reinventing Debate as Talk on the *Oprah Winfrey Show*

Oprah exemplifies this new form of evidence. Here, there is a continual tension between rational educated forms of evidence and the direct "authentic" experience of the audience. *Oprah does* challenge the supposed objectivity of traditional patriarchal power. The host—a black woman— undercuts the authority of the debate format with her self-confessional style; she routinely admits her early sexual and drug abuse and her erstwhile struggle to lose weight. *Oprah* also represents potentially a radical public sphere that privileges process over a single truth or closure. It often presents what Masciarotte calls an "irritated middle."[39]

Nevertheless, the structure of an *Oprah* program is typical of most daytime talk shows: problem solution. Most often, the problem is introduced as a personal problem (for example, obesity, HIV+, a bisexual spouse) but then generalized to a larger social issue. For instance, an April 15, 1994, program on mothers who want to give up their violent children becomes generalized by Winfrey to "What really makes a child act this way?" Either by taking the opposite side or teasing out other views, Winfrey questions the guests to flesh out the problem. The identifications of guests underline their social representativeness; for example, one is a "mother who wants to give away a violent child," another is a "convicted woman who plotted her husband's death." The labeling offers a popularized version of the logic of identity politics, wherein identity is constructed as a series of sectional needs (black, woman, lesbian, worker). Mary Louise Adams and Linda Briskin detail how identity politics began as an attempt to break down the hegemonic notion of homogeneity, that "we all are one."[40] On talk shows these social identities become broader. The labeling tends toward more generic or psychosociological characterizations ("man who raped woman at gun point") than the social topology produced by identity politics (race, gender, nation, class). It is not understanding social identity but creating identification with the participants that is paramount for the narratives of commercial television.

Nevertheless, Winfrey slowly invokes the audience as a larger social collectivity. She directs the debate toward social issues through her selection of questioners and specifically through the rhetorical use of the pronouns "you," "I," and "we." To illustrate: she says, "I am sure what

mothers out there are thinking," or "When I first heard about this, like everybody, I wondered what the big deal is," or (my favorite because it's Winfrey at her most self-aggrandizing), "The question we all have, I am speaking for the audience here and the audience around the world listening to you. . . ." Or consider Donahue's well-known address to the audience: "Ladies and gentlemen of the jury." As the above quotations reveal, the audience represents not only society at large, but a society that thinks and adjudicates.

Another aspect indicated by the quotations is when the host moves from authority—controller of the program—to positioning herself or himself with the audience as one of the observers or judges who has a social or personal stake. But control is not thereby relinquished. What many people applaud as Winfrey's debunking of her authority—she will even sit in the audience—can also be seen as a move that subtly allows her to orchestrate a collective response from the audience.

When Wendy Kaminer says of her experience on *Oprah*, "If all issues are personalized, we lose our capacity to entertain ideas, to generalize from our own or someone else's experiences, to think abstractly,"[41] she has missed the point. Such shows continually move from personal identification to larger group identification in order to be popular on a broad commercial medium. The host generalizes the particular experience into a larger social frame to capture the interest of a larger audience. For all their individualized narratives, the shows speak in social generalities, but not about changing specific social and political institutions.

As much as daytime talk show audiences are purveyed as a representative random sample of American women, they are not democratic entities. First, during segment breaks, producers monitor, guide, and select questioners: Oprah often segues with "As you were saying during the break, . . ." Second, some shows selectively hand out tickets to particular programs in order to get a certain type of audience makeup. *Donahue's* NBC pages seek out middle-class, well-dressed, women tourists on nearby streets in a quest for articulate guests. Often the audience coordinators call and invite people who have a personal stake in an issue. Audience guests move from being identified guests (relatives, representatives of social organizations, or similar victims) to part of the microcosm, the studio audience, a stand-in for the larger society.

Yet the show creates a flow between stage guests, audience guests, and audience members that empowers audience authority. For example, on a *Oprah* program on violence in schools on April 7, 1994, the audience was dominated by angry schoolteachers. Or on a *Oprah* show about HIV on February 17, 1994, 60 percent of the audience were HIV positive. A

debate about the morality of homosexuality or certain sexual practices did not take place on the latter because HIV-positive people were normalized as the majority of this microcosm. Hence, guests and studio audience were united in their acceptance of homosexuality.

To a large degree, the constitution of the audience draws from the identity politics movement. Identity politics has institutionalized around organizations that represent particular political issues. Producers book a guest based on the perception that he or she is involved in a topical social problem, calling upon such organizations as ACT-UP, the National Organization for Women, various battered women's shelters, and the National Association for the Advancement of Colored People to line up experts, guests, or audience members. For example, for a program on nonsafe sex, *Geraldo* producers worked closely with New York gay rights organizations not only to arrange for participants but to produce a program free of stereotype. It is advantageous for these organizations to stack the audience and the debate, and thereby create the rare opportunity for their members to have a "majority" experience. Even so, the program will encourage non-members or off-the-street audience recruits to speak up if they disagree. As one *Donahue* producer commented during the warm-up of the studio audience: "We like emotion and controversy."

Oprah usually stacks the debate in a clear direction, allowing for a subtle form of closure based on a selected majority rule. Winfrey's monitoring of questions confers on her the gatekeeping function. On a March 8, 1994, program on why girls fall behind in high school, audience questioners were overwhelmingly women teachers and female students who had experienced sexism; only two of twelve speakers resisted the premise that sexism was a problem for teenage girls.

Most *Oprah* programs end with solutions offered by the experts and underlined by a pithy remark by Winfrey and/or an audience member. Sometimes the programs, such as the problem-child program, do not end in a resolution/solution; this one closed as the debate between mothers continued. This is the "irritated middle," or the "cacophony of 'I's," with no sense of a sociological answer that Masciocotte asserts makes daytime talk shows radical. But in general *Oprah* offers a subtle form of "we," achieved through her slow process of consensus building.

Oprah's Audience and the Prozac Program

Talk shows do represent a change in the concept of proof of social truths. Although a program and its experts establish and resolve the debate on the presented issue, the distant evidence of the expert knowledge is no

longer valid. Nor are the synthetic spectacles of television acceptable. Oddly, in the age of postmodern simulacra, talk is consumed in corroborating the authenticity of lived experience as a social truth. It relies on the tangible or physical signs of the experience of its audience: testimonials, emotions, and the body. The daytime talk show genre represents a grow- ing distrust of both the learned knowledge of expertise and the simulated truths of fiction and the media in general.

Janice Peck warns, however, that common sense is a vague term that veils a complex process whereby the shows individualize what should be understood as social issues. In her study of the popular discourse of race on *Oprah*, Peck analyzes how audience members privilege individual experience as the "primary source of truth." Through their self-help logic, the shows encourage taking responsibility for one's own feelings and behavior, basing the encouragement on an assumption that participants are "powerless to change anything beyond [their] own lives."[42] Through the discourses of Protestantism, liberalism, and the therapeutic, the shows reproduce the dominant ideology of "self-contained individualism"—the foundation of the existing American social order. Peck looks at a thirteen-part *Oprah* series, "Racism 1992." Here, racism is understood by the participants as a result of individual opinions, experience, and rights. Ending racism, for the talk show, becomes a matter of healing oneself of prejudice as opposed to collective political change. For Peck, even identity politics with its structural awareness of power fails to offer an avenue for political change; its emphasis on various identities does not imply the necessity of a political struggle.[43]

What is not addressed by Peck is that daytime talk shows depend on a unity-in-diversity model as women share their individual, different experiences of the struggle of a shared female existence. The audience formulates a critique of the traditional methods of arriving at knowledge or truth through a demand for the test of lived experience. Conventional notions of evidence exclude the personal as subjective and not representative. *Oprah* turns these notions around by offering spontaneous and raw evidence. A single program on a controversial medication illustrates the tension between expertise and experience. The program (April 14, 1994) presents several Prozac-takers of Wenatchee, Washington, and their psychologist through direct satellite broadcast. Oprah speaks of the latter's abundant prescriptions of the medication and of his patients as potentially either representative or anomalous from the start of the hour. "You know our society is always looking for the fastest, the easiest, the quickest fix, but is this right?" It is only the slow process of individual audience members getting up and testifying to their similar experiences that leads

to the concept of a larger community—society at large—and evidence of a social problem or issue.

Almost every daytime talk show starts out a bit at risk: Will the guests be seen as anomalous and alone, hence as potential freaks in a sideshow, and will audience members spontaneously reveal their shared experiences? Lurking below the surface is the supposition that rational people do not expose their private lives on national TV unless they deem doing so socially important. The show depends on this tension for excitement. Even with an audience populated with Prozac-takers, the question remains: Will these women overcome their inhibitions or societal repression and testify? The spontaneous breakthroughs increase as audience members in Wenatchee call the show and in the studio jump to the mike and emotionally acknowledge their use of Prozac. As one woman states: "My secret is out." The rising tide of testimony leads not only to a truth based on sheer numbers but also to a truth based on experiences that are real and not on the expert's numbers and sociological language. The zoom serves as a microscope-like tool with which we can judge the veracity of the performance.

The Prozac program relies on a classical relay where the guests on the stage initiate the emotional displays that center on the subject: Prozac use. Then an invited Prozac user in the audience makes an angry retort to the assertion that Prozac creates a false personality. Intensity builds with more testimonials as to the normalcy of the Prozac experience until one has the sense that if the audience as predicated by the show's logic is representative, America and its particularly female citizenry is a nation of born-again, well-adjusted, but highly emotional people on Prozac.

The emphasis in identity politics on a hierarchy of oppression contributes to the emotion of the debate on the *Oprah* program. Daytime talk show audience members often attempt to close down discussion by asserting that by nature of their oppression—race, gender, or class standing—they are a priori morally right. This "one-up oppressionship" allows *Oprah*'s Prozac-taking audience members to "disqualify" the experts for having only "academic knowledge" of the pain of depression. When Dr. Peter Breggin (author of *Toxic Psychiatry*) declares: "Oprah, people want to believe—we want to believe that it is a biochemical imbalance," the Prozac-takers respond determinedly, "It is!" So powerful is the belief in the power of personal experience (particularly of physical and emotional suffering) that the audience knows more about the chemistry of psychopharmacology by virtue of experience than does a psychiatrist who is a leading authority.

The topic of Prozac represents an important test of the authenticity of

these displays because of concern over whether people are "themselves" on Prozac. A principal pleasure afforded viewers by daytime talk shows is assessing to what degree a guest is authentic or "just an act." Oprah poses the question "Does a drug like this hide or enhance who we really are?" The program becomes an exercise in discerning whether it is a person or Prozac speaking. The Prozac-takers in the studio audience argue that they are themselves but now "enabled" or "chemically balanced." Yet the two experts argue against Prozac use because it is not "natural." It falls to an expert to close the debate. As the credits roll, Peter Kramer (author of *Listening to Prozac*) declares that the success of Prozac therapy and medication is "unarguable," but only for situations deemed sufficiently serious by a qualified physician. Here, bourgeois expertise still dominates. The audience may be posed as judges listening and weighing evidence based on common sense and personal experience, but it is the expert who most often closes or shuts down the debate.

The shows do not follow the tradition of the bourgeois public sphere, where J. B. Thompson says, "the authority of the state could be criticized by an informed and reasoning public or 'publicness.'"[44] Rather, the shows rely on testimonials, emotions, and the body as well as laughter, facial expression, and tears. These are forms of argument and evidence available to nonexperts or the lower classes, and they are gaining acceptance as the shows test the centrality of the educated bourgeoisie in defining politics and debate. In this postmodern age of simulations, daytime talk shows demand a belief in the authenticity of lived experience as a social truth. Perhaps such raw physical directness is what makes the educated middle class so uncomfortable with the so-called "oprahfication" of America. As one *Oprah* audience member stated on April 14, 1994: "Don't tell me how to feel. I am my experience."

Daytime Talk Shows, Race, and Black Expertise

How does the potential subversion of bourgeois expertise hold up when black intellectuals appear on daytime talk shows? We need to consider that the dominant ideology is not only anti-intellectual but does not traditionally accord the rights of expertise to women and, most particularly, to African-Americans. Even though the intelligentsia is economically advantaged, it is culturally a political minority—and black intellectuals are an even smaller minority.

Nevertheless, the shows are arenas for a disappearing breed of bourgeois intelligentsia: public intellectuals, people interested in a popular discourse. They want to bridge the cultural class system by appearing on

or writing in popular culture venues in the name of political change. These intellectuals are distinguished from the so-called experts who populate the shows. *Expert* is a nomination that the program assigns to an individual based on an advanced degree, a publication, or a position with an institution. As stated earlier, experts often are chosen from the social services bureaucracy, which has a stake in maintaining the system or they are lone self-promoters. Talk shows use experts to assert control and define acceptable behavior. However, intellectuals (who can also promote themselves as experts) question the very premises of the language, political assertion, or action, complicating the debate in the name of rethinking assumptions. Interestingly, more than other mass media vehicles, the shows frequently turn to African-American intellectuals to explain social (albeit race-related) issues. *Oprah* is a predominant venue for the popular presentation of black intellectuals.

Race, like feminism, is a rarely stated topic. Yet race is woven into the fabric of programs through the color of guests, audience members, and hosts. Most often racial difference is implicit. The aforementioned *Oprah* program never actually states that Jawad is a light-skinned black Moroccan who speaks broken English. The camera does so: he is seen full-face. Debbie, an American, is hidden in the shadows; her race is indeterminate. The initial story is framed from her perspective. Even though *Oprah* is considered the most race-conscious daytime talk show, the guests' racial and national differences are not discussed, although a white American in the audience slurs the man as "not a good example of a Moroccan."

A second rape story on the program has a similar racial scenario: a rape described from a white American woman's perspective. This time we see her. A taped interview is shown with the imprisoned Hispanic perpetrator, who has such a strong accent that his words appear in subtitles. Again no mention is made of racial and national differences. It is programs like this that perpetuate the worst racist and xenophobic stereotypes because they do not speak to the inequities of representation. In classic hegemonic fashion they "naturalize" racial and national distinctions as part of their morality play of good versus bad: virtuous white American woman and amoral "colored" foreign man.

Yet the daytime talk shows attempt to undercut racial differences through statements of belief in the homogeneity of the American and international experience. The central ideology of the shows is that despite our external differences we are all one. As Peck ably demonstrates, the shows present people of color as individuals whose difference derives from personal psychological factors.[45] This is why *Oprah* can brag unselfconsciously that it is enjoyed in more than sixty-four countries. The hope is that a

viewer identifies better with, say, a Moroccan who is not self-consciously divided off as a national or racial "other." When *Geraldo* does a program on "gang members" (March 8, 1994), the majority are black and Hispanic, but race is a minor issue if not absent. The point is human behavior, not so much class and race divisions.

Yet, the shows' treatment of race is not a case of simple individuation of issues. The shows are major arenas for disadvantaged African-Americans to enunciate their anger at a white system, even though the shows avoid sanctioning anger or militancy. Guest lists are balanced in respect to gender and race for social representativeness and commercial appeal. In my three-month study only in 5 of 260 programs was race the explicit subject: "Teens Who Are Racist" (*Sally*, two programs, February 7–8, 1994); "What Race Are You?" (*Oprah*, February 8, 1994); "Race Relations" (*Geraldo*, February 7, 1994); and "How Did Black Men Get So Feared?" (*Oprah*, March 22, 1994). Race was also a topic but not explicitly stated in such programs as "Heartland Hate Summit" (*Geraldo*, January 31, 1994); "Is Affirmative Action Misguided?" (*Donahue*, March 21, 1994); "Klan Renegades" (*Geraldo*, February 1, 1994); "KKK Members Who Home School" (*Donahue*, April 28, 1994); "Rodney King-like Beatings" (*Donahue*, March 11, 1994); and "Vidor, Texas" (*Sally*, March 3, 1994). Yet it is important to know that almost all programs presented people of color as either guests or speaking audience members.

Black experts and intellectuals are still a minority on daytime talk shows, yet they offer a rare significant presence. Drew Brown, a black self-help writer, attempts to reason with racist teens on *Sally*; Margaret Taylor, black author of *The Sweeter the Juice*, is the sole authority on the history of "passing" on *Oprah's* "What Race Are You?"; and Dr. Jamie Washington is the black college administrator on a panel (three men, three women) with five whites on *Donahue*.

In fact, most critics who write about the shows as an oppositional public sphere are speaking of programs on which the experts are white males; the Prozac program is in this category. An audience member castigates white Peter Breggin, author of *Toxic Psychiatry*, for his contradictions: he is against the use of medication for depression but inadvertently reveals his own pleasure in alcohol. Within the ethos of daytime talk shows, one must live what one advocates; truth must be drawn from experience.

This anti-intellectual, or antibourgeois, sensibility empowers the normally disempowered classes. Its logic leads Carpignano and his colleagues to praise the *Morton Downey Show* for promoting its audience of angry working-class males and their knowledge based on common sense. Here,

the values of the audience are not examined; empowerment of the weak—no matter how reactionary, racist, and antiwomen—stands as the central value of daytime talk shows. The authors' championing of *Downey's* working class worries McLaughlin: "This peculiarly 'macho' description does not bode well for a new public sphere where participation is enacted on an equal basis. By defining the public as male and class specific, it effectively re-creates the unequal conditions of the bourgeois public sphere."[46] Paul Willemen deplores what he sees as a recent loss in responsibility on the part of media critics, who are "in favour of the celebration of existing patterns of consumption based on a principled refusal to countenance the possibility that vast sections of the population have come to derive pleasure from the conservative oriented media discourses."[47]

I was constantly asked by academics as I was writing this book, "Would you go on a talk show as an expert?" My usual response was yes, I would not give up a chance to affect a national popular debate. But inherent in such a question is, on one hand, fear that the shows make a mockery of rational thinking, intellectual behavior, and progressive politics, and on the other hand, suspicion that if the shows are a bastion of populist rebellion against repressive authority, the appearance on them of a bourgeois expert might reinforce the authority. Accordingly, we need to address the place of the intellectual on commercial talk shows (as well as of one writing about talk shows) in late capitalism.

Talk Shows, Race, and Black Expertise

No more complex case exists for understanding the role of the media critic than the role of the black intellectual on American talk shows. From Harold Cruse's *Crisis of the Negro Intellectual* (1967) to a 1995 *Atlantic Monthly* cover story on the new black intellectual class, writers have told how African-Americans have not easily embraced their own representatives in the bourgeois public sphere. Yet black intellectuals such as Cornel West, Henry Louis Gates, Jr., and Maya Angelou have used commercial TV and newspapers to reach not only their community but a dominant white society. West argues that the black intellectual is an unusually marginalized individual, "caught between an insolent American society and an insouciant black community. . ."[48] Very few academic institutions or journals are devoted to black thought and culture. And within the black community it is the applied cultural leaders who are respected: jazz musicians, preachers, and political activists.

For West, the rejection by the black community (especially by its middle class) springs from not only the black intellectuals' haughty style,

but also their failure to remain "organically" linked to the community. They often marry whites, they tend to work within the high theory traditions of white European culture, and they often leave black educational institutions for vaunted white educational institutions (for example, the "Ivies").[49] Bell hooks writes that critical thinking within the black community has connotations of "dissin"—a "disabling concept" that forces one black group to disrespect (to compete against) another by means of negative comparison.[50]

Such differences among African-Americans lead many black social critics to support the black organic intellectual, who as an outsider in the dominant culture, must break from established academic positions. For West, the black intellectual cannot take part in the white bourgeois humanist tradition of intellectualism in that it would be "stultifying" because he or she would be in the defensive position of always being inferior or anterior to that tradition. Nor can the black intellectual simply become a Marxist, for all Marxist theory's capacity to elicit a critical consciousness. Race is secondary to class within Marxism. Neither is the Foucaultian critic a model. Even with the postmodern critical awareness of the power of intellectual discourse, the Foucaultian intellectual is decapitated by cynicism and distance.[51]

"Organic intellectual" is a term derived from Antonio Gramsci's thought:

> Every social group, coming into existence on the original terrain of essential function in the world of economic production, creates together with itself, organically, one or more strata of intellectuals which give it homogeneity and an awareness of its own function not only in the economic but also in the social and political fields.[52]

For Gramsci, intellectuals are no longer only the elites who exist outside or above society. Rather a new class of intellectuals has emerged from the particular communities they want to represent. The simple binary bourgeois intellectual/working-class nonintellectual no longer holds. The working-class individual (the so-called average member of a talk show audience) always has an intellectual or abstract component to her or his contribution to the discussion.

Gramsci called for the nomination of working-class thought as a form of intellectualism at its "most primitive and unqualified level."[53] The working class understands the sphere of production and day-to-day experience. Its role is to enunciate that experience in order to enact

political change. The working class comprises, among others, teachers, industrial workers, and organizers who have become aware or self-conscious about their culture, people who are "mediators as they are mediated by their constituency."[54] Gramsci writes:

> The mode of new intellectuals can no longer consist of eloquence, which is an exterior and momentary mover of feelings and passions. Rather it participates actively in practical life as constructor, organizer and "permanent persuader" and not just a simple orator.[55]

West construes *organic intellectual* for black culture to mean the intellectual who does not divide herself or himself from the African-American community but stays firmly grounded in its traditions—gospel and orality, the rhythms of jazz to blues—and the nuances of its popular culture. To build insurgency, the organic intellectuals need to create high-quality institutions of black critical learning. And they should establish alternative practices that are communal within African-American culture as well as work alongside European models of intellectualism that still shape black culture. Further, the black organic intellectual needs to continually evaluate her or his general cultural role, and the historical and social forces operational in the black community. No longer can the bourgeois intellectual represent the needs of a people with whom she or he has no direct connection.

The *Oprah* Program "How Did Black Men Become So Feared?"

How does the model of the black organic intellectual work out in practice on a daytime talk show? Cornel West's theory represents a number of critical discourses that are known and get played out in any public forum for black intellectuals. It would be difficult to describe *Oprah*—an internationally syndicated show—as an African-American institution, even though the host is black, the production company (HARPO Productions) is owned by a race-conscious black woman, and its staff is dominated by people of color. As Peck argues, the show neutralizes its racial elements through the leveling effect of individualist ideology. Nevertheless it routinely features black experts who often become the site of political resistance.

All daytime talk shows, including *Oprah*, are constrained by the dominant Western discourses on race that make them a success with a broad audience. Because the genre is based on representative social or

interpersonal conflicts, the shows rely on racial stereotypes. An issue or problem is staged as a conflict, which is telegraphed by means of clear oppositions leading to a quick solution or closure. Commercial pressures do not allow for the complexity of social or historical context, which is why the shows are not a platform for the subtleties of racial issues or the complications of public sphere debate. Rather, they resort to the universals of personal experience as the knowledge source from which the narrative is woven. It is here that the racial reductions or leveling of distinctions occur with which each member of the audience is asked to identify. However, the shows' imperatives as a capitalist institution must be separated from the discourses of the intellectual or expert as well as audience members.

How do black intellectuals negotiate the limitations of a race discourse on daytime talk shows, that "we all are one" and the naturalization of unstated racial stereotypes (for example, black perpetrator, white victim) and intricacies of social explanation. The program "How Did Black Men Become So Feared" (*Oprah*, March 22, 1994) features four black intellectual men: two academics (Michael Dyson, an American civilization professor at Brown University, and Walter Allen, a sociologist at UCLA) and two writers (Brent Staples of the *New York Times* and Nathan McCall of the *Washington Post*).

Interestingly, when talk shows attempt a traditional public sphere discussion, it is *not* a debate with the public, but more often a dialogue among experts. Overtly political topics are too volatile for the shows to throw open to an unselected audience; the risk of financial loss is too great. The *Oprah* program is no exception. The first ten minutes of the hour is consumed in an elaborate recounting of the history of the African-American male. Winfrey and the two academics quote from such materials as slave narratives, slave advertisements, and the memoirs of renowned black writers, ending with a reading by McCall of his memoir covering his youth on the street. They move through migration from the South, the rise of segregation, and northern ghettos to the advent of crack to give a highly schematic (if not problematic) context for their discussion. The introductory segment is a rarity in its use of media and didacticism.

In fact, the black experts dominate the program, and audience participation nearly disappears. Only three audience members speak; the famed democratic aspect of the shows recedes. On one level this change results from the lengthy presentation of the context of a political issue for a less-informed audience. On another level, talk shows seemingly do not know how to juggle the urge to teach politics with their tradition of audience discussion. It is only when a show populates the audience with preselected "informed citizens," as *Donahue* did for its affirmative action

program, that the audience comes alive.

Nevertheless, a different kind of democratic participation takes place on this *Oprah* program: the experts become representative or average blacks because their knowledge is based on their own lives. Three tell of growing up in a ghetto or how he or a brother was arrested for illicit behavior. The reporters read from their memoirs, which were replete with streetwise experience and dialect. Dyson slips in and out of the King's English while peppering his discussion with references to the Christian faith, black writers (for example, Richard Wright), and popular culture (an instance: Snoop Doggy Dogg). Similarly, on *Donahue's* affirmative action program (March 21, 1994), it falls to Jamie Washington to speak as both expert (college administrator) and one who has experienced a world without affirmative action. Each of men has moved out of the black community and returned as a top-down authority. This is the daytime talk show version of the organic intellectual: an urbane middle-class spokesperson who can approach or analyze a social issue from the vantage point of his or her own experience. Although such a person comes closer to Gramsci's notion of the working-class intellectual than do many other experts, it is the audience members who intellectualize social problems most consistently from within a community.

Organic intellectuals dismiss the simplistic discourse of self-help or rugged individualism that predominates on daytime talk shows. As a commercial medium, the shows emphasize a "can-do" (or "can-consume") solution to or a spiritual transcendence of social issues. In fact, *Oprah* is the most well known for this logic; it is marked by its affirmation of individual will and spirituality as represented by Oprah's battle with weight and references to a higher power. When Staples paints a rose-colored picture of black life ("The black experience in America has so much vitality and love in it") or when Oprah adverts again and again to one individual's helping another as the source of change, the academics are unaccepting. Dyson describes slavery as a "deeply ingrained tradition in the mores and folkways of American culture." Allen asserts that several myths are operating in the discussion: "equal opportunities," "individualism," and "how one makes it in society." But Oprah maintains her show's emphasis on individualism: "Isn't the bottom line, You do have to turn to yourself?"

Ultimately, it falls to McCall to translate between the structural determinism of the academics and the individualist ideology of the show, offering a parable:

I think that there is another element too. You have to be able to look around in your environment and get reinforcement for some

of the notions and some of the ideas. . . . It is hard to talk to the brother on the block and say that you can be president of the United States one day. And he goes to the encyclopedia and sees all the presidents thus far have been white males. It's hard to convince him of that.

McCall has been positioned as a street poet—a more established community figure than the academics—from the start of the program with his reading. He has done time for criminal activity. He refuses the embourgeoisement of formality of academic appearance (for example, horn-rimmed glasses and a suit) yet balks at homilies and simplified answers: "We are dealing largely with perceptions here. When I was coming up, once I became convinced that there was no way out and that I was rejected and despised by this society. I wouldn't even try, man. I wouldn't even try." Although all the men are variations of the black organic intellectual, McCall reveals the most about his experience, his emotions, and his pain—the hallmark of credibility for the daytime talk show audience.

However, it is these intellectuals' self-consciousness about their authority that is the central marker revealing their organic connection to their community. Within the first twenty minutes, the problem of the "exceptional Negro" is posed. Dyson begins:

> I have personally been impacted when we talk of slavery. I have a brother also who is serving life in prison. . . . I then get a Ph.D. from Princeton University. People say you made it . . . you got out of it, why should we be any more sensitive to your brother. . . . ? My answer is not only by the grace of god, but I was identified at any early age as a gifted child and that presented me with a set of opportunities for me to escape in ways that other black men weren't able to make it.

Each man attempts to maintain this balance—repeatedly declaring that he is out of the community, but none is actually representative. In my survey of 260 broadcast hours, I rarely came across an expert willing to question the limits of her or his authority and personal experience. Programs depend on experts to organize the discussion and emotion, yet these men are prideful in their authority while evoking the discomfort and sense of responsibility that middle-class black intellectuals carry. Dyson: "When we get these Ph.D.'s, we have got to be responsible for these young black brothers. [applause] We must be very careful that our analyses are not harming the very people that we got the Ph.D.s for in the first place."

With this self-consciousness, the organic black intellectuals are much more complex figures than an hourlong antibourgeois talk show can evoke.

Yet for all our questioning, the *Oprah* program asserts closure: it returns to belief in individual agency. In the last ten minutes, Oprah interviews Joe Marshall, a San Francisco radio talk show host (*Street Soldiers*). Positioned in the audience along with Oprah, Marshall represents a more traditional talk show expert; anti-intellectual and given to quick inspirational answers. "I think it is important for us to drop these labels. Lower class, middle class. These are our people! . . . I think these labels just divide; we don't need any more divide and conquer." Oprah nods in agreement: "Unless everyone comes together to try lift everyone up, we are going to fall together." And when Marshall issues "a challenge to all men" to create the extended family or "to be fathers to . . . many young men and young women," Oprah pronounces "You can be the light."

It is naive to assume that daytime talk shows are a public sphere untainted by capitalism, the state, or even the bourgeois intellectual. Because they are based in commercialism, popular culture, and the identity politics of the 1970s, they stage a contradictory set of tensions where groups that normally do not have a voice are allowed a powerful platform. The genre challenges accepted notions of political discussion. Not only do the shows question what constitutes politics, they challenge who is allowed to speak. As we move from the age of mechanically reproduced debates to one of electronically reproduced discussions, the shows represent an uncomfortable public sphere. They reveal a profound political change: the authority of everyday lived experience, whether in reactionary or progressive form. As they manifest this change with programs on militias, domestic violence, and black pride, among other topics, the empowerment of the knowledge of people who are not formally educated can be seen as the failure or the triumph of liberal democratic thought.

FREUD vs. WOMEN

The Popularization of Therapy on Daytime Talk Shows

Once you lose your self-esteem as a child . . . without going into therapy, how do you get your self-esteem back? I still have no self-esteem.

 Woman in daytime talk show audience

I think other women can help women to feel good about themselves. Other women can pitch in and help women go through the process of self-creation.

 Janie Wavel, psychologist for minority girls

I see myself in Janeesa [an eleven-year-old guest]. You know, when I was younger than Janeesa, I use to hate my nose. I will tell you this: you grow into it, Janeesa. I used to try to put a clothespin on my nose to make it go up because I used to think that people who had pointed noses were better than people who do not.

 Oprah Winfrey, *Oprah Winfrey Show*, April 19, 1994

◈

I am often amazed at the confessions, emotions, and community of day-time talk shows. Women discuss and debate "the problems of self-esteem in little girls" on *Oprah* on April 19, 1994, with a missionary zeal rarely found on network TV. Of all TV programming, the four major daytime talk shows are the most directly linked to the therapeutic discourse. Not only do they invoke Freud's concept of the "talking cure" with their emphasis on the free flow of talk but two-thirds of their programs deal with psychological or sociopsychological issues. Typical are: a *Donahue* program devoted to a test designed to enable couples to understand their strengths and weaknesses (January 31, 1994); a *Geraldo* program on "women who have taken back their lying, cheating dog of a husband" (March 23, 1994);

and a *Sally* program on couples who do not want to have children (March 31, 1994).

As discussed in chapter 2, daytime talk shows rely overwhelmingly on experts out of the mental health industry: psychologists, social workers, therapists, and self-help book authors. They use the language of psychology, whether it be Freudian (*repression, drives, the unconscious*) or American twelve-step revisions (*dysfunctionality, healing, addiction, codependency*). Much like Freud's freeing of the unconscious, talk shows depend on the belief that "real" emotion, conflicts, and psychological truths will surface; between the spontaneity of the free-for-all discussion and the scrutiny of the expert, audience and host repression will give way.

According to Mimi White, daytime talk shows are not the only example of how American TV thrives on the therapeutic for emotional power. Shows as diverse as *Alf, 700 Club,* and *Love Connection* depend on "the confessional and therapeutic discourses" as both "the subject of programming and its mode of narrativization."[1] White's thesis broadens the definition of therapy beyond the common understanding of therapy as the healing of emotional problems, offering a more complex and sinister view: the media and their use of confessional formats to exert a form of social control. TV as an agent of the dominant culture exercises its power over unwitting viewers by naturalizing therapeutic psychology as a neutral method to free the self, when it is in fact the very opposite: a form of social control. Talk show viewers learn to police themselves in the name of "mental health."

White's point of view extends Michel Foucault's belief in the "productive power" of modern times, which "works to manage and manipulate people by instilling in them a specific sort of interpretation of who they are and what they want."[2] In *The History of Sexuality* he argues that the confession—a principal feature of talk shows—serves as a central means to elicit truth in our culture. It establishes a power hierarchy of interlocutor and confessor. The analyst or therapist becomes "the authority who requires the confession, prescribes and appreciates it and intervenes in order to judge, punish, forgive, console, and reconcile; a ritual in which the truth is corroborated by the obstacles it has surmounted in order to be formulated."[3] It is important, then, to question the degree to which daytime talk shows take part in a larger power hierarchy that uses the therapeutic concepts of "self knowledge," "self-actualization," and "emotional freedom" to regiment and control viewers. But the shows' rhetoric is not that simple. Their conventions, values, and ultimate power spring from the feminist movement as a challenge to patriarchy. As a result, the relationship of the shows to the dominant power is not easily located. Although Foucault

offers a cautionary model against a rush to characterize the shows as feminist, his critical stance does not allow for the possibility of emancipatory movements such as feminism.[4] This chapter traces how the contradictory tensions between the dominant culture and insurgent cultures are played out in a popular medium.

To begin, daytime talk shows throw into question the top-down therapeutic logic of the therapist/interlocutor and patient/confessor. If we look at the direct influences of the American revisions of Freudian psychoanalysis—humanist therapy, the self-help movement, and feminist therapy—that have directly affected the logic of the shows, we see in the talk show a set of power relations much more complex and vertiginous than Foucault's. Who is the therapist? The expert? The host? The studio audience? Who are the patients? Those on stage with the reductive name tags such as "female gang member," "incest survivor," and "husband locked her to bed"? Or "we" the viewers? Or Oprah, who routinely confesses her abusive childhood and displeasure with her body? And to what degree are the confessions, emotions, and interactions understood as "truth"?

Psychology is changing in the late twentieth century as therapy moves from the confessional to the public arena. Indeed, TV therapy is closer to testimonials of faith than to the guilt-ridden whispers of the confessional. No longer is the therapeutic a matter of secrets pried from the unconscious. Rather, therapy is an ideology based on the power to affirm the survival of emotional weakness, repression, and subordination—all sensibilities derived from feminist therapy. Obviously, the daytime talk shows are not as theoretically inclined or as systematic as traditional clinical therapies, yet one needs to make manifest the implicit role of American psychology. If therapy is an agency designed to bring about emotional adjustment and/or social control, we should look more closely at the specifics of its talk show incarnation—after all nineteen million people tune into *Oprah* daily. With an audience of 80 percent women, the shows are not only the leading form of daytime entertainment but a powerful element in the creation of femininity.

The Humanist Challenge to Freud

The daytime talk show gets its wider therapeutic "can-do" logic from the American revisions of Freud's psychoanalysis. In many ways it is a misleading to liken its seemingly obsessive talk to Freud's talking cure, which called for free association, the individual's saying whatever comes to mind. Such unconsidered speech breaks down social constraints on communication and rationality, allowing the patient to reveal subconscious desires

through certain compulsive repetitions.[5] When Anna O. (Bertha von Pappenheim) dubbed Freud's method "the talking cure," she could not have foreseen the highly orchestrated world of televised talk as a Freudian venue. Under the industrial formula of a seven-segment structure, commercial breaks, and the studio taping process, TV's talking cure emanates more from the preconstructed clash of "I's," or knowing egos, than from the dark, uncontrolled id of Freud's theory of the unconscious.

The daytime talk shows have reinvented talking as a curative as a consequence of ego psychology and the American cultural psychology. Many twentieth-century clinical psychologists have sought to limit the authority of the Freudian therapist and Freud's highly prescriptive theory of the unconscious, to which only the therapist has access. Ego psychology argues that the ego develops a measure of independence from the unconscious and the id. Psychologists such as Erik Erikson, Heinz Hartmann, and T. C. Kroeber argued that the ego is not as dependent on the id as Freud postulated. They viewed it as a rational agency responsible for the individual's intellectual and social actions.[6] Hartmann said that such a position offered "a more balanced consideration of the biological and social cultural aspects of human behavior."[7]

Evolving out of the antiauthoritarian post–World War II climate, individual-oriented therapy extended ego theory to grant the patient active agency and control. The most successful rethinking of therapist authority occurred in the 1960s with the growing activist American orientation and the psychological community's parallel theory of self-actualization. The patient became a self-determining figure in regard to mental health. As early as 1927 Alfred Adler broke with Freud and argued that personality was determined by conscious elements—social and interpersonal factors—rather than by a controlling unconscious to which only the therapist had access. Psychoanalyst Karen Horney in the late 1930s argued for the critical role that active "self-esteem" played in human development. In the 1960s Erich Fromm, a member of the Frankfurt School, "explicitly rejected Freudian notions of innate, undesirable human traits (for example, death instinct or aggressive instinct) and emphasized the positive nature of human nature."[8] By 1969 psychologist George Miller was arguing in the *American Psychologist* "to give psychology away to the people."[9]

The American revisions of Freud put the patient in charge of her or his mental health. Rachel Hare-Mustin points out Freud's authoritarianism. In his famed case of Anna O., he revealed his misogyny when he blamed Anna's neuroses and departure from his therapy on her mother without questioning her disturbing relationship with her father. Moreover, Freud refused to question how the incident might reveal the limits or

problems of his practice.[10] It is the Freudian analyst who serves as the model for Foucault's powerful secular interlocutor whose silence provokes the supine patient into a submissive confessional mode. At issue, then, is whether with the rise of self-determination in American therapy the unequal power relations dissolve? Or are they reinvented in a more complex and insidious form wherein the patient polices himself or herself in the name of "self-actualization"? In its self-help ethos, the daytime talk show offers an explicit case of the potential value and problems of the self-determination model of American psychology.

Through its fragmented structure, the talk show undercuts the rigors of therapeutic practices and reduces the power of the therapist or expert; it should not be confused with the precision and authority of Freudian psychoanalysis or even clinical psychology. However, talk shows are predicated on a belief in the individual's active cognition of his or her problems. For example, a *Geraldo* program on "strange obsessions" (March 9, 1994) opens with each guest describing her or his compulsion (agoraphobia, obsessive hairpulling, self-hate). "Shani" tells of her fear "that God was after me and that he would zap me." "Sandy" describes her obsession with numbers: "I would have to rinse the cup either three or seven or a hundred times." "Heather" declares, "I was totally obsessed by the mirror. . . . Part of the hair obsession was I get concerned with it being even and symmetrical . . . I couldn't stop it at the time." Even though the program plays into a tabloid sensationalism that depicts these women as bizarre curiosities, each is asked to evaluate her problem as a dispassionate observer. Rivera addresses them as rational thinkers able to distinguish between healthy and unhealthy behaviors, as he pronounces them "courageous" copers.

Also consider the Prozac program on *Oprah* discussed in chapter 4. A man in the audience describes his depression as a "chemical imbalance . . . And it's the thing that . . . that . . . that Hemingway and Winston Churchill and van Gogh and those sort of people suffer with. I mean, this is what my psychiatrist . . . maybe he's putting me on so that I can feel better about myself. But I am a rapid cycler manic depressive." This man (as do the *Geraldo* participants) reveals a consciousness of the language of psychology as well as the potential abuse of the power of the psychiatrist to define and control a patient's emotional health. Recall, too, how psychiatrist Peter Brueggin is later attacked by the audience member. Further, the language and practice of therapy are sources of humor. The above Prozac-taker kids Oprah that he is not sure if it is the medication speaking, but she looks great. Donahue often asks ironically, "All she needs is to go into therapy and everything will be nice?" As much as the therapeutic is the dominant

discourse on talk shows, the move toward self-help in American therapy has led to a debunking of authority and the prescriptive mode.

By the 1960s and 1970s American humanist therapy represented a new psychology, or the "third force" (the first and second forces: psychoanalysis and behaviorism). It was based in a belief in an inherent tendency toward self-actualization, growth, and enhancement rather than in Freud's more negative theory concerning such instincts and drives as masculine sadism, feminine masochism, and a death wish. It called for renewed attention to the specifics or individualism of clients' problems as opposed to the prescriptions of Freudian theory and the authority of the therapist.[11]

Rational emotive therapy (RET) is the most influential of these self-actualization revisions and a source for the recent self-help movement. Rejecting the role of the unconscious and early childhood experience, it opposes any logic of indirect or inactive methods of change. The therapy is highly confrontational: the therapist/practitioner points out "unscientific" or irrational assumptions, ideas, and beliefs that seem to be at the core of a problem. With a rational emotive modality, many people get blocked in attempting to achieve happiness and self-actualization. They become neurotic because they turn their strong preferences for success, approval, and comfort into absolutes: shoulds, musts, demands.

Born of this post-Freudian therapy, talking or self-disclosure has become the most common mechanism for the individual to make manifest his or her neurotic behaviors. No longer is self-disclosure the result of involuntary slips such as Freud's talking cure; it is the result of an active decision to overcome shame, guilt, and inhibition. During a daytime talk show a guest is expected to break through the guilt-ridden, chaotic world of internalized emotion to the rational and open world of personal narrative, human interaction, and community. Yet this unburdening process has tested limits of the liberal bourgeois openness: the established press continually condemns the shows as excessive. For example, Janet Maslin of the New York Times calls them "muck marathons."[12] And Anna Quinlan, a Times columnist, describes them as "the dark night of split levels."[13] There is no self-consciousness that privacy might be a luxury of middle-class life; people can distance themselves from other people and other classes in particular. The anger on the shows reveals the limits of what the middle class defines as "proper" public display of private emotions and activities.

Self-Actualization and Daytime Talk Shows

The active or cognitive approach of American therapy on daytime talk shows is twofold. There is the self-help approach based on basic "no-

nonsense" prescriptions that the patient, TV guest, or audience member can administer, such as the couples test on *Donahue* (January 31, 1995), as mentioned earlier. The test enables couples to evaluate their capacity to endure. The guests (selected audience members) are asked to react to a series of statements on a yes/no basis, such as "I am very satisfied with the amount of affection that I receive from my partner," "We have clearly decided how we will share household responsibilities," and "At times I feel pressure to participate in activities my partner enjoys." Although the announced purpose of the test is to help couples decide if they should marry, the deeper sense is to get them to start "talking" about their relationships.

Another example of a direct cognitive approach is an *Oprah* program (February 23, 1994) that offers a typical self-help issue: compulsive spending. The expert/writer Neale Godfrey (*Money Doesn't Grow On Trees*) suggests a commonsensical behavioral formula for people who cannot control their spending that involves charts, money jars, and incentives. There is no attempt to ascertain the sources of unrestrained buying.

Another example of the cognitive approach is the continual use of self-help lists on the subject of the day on *Oprah*. During the program "Do Girls Get Ignored by Teachers?" (March 8, 1994), a graph appears on the screen, "Tips for Teachers":

- Call on girls and boys equally
- Arrange seating to mix girls with boys
- Don't patronize girls
- Invite women scientists and mathematicians into your classroom

A similar graphic is used for the April 4, 1994 program on girls and self-esteem: "Warning Signs of Drop in Girls' Self-Esteem."

The usual daytime talk show is structured in this fashion: its first quarter identifies the problem; in the second quarter the audience begins to confront guests' inconsistencies as the host plays moderator; in the third and fourth quarters the therapist becomes engaged, but often audience members point out the lack of logic in or the irrationality of a belief system and begin to offer their solutions even before the therapist (if present) enters the talk arena. The solutions combine a generalized knowledge of therapy and popular wisdom derived from everyday pragmatism. The emotive and cognitive methods of RET practice read like a litany of daytime talk show practices: shame-attacking exercises; role playing; unconditional acceptance of guests by host and expert; use of forceful statements; and behavioral techniques as reinforcement; penalizing; assertiveness;

activity homework assignments; bibliotherapy; and skill training. *Geraldo* has obsessive compulsives enact examples of their obsessions, in part as a therapeutic test and in part as a demonstration of the problems. *Oprah* invites back guests who have been assigned home activities to remedy compulsive spending. A therapist on *Sally* tells a beleaguered wife to speak up and direct her anger at her unfaithful husband. Even though the audience is already familiar with these basic methods, most appearances of an expert or therapist are predicated on his or her book as a continuation of a program's limited therapy.

Additionally, programs about personal relational issues, such as "Married Women Who Have Affairs with Married Men" on *Sally* (February 23, 1994), depend on the confrontational logic of rational emotive practice. For the first twenty minutes Sally teases out the stories of two women in disguise, Ann and Laura, who are having affairs. After establishing the issue, the host lets her audience confront the women.

> First audience member: Where are your morals? When you get married, you take vows. They are down in hell, baby! . . . I was married 35 years and some woman came took off with my husband.
>
> Ann responds: I do not want to take off with him. I just want the sex.
>
> First audience member: Well, there are people who do fall in love.
>
> Ann: This is true. When you let emotions get in the way of sex . . .
>
> First audience member: What about my emotions? 35 years!
>
> Second audience member: You know, I've been married since I'm 19 to the same man. I will be married 40 years. OK? You're a very selfish person. You're a liar and cheat. If you're not satisfied, then you satisfy yourself. You don't go out (applause), you go out of the marriage. You, the blond, you want excitement? You're sleeping with a married man. You're also a cheat. Take up bungee jumping or sky diving.

Obviously, the *Sally* staff has slanted the debate by populating the audience with women who have lost a husband to an another woman. And because the audience usually is a stand-in for the at-home viewer or the average American, the "normal" psyche of the viewer is set in opposition

to the "promiscuous psychosis" of the guests. Although usually not so morally unified, the audience of the show functions in this confrontational role more than the expert/therapist, who plays a much smaller and more deferential role under the host's control. Here, one could argue that the audience has so internalized the policing practices of modern psychology that the therapist has become an inconsequential element. Yet, the therapist remains a central agent who synthesizes the audience's disparate advice.

In this *Sally* program, the relationships expert, Dr. Gilda Carle, appears halfway through the discussion. Her first act is to hug a crying woman whose husband has just confessed to cheating on her. Carle asks, "Can you tell me how you feel?" Hunched over in grief, the woman responds, "I feel sick." Raphaël pipes up from the audience, "I don't blame her." Carle reacts, "I don't blame her either. This is exactly what happens when people do cheat." Carle's role is more classically therapeutic than the audience's; she exudes the feminine virtues of understanding, nurturing, and bourgeois etiquette. She coaches the docile woman to assert herself by speaking up to her domineering husband.

Consider *Geraldo*'s program "Mothers and Daughters at War" (February 23, 1994). Randy Roffe (family therapist and author of *You Can Postpone Anything But Love*), is a minor, almost meek figure, speaking in only the last ten minutes of the hour. The audience and Rivera identify the mothers' inconsistent statements and actions. Addressing one mother who is "a drug addict" and "prostituted her daughter for drugs," a woman in the audience says, "I thinking you are disgusting. What kind of role model are you to your kids? How are they to learn good from bad when you are like the way you are?" The scolding reveals the degree to which the response of the studio audience is based on normative social roles, here specifically motherhood as self-sacrifice—a dominant image on the shows. The *Geraldo* audience member fails to show proper therapeutic respect to the guest, but Rivera persists more graciously: "What about the larger issue, Jane? Don't you have a responsibility to try and be something? . . . Have you dropped the ball of motherhood?" The next speaker from the audience, a more measured participant, addresses Jane's daughters: "I think it is time that you two sisters moved on and take care of yourselves Obviously at this point in time your mom is not mature enough to take care of herself." The audience erupts in approving applause. Although the audience tends to be judgmental and even cruel, the logic still remains: to dispute inconsistencies in behavior and logic. The clash of moralities makes for TV drama and is arranged for by selecting guests on opposing sides of an emotional issue.

Daytime talk shows' techniques are a loose reworking of a rational emotive therapy's disputational method for overcoming unrealistic and irrational feelings and actions. It involves detecting irrational beliefs, debating them, showing why they are irrational, and reformulating them. RET works on specific problems and hence is easily adapted to the fragmented format of the talk show. Talk show therapy is at best "band-aid" therapy, not the fundamental psychic reorientation that Foucault's model implies. Its logic downplays environmental factors or an awareness of what might be described as social subjectivity. It depends on a problem/solution format that according to the founder of rational emotive therapy, Albert Ellis, "places man squarely in the center of his universe and of his emotional fate and gives him almost full responsibility for choosing to make or not make himself seriously disturbed."[14]

The therapeutic logic of talk shows offers the potential for a high degree of self-absorption. Audience members often jump to the microphone to tell their own stories, seemingly competing for the most egregious example of personal pain. As a result, talk shows are frequently indicted for their excessive emphasis on egomaniacal "I," or what Christopher Lasch sees as the cultural narcissism of the post-1960s period. The individual is so caught up in self-examination and self-determination that she or he denies any larger social causation.[15] Depression has its social roots, yet it is denied here. Philip Rieff proclaims that this individualism in American therapy leads to a severely limited sense of ethics wherein the self determines experience and Western culture "stands for nothing."[16] This selfish ideology leads Wendy Kaminer to label talk shows as part of a new pathological individualism.[17] Yet in all these cases it is simplistic to blame recent postmodern culture because American ideology has always had its roots in individualism. From Tocqueville's treatise on American culture to the entrepreneurial capitalism of the nineteenth century to the populist movement, the American discourse of individualism transcends the late twentieth century and the psychology of the world of the marketplace.

From a Marxist or Foucaultian point of view, the pragmatics of self-therapy perpetuates the naive discourse of American ideology, which denies the role of society, economics, and language in the formation of the individual.[18] We need to consider Wendy Simmonds's warning in *Women and Self-Help Culture*: "Such talk fails us when it does not challenge the general faith in psychological rhetoric and reactionary political developments that encourage us to conceive of individual action as either a cure-all or the cause of all problems, and to believe we are entitled to the answers to our problems."[19]

Potentially, this rationalist psychotherapeutic approach does lead to a

secular pragmatism devoid of the morality authority and sense of meaning provided by religion and its secular forms, such as politics and psycho-analysis. As much as daytime talk shows have a sociopsychological bent to them, they are often remarkably apolitical, caught up in a battle to affirm the individual's power to overcome pain and problems. A majority of the guests/patients are from the lower class—people who do not have access to middle-class therapeutic language and practices. Even though *Sally's* couple lives in a trailer park and the unfaithful husband cannot find full-time work, the program avoids discussion of possible economic determi-nants of their problem. Instead, the program and others like it affirm the individual's ability to pursue emotional happiness by offering pragmatic measures.

The utilitarian logic of rational emotive therapy also lends itself to a consumer orientation. Although the program/expert/product is necessary to confront the problem, the viewer/guest is called upon to be active and use the method/therapy to his or her own advantage. The commercials handily extend this sensibility; advertisements for weight-loss clinics, cleaning products, and personal-injury lawyers emphasize the logic of im-mediacy, choice, and fulfillment. Perhaps herein lies the Foucaultian nightmare: the daytime talk show manufactures consumer desires as it produces a notion of the emptiness of the self.[20] The show, the therapy, and the products create a self-aggrandizing discourse as they become a way for filling the void. Yet it is also too simple to argue that the shows en-gender a slavish belief in self-help through individual consumption and self-regulation. The denial of the self and awareness of the pitfalls of be-lieving in personal agency might be good exercises for the white bourgeois male, but the shows appeal to women who have historically been taught to efface their needs and themselves in the name of family. As Jana Sawicki points out, "The absence of a sense of self, of one's value and authority, and of the legitimacy of one's needs and feelings is the hallmark of femininity as it has been defined in many patriarchal contexts."[21] The affirmation of the power and rights of the individual might be a rare moment of illumi-nation for the lower-class housewives who dominate the shows' audience.

Talk Shows and Feminism

In the end daytime talk shows are not caught up purely in pragmatic indi-vidualism; they also solicit a collective consciousness—the female audi-ence. Like all cultural practices, the shows exert contradictory demands for power. But their claim to personal fulfillment through commercial con-sumption is counterbalanced by their veiled feminism and a consciousness

of the inequalities of power. Their principal social aim has been to build up women's self-esteem, confidence, and identity. Unlike most self-help books about which Simmonds writes, the shows take place in an arena of collective feminine experience. The form of their practice results from the women's movement and feminist therapy—specifically, the consciousness-raising group as a democratic forum—a place where women create community in the absence of authority by drawing on their social experiences and morality. Here advice does not come top-down but from within the group and its shared oppression.

Through their rewriting of feminism, daytime talk shows retain their moral power. This role cannot be reduced to the complex therapeutic power of a consumerist culture but involves the nascent claims to power for women as a subordinated group. Ultimately, *Oprah* and the other shows offer a utopian vision of female equality, a vision that keeps them from falling into problems associated with the pragmatic individualism of modern mass culture: selfishness, isolation, and alienation, as well as the stultifying nihilism of Foucaultian skepticism. If the individual polices herself or himself for society through talk shows, the process is always complicated by the dissident values of American feminism. The shows are venues where women of different races and classes attempt to claim power.

Historically, feminist psychology represents a further elaboration of the American rewriting of Freud than does ego psychology. By the mid-1970s feminist psychologists had firmly critiqued Freudian theories for dependence on a male developmental model, for attributing biological inferiority to women because of anatomical differences between sexes. This resulted in a tendency to see women as passive, dependent, and of lesser moral stature. Feminist theorists have attacked three major constructs of Freud's personality theory of women: penis envy, the Oedipus complex, and the focus of female sexuality as the vagina and not the clitoris. Whereas psychoanalytic feminists in media studies have been attracted to Freud's comprehensive theory of masculine domination through the oedipal scenario, practicing psychologists for two decades have critiqued psychoanalysis as oppressive to women.

In 1975 Julia Sherman detailed ways that psychoanalysis has been destructive to women patients:

(1) the authoritative relationship that analysts have with patients, which promotes dependency and mystification; (2) the analytic practice of locating the problem and the blame within women—"victimizing the victim"; (3) providing a negative view of women;

(4) providing a view of women as to engender iatrogenic disease; and (5) handy rationales for the oppression of women.[22]

That year the American Psychological Association created a task force on sex bias and sex role stereotyping in psychotherapeutic practice. The panel argued that psychoanalytic practice often insisted on Freudian interpretation, ignoring reality factors (for example, how the patient felt about the therapist or a given incident). Many Freudian therapists maintained that vaginal orgasm was a prerequisite to emotional maturity. They also problematically labeled female assertativeness and ambition as unhealthy, a form of penis envy.[23]

A major goal of feminist therapy has been egalitarianism, whether in personal relationships or in therapeutic practice. Feminist reform shares the self-actualization orientation of the third movement of American humanist psychology. Feminists developed several humanist techniques that are loosely replicated by daytime talk shows: sharing, group discussion, and assertiveness training. What differentiated feminist therapy was and is the implicit assumption of unequal power relations between men and women. Using the humanist model, feminist therapists reconfigured the image of women as active, complex, and ever-changing individuals who have capacity to choose, to assign meaning to their lives, and to be autonomous.[24]

Feminist therapy (unlike other humanist therapies) returns to the environment (not childhood per se) as a determining element of female psychology. Where many humanist psychologists saw feminine and masculine as given categories, feminist therapy involves analysis of the social construction of sex roles and power; therefore, there is always a sense of shared, not isolated victimization. Nevertheless, the logic of the therapy has been resolutely active. Feminist therapy turns the humanist concept of self-actualization around and places it within a critique of social constraint. Feminism named the process "empowerment," which has become a central discourse of talk shows. In fact, an audience member jumped up during a discussion of bad husbands and announced to Oprah: "It's about power and empowerment."

The Feminist Psychologist:
The Women Experts of Talk Shows

As stated earlier, daytime talk shows overwhelmingly populate their programs with female experts. In my three-month study, four out of every five therapists (Ph.D.'s, M.D.'s, M.S.W.'s, or "psychotherapists") were women.

Male experts are typically medical doctors, investigators, or agency heads empowered by their official knowledge. Although knowledge is also a factor, women experts are called more often to carry out their practices on stage—to nurture, interact, and solve dilemmas by offering short-term solutions. Although all four hosts have stated a vague allegiance to feminism, it falls to the experts who are not officially tied to the shows to represent feminist ideology.[25] Both their on-camera advice and their self-help books often approximate toned-down and broadly applied feminist therapy manuals. The experts are the central popularizers of feminist theory on TV.

The feminisms of the therapists diverge widely. According to Ann Kaplan, in the 1970s and 1980s there were loosely four broad types of "feminism":

bourgeois feminism (women's concern to obtain equal rights and freedom, within a capitalist system);

Marxist feminism (the linking of specific female oppressions to the larger structure of capitalism and to oppressions of other groups: gays, minorities, the working classes, and so on);

radical feminism (the designation of women as different from men and the desire to establish separate female communities to forward women's specific needs and desires);

post-structural feminism (the idea that we need to analyze the language order through which we learn what our culture calls "women"—distinct from a group called men—as we attempt to bring about change beneficial to women)[26]

Generally, the women therapists of daytime talk shows come out of bourgeois feminism. They believe that equal rights are attainable once women become aware of the social and sexual repressions to which they are victim. Like Gilda Carle's quick answers, their therapy tends to be blind to the differences caused by race, sexual preference, and class. Because their advice is constrained by TV's segmented form, it is often reduced to exercises, simple cause-and-effect models, and self-help formulas to which "anyone" can have access. For all of bourgeois feminism's critique of women's oppression, these experts espouse a democratic notion of equal sharing of power between men and women as opposed to a negative social critique of male domination.

For example, Donahue aired the program "Daughters Who Are Unusually Close to Their Fathers" (March 9, 1994), on which the therapist, Dr. Victoria Secunda, argues that the problem stems from the father's need to

be idealized by his daughter. The daughter is attracted to him because of his absence from the difficulties attendant upon her rearing; the mother is devalued as the disciplinarian. Secunda's solution: the parents must equally share the responsibilities of child rearing. But Donahue continually tempers her critique by stating that he approves of father/daughter closeness. He declares, for instance, "If you ask me (and nobody has) we want to first celebrate the wonderful love and mutual affection and admiration."

Another example is the *Oprah* program devoted to how to get married (March 14, 1994). Oprah introduces Dr. Pat Allen and her book, *Getting to "I Do."*[27] and states that Allen promises the audience that "if you follow her advice, you will snag a man within a year!" The program starts with the patriarchal belief in a male-centered model of femininity where women scheme to marry. But it turns out that Allen's argument is predicated on the assumption (as Oprah puts it) that all men and women have "masculine and feminine energy." In fact, Allen's first words are "Everyone is both masculine and feminine." She continues, "There is no such thing as a woman that is too masculine." A few minutes later, she proclaims, "The problem is we don't need to marry any more. Men can go to a gourmet cooking class and we can go to a sperm bank." The audience laughs wildly and applauds at her declaration of female independence. But Oprah keeps on course: "What is really great about this marriage thing" "So if you want to get married" But Allen later argues that "we still have as much a man's liberation movement ahead as we have a woman's." Her position becomes that men have the right to be feminine—an issue of universal victimization.

Here, we also get the mixed message from the therapist that although women and men are blends of masculinity and femininity, the terms *masculine* and *feminine* are essentialized as active and passive, respectively. And what women need to do to get married is return to their feminine selves. Such a contradictory message—which combines a male-centered model and feminism—is endemic to the shows, which tend to cater to both sides on the gender issue. But this is an unusual program in that both sides are evoked by one therapist. Even when critic Naomi Wolf attempts to point out the problems of essentializing feminine behavior as passive, the continual interrupting by Allen, commercial breaks, Oprah's interjections, and audience questions keep a clearly articulated counterstatement from being made.

Ultimately, good talk show therapists must be good performers, neither beacons of rationality nor politically astute feminists. They are in an odd way comparable to the itinerant performers of the nineteenth century.

There are the "star" or repeat therapists, who are discovered and nurtured and appear regularly on a particular show. Carle is a *Sally* regular, as is Randy Rolfe on *Geraldo*. Many therapists travel what is known in the business as the "talk show circuit." For example, Secunda appeared on three different talk shows between March 9 and June 30, 1994. Although the therapists are not paid, they get to publicize their services and books (Carle's *Interchange Communications Training,* or Secunda's most recent volume, *Women and Their Fathers*).

As much as the therapist represents psychology and feminism, she is rated on her performative skills. The "original" model is Dr. Joyce Brothers, the first "star" therapist of daytime TV. The therapist is inserted deus ex machina, usually, into the third or fourth segment of a show. According to an interview (June 21, 1994) with executive producer Rose Mary Henri of *Sally*, therapists are chosen for their ability to relate emotionally to the guests and audience. Feminine, colorful clothing is presecibed. Their style is somewhere between that of the old medicine show "doctor" hawking his quick remedy and that of the hero who comes to the rescue in an old-time melodrama.

Carle has replaced Brothers as the prototypical therapist on talk shows in the 1990s. Acknowledging her debt to Brothers, Carle has done more than one hundred talk shows in the past five years. Unlike Brothers, she has a degree not in psychology but in organizational studies. Her consulting firm specializes in communication, and she has advised IBM and the New York City government. Having written no books, she self-promoted herself onto talk shows by means of a video infomercial she sent to the producers. Once she appeared on *Geraldo*, her career took off. Recompense is exposure for her and her firm; she maintains that she does the work because she "cares." Given format time constraints (a therapist averages two minutes per guest), Carle argues that she does not do "therapy" on the shows but gives "therapeutic tips."[28]

According to Henri, Carle is considered "an excellent TV therapist" in the industry because "she can emotionally identify with the guests and speak a simple jargon-free therapy." Secunda, who is more measured in performance and language, is described less enthusiastically as "formal." One can perhaps conclude that part of Naomi Wolf's problem in her appearance as an expert on *Oprah's* getting-to-the-alter program was that Pat Allen outperformed her with quick upbeat statements, use of the inclusive "we," direct address to the audience, and expansive gestures. But all the therapists can neatly offer tentative solutions within their allotted minutes.

A typical performance entails the therapist's interacting with the guests while turning to the audience to put a therapeutic point across. For

example, after hugging and stroking the crying wife in the previously mentioned program on affairs, Carle with intense emotion asks the audience: "What about the other party? What about the spouse? What if the other party finds out? All we have been hearing about is: me, me, me." Applause erupts. We see close-ups of the approving women in the audience who have been cheated on. Pleased by their reaction to her performance, Carle continues: "One of things we have to do is to take that 'm' in me and turn it around to 'w' in we." More enthusiastic applause. The dual performative style undercuts the authenticity of the therapist's interaction with her "patients." Her gestures are ultimately an "act" in that her object is to reach the larger viewing audience. Carle represents a crass caricature of the productive power involved in any authoritative claim as to what is *correct* femininity or the *truth* in regard to mental happiness on talk shows. She, as so many like her, evokes the "we" of feminism, effacing social difference and the implicit power involved in defining an all-inclusive category.

Although the established media would attack Carle's astute use of "sound bites" as pandering to the lowest emotions, I argue that her method is an example of classic showwomanship. It is naive to believe that there can be authenticity on national TV, a discourse that the daytime talk shows trade on. I will also argue more thoroughly in chapter 6 that viewers do not automatically look upon the therapist as genuine. We may cringe at the callous use of a woman guest's private pain for public promotion, but talk shows are not traditional therapy. They are shows.

The therapist is not the only performer. Unlike medicine shows and vaudeville, everyone performs on talk shows. They are closer to public performances of personal narratives of emotional pain, frustration and recovery. The guests and audience members do not come as naive to the TV arena. Audience members primp in the restroom upon arrival to look "good" if the camera catches them. Before the taping they play musical chairs as they shift seats in order to get as close as they can to the host and the microphone. They vie to ask questions. They have watched the programs and have absorbed many of the conventions. They call the hosts by first names. Generally, they know what are permissible questions and behavior (many are savvy enough to ask their questions straight to the camera). They have thought out their narratives beforehand. They speak the language of talk shows and therapy. For example, many elderly women in the *Donahue* audiences seem prepared for the host's game of flirting and attempt to top him by embarrassing him with their forwardness.

A *Sally* program on February 23, 1994, was stopped when a husband confessed his affairs to his wife, but it was the wife's decision to resume taping. Asked by Sally why she wants it to continue, the woman says, "I

must stop and realize that my husband must love me to come on the show and tell everybody that (applause) he is sorry and that he wants to try and make our relationship and our marriage work." It was an occasion when actions and beliefs could affirm the importance of their lives before a "jury" numbered in millions. With daytime talk shows, we are caught between anger at the exploitation of people's emotions for profit and awe at this venue for testimonials where average women elect to perform and are validated and empowered by their performances.

Talk's Psychic Structure: The Feminist Consciousness-Raising Group

It is not the courtroom but the consciousness-raising group that is the logic of the daytime talk shows. Patricia Mellencamp argues: "It's not too far-fetched to imagine daytime talk as the electronic syndicated version of consciousness-raising groups of the women's movement." For her, they represent a shift away from the arcane worlds of medicine, psychiatry, and law, "away from the experts and toward self-help, away from individuality and toward a group or collective mentality."[29]

Gloria-Jean Masciarotte points out that a 1966–1967 outline of the rules of consciousness-raising "could form the production notes for Phil Donahue or Oprah Winfrey's shows":

 I. The "bitch session" cell group
 A. Ongoing consciousness expansion
 1. Personal recognition and testimony
 2. Personal testimony—methods
 a. Going around the room with key questions
 on key topics
 b. Speaking out experience at random
 c. Cross-examination
 3. Relating and generalizing individual testimony
 B. "Starting to stop"—overcoming repressions and
 delusions . . . daring to share one's experience with
 the group.[30]

Consciousness-raising groups have always been a hybrid: part therapy and part political activism. When *Donahue*, the prototype feminine-issues daytime talk show, began in 1967, consciousness-raising groups were evolving from a political organizing tool to an arena where women shared personal information and discovered commonalities.[31] The groups and

even their talk show incarnation have been held together by empowering women through collectively constructing self-esteem.

"Self-esteem" has been attacked by academic feminists as an empty concept that daytime talk shows use to avoid more complex problems, such as social repression.[32] Yet self-esteem remains central for the feminist therapy movement. Jana Sawicki in her claim for Foucaultian feminism argues that such criticism reveals a lack of awareness of the class and gender bias involved in political awareness: "A principal aim of feminism has been to build women's self-esteem—the sense of confidence and identity necessary for developing an oppositional movement."[33]

Daytime talk shows have taken this mission of feminism's one step further in the 1980s and 1990s. What neither Mellencamp nor Masciarotte takes note of is the degree to which talk shows avoid critical analysis of the context of male power. Central to the consciousness-raising group of feminism is a form of political education. According to feminist psychologist Diane Kravetz, "Understanding the nature of female oppression in a sexist society has been essential for assessing needs, establishing goals, and providing alternative programs and services." Consciousness-raising groups are where "institutional structures and social norms, as well as individual attitudes and behaviors, provide the framework for analysis."[34] They have moved from political groups to emotional "support" groups in the language of the 1980s and 1990s. The shows mirror this depoliticization in focusing on the individual and the proactive nature of humanist therapy in understanding cultural malaise. Their analysis takes place in a historical and institutional vacuum, preferring the narratives of virtue and transcendence over the negativism and complexity of social analysis. This sensibility underlines Donahue's epiphany about being a homemaker in his biography: "I don't know how the hell they [women] do it. My fantasies about 'my four sons' have been lowered, and my consciousness raised."[35] The shows' sense of consciousness-raising has to do with women's day-to-day experiences and how individual women can immediately effect changes rather than with a more detached view of the political origins of the experiences.

Much like the consciousness-raising groups, the shows range from cognitive-oriented discussions, as in rational emotive therapy, to a more personal, emotional sharing. Although the consciousness-raising process involves discovering the social or external roots of those experiences related to living in a sexist environment, the shows avoid clear social categories, such as economic power or even the patriarchy. They phobically avoid male bashing, doing at most one or two openly feminist topics a season. As a result, their critique of masculine power is always implied and

rarely stated. It is primarily through programming—woman as a social category, the value of lived experiences, and the nonhierarchical structure—that program makers convey the shows' feminism.

Because the shows are public arenas they do not evoke the intimacy and thoroughness of therapy or even consciousness-raising groups. But because of their ties to a social ideology such as feminism, their discursive structure involves testimonials rather than confessions. Here, feminism becomes more a secular religion than a political practice. The testimonial or witnessing has a long history in American fundamentalism and media evangelism.[36] And it has been reinvigorated in the twelve-step movement, a secular model of witnessing. The original religious sense of the practice means the public testimony given by Christian witnesses to Christ and his saving power. Within evangelicalism the act of standing up and speaking one's religious experience is a social obligation—done without regard for personal safety and comfort.[37] The feminism that underlies the daytime talk shows has changed the logic of therapy: women are no longer passive sufferers but, rather, witnesses to the power of overcoming oppression. This extends the role that witnessing has played in women's history, beginning with abolition and then extending to suffrage and temperance.[38]

Masciarotte argues that "the talk show's subject is not an ego-centered version of the talking cure in which the free flow of the subject's voice echoes back strong individual boundaries. But rather talk shows construct a serial spectacle of "I's."[39] The transgression or problem is no longer a sign of individual shame; instead, it is part of a larger problem and the individual's experience becomes one of many examples.

Like Christians overcoming evil through faith, the women in the daytime talk show audience attest the power of the individual and the feminine community by speaking their individual experience of the evils of social subordination and testify to their strength or survival to their community. The pretaping audiences that I have participated in have the feel of a congregation. The women interact as friends exchanging views, compliments, and intimacies as if they are part of a larger ethos.

Consider a program devoted to HIV-positive men and women (*Oprah*, February 17, 1994). The project becomes the reconciliation of an HIV-positive daughter and her estranged mother. Not only does the program present a formerly homophobic mother who supported her dying son, audience members who are HIV-positive get up one by one and testify to the understanding or lack of support of their families. In fact, the program is a follow-up of a program a week earlier in which a closeted HIV-positive guest, Brian, "came out" on national TV (and to his family afterward). Asked why he did it by Oprah during the second program, Brian responds

that he had to "unburden" himself and that he did it for others. And as the camera pans across a row of the audience, Oprah says:

Brian is not alone. These are faces of the people who have tested HIV-positive. Some of them have been spat upon, yelled at, kicked out of classrooms, throw out on the street and outright disowned by everybody that they loved. But they are here today to tell their stories of life—in this age of AIDS.

The issue is not gendered. The concept of healing through narratives and community remains the springboard for faith.

Feminism, like all ideologies, shares with religion a spirituality of community and a myth of utopian transcendence—a world of gender equality. Hence, daytime talk show programs on makeovers, superstar women in second careers, and returning reformed guests from earlier programs emphasize the ability to grow, change, and transcend. It should come as no surprise that many of the nontherapy topics of the programs have a quasi-religious sensibility: "Random Acts of Kindness" (*Oprah*, February 15, 1994); "People on Schindler's List" (*Donahue*, February 28, 1994); "Visionaries" (*Sally*, March 3, 1994); "Holocaust Heroes" (*Oprah*, March 18, 1994); "Angels Who Have Altered People's Lives" (*Donahue*, March 31, 1994); "Faith Healing" (*Geraldo*, April 1, 1994). For all talk shows are indicted as part of the "new" culture of victimization, they are as caught up in affirming the ideals of familial love, the transcendence of emotional pain, and equality.

In *Life Stories* Charlotte Linde defines the individual narrative as

an oral unit that is told over many occasions. Conventionally, it includes certain landmark events, such as choice of profession, marriage, divorce, and religious or ideological conversion, if any. Both in its content (the items that it includes and excludes) and in its form (the structures that are used to make it coherent), it is the product of a member of a particular culture. . . . Indeed, the notion of a "life story" itself is not universal, but is the product of a particular culture.[40]

Each program, then, becomes a variation on the feminine community as each guest brings her life story to the televised theater. Robyn Warhol and Helena Michie suggest such life stories are central to the twelve-step programs and the concept of recovery—a process talk shows draw on for their therapeutic logic. Whereas Alcoholics Anonymous looks to the frame

provided by Bill W. and his story of alcoholism and recovery as the frame for alcoholics' own stories, daytime talk show guests and audience look to the long tradition of melodrama and the long narrative tradition of mythic female virtue, victimization, and transcendence (see chapter 3).[41]

Talk's Therapeutic Narrative

In this section I want to describe the daytime talk shows' personal narrative process in some detail. I have picked an atypical program, "Men Who Teach Their Sons to Be Sexist" (*Sally*, March 29, 1994), because it is on an overtly feminist issue. Although I believe that the shows are potentially the most radically feminist of nationally televised programming, I want to outline the possibilities and limits of televisual therapy as a feminist act. Throughout the three months of this study there were only six overtly feminist topics that used the language of the women's movement: "Domestic Violence" (*Donahue*, February 1, 1994); "Sexual Harassment Among Teens" (*Sally*, March 7, 1994); "Sexism in the Classroom" (*Oprah*, March 8, 1994); "Pregnant Women Who Get Battered" (*Sally*, March 30, 1994); "Self-Esteem in Little Girls" (*Oprah*, April 19, 1994); and my example.

My program example begins with Raphaël spinning out the narrative of two working-class families: Phil, Chelsey, Tony; J. C., Nancy, and Ben. She sets up the conflict between the husbands and wives over their sons. Phil is the more combative of the fathers; his story is conveyed through assertions.

> Sally: Meet Phil He says women are here for one thing—to please men. (The audience boos.) He says: "It is never too early to start."

A home video of Tony's thirteenth birthday is shown in which a woman hired by Phil comes on to Tony sexually.

> Sally: You can imagine how angry Phil's wife Chelsey could be. In fact, she says that she is so angry about what Phil is teaching their son about sex and women that she may divorce Phil. (The camera pans the audience as the people applaud wildly.). . . . What are the two types of women?

> Phil (proudly): There are two basic kinds of women. There are women who are so stupid that they think they are smart. And there are women who are smart because they realize just what

they do not know. (Phil smiles coyly and the audience boos wildly.)

Raphaël continues to draw out Phil's sexist ideas and homilies and talks to Tony about his sex life. The audience grows more and more outraged. Whereas Phil's narrative is conveyed through assertion and bluff, his wife, Chelsey, is addressed as an emotionally three-dimensional person. Sally asks Chelsey, "What's it like?" and "What happens in the home?" Sally encourages Chelsey: "Tell me about how it feels." The men perform a cartoon version of their sexism purposely to provoke the audience. Phil enjoys his power over the audience.

This program follows the classic daytime talk show structure. After an initial period when the audience angrily condemns Phil and disputes his logic, the program moves to the issue of female (and/or child) victimization. Here, we have men objectifying women through their sons: the women and the children are paralleled as victims. (One finds this sensibility in such programs as "Teenagers Who Have Been Raped" or "Mothers at Odds with Daughters.") It is only after half the hour goes by that the second family is introduced to tell their story and add to the drama. The structure is the same: Raphaël quoting and the father boasting.

This narrative of women as melodramatic victims results from the underlying Freudian critique: women's oppression emanates from their upbringing and their socialization. Raphaël underscores the inequality by asking Chelsey, "Are you afraid of him? You are kinda shaking." After Chelsey answers that she is just nervous, Raphaël says, "I got disturbed by that. It worried me." Practically all guests are nervous on talk shows, but Raphaël points out the wife's tension to develop her as a victim. The interaction empowers an audience member to start the therapeutic logic and question Chelsey about her childhood and her father. Chelsey responds that she was close to him, but he beat her mother and divorced her when Chelsey was eleven. This statement leads the therapist to declare later that Chelsey's acceptance of the situation is that she had unconsciously "married her father."

The program also pronounces an equally Freudian interpretation of the father's sexism: homophobia and the implied reasoning that sexism is a defense for castration anxiety. Dr. Ruth Peters (author of *Who's in Charge? A Positive Parenting Approach to Disciplining Children*) introduces the idea right away: "I think a lot of it has to do . . . I think their dads may have some feelings of homophobia. They are afraid that they themselves. . . ."[42] The audience applauds and hoots. An audience member takes up the interpretation: "I am sorry, Phil. . . . You mentioned moments back that you

are trying to protect your son from the dangers of sex. Well, I don't buy that. I think that you're trying to protect yourself because you believe that if you talk like this people are going to believe that you're not gay." The audience applauds ecstatically in agreement. Such unanimity reveals not only the influence of Freudian thinking among the American populace, but also the degree to which daytime talk shows espouse the unconscious as the source for social behavior.

Ruth Peters is a clinical psychologist who specializes in the diagnosis and treatment of child and adolescent emotional and behavioral problems. She is also "authenticated" by the future head of the American Psychological Association in the forward of her book. Although her perspective seems Freudian on this program, she writes that her method is "behavioral"—a set of "realistic" prescriptive problems and solution scenarios for behavior management.[43] The method, which involves a series of clearly defined no-nonsense steps, fits well into the logic of talk show therapy. She offers a clear formula.

Nevertheless, the program also espouses a more humanist approach that implies that the women are able to self-actualize, the basis of the behavioral approach of Peters's book. The audience tells them again and again to leave their sexist husbands. The therapist typically tells them that they are to a degree responsible for this sexist behavior and advises them to learn from the program and to go out and change their situation.

The program does not offer a humanist interpretation of the male behavior, however. As Peters says in her homey language halfway through the program, "We've got some people whose ideas are set and they're not willing to change." The audience repeats this notion of masculine subjectivity by insulting the men and telling the women to leave them. But more important, the deterministic view of masculinity is continually expressed in the discussion about the boys. Several audience members imply that such early sexist behavior leads directly to rape and prison. Peters underlines this appraisal when she states that the mothers have only two years to take remedial action before the boys will be confirmed abusers of women. Raphaël resignedly closes the program on the men's refusal to change: "I have tried."

What is unusual about this particular program is the degree to which both host and therapist reveal their value system and judge the men negatively. As Pat Mellencamp points out, the daytime talk show host and therapist are to act as model listeners, treating all participants with unconditional respect.[44] It is usually the audience's role to reveal outrage and/or moralism over guests' ideas and behaviors. Only after their shaming of the guests, are audience members to testify to their personal

transcendence or survival of the problem at issue. As a man in the *Sally* audience announces:

> I am from Oklahoma, a small rural place in Oklahoma. Every man including my father whose favorite line is: "Women are great. Everybody should own 4 or 5." Now that has been the problem—My mother, my sister and most of their friends who have been through numerous relationships, marriages and bad relationships with their families because they have poor self-esteem.

When the expert and host move into this realm of personal experience, they lose their objective status. Raphaël begins the program with the assumption that sexist behavior is unacceptable. Peters reveals her disdain for the men throughout the hour. Raphaël repeats: "Not in my home." The loss of the show's usual distance and balanced debate causes J. C. (one of the fathers) to exclaim at the end: "I know what is wrong with the country. The country is being overrun by women. You all saying you're 53 percent [of the population]. That's the problem with the country today." The shows demand change as part of their drama. These men maintain their authority throughout and are therefore antagonistic to the very premise of the drama.

Obviously, this program reveals its debt to not only feminism but feminist therapy for its combination of Freudian and humanist methods. But because daytime talk shows must be both popular and nationally syndicated, the program carefully paints these men as anomalous, not representative of a general social condition. Part of the scapegoating of these men is based on their class and educational differences, which are never addressed by the program's authorities, the host and therapist. The middle-class male teachers on the program on girls and sexism in the classroom fared much better. They were quiet, not openly combative men being set up as examples of incorrect behavior.

For all its feminism, the program continually affirms the importance of marriage, heterosexuality, and family. Although the audience repeatedly tells the women to leave their sexist husbands, both host and psychologist say at the end of the program that the women can save the boys without divorcing the men. Sally declares, "It doesn't mean getting divorced. We are not saying get divorced. And we're not saying it's easy. No one is telling you to get divorced. I want to make that [clear]." She affirms the sanctity of marriage—a principal tenet of daytime talk shows. The program does not address the fact that to continue in the marriages might be repressive for the wives. Indeed, central to the shows is the Victorian conceit that

women are the emotionally stronger gender—the moral bricks of the family—but they must often efface their needs for the good of the family. This sensibility is obsessional, brought home on *Sally* by Raphaël's rejoinder on many programs: "and the children."

Conclusion

Essentially, daytime talk shows are not feminist; they do not espouse a clearly laid out political position for the empowerment of women. They often champion women who deny themselves for the good of the family. The shows do represent popular TV at its most feminist, nonetheless; they articulate the frustrations of women's subordination in a "man's world." They are not authoritarian in the way TV traditionally displays the therapeutic. They give a voice to normally voiceless women: working-class women, housewives, lesbians, sexually active older women, among others. What is important is that they speak for themselves and are valued for their experience, even if their stories are highly prescribed. Moreover, the shows represent a practical application of a central debate in cultural studies through their employment of the therapeutic: the tension between theories of power and control as described by Freud and Foucault and an active/activist individual who has the capacity to think and disagree.

For daytime talk shows, we need to rewrite Foucault's theory of the confession: The only credible interlocutor is a "recovering" interlocutor, for he or she too must testify to her or his weakness to belong to the community. For all their technological distance, the shows are about belongingness—community in late capitalism. It is no wonder that Winfrey as a self-confessed victim of child abuse, drugs, and self-hate is the most highly paid woman interlocutor. The private has become public. The personal is political. And the ability to confess publicly has become a sign of power and control. Such public therapy is an ideology that combines the negative hermeneutics of Freudian subjectivity with the affirmation of the active individual within a shared community. And that tension is ultimately the therapeutic power of talk on TV.

"GO RICKI"

Politics, Perversion, and Pleasure in the 1990s

Today, we turn our attention to television. Now these days there is a lot of criticism directed at television—the casual cruelty, the rampant promiscuity, the mindlessness of sitcoms and soap operas. Most of the criticisms are justified. But this is not the worst of it. The worst television is the day-time television talk shows we have identified. In these shows, indecent exposure is celebrated as a virtue.

> William Bennett, former U.S. Secretary of Education,
> October 26, 1995

Today's talk shows celebrate the victim and the victimizer equally; they draw no lines and have no values except the almighty dollar. And as cheap as they are to produce, they pay: Over the past decade, television talk shows have proliferated like roaches in the walls of a New York apartment.

> Jill Nelson, "Talk Is Cheap," *The Nation*, June 5, 1995

I think the show is almost gay sometimes.

> Viewer, *Ricki Lake* Message Board, *America Online*, July 4, 1995

◆

After half a decade of the dominance of four daytime talk shows with a general political commitment, talk shows seemingly lost their tie to the public sphere. Scores of new shows aired, among them the *Jerry Springer Show* (1991), *Maury Povich* (1991), *Montel Williams* (1991), *Jenny Jones* (1991), *Ricki Lake* (1993), *Gordon Elliott* (1994), *Carnie* (1995), and *Tempestt* (1995).[1] Topics moved from personal issues connected to a social injustice to interpersonal conflicts that emphasized the visceral nature of

confrontation, emotion, and sexual titillation. The expert disappeared as the number of guests proliferated, each program staging in whirlwind succession five-minute bites of conflict, crisis, and resolution.

Everything also got younger: the guests, the studio audience, the host, and even the demographics. The hosts—Danny Bonaduce (the *Partridge Family*), Gabrielle Carteris (*Beverly Hills 90210*), Tempestt Bledsoe (*The Cosby Show*), Carnie Wilson (Wilson Phillips)—came out of the entertainment industry instead of news. Suddenly, they were nominated "experts" based on claims of their "averageness" as products of middlebrow commercial culture. The studio audience moved from the role of citizens making common-sense judgments to spectators hungering for confrontation. The shows seemed more like a televised coliseum where the screaming battles of the lower class are carried out as a voyeuristic spectacle than a venue for social change. The audience cry, "Go Ricki!!" symbolized the death of not only the public sphere but the private. Nothing now seems taboo.

Reacting to the greater tabloidization, the political left and right exploded in anger. Liberal-to-left magazines (*Ms.*, the *New Yorker*, and the *Nation*) decried the lack of social consciousness of the programs. William Bennett, the neoconservative former secretary of education, launched a campaign against the new shows in October 1995. He labeled them a form of "perversion" while oddly praising forerunners *Oprah* and *Donahue* (once considered purveyors of abnormality) for upholding family values. How could such a moment have come to pass?

The significant difference in program content and reception allows us to examine the change within the genre and the role that identity politics played as it was popularized within a commercial medium. So far this book has emphasized the structure of the genre, presenting the industrial, narrative, psychological, and political underpinnings of the first generation of issue-oriented shows. This structural approach has admittedly undercut the complexity of differences between shows and the changes over time. In comparison to the three-hundred-year-history of melodrama, the twenty-nine-year history of TV talk shows seems negligible and underdeveloped. However, in those decades, the genre has received more front-page news coverage than any other daytime genre since TV began in the late 1940s.[2]

Traditional theories of generic evolution hold that a genre begins in a naive state, evolving toward greater awareness of its own myths and conventions.[3] Here, a self-consciousness of the medium has produced programs in the 1990s that communicate at a number of levels commenting on its own history and methods. Because of the phenomenal popularity of

Oprah, the shows of the 1990s emerged out of the need of commercial TV to try to replicate success. In an attempt to create a different market, the new shows reached out to a younger audience and constructed a new form based on the sheer pleasure of breaking social taboos—especially those maintained by the older generation of "serious" shows.

Further, daytime talk shows are dynamic cultural objects; they have signaled major changes in the culture, the TV industry, and other TV shows. In the 1990s they abandoned the unwritten guidelines that identity politics once provided the genre in defining social injustice in terms of race, gender, class, and sexual preference. On one hand, the new shows stem from a general shift in the American political temperament as gay rights, affirmative action, and abortion rights have come under neoconservative fire. On the other hand, they stem from the voracious appetite of commercial TV; innovation has led to a self-conscious gutting of the feminist notions of empowerment based on confession, testimony, and social conversion. Rather, *Ricki* and the others attest the power of the broader pleasures of youthful rule breaking and renegade individualism in the face of the social regulation imposed by identity politics in the 1990s and the established talk shows in the 1980s. This chapter outlines the important distinctions between Empower America's campaign against perversion, identity politics, and the content of talk shows. It chronicles how antisocial behavior has been conflated with sexual freedom in the 1990s.

The Campaign to Define Talk Shows as Perversion

On October 26, 1995, William Bennett launched a campaign against the new set of daytime talk shows through his neoconservative think tank Empower America. Joining forces with moderate Republicans and with Democrats such as Senators Joseph Lieberman of Connecticut and Sam Nunn of Georgia, Bennett listed his objectives: "to raise a hue and cry across the land; to cast some light on what's being produced and distributed; . . . and to petition men and women of goodwill—producers, sponsors, advertisers, and viewers—to rethink their support and sponsorship, participation, and promotion of these programs."[4] The call also came from liberals such as Donna Shalala (secretary of health and human services under Clinton), Oprah Winfrey, and liberal-to-left writers. What brought together the partnership? Should we be worried about such unity?

The liberals' revulsion is based in part on how the shows do not live up to the paternalistic ideal of the "public interest" on which American TV was founded. The liberals' stance is that TV as a public medium is obliged to set a standard of honesty and decency. This sensibility comes to the

surface in comparisons of the quiz show scandals of the 1950s with the use of fake guests on daytime talk shows forty years later. Ken Auletta writes, "Does television still cheat? Those who confess to Geraldo Rivera that they slept with their mothers, or tell Oprah Winfrey why they swapped spouses . . . are coaxed in much the same way as [was] Charles Van Doren." The only difference in the 1990s is that "we seem to expect, and tolerate, cheating."[5] Columnist Ellen Goodman compares the *Jenny Jones* murder to the quiz show scandals and concludes the talk shows "trick viewers into believing they are watching real emotions."[6] Beneath Auletta's and Goodman's indignation lies the assumption that the viewer needs to be protected from the manipulations of commercial interests, that she or he is easily bamboozled or too complacent to care.

On another level, the liberals' revulsion results from the class antagonism of the established press toward tabloid talk shows and their guests. For example, Walter Goodman in the *New York Times* writes ironically:

> So it's party time. Ricki Lake prods the audience by saying of one of her distraught guests, "And we're here for her, right?" You can count on the howling affirmation of solidarity. They are into the show, at once voyeurs and judges, oohing at the confessions then in their 30-second star turns on camera, remonstrating with the confessors.[7]

Here, the guests and audience members become mindless pawns as the show exploits their lack of education, need for public approval, and mob mentality. The age-old middle-class fear of the lower classes as a faceless throng surfaces.

Another related response is the outcry against the new talk shows as "freak shows," "geek shows," or, in the words of the *New York Post*, "sicko circuses."[8] Stephen Schiff writes that "a geek was a sideshow or carnival performer who distinguished himself by his willingness to commit the most loathsome and humiliating acts onstage—commonly, by biting the heads off chickens."[9] Implicit within such labeling is a class-based distinction: respectable human beings do not do or say certain things in public. As Schiff points out, the majority of the guests and audiences members on tabloid talk shows are lower class and people of color: "The spectacle of so many unfamiliar gestures, hairstyles, fashions, and bits of jargon may shock politicians whose previous contact with people like these has come from statistical samples and made-for-TV samples."[10] Although the corporate-owned shows are not a "realistic" staging ground for lower-class lifestyles, they have given the middle class (even the liberal intelligentsia)

exposure to a culture from which it has been economically and geographically separated.

Finally, the most openly political position of the left argues that the shows fail to reveal the social context of the interactions they stage. Jill Nelson of the *Nation* represents this critique. She sees the leveling effect when the shows draw no clear orienting boundaries of victim and victimizer. Men flaunt their abuse of women to audience applause; overweight women are taunted; the poor are jeered for laziness. Nelson writes: "I'm more terrified by the daily killing off of any sense of understanding, connectedness, collective responsibility and the potential for redemption that these talk shows foster."[11] There is no longer a larger social system or even an allusion to a history of victimization that can give the tears, anger, and potential violence (which the shows trade on) any perspective. The shows stage the battle of deprived people, such as poor black men, families without work, and gang members, but the battles are between the deprived people themselves and no longer against larger social determinants. say, racism, sexism, and capitalism.

On one level, the daytime talk shows still reveal their debt to feminism in presenting primarily women speaking about their unhappiness, but the practice is highly problematic. As Jeanne Heaton and Nona Wilson argue: "The shows provide a forum for women to complain, confront, and cajole, but because there is never any change as a result of letting loose, this supports the mistaken notion that women's complaints have 'no weight,' that they cannot effect real change."[12] For these feminist critics, the prime example of the exploitation of feminine unhappiness was perpetrated by *Maury Povich* producers. After reading about a poor unemployed nurse who cut her silicone breast implants out of herself, they scheduled her to appear. In the meantime *Sally* lined up an earlier appearance when the woman was still infected and on painkillers. The *Povich* producers reached her at the hotel, asking only if they only could all "talk" at their offices. Within an hour the woman was being taped, Maury Povich leading off with

> Just two weeks ago at one a.m. in the morning, in the privacy of her bathroom, she took a razor blade and attempted to perform surgery on herself. I mean, we can't even imagine—the audience is breathless, and so am I. What would make you do such a thing?[13]

Not only does the show not care for the health of a guest, it plays to the most prurient and horrific images, frightening women already wary of

breast implants. Today's daytime talk shows reveal TV at its most commercially exploitive.

Nelson sees a growing alliance between popular culture and the right: "Talk shows are the stormtroopers of the right, erasing the line between anecdotal and factual. Both focus attention on the individual, aberrant behavior of a small number of citizens and declare them representative of a group."[14] She attributes the shows' popularity to the "despair and rage of the growing underclass under the conservative agenda—lack of entry-level jobs, the dissolution of communities and no government support programs for youth and families of the poor."[15] This argument extends the Frankfurt school critique of popular culture as the ideological arm of capitalism and the right—most particularly under fascism.[16] It evokes images of talk show producers squashing resistance to political change and undercutting cultural difference based on the agenda of a white, male elite. The position rides roughshod over the contradictory elements within the shows and American liberal politics, both of which embrace "aberrant behavior" as a legal right and a social identity. Most particularly, it ignores the fact that these same shows are denigrated by the right as a form of perversion. The politics of contemporary talk shows cannot be aligned simply with any established political position.

The Empower America campaign against the newer daytime talk shows reveals a new arena for the portrayal of social behavior normally not aired in the public sphere. Here, the bourgeois demand for civility unites the right and the liberal establishment. Senator Lieberman, quoted in the above-mentioned Empower America press release, exemplifies this when he announced that the shows are *pushing the envelope of civility and morality in a way that drags the rest of the culture down with it*" (his emphasis).[17] As sexual, class, and race relations grew to define the politics of a citizen in the 1960s through 1980s, TV used the moral authority of identity politics to air traditionally taboo private lifestyles. But by 1990s the acceptance of the exhibiting of social differences was under fire. And what better target could there be than the shows' excesses in tabloid stereotyping.

Empower America's antipathy toward the daytime talk shows is a facet of a general neoconservative agenda, which includes the Contract with America. The institute was founded in 1993 to combine policy analysis with grassroots political action and now proclaims that it is one of the largest of such organizations (300,000 members). Its mission is "to promote progressive conservative public policies at both the state and national level, based on principles of economic growth, international leadership and cultural empowerment." The board of directors includes Bennett, Jack Kemp, Jeane Kirkpatrick, Newt Gingrich, and Michael

Novak, among others. It works in conjunction with the American Conservative Union, Americans for Tax Reform, Citizens Against Government Waste, the Heritage Foundation, *National Review*, and *The Washington Times' National Weekly*.[18]

More important, Empower America produces much of the powerful ideology for the right's political and cultural agenda in the mid-1990s. On a political level, it promotes the country's role in advancing freedom and democratic capitalism around the world. It has developed many of the ideas behind the flat tax and government downsizing that are part of the Contract with America. But on a cultural level, it sees a United States that pursues "new approaches to social and cultural issues such as poverty, education and health care which are based in empowering families and people, not government bureaucracies."[19]

As a result, the media, not government, have become a main focus of the empowerment schema of the right. Empower America wants to return to the affirmative values of classic Hollywood films and 1950s TV. One needs only to look no further than Bennett's anthology, *The Book of Virtues: A Treasury of Great Moral Stories*, to see this sensibility. He has collected well-known fables, folklore, and fiction (for example, from Aesop, Dickens, Tolstoy, Shakespeare, Baldwin) with the expressed purpose to teach honesty, courage, compassion, friendship, and faith. It is a volume that eschews social criticism in favor of affirmation.[20]

The institute's first major action was to join forces with C. Delores Tucker of the National Political Congress of Black Women to pressure Time-Warner to sell its 50 percent stake in Interscope Records, which produces gangsta rap music. The strategy is to shame major media outlets into not selling, into altering, or into stopping production of products that the right finds ideologically objectionable. The strategy avoids the stigma of censorship but does use the threat of blackening the reputation of a company through public boycott, with a consequent drop in revenues as advertisers pull out. Fellow Empower America traveler Lieberman used a similar means in 1993 when he convinced the video industry that it was in its interest to adopt voluntary ratings to avoid congressional interference. It was a replay of the Catholic Church's threat of boycott against Hollywood films in the early 1930s and the resulting self-censorship of the Production Code.[21]

Empower America's campaign against daytime talk shows is a casebook example the right's ideological agenda to recast the rhetoric and ideas of the left. It did not direct its fury at all talk shows (*Oprah* and *Donahue* were spared), but singled out *Jenny Jones, Sally Jessy Raphaël, Jerry Springer, Montel Williams, Maury Povich, Geraldo, Charles Perez, Rolonda,*

Richard Bey, and *Ricki Lake*. The 1995 shows were, it seems, too new and undeveloped to merit attention.

First, we need to consider how the institute has adopted the language of the identity politics movement and talk shows. The term *empowerment* has always been more slogan than political concept. Nevertheless, in the 1960s and 1970s it connoted a social and psychological reorientation of a socially disadvantaged group, such as women and blacks, in order to increase their potential for social power. For Empower America, the term refers to the belief in individual self-sufficiency; society need not shoulder responsibility for the disadvantaged.

Second, Empower America has focused on "moral-uplift" issues—a staple of early daytime talk shows. However, instead of weighing the moral-uplift message against social criticism of unequal opportunity (a stance the shows take), Bennett transformed the message of the institute's campaign against the shows into a generalized notion of positive images. Notice how he turned around the words of one of the prime movers of identity politics:

> What exactly is the harm being done by these programs? In his "Letter from Birmingham City Jail," Martin Luther King Jr. instructed us that which "uplifts human personality" is just and that which "degrades human personality" is unjust. Can anybody doubt that these shows degrade human personality?

Indeed, King saw part of the civil rights movement tied to a positive image of African-Americans, but he connected his uplift message to political rights, increased freedoms, and institutional change. Here, Bennett depoliticized the identity politics message of collective pride, whether black, gay, or female:

> Let me put this campaign in a broader context of the state of our popular culture, our country, and our civilization. What is happening today is the pollution of the human environment, a kind of tropism toward the sordid. The nation desperately needs more opportunities for moral uplift. We believe that progress can be made through moral suasion and justifiable public discontent.[22]

Missing are not only the specifics of Bennett's vision of moral suasion but also any mention of the social source of the "pollution." Rather, Bennett cast the campaign as "a Resistance Operation to the giant popular

culture sleaze machine."[23] The dominant power was no longer capitalism or a white American male elite; it was popular culture, a breeding ground for negativism.

What goes unanswered is the degree to which daytime talk shows construct or celebrate an "uncomfortable" nation. They *do* reveal Americans who act outside conservative polite behavior: uneducated poor people, ghetto blacks who refuse the king's English, gays who resist being family men, lesbians who flaunt their desire, and seemingly nice middle-class whites who are not what they appear to be. Here, Bennett steals the rhetoric of the political outsider for what amounts to a classic conservative morality campaign for "family values." Popular culture serves as a perfect foil: Bennett elicits the traditional left-wing fear of capitalism and its ideological control while playing into the right's fear of popular culture as a staging ground for asocial behavior.

Most specifically, Empower America's campaign against the "perversion" of daytime talk shows crystallizes in its rewriting of identity politics. At its kickoff press conference Senator Lieberman (a conservative Orthodox Jew) stated: "After watching a number of these shows, and learning about the behavior of their host and producers, *it is clear that talk is indeed cheap—and too often demeaning, exploitative, perverted, divisive, or at best, amoral*" (his emphasis).[24] For evidence, he told of the murder of a gay secret admirer by a straight male after they appeared on *Jenny Jones* and then listed the more salacious programs aired during the February 1995 sweep period ("I Use Sex to Get What I Want"; "Sex Caught on Tape"; and "Get Bigger Breasts or Else"). He concluded: "Trashy TV talk shows are wildly distorting our perception of what are normal and acceptable forms of behavior, *adding to the already overloaded cultural dictionary that is helping, in Pat Moynihan's words, to define deviancy down*" (his emphasis).[25] Moynihan's "defining deviancy down" became a central trope in a series of letters sent to the CEOs of the corporate syndication companies (Sony Columbia TriStar, Multimedia, Viacom, and Tribune) asking that each company "recognize its responsibility and take the necessary steps to clean up the programming [being put] on the air."[26]

If a deviant is someone who significantly departs from the behavioral norms of a society, we need to ascertain who or what is a "deviant" in the eyes of Empower America. When one surveys the press releases of the institute, one sees a pattern of repeated daytime talk show images. If the liberal anger is directed at the degrading images of such groups as women, blacks, and the poor, the right's anger is directed at the representation of the marriage breakdown, pornography, underage sex, promiscuity, gay

relationships, and emotional violence.

The Empower America campaign listed the following as guilty of excesses:

- *Jerry Springer:* "A Mother Who Ran off with Her Daughter's Fiance" and "Women Discuss Their Sex Lives"
- *Charles Perez:* "They're Out of Control . . . Sex" and "Sister! Stop Stealing My Man"
- *Ricki Lake:* "Women Confront Ex Who Cheated and Warn New Girlfriend" and "Now That I Slept With Him, He Treats Me Like Dirt"
- *Geraldo:*"Men Who Sell Themselves to Women for a Living" and "Women Who Marry Their Rapists"
- *Sally Jessy Raphaël:* "My Daughter Is Living as a Boy" and "I'm Marrying a 14-year-old Boy"[27]

It is an arbitrary list of programs whose topics conflicted with the conservative discourse on sex—monogamous heterosexuality within a legal marriage. No programs dealing with, say, racism, abuse of women, or problems of the lower classes were listed. Even so, the campaign extends the family values ideology born in the Reagan administration. In the rest of this chapter, I present a more even picture of daytime talk shows based on a random sample of forty programs which aired October 1, 1995, through January 1, 1996. Much of the attack against talk shows from all sides of the political spectrum comes from people who do not watch them regularly, if at all.

The Evolution of 1990s Daytime Talk Shows

The new generation of daytime talk shows did not suddenly appear to destroy the innocence of Americans, as some commentators would have us to believe. Rather, they are continuing the commercial baring of private lives that began with nineteenth-century tabloids and the penny press. The deregulation of TV in the 1980s enabled *Geraldo* to break open the daytime talk show in 1987, moving it beyond "restrained" discussions of the relation of the personal and the political. It now emphasized the confidential world and its conflicts—a sensibility implicit in the concept of the personal as political. By 1994 *Oprah* proved the tremendous financial reward of this new inexpensive combination of the sensational with the political: $180 million in revenues (see chapter 3).

Ricki Lake is the show most often cited for innovating the no-holds-

barred youth format of talk in the 1990s. Its history undercuts the industry discourse that the new tabloid talk shows grew out of audience demand or popular tastes. *Ricki Lake* was created and engineered to capitalize on the youth market and the growth in cable channels. When it premiered in 1993 there were twenty other daytime talk shows, all playing to a demographic market of women eighteen to forty-nine years old. The producers chose to go after a segment at the lower end, eighteen to thirty-four, counterprogramming against *Oprah's* older viewers.

The programming strategy stems from the narrowcasting that came about in the late 1980s and early 1990s when the opening of the broadcast spectrum and expansion of cable broke down the general "network" audience. Garth Ancier, creator of *Ricki Lake*, was one of the founders of the Fox network, where he was head of programming from 1986 to 1989. He and his team brought out *Married . . . with Children*, the *Simpsons*, *In Living Color*, *21 Jump St.*, and the *Tracy Ullman Show*—all of which gave Fox a reputation for youthful irreverence. *Ricki Lake*, with its penchant for asocial and humorous personal confrontations, found a comfortable home on Fox affiliates across the country. (Ancier has strong ties to the Democratic Party and served as a media consultant for the 1992 convention.)

Fox producers used the established talk shows as models but, to appeal to the exuberance and rebelliousness of youth, altered the format. Adding more guests made for a faster pace and adding more people of color broadened appeal. The other *Ricki Lake* executive producer, Gail Steinberg (who produced *Donahue* for six and a half years), states:

> We saw no reason why [a youthful approach] couldn't be successful in daytime and a lot of people didn't agree. They said these people aren't home to watch daytime TV. They said it would never work You can't be a better 'Oprah.' She is the best. So we decided we wouldn't even try. We would carve out a new niche for ourselves.[28]

A twenty-six-year-old host was found: Ricki Lake. Lake says that "this show is geared toward a totally different audience, which could not relate to talk shows before we came along. So in that sense I guess we are a voice for younger people."[29] Yet Lake looked to the established shows to prepare; she watched *Oprah* and *Donahue* with a trainer.

Through more general topics, fewer in-depth interviews, and six rather than three guests, *Ricki Lake* stages broad conflicts at breakneck pace. For example, a program on unwed mothers and fathers-to-be (September 9, 1995) sets ups the antagonism by means of prerecorded

statements by the family of Danielle even before she herself speaks. Each family member declares, in a rehearsed style, "I hate Max" and goes on with a reason. The conflict is made clear and inflamed within the first five minutes. In each successive segment of the "*Melrose Place* of talk shows,"[30] a new pair of guests in conflict is presented. Lake then moves quickly to the controversy implicit in the program topic by prodding for more details, and at last comes to the energizing question (for example, "Danielle, how does that make you feel to hear them say what they have to say?") The hope is that emotions will explode.

Morton Downey Jr. sees in *Rickie Lake* a parallel to his highly explosive program: "Ricki Lake is the female Morton Downey Jr. except there was more meanness in [his] show than in 'Ricki.' Her show is designed to show the niceness as well as the outrageousness. I think that she is doing it right."[31] The success of the *Ricki Lake* formula of social shock with therapeutic overtones in the first season was phenomenal. Beginning in the fall of 1993, the show was being seen on 212 stations by December 12, 1994, breaking *Oprah's* record of 179 stations in a little more than one season. *Ricki Lake's* triumph changed the daytime talk show industry. Old shows became more confrontational, and new shows popped up "trying to out-Ricki Ricki" in pace, number of guests, glitzy graphics, and anything else that bore the Ricki Lake signature.[32]

So far in the 1990s there have been two developmental stages in the daytime talk show genre. The first is the year 1991, when a number of shows premiered that were similar to the 1980s shows but less overtly political, giving more emphasis to entertainment and sensation: *Maury Povich, Montel Williams, Richard Bey, Jerry Springer*, and *Jenny Jones*. As a whole, they were hosted by personalities who were over the age of forty and not clearly tied to the news industry. For example, *Jenny Jones*, launched on 176 stations in 1991, slowly moved from a softer talk show alternating titillating subjects with homespun topics (for example, "Fruits and Vegetables at War in Your Refrigerator") to a purely personal-issue-oriented show by 1993. The show initially had a tie to the identity politics movement of the 1970s in that it came out of Jones's strongly feminist stand-up comedy routine "Girls' Night Out"—a females-only routine described as "equal parts pajama party, group therapy, and male bash-athon."[33] Although marginally successful at first, these early-1990s shows soon benefited greatly from *Ricki Lake's* example as they changed to "a more youthful, energetic format and increased audience participation."[34] For example, the *Gordon Elliott* show began in 1994. The host was also a former comic in his forties (but Australian). However, from the start the

show incorporated some *"Ricki"* elements: first-person topics, on-camera guest entrances and exits.

The second stage is the 1995 youth-oriented daytime talk shows, which caused a national debate. In part, the controversy emanated from the overwhelming number of these mass-duplicated wannabes. They were stylistically uniform in attempting to replicate the glitz, the sensationalism, and the twenty-some-year-old host of *Ricki Lake*.[35] According to Richard Tobenkin, in late 1994 thirteen or so were scheduled for national release in the fall of 1995.[36] Those that made it were *Carnie, Tempestt, Charles Perez, Gabrielle, Danny!,* and *Mark.* By 1995 many TV markets were running as many as fifteen "issue-oriented" shows on a given day. These shows represented not only a noticeable generic shift but a different stage in the industry.

The Industrial Structure of Talk in the 1990s

If one considers the industrial role of the new daytime talk shows, one sees that they are constructed as economic and cultural ephemera. One of the reasons for their existence is the entry of huge international media conglomerates into the talk show market in the 1990s. The old vertically integrated American syndication firms were medium-size corporations and the talk shows represented a good part of its profits. The more recent firms are highly diversified, with interests in several fields. Sony Columbia Tristar TV distributes *Ricki* and *Tempestt*; Time-Warner, through Warner Bros., distributes *Jenny Jones* and *Carnie*; Viacom, via Paramount Domestic Television, owns *Montel Williams*; and Chris Craft/United owns and produces *Richard Bey*. Following the arrivals of the newcomers, the old syndicators added to their "stables," for example, Tribune added *Charles Perez* and Multimedia added *Jerry Springer, Dennis Prager* and *Susan Powter.*

In the 1980s the TV industry underwent a period of transformation when a large number of TV companies were taken over, such as CBS by General Electric. Sony, the parent company of Columbia TriStar Television Distribution, is typical of the change. A Japan-based international media conglomerate, Sony still anchors its holdings on the manufacture of electronic media equipment. It has diversified with ownership of Sony Music Entertainment Corporation (Columbia and Epic labels); Sony Pictures Entertainment (Columbia TriStar Pictures); Sony Television Entertainment (Columbia TriStar International Television, Columbia TriStar Television Distribution, Columbia TriStar International); Culver Studios; and Sony Theatres (a chain).

Sony Television Entertainment through Columbia TriStar International Television has substantially invested in HBO Ole in Latin America, VIVA Television in Germany, Galaxy/Australis in Australia, HBO Asia in the Far East, and CityTV in Canada. It has launched the Game Show Network. It produces the soap operas *Days of Our Lives* and *The Young and the Restless*, as well as the top game shows *Wheel of Fortune* and *Jeopardy!*. Columbia TriStar Television Distribution distributes *Seinfeld* and *Mad About You*. In an annual report Sony describes *Ricki Lake* as having charted "new ground" and as "the fastest growing talk show in the history of television."[37] *Tempestt*, a less important product, is not mentioned.

Given the size of these conglomerates, TV companies have more money to invest in questionable new shows with potential high profitablilty. In other words, many of the shows launched in 1995 represented less than a $6 million investment apiece. They were willing to chance a $6 million loss against a possible $40 million gain after a year, given the histories of *Oprah* and *Ricki* .

Another determining factor in the growth of daytime talk shows is the expansion of the broadcasting environment: the affiliates of new national networks (such as Fox and UPN [United Paramount Network]) and independent stations that are relatively open to the cheaper and more "tawdry" shows. The forerunner shows had been the exclusive domain of network affiliates in the 1980s. Because of the larger number of shows competing for air time on the new and old outlets, the new shows have a make-or-break two or three weeks to deliver respectable overnight ratings. *Variety* states that "there is a sizeable contingent of competitors waiting to pounce on the weak links in the cackle ecosystem, each with its own notion of what works."[38] Shows appearing in the Boston market in late 1995 are listed below.

Daytime Talk Show Schedule, November 1995

Morning
9:00 *Jenny Jones*, WBZ/CBS
 Donahue, WCVB/ABC
 Danny!, WSBK/UPN
10:00 *Jerry Springer*, WCVB/ABC
 Leeza, WHDH/NBC
 Mark Wahlberg, WFXT/FOX
11:00 *Sally*, WCVB/ABC
 Leeza, WHDH/NBC
 Gabrielle, WFXT/FOX

Afternoon
12:00 *Carnie*, WFXT/FOX
1:00 *Montel Williams*, WFXT/FOX
2:00 *Gordon Elliott*, WFXT/FOX
3:00 *Maury Povich*, WBZ/CBS
 Geraldo, WHDH/NBC
4:00 *Oprah*, WCVB/ABC
5:00 *Ricki Lake*, WFXT/FOX

Night/Overnight
11:00 *Ricki Lake*, WFXT/FOX
12:00 *Gordon Elliott*, WFXT/FOX
1:00 *Montel Williams*, WFXT/FOX
2:00 *Carnie*, WFXT/FOX
 Richard Bey, WSBK/UPN
3:00 *Gabrielle*, WFXT/FOX
4:00 *Mark Wahlberg*, WFXT/FOX

The Boston Fox affiliate constructed a four-hour, late-morning/early-afternoon block of new shows to compete against the more established talk shows and soap operas. It did not attempt to compete at first against *Oprah*. The station now counter-programs *Ricki Lake* against the local evening news. However, when *Ricki Lake* became the "No. 2" show in the ratings and was pushed into the crucial 4:00–6:00 P.M. slot, it lost 25 percent of the audience of the shows it replaced—but its audience is growing. The station repeats the block at night, with *Ricki Lake* as the lead-off competing against the local nightly news. The weaker network, UPN, took on the more questionable talk shows (financially or topically), such as *Danny!* and *Richard Bey*.

Advertising, usually considered a conservatizing force, did not change much with the new programs in 1995. A broad survey of advertisers on the new talk shows in November 1995 reveals that commercials for weight loss clinics, personal-injury lawyers and local discount firms dominated in the Boston market. According to one talk industry spokesman: "It does not matter what the content is. It's business as usual as far as I can see."[39]

Because of long, solid blocks of talk shows, one can argue that the viewer does not automatically watch specific talk shows but, rather, watches a generalized notion of "talk." According to Bert Dubrow (creator of *Sally*, *Susan Powter*, and *Jerry Springer*), other than *Oprah*, talk shows have not had the faithful viewer following or fans experienced by specific soap operas.[40] Jane Feuer points to a 1990 *TV Guide* survey that found

that 70 percent of TV viewers have a remote control. Of those, 30 percent said they like to watch two or more programs simultaneously, and 37 percent said they like to channel surf. Feuer suggests:

> These viewing practices could mean the end of the genre. . . . Yet it could also mean that the rapid flow from one genre to another will come to represent the typical viewing experience. Our ability to distinguish genres would have to become even more intuitive and rapidly accessed, even more operative as a subconscious experience.[41]

With the growing use of remote controls—channel surfing—the three-talk-shows-per-hour-density during the day allows considerable sampling. (Consider how *Talk Soup* replicates the sampling sensibility as its aesthetic.) In fact, show producers are conscious of this transformation, and the 1990s shows compete for the roving viewer with more eye-catching material.

No longer are programs built around one conflict; rather, there are a series of conflicts that one by one tempt the viewer to remain and catch the next. A program also endlessly repeats the topic, the stage it is at, and the players' and guests' names through the narrator/host and computer-generated graphics. The redundancy overwhelms the forward movement of the narrative, revealing that the show is more concerned with capturing the inconstant viewer than rewarding the attentive viewer with detailed narrative à la the soap opera.

The primary means of differentiating the new shows is the host. The custom is retained of entitling a show with the first name of the host to create a sense of instant friendship and intimacy. But unlike their predecessors, these hosts do not develop their ability and interview skills by apprenticeships on local news and talk shows before going national. The post-1990 host is primarily a former TV actor. She or he gained their "reputation" (or intertextual complexity) as a supporting character, a teen or a young adult, on a relatively popular television show: Ricki Lake on *China Beach* or Gabrielle Cateris on *Beverly Hills 90210* come to mind. Although coming out of the pop rock group Wilson Phillips, Carnie Wilson (*Carnie*) easily fits this convention in that the group, too, was an "act" resulting more from packaging (MTV videos and studio recordings) than musical talent. These TV roles are the central cultural intertext for the host's recognizability, credibility, and character depth as a talk show star.

Carnie's opening credits echo the cute "girls just having fun" sensibility

of Wilson Phillips's videos as Carnie dances with daisies through urban scenes while an all-girl pop song bops along in the background. Alan Perris, senior vice president of programming for Columbia TriStar, states that Ricki Lake is to appear to be "the girl next door"—again, a figure she played as nurse Holly Pelagrino (albeit a promiscuous one) in *China Beach* and as the iconic American (albeit campy) teen in John Waters's films, such as *Hairspray* and *Serial Mom*. These hosts do not have a career tie to the program through ownership (for example, Winfrey and Rivera) or a management role (for example, Donahue). They are hired faces. Lake describes the host role as just one more facet of her career.[42] The scheduling, form, and content of the new shows suggest the construction of a new kind of daytime audience: out-of-work or out-of-school teens and twenty-year-olds who negotiate viewing differently: sampling high points of conflict instead of the entire program.

An examination of the economic impact of *Ricki Lake* is enlightening about the logic of the shift in the genre's style and content. The October 1994 demographics of the Boston audience tell us that *Ricki Lake* had become the top talk show for women ages eighteen to thirty-four, and a runner-up, behind *Oprah*, among women twenty-five to fifty-four. Also consider the national change in ratings after *Ricki Lake's* first year.

Afternoon Talk Show Ratings, Boston, November 1994

RANK	SHOW	A/HH RATING	A/HH 1 YEAR AGO	PERCENT CHANGE
1	Oprah Winfrey	9.7	10.9	-11
2	Ricki Lake	5.4	2.6	+104
3	Jenny Jones	4.5	2.4	+88
4	Sally Jessy Raphaël	4.5	.2	-13
5	Maury Povich	4.2	4.2	0
6	Donahue	4.1	5.2	-21
7	Montel Williams	3.8	3.0	+27
8	Geraldo	3.4	3.9	-12
9	Jerry Springer	2.0	1.6	+25%
10	Gordon Elliott	2.5	—	—
11	Rolonda	1.9	—	—

Source: Nielsen Syndication Service Ranking Report: August 30–November, 14 periods, 1994.
Notes: H = Households. First season programs do not have a previous record. One ratings point = 959,000 TV households.

Ricki Lake's new format increased the total number of viewers by attracting teens but drew viewers away from the established talk shows. Although *Oprah* remained highest rated, it lost 25 percent of its audience, declining from 11 percent to a 9.7 rating in one year; its all-time high came in the early 1990s, when it had nineteen million viewers. Multimedia's *Donahue* dropped 21 percent in the ratings to a 4.1 rating and its *Sally* fell 13 percent to a 4.5 rating. *Geraldo* fell 12 percent to a 3.4 rating. In fact, overall viewership of the new talk shows in 1995 was negligible, less than one to two million people, or 2 percent of the audience in their first two months. In October 1995 *Carnie* led the new shows, ranking 55, with a 2.0 rating. There followed *Tempestt*, No. 64 (1.8); *Gabrielle*, 71 (1.6); *Mark Wahlberg*, 83 (1.4); and *Danny!*, 88 (1.3).[43] For all the political anger these shows elicited, they were never successful in terms of industry indicators. They were gambles: cheaply and easily produced, and of marginal importance to their conglomerate parents.

The Mode of Production of Talk Shows in the 1990s

It is too simplistic to paint the change in production between the early talk shows and later ones as the loss of social scruples under the corrupting influence of profit and competition. Winfrey's announcement in September 1994 trades on this coloration when she declared she would no longer do "trash TV." In a cover story in *TV Guide* a few well-timed months later, she said, "I understand the push for ratings caused programmers to air what is popular, and that is not going to change. I am embarrassed by how far over the line the topics have gone, but I also recognize my contribution to this phenomenon."[44] On one level, she fails also to confess that her pledge to take the high road serves as a shrewd move to differentiate her show from the indistinguishable tabloid shows. She will reign over her self-created moral-uplift market for talk shows while the other first-generation shows take a small share of the crowded tabloid market.

On a more important level, Winfrey's statement perpetuates the myth that TV merely follows popular tastes toward tabloidization instead of creating tastes. However, she promises to create a new market with her oath to create "shows with images of what we would like to be."[45] As a result, *Oprah* has turned to bourgeois knowledge as the source of programming; upbeat interviews with "exemplar" celebrities and self-help discussions with experts, with a quiescent audience nodding in approval.[46] The youth-oriented talk shows continue to solicit an active audience by constructing their vision of a younger, more fun-loving consumer. The process has been called "sensationalizing" the medium—a rather inexact term,

given that the genre has always been sensational.

A more exacting analysis of the production and publicity process in the 1990s reveals the construction of what I call an implied "self-conscious" or "playful" viewer/consumer. I argue that present talk shows are unusually polysemic. On one level, they can still be read as straight talk shows offering "individual" solutions to the lower classes' everyday personal dilemmas. Both Springer and Lake end their programs by moving off to one side to comment on the conflict and offer advice. After the angry program on un-wed parents-to-be (September 9, 1995) Lake offered: "It is difficult when the one you love is hated by everyone else in your family. It is important not to close the doors on your family because they do love you and want the best for you. But they just may not be able to express their feelings." Platitudes and biblical-style commands ("honor your mother and father") have replaced the socially conscious language of Freudian therapists as talk shows have sought to broaden the seriousness of their audience appeal.

The newer shows invite a second interpretation, which deconstructs the serious or liberal "do-good" intentions of 1980s talk shows by inviting an ironic reading. Here, the methods of the earlier programs are so excessively overplayed that they highlight the contradictions of any talk show—particularly first-generation *Oprah* and *Donahue* (even *Geraldo*)—that unctuously attempts to help disadvantaged people while it simultaneously profits from the act. According to Alan Perris, senior vice president of programming at Columbia TriStar Television Distribution, "Geraldo does things that are pretty much on the edge a lot, but he calls himself a journalist. We have an actress and it's fun."[47] Although the new shows flaunt their asocial values to the point of a callous lack of care, the behavior and attitude cannot be subsumed within right-wing ideology. The shows' style and content derives from the sexual liberation movement of identity politics (gay, lesbian, and bisexual culture, and feminism).

The topics for a majority of the shows' programs are not new but simply recycled topics approached more boldly and directly. Reunions, secret crushes, meet a celebrity, confronting the perpetrator, return guests, and makeovers are all staples, established, successful, borrowed. But instead of labeling a program in terms of a social issue to be debated or investigated neutrally (for example, "A Rare Look into the Lives of the Obese," *Oprah*, February 2, 1994) or "Sexual Harassment Among Teens" (*Sally*, March 7, 1994), the new programs employ first- and second-person exclamations or imperatives not only to increase personal identification but to move away from the "pseudo-seriousness" of the third-person objective distance of the shows associated with identity politics. Some representative titles of programs aired November 20–24, 1995, appear below.

Gordon Elliott
"Gordon: Hook Me Up with a Hollywood Hunk"
"Incredible Twin Reunions"
"Relationship Rehab"
"Big, Bad, Beautiful Babes"

Carnie
"Your Flirting Has Gone Too Far"
"Left at the Altar"
"I Know That I Shouldn't Want You, But I Do"
"Dream Come True Makeovers"

Ricki Lake
"Listen, Family, I'm Gay . . . It's Not a Phase . . . Get Over It!"
"Girl, You're Easy Because You're Fat . . . Respect Yourself ASAP"
"My Family Hates My Friend Because She Is Black"
"Someone Slap Me! Today I Meet My All-Time Favorite Star"

Gone are the topics that we tied directly to explicit public-sphere debates, such as "Press Actions on Whitewater," with reporters (*Donahue*, March 16, 1994) and "Strip Searching in Schools," with school administrators (*Sally*, March 13, 1994). Nor are personal topics generalized into social issues, such as "When Mothers Sell Babies for Drugs" (*Geraldo*, March 17, 1994), "Custody Battles with Your In-Laws" (*Sally*, April 22, 1994) and "Domestic Violence" (*Donahue*, February 1, 1994); rather, they are presented as interpersonal issues in English that is colloquial or imperfect to signify that the discussion is not formal but like conversation among friends. Further, the topics are presented as directives, which implies a certain amount of humorous hyperbole, but, more important, there is a level of aggression in their urgency that signals potential conflict.

The new shows come in two broad types: tongue-in-cheek, just-for-fun kind; and the do-gooder interpersonal kind. The first presents programs derived from the old shows' celebrity programs, such as "Celebrity Look-a-like Contests Between Kerrigan and Harding Look-a-Likes" (*Geraldo*, March 1, 1994), "The Stars of *Naked Gun*" (*Donahue*, March 4, 1994), and "Flamboyant Drag Queens" (*Geraldo*, March 4, 1994). The new variation tends to recycle stars from 1970s middle-brow TV culture such as *Ricki Lake*'s "Someone Slap Me! Today I Meet My All-Time Favorite

Star" (November 23) where guests meet their favorite star such as Gary Coleman (*Different Strokes*) and Debbie Gibson. On the *Gordon Elliott* program "Gordon: Hook Me Up with a Hollywood Hunk," audience members go on dates with celebrity look-alikes and the show's cameras tag along.

In general, audience members participate much more directly in the new shows, becoming part of the drama. However, I argue that the programs have become preconstructed from beginning to end. There is much less spontaneity; the surprise and pleasure comes from the gamble of whether an audience member or guest will be embarrassed or fall in with the forced role. As in the forerunner celebrity programs, these function as comic relief from the "heavier" topics about relationships.

The more frequent type of program (and the object of public ire) is the interpersonal or relationship conflict show. These programs are about the emotional conflicts involved in breaking sexual and social taboos. In a study commissioned by the Kaiser Family Foundation, Bradley S. Greenberg and Sandi Smith (Michigan State University) evaluated two hundred videotapes and transcripts covering one summer. They found that the hosts and guests talk mostly about family, relationships, and sex. The most common disclosures per hour were five of a sexual nature, including one of sexual orientation, and four that concerned a personal attribute, such as addiction or health. They also found that sixteen disclosures per hour were "ambush disclosures"—a guest surprises an acquaintance, a friend, or family member with a secret.[48]

Although the salacious content of some older talk shows (*Geraldo*, for one) looks indistinguishable from that of the newer shows, there are still important generational differences. The newer shows' programs maintain the six-segment structure, but instead of three guests discussing an issue in some depth, each segment offers a new guest pair. The performance is choreographed around the introduction of the aggrieved person while the problem person waits "unknowingly" offstage under the eye of a camera. At the host's prodding, the complainant reveals intimate details about, say, the other's deviant sexual activity. Together, host and complainant come to the conclusion that the person waiting has a problem: the program has its necessary "conflict."[49]

An "ambush disclosure" (or, making the private public) is an extension of a therapeutic logic: keeping something to oneself signifies repression. The host calls the person waiting to the stage and tries to ascertain if her or his story parallels the complainants'. If it does, admonishment begins for breaking social rules, causing emotional pain, and not being open. The scenario is usually repeated six times with different guest pairs; duplication that results in only slight variations. The degree of similarity

among the pairs occasions a sense of a sociological revelation: the problems displayed *must* be representative of a social issue. But the parallel acts and their differences are made to seem like harmless entertainment when the audience is invited to chortle at the foibles of human beings.

Aesthetically, what is important is the form, not the content, of these scenarios. How, for instance, *Ricki Lake* varies presentation, graphics, and narrative setup. Programs focus on visual spectacle: entrances of guests, audience reaction, and a set of rituals, à la game shows (weddings, proposals, punishments, and contests). In fact, rituals of other TV genres have been incorporated into the shows. Not only do genres become more self-conscious as they age; they hybridize with other genres in search of innovation. Cameras furtively follow guests into public situations (*Candid Camera*); romantic problems are worked out by arranging dates (*Dating Game*); guests perform as in a talent show (*Star Search*). The at-home and studio audience derives pleasure from recognizing an original source and judging how well its conventions are mimicked. That the show and host construct the stories by means of the production process does not matter. The parallels in behavior and the telling of pieces of life stories repeat the predestined logic of the lower-class culture, which historically does not have the power to control their lives.

Essentially, program topics are staged by the talk shows on the pretext of doing social good. (Ricki often coos: "We are here to help you.") They offer advice on and solutions for problems such as promiscuity, betrayal, and lack of self-esteem. Children of the therapeutic programs that defined the first generation of talk shows, they have lost sight of the difference between social identity and private emotions. And like good children, they have learned so much from the parental generation that they rarely use therapists; the host assumes the role and dispenses commonsense advice.

However, even though the first-generation shows did relationship programs (for example,"You Are Not the Man I Married" [*Geraldo*, February 14, 1994]; "Broken Engagements" [*Oprah*, January 31, 1994]; "How to Marry a Rich Man" [*Sally*, March 25, 1994]), there was a sense of objectivity and detachment because both sides of a conflict were presented. The new shows' programs are biased from the start, siding with one person— usually the "I" of the title, who is typically a woman. That person confronts the "you" for his (most often) or her moral failings and demands change. The following 1995 *Ricki* program titles baldly reveal this preconstructed dramatic structure: "You Act Like You Don't Want Me . . . But I Know That You Do" (December 18); "Yeah Mom, I'm 13 . . . But I Am Going to Make a Baby!" (December 20); and "Yeah, Mom/Dad, I'm Marrying 'That Jerk' . . . Whether You Come to the Wedding or Not" (December 27).

The morality play of the newer shows has an even heavier, more controlled logic; it is unnuanced. There are clear victims and clear victimizers. The victims are accusatory and aggressive; they want justice and often revenge, which the show enacts. Retaliation is a frequent form of closure: *Richard Bey* takes it to an absurd conclusion when an errant male is put into stockades by his girlfriend on a program devoted to the ritual of reprisal: "Yo! You're Busted" (October 5, 1995). Another example, *Carnie's* "Left at the Altar" (November 22, 1995) allows each rejected spouse-to-be to impose a milder form of retaliation on the partner who reneged. On a certain level, the world of new talk is much more moralistic than the 1980s world. Right is right and wrong is wrong, penalties follow upon wrongful actions. The humor often lies in knowing that justice will inevitably prevail. These shows deny restraint; they are more extravagantly theatrical and self-conscious than any nineteenth-century melodrama. They are closer to the highly controlled game shows or World Wrestling Federation (WWF) matches in their excessive style, emphasis on ritual, and, most important, audience participation. Roland Barthes writes that the attraction of wrestling was once the "spectacle of excess" evoked by means of grandiloquent gestures and violent contact. It was a lower form of tragedy, a restaging of the age-old battle between "the perfect bastard" and the suffering hero.[50] Like wrestling, talk shows celebrate the self-consciousness of the drama where the performance breaks through the orienting boundaries of stage theatrics into the audience.

If the studio audience member represents the ideal viewer from the program's point of view, the viewer is a woman of color under thirty. However, these audiences have noticeably more men than the first generation. Moreover, these newer programs demand an active or "edgy" studio viewer in the words of *Ricki Lake* producers. These are not the nice middle-class white women who populate *Donahue's* audience nor even the tasteful rainbow of women at *Oprah*. Rather, its studio audience members are streetwise; they must go through a metal detector upon arrival, and guns are routinely confiscated. Anonymous security guards sit in the audience, ready to spring if anyone becomes too aggressive. It is not that the show is beset by people prone to violence; it actively constructs them.

To warm up the studio audience and rehearse its behavior in the upcoming hour, a producer asks the members to be like a *"Ricki* audience." She or he randomly picks out a member to read a prepared fake statement of a fictional guest, such as the preposterous revelation "I have been impregnated by aliens." In a highly theatrical manner the producer scolds the assembly "for sounding like a *Donahue* audience" by reacting too genteelly. When the woman reads the statement again, audience reaction is

tumultuous—"huge, loud, almost crazed."[51] And the producer congratu-
lates it on a *"Ricki"* response. Where once *Rickie Lake* audiences applauded
lavishly to signal segment changes, the "Go Ricki" chant and arms swirling
over heads have replaced the clapping—a new level of emotional and
physical response, the desired edginess. The audience is reactive, perhaps
a bit unstable, not intellectually contemplative.

But it is neither undisciplined nor slow-witted; it participates and
takes great pleasure in the outrageousness of the prescribed rituals. It re-
acts as asked, and many of its audience responses have become set pieces
with pre-ordained gestures, wild boasts, warnings, and exclamations. The
audience, which knows the show's rules, has come prepared to out-per-
form the show itself.

To illustrate the foregoing, let us consider the *Ricki Lake* program "I
Talk Virgins into Sleeping with Me . . . And You May Be Next" (October
5, 1995). When Charles, the perpetrator, comes onstage, the audience un-
leashes a storm of warring boos (women) and applause (men). As each of
three formerly virginal women testifies regarding his "lying" ways, the
men in the audience erupt with hoots of glee and the women with howls
of anger. When the audience later questions Charles, many (black and
white) perform homilies in order to lecture him or support his behavior.
One man starts, "You represent to the fullness"—to indicate a coded no-
tion of respect. A woman scolds:

> I have a comment for Charles. You should not go around hurting
> people and taking girls' virginity . . . because, remember this, the
> world is not flat and it is round. And what comes around goes
> around. And someday you may have a daughter and she may run
> into a dog just like you.

Pleased, Charles flashes her a smile and a victory sign. This is not the image
of a pitiable lower class easily swept up in a show's predatory needs that
much of the press deplores. Nor are these people with small egos in search
of fifteen minutes of fame. The show's needs may be exploitive, but the au-
dience is amazingly proud of and creative in its responses. The audience's
performance usually outclasses the host's uncomfortable performance; it
reveals a flair for drama, poetic cadence, and self-satisfying pleasure.

Beyond producers and studio audience, authenticity of guests has
been a prominent issue in the debate about talk shows in 1995. The new
shows make headlines for their duplicity not only for coaching guests to
repeat word for word and act for act the drama that the producers have
"scripted" but for manufacturing guests. For example, the *New York Post* in

late 1995 announced in a headline, "Daytime Talk Shows: Fake Guests Common in Battle for Ratings."[52] Talk shows in the 1990s are different creatures: they are not concerned about social truths; they reveal the performance behind the notion of truth.

As discussed in chapter 3, the credibility of daytime talk shows depends on the legitimacy of guests and stories. Day after day *Donahue*, *Geraldo*, and the *Oprah* stage the stories of the lower class. Their programs are predicated on the clear societal boundaries between victims and victimizers. The *Donahue* program "Crooked Attorneys" (February 9, 1994) "works" because we can identify with detailed and idiosyncratic stories of victimization at the hands of lawyers. The logic is a social group with a shared problem. Yet the program allows the guests to construct their own stories. Sometimes they may be boring, and the host hurries them on, but the stories are theirs. The signs of authenticity empower the melodrama of such shows.

By 1995 talk show programs were having actors or imitation guests regularly. Eight shows located in New York City make for a highly crowded, competitive industry that must be innovative. The shows search for good "acts" or actors who can stylistically spin a good story. The producers' public stance is that potential stories are subject to verification, but schedule constraints inevitably allow some questionable guests to slip through. Garth Ancier argues that inauthenticity results from the differences in generational ethics: "A younger audience implies a different ethical mix, we have had to be extremely tough on the veracity of the stories."[53] Generally, if a show needs a certain kind of guest, the bookers will look the other way if they have the sense that a potential guest is a poseur. The controversy over fake guests has functioned as an advertisement for viewers to try their hand at acting by calling the 1-800 numbers of the shows that travel across the TV screen, numbers that often appear continually during a program, like a weather alert. The shows have a voracious appetite for anyone willing go "onstage."

In late 1995 newspapers were saying that the shows were paying stringers, who held "cattle calls" for actors to "play" lesbians and bikers who would be paid indirectly by the shows through the stringer's fees.[54] The notion of fake guests has been part of popular press reportage on about talk shows for more than a decade. The audience has slowly come to look askance at the "truth" of talk. By 1995 questions shifted from "Where do they get those people?" to "Are those people real?"

Authenticity of the stories is not as important as the ritual of performance to the success of a *Tempestt*, a *Gordon Elliott*, or even a *Jerry Springer*. "Left at the Altar" (*Carnie*, November 22, 1995) reveals what seems to be

actors playing rather ungracefully the roles of jealous lovers. Stacy, aggrieved bride-to-be, tells in a highly rehearsed style how she discovered that Jason, her former fiancé, was cheating on her. Nothing is spontaneous: her delivery is clipped; the story is replete with the worst romanticized clichés I have heard on a talk show. When Jason comes on, he gets his story wrong several times and turns silent. And when the "other woman," Jacqueline, appears, a theatrical rendering of a "catfight" takes place. The audience loves the game, hooting at Jason, groaning at convolutions and embellishments. Shots show shaking heads, continuous laughter, signs of disrespect. When Jason proposes (a common ritual on such shows) and Stacy throws the ring into the audience with the aplomb of a bad version of Alexis Carrington, frenzy erupts. The three pairs of guests who follow are equally self-conscious and clumsy in performance.

Even guests who are "authentic" often use the occasion for theatrics. Typical in that regard is the *Jerry Springer* program "Couples in Crisis" (October 5, 1995). The first half hour is devoted to accusations between a "redneck" wife and her cheating best friend, and the inevitable physical fight that breaks out. Then a punk couple, Mike and Dementia, is added to the cast. Mike blames Dementia (who is in complete gothic regalia and whose white face and lips are framed by black-and-red dreadlocks) and her style for their problems. Not only is Dementia all theater, but so is her friend Ollie, who is there to support her. He too is gothic (white makeup with blue lips), but he is also more than six feet tall and his two hundred pounds are sporting a black patent-leather jumpsuit, five-inch platform shoes, and short-cropped bleached hair. He enters tossing confetti and sashaying to the rhythmic beat of the clapping. The audience loves him. Springer plays straight to Ollie's outrageous drag-queen performance, asking what he thinks about the couple's problem. Not only is the contrast between the "rednecks" and the "gothics" incongruous, the difference between the straight performance of the program, which must maintain its sincerity, and the theatrics on the stage is even more absurd.

Such theatrics have always simmered on the periphery of talk shows. Consider *Geraldo's* penchant for displaying drag queens or *Donahue's* willingness to dress the part for a program on drag or one on baldness. Moreover, the perennial favorite, the makeover program, on which even Dr. Joyce Brothers can be made to look like a biker in drag, speaks to the self-consciousness of facades and appearances on talk shows. Like all genres, talk shows have aged; they now comment on their own methods. By 1995 almost everyone was "acting" on them, breaking the realist ideology that fed its identity politics beginnings and now is frustrating the viewing public's desire for social truths.

Talk in 1995: The Triumph of the Camp Aesthetic

Gay camp is the aesthetic that underlines the new talk shows in the 1990s, though many people might balk at such an assertion. Camp "exists in the besmirk of the holder."[55] It sets up a cultural distinction between the ignorati and the cognoscenti: those who do and do not recognize the ironic attitude that is struck in talk shows. Gays have fashioned their own subversive style that serves as a dissonance critiquing the seriousness of the cultural object on display. It is a complex concept; it involves an attitude: a way of seeing the world as an outsider who refuses to take dominant tastes seriously.

Ever since Stonewall—the first public rebellion by gay men against discrimination, in 1969—gays have slowly become an unspoken taste-making culture. Certain "style professions"—ballet, musicals, interior design, fashion design, and most recently television design and production—are dominated by gays. In my interviews in the talk show industry, I ran into two kinds of producers: straight women and gay men. Martin Berman, executive producer of *Geraldo*, assured me, "Gay men are some of the best producers in the talk show industry."[56] As Richard Dyer points out, much of gays' professional work is clearly marked as the acceptable kind of gay camp in that

> they are style for style's sake, they don't have "serious" content (a hairstyle is not about anything), they don't have a practical use (they're just nice) and the actual forms taken accentuate artifice, fun and occasionally outrageousness—all that chi-chi and tat, those pinks and lace and sequins and tassels, curlicues and "features'" in the hair, satin drapes and chiffon scarves and fussy ornaments, all that paraphernalia of a camp sensibility that has provided gay men with a certain legitimacy in the world.[57]

But as much as camp can revel in mindless pleasure with style, it has also been marked as a form of social commentary. Such a sensibility comes from a gay critique of the dominant "straight" tastes of a culture and how those tastes repress others. Jack Babuscio writes that that sensibility is "a creative energy reflecting a consciousness that is different from the mainstream; a heightened awareness of certain human complications of feeling that spring from the fact of social oppression."[58] It springs from the identity politics movement of the 1970s, when gays finally found a public identity that was their own.

Along with feminism, gay camp is a thorn in the side of macho male-

heterosexuality. However, as a political tactic, it has always had an uncomfortable relationship with conventional activism. It divides the gay community when the "straight" gay disagrees with the tactics of the more rebellious, proud "queer" (replicating the generational split within many identity politics groups). The latter refuses the "straight" gay his closet by publicly outing him. Michelangelo Signorile, the *OutWeek* warrior who has outed many celebrities, even appears on *Ricki Lake* as an expert on gay teens (program airing November 20, 1995). Additionally, ACT-UP, Queer Nation, Lesbian Avengers, and Guerilla Girls have turned around the dominant homophobic notions of gays as "queers" and of the "good" gay who passes as "straight." These organizations have used camp—flaming queens, macho man costumes, drag balls, queer die-ins, and even guerilla masks—to politicize the notion of the "acceptable" gay and lesbian. However, they have alienated other political groups that seek to work within the dominant system that camp parodies.

Talk shows have been the source of campy parody in general. *Talk Soup* premiered on the "E" network in 1993 as a tongue-in-cheek, late-night digest of the most outrageous moments from the day's shows. The initial host, Greg Kinnear, established the show's humor; he played for wry laughs with his pseudoserious commentary laced with icy irony. There was none of the daytime ambiguity between seriousness and outrageousness. We can trace this logic back to *Fernwood 2-Night* (1977), which parodied celebrity talk shows' mock seriousness. The genre of talk parody resurfaces with *My Talk Show* (1990), which had a housewife as the host and was set in the living room of a home in Derby, Wisconsin. In December 1995, *Night Stand* premiered as a spoof of talk shows, with a buffoon host and programs such as "Teenage Hardbody Prostitutes" and "Sexaholics: The Problem, the Cure and Where to Meet Them." Jerry Springer has himself appeared on it, revealing the ironic self-consciousness of the new talk shows.[59] But Susie Bright's essay "I Got this Way from Kissing Donahue" best exemplifies the sexual playfulness of a campy send-up. She creates a sexual fantasy about appearing on *Donahue*: she is a pregnant lesbian sex expert; and Donahue is gay but having his first affair with a woman.[60]

How are talk shows themselves camp? First, contemplate the "queen" of new talk: Ricki Lake, famous for her roles in the films of John Waters—the "straight" originator of the camp sensibility for feature films. In contrast to Winfrey's acting career in middlebrow do-good films, Lake played the archetypal American teen in *Hairspray* (1988), *Cry Baby* (1990), and *Serial Mom* (1994)—all send-ups of icky-sweet family values. Her supporting role on a 1970s and 1980s TV show (*China Beach*) aligns Lake

with a number of the new talk show hosts as marginal figures retrieved from past popular culture and given a "false" celebrityhood as hosts of lowbrow talk shows. Mark Booth comments that camp strategy is often "to present oneself as being committed to the marginal with a commitment greater than the marginal merits."[61] Here, camp takes pleasure in the self-consciousness of wooden acting, not in the earnest content of the programming.

Moreover, these shows use style to critique the "seriousness" of the forerunner shows and their pretension to therapeutic help. Here, style can be seen as a form of defiance, a refusal to be moral when the concern with identity politics of the old talk shows is so fraught with self-gain and market strategies. Fake guests reveal the inauthenticity of any claim to truth on talk shows. Camp reacts against puritanical morality of the identity politics of the Winfreys, the Donahues and even the early Raphaëls and Riveras. Susan Sontag argues that camp "neutralizes moral indignation."[62] At its best, it celebrates the outlaw nature of a people who are repressed by the dominant ethos of "thou shalt nots" while it pleads for a certain sympathy and consideration for the differences and inequality in social circumstances.[63]

Herein lies the political contradiction of camp on the new talk shows: it is both progressive and reactionary. At its best, the camping turns around the rhetoric of the old talk shows, where people of color, women, and gays were seen as victims; camp becomes a celebration of rule breaking. The guests and audience members of *Carnie*, *Ricki*, *Tempestt*, and *Charles Perez* no longer sit around in long, sober, sad conversation about discrimination, sexism, and homophobia. Rather, they play act, applaud, and revel in their difference. Seriousness is intercut with colorful and often silly graphics, the shriek of an audience member, or mock fights between guests.

Decorum and civility are not the mode of new talk. These programs are upbeat, fun, and "in your face," much like the tactics of an ACT-UP demonstration for more AIDS funding. They talk about multipartner sex, promiscuity, and the body without much apology. It is no wonder that conservative Americans, Empower America among them, are appalled. These people are out of control—their control. *Ricki Lake* and the other new shows have not only incorporated the outrageousness of camp, but added the language, gestures, and rituals of poor blacks and Hispanics when guests and audience members use the street language and gestures of African-Americans. The programs encourage the use of black signs. Program titles are sometimes in street vernacular (for example, "Yo! You're Busted," *Richard Bey*, on October 5, 1995). Lake is known for her

appropriation of "girl!" from black female culture as a tease on the program. The guests and audience respond by willingly signaling their racial otherness through jewelry, gang colors, and clothing. There is an aggressive refusal to be proper evidenced in the boasting of heroic sexual conquests and pleasure in the excesses of the body.

Generally, the press has reacted in horror to the racial and class stereotypes being played out on these talk shows. The "outlaw" type has had a long and celebrated history, however, in American media. Bell hooks argues that blacks have learned the gangster culture from white society by watching white-gangster mythology being played out in films and on TV. This shared outsider status is why she, a strong black feminist, can interview Ice Cube, a rapper renowned for misogynist lyrics, and they can find common ground. The issue for her is the white misogynist society that produces black popular culture. She writes that the American outrage at black transgression is duplicitous in that the misogyny of the black form is conditioned by the prevailing sexism of "white supremacist capitalism" that produces and encourages such cultural expression for profits. In fact, the press's anger at talk show representations only encourages greater interest in, and therefore more profits from, the white-produced shows.[64]

Henry Louis Gates argues that representation of black outlaw culture is even more complex. On one level, he suggests, much of the black celebration of O. J. Simpson's acquittal stemmed from not only the subversion of a white justice system that has failed blacks repeatedly but the display of black prowess during the trial. But on another level, he warns about this tendency of "outlaw culture: the tendency which unites our lumpenproles with our postmodern ironists, to celebrate transgression for its own sake."[65] Here the guests and audience members have triumphed in the rebellion against the social and sexual civility of the white middle class that has characterized "advice" in the United States since the latter half of the 1800s. But Gates worries if such displays of being *bad* have lost their attachment to a social agenda and are now merely playful.

Such a sensibility is also reactionary, however; it stops political change. If nothing is to be taken seriously, then nothing needs to change. Yet the new talk shows still depend on real social issues as fodder for their content. Their programs are about unprotected sex with AIDS (*Jerry Springer*, October 2, 1995); women with little or no self-esteem (*Ricki Lake* November 21, 1995); black women who are beat up by gangsta boyfriends (*Richard Bey*, November 2, 1995); and drug users (*Montel Williams*, November 22, 1995). They parade people from the lower class —often missing teeth, drugged and unable to talk, and/or intimidated by

the TV process—all marked by an unjust social system. But then the process camps it up, leaving the sensibility that one cannot take anything too seriously, not even the poverty and physical abuse suffered by blacks. Not everything is a joke; we need to know about the social logic of the repression. The camp aesthetic stops the questioning. This is why the left has reacted so angrily to talk shows.

To reveal the effect of this contradictory aesthetic, I want to offer a close analysis of the just-mentioned *Richard Bey* program "Dump Your Jailhouse Boyfriend," which has what Babuscio defines as the four characteristics of the camp aesthetic: aestheticism, theatricality, humor, and irony.[66] The program involves four women, each of whom is in love with a criminal ("a gangsta"). A disapproving relative or friend serves as the counterpoint in this issue. Given the originality of their demeanor, language, and presentation, these are *real* women off New York streets.

The over-produced déclassé look of talk shows fits camp aestheticism. The set for the *Richard Bey* program is a stage within stage. To one side is a proscenium arch lined with flickering marquee-style lights; a blood-red curtain falls from it. To the other side is an elaborate staircase; beneath it banks of art-deco lights form columns, in front which the guests sit, dwarfed by the decor. This set is excessive; it parodies all the faux-living-room sets that talk shows use, giving whatever is said on the stage a silly overtone. This stylized formalism dominates throughout the program. The camera cuts to a dancing "Richard Bey" logo to introduce each segment while it dissolves into a moving shot of a standing audience clapping in unison, over which is imposed a dancing cartoon graphic "Jump that jailbird NOW!" Timing is everything. The effect is to layer artifice on top of artifice until excessiveness shields us from taking the program's content seriously. This program has supplanted the emotional extravagance of the melodrama of 1980s talk shows, which was measured by the test of "real" emotion, with visual and aural overkill; nothing is authentic.

The theatricality is telegraphed from the beginning. The program starts with a game show à la *Love Connection*. A Hispanic woman discusses her love for a criminal who has treated her badly. She is promptly subjected to the punishment of a bad date. She must question and choose between hidden men who are impersonating Joey Buttofuoco, Mike Tyson, and Pee-Wee Herman. Her sentence is to date the Tyson figure. She is disgusted yet goes along, controlled by the mock drama. This opening captures the life-as-a-theater sensibility that permeates these talk shows. Getting involved with a violent man is metaphorically part of a game with its preconceived results. The opening reveals that violence in men is a facade or act through the clownlike impersonations of violent tabloid-

newsmaking men. One should also note inclusion of Hermann, a mild campy figure of gay identification. Talk show camp is unsparing.

The lack of respect for the boundary between the serious and the humorous becomes immediately apparent when Bey attempts to talk earnestly to the four women about their attraction to violent asocial men.

Richard Bey: You're upset that Colleen is dating this guy in jail. What is he in jail for?

Yadira (a relative): He killed a woman with a shoelace . . . because she stole his wallet.

Richard Bey: He killed a woman with a shoelace?! (Bey laughs and then audience laughs uproariously.) I do see that Colleen is wearing loafers just as. . . . (Everyone laughs loudly. The camera cuts to her feet. The sound effect of a loud horn plays for a laugh.)

Richard Bey: What was the charge? Murder? That should be a long time. (An ironic "ding" sound effect is heard, indicating Bey has had a "major" revelation.)

Richard Bey (in an ironic tone): You say "should be a long time". . . but in our society, forget about it. When you get a life sentence, you're out in a week. (applause) (In a mock serious voice) But that's a totally different show; watch Ted Koppel.

Bey's attempt to mix humor with a discussion about violence and justice leaves him sputtering and defensive. The signature use of sound effects for irony overwhelms the forward movement of the discussion. As the program fitfully progresses, there are several short shouting matches between the unrepentant gangsta-loving women and their family members and Bey, who is trying to warn them of the physical danger on the streets with these men. When Bey attempts to relate a story from his youth of a man who was a victim of a driveby shooting, one hears the sound effect of a moving car. He is infuriated by the campy intrusion: "Cut it out, Walter! It is not funny!!" The black woman to whom he is speaking goes into a tirade about how she does not ride in stolen cars. When Bey persists, she outyells him until he screams, "Shut up." At this point, content has dissolved and we are left the bald signs of power: a tall white man standing over and shouting at a small black woman who is shouting back. It is numbing in its intensity.

The program quickly shifts to its playful distance. Bey takes the

belligerent woman by the hand and turns her over to a group of bare-chested "pumped" cops (a combination of two gay icons: the Chippendales meet the Village People) who handcuff her. The woman bubbles with enthusiasm, "Hoooo, I am going be *bad*!!!" to the soundtrack from *Dragnet*. Being *bad* is reduced to a joke and the orienting boundaries of social morality are gone. It is all ultimately theater, whether street or talk show. The program culminates in the appearance of Gilda Carle, the popular therapist from the issue-oriented talk shows. She wears a spandex-and-Mylar outfit, draped on the Chippendale cops. Introduced as the new "MTV therapist," she mugs for the camera and generally overacts. TV therapy has been reduced to nothing more than a "performance."

Conclusion

The *Richard Bey Show* is perhaps the most "notorious" for the excessive irony that pervades the new talk shows, but it does represent clearly the tension between content and style for the newer generation of talk. In many ways it can be read as a celebration of outlaw culture: gay, black, and/or female. None of the shows is as simplistic or mindless as the established press says. They may be amoral, but their tone, political point of view, and style are vertiginous and contradictory. At their worst, they exploit and inure people to social injustice. But at their best, they offer, at last, an active, even aggressive, in-your-face identity to people who have been represented either as victims or perverts by the dominant culture.

On one level, this argument supports a classic reading in cultural studies: the carnivalesque. Through their emphasis on the physical excesses and scandal, and in their offensiveness to the status quo, the shows reproduce much of the same liberatory pleasures that carnival provided in the world of Rabelais. Mikhail Bakhtin writes: "Carnival celebrated the temporary liberation from the prevailing truth of the established order: it marked the suspension of all hierarchical rank, norms, and prohibitions."[67] Umberto Eco cautions that such rule breaking could also be a form of "authorized transgression," that although comedy is built around breaking rules, the rules are always in the background: "Our pleasure is a mixed one because we enjoy not only the breaking of the rule, but also the disgrace of an animal-like individual [the transgressor]."[68] The new talk shows repeat this form of law enforcement because we are able to play out our transgressive desires through identification with this "low" culture of the shows' guests without ever having to leave our orderly complacent world.

CONCLUSION
The Inconclusive Audience

Finally, what we are talking about is human dignity, the dignity of God's greatest creation—and whether or not we still believe in it.

> William Bennett, former U.S. Secretary of Education,
> October 26, 1995

The new talk shows trick viewers into believing they are watching real emotions in action. They trick the guests with the belief that life's problems can be solved in one public hour.

> Ellen Goodman, *Boston Globe*, March 16, 1995

When it comes right down to it, a [talk show] is just about human interest stories which are about human behavior . . . about people. It's not a high intellectual level, but it is just about everyday lives.

> Talk show viewer, April 29, 1995

◈

I walked into a sterile waiting room of the radiology department of my health maintenance organization. There sat five women in hospital gowns nervously reading and glancing at a *Gordon Elliott* program on men who liked big-breasted women. Black, brown, and white and ranging in age, they laughed, groaned, and shook their heads. I thought they had to be typical of the audience that talk shows create, so I asked, nodding over at the TV screen, "Don't you think that guy is a jerk?" Several murmured yes, but that was it. There was no other interaction. I realized then that the audience I had visualized would not be easy to define or reach, let alone create.

Implicit in the anger of the press and William Bennett—one of the prime movers in Empower America, a conservative think tank—at talk shows are three kinds of people in their audience: "cry babies," "perverts," and/or "dumb people." I have also been told during my research that they

are "babbling idiots," "emotional cripples," "housewives with nothing else to do," "psychopaths," and "the mindless underclass," among other things. (I often wonder what that makes me, as a viewer of and writer about them; a "very sick psychopath"?) In most instances the descriptors did not spring from knowledge of the viewers, let alone of the genre. Rarely was there a positive generalization. Even the shows' fans rush to defend their tastes by separating themselves from the figurative "trash" viewer. Who is the mysterious and often maligned talk show viewer?

This chapter explores how the "actual" viewer understands and uses talk shows. Such exploration involves a translation process that requires what Renato Rosaldo describes as understanding "other forms of life in their own terms."[1] On one hand, as a talk show viewer, I am part of the form of life I seek to understand. But on the other hand, my "terms" are not those of the typical viewer. My middle-class status and education set me apart. But why should they? I have talked to hundreds of viewers in the past three years. Yet my attempt to bridge the gap between the constructed viewer (an individual produced by the show, the industry, and the interpretative process) and the actual viewer has been fraught with pitfalls. Nevertheless, I believe there is community of talk show viewers, but it is not a subcultural fan community. Rather, it is defined by citizenship and the right to speak out. Hence this chapter is a meditative study on the complexity of trying to know and generalize about what the talk show viewer thinks.

In a comparable study on soap operas in 1985, Robert Allen was skeptical as to whether we could know how the viewers "engaged" TV in the *real world*. He argued that an adequate methodology did not exist. He ended his work with a series of questions for future media researchers to solve the theoretical problems involved in audience research, questions I want to address:

1. What is the extent of the determination of meaning exercised by the text itself?
2. What forces condition the activations of texts within individual readers and among groups of readers?
3. What levels of the reading process are available to empirical investigation and what methods are appropriate to that study?
4. What is the role of the investigator vis-à-vis both the text he or she wishes to study and the reader who consumes the text?
5. What is the epistemological status of articulated responses of readers in understanding the relationships between reader, text, and institutions?[2]

In the past ten years audience research has become much more sophisticated as cultural studies has supplemented the statistics of quantitative or content analysis through ethnographic and textual studies, revealing the rich and active relationship that viewers have with television.[3]

In reference to Allen's fourth question, I want to raise the thorny issue of how educational cultural competence and the cultural class system impact audience research. Central to many of the "educated" assumptions about talk show viewers is that they lack the intellectual skills and moral training to judge the content of a show with any critical or intellectual distance. What underlines the Empower America campaign is the fear that talk shows are creating a generation lacking in morality. What underlines the outrage of the *New York Times* critics cited in chapter 4 is that the shows are "dumbing" Americans away from the standards set by middle-class education standards.

Sociologist Pierre Bourdieu argues that there are differentially acquired competences that are hierarchically ordered as cultural capital: the power to define what is a "sophisticated" or "proper" response and its opposite.[4] Much of the hierarchy is determined by education and by economic-class origin (which determines the kind of education an individual receives). The construction of Bennett's and the journalists' talk show viewer is based on the priorities of their cultural training. Their arguments are steeped in class-based agendas about what constitutes acceptable culture. However, there still remains a huge disparity between the cultural situation of a lower-class viewer and even a sympathetic academic researcher: language, attitudes, and class and race antagonisms. To carry out the research I employed three research methodologies: surveys, ethnographic interviews, and analysis of fan writings. Each reveals information but also the problems of traversing differences in cultural competences.

Surveying Viewers at Boston Hospitals

The survey—a questionnaire—served as the empirical foundation of the study. Similar to industry audience research, the quantitative analysis results in a narrow statistical understanding of the viewing process. I constructed a survey that would disclose the viewing practices of talk show viewers: how much they watched, what they watched, how they watched, and with whom they discussed what they had watched. I also asked three other questions requiring open-ended responses to provide the beginnings of a picture of the reception process. Respondents were also requested to provide a socio-economic profile (race, age, occupation, gender).

I chose to carry out my research in an area where there were clear

divisions in education and income level: the cafeterias of two major research hospitals in Boston (City Hospital, affiliated with Boston University Medical School, and Brigham and Women's Hospital, affiliated with Harvard University Medical School). They are sites where unskilled workers, skilled professionals, and visitors mingle daily. Admittedly, the sites skewed my sample toward working and educated people in the health care field which does not fit the industry demographics of a lower-income housewife/mother employed at home. However, the cafeterias allowed access to a general cross-section of people in a relaxed environment who would take time to write answers to the more subjective questions. I could not get the same attention level in any other public area, such as shopping malls, sporting events, or exercise clubs. The research took place in March 1995.

Backed with a sign stating our project, my research assistant, Sara Beechner, and I addressed persons as they entered the cafeteria: "Do you watch talk shows? We would like to know." We netted 118 responses from "regular" watchers. Many of them chose to respond only to some questions; hence, the sample is not statistically representative of a larger audience. But the survey does reveal some significant themes and patterns among the group. What follows is a general quantitative summary, by Beechner and me, of the responses to the self-selected questions.

Socio-economic Characteristics of Respondents

Seventy-nine women and 32 men answered the questionnaire, numbers that correspond to the talk show demographics reported by the TV industry in 1995 (see chapter 3). Of the women, 64 percent were between twenty-one and forty years old and college-educated; 59.9 percent were white and 27 percent were black; 5 were Hispanic; 2 Native American; and 1 Asian. The men were primarily between twenty-one and fifty years old, and less educated than the women—fewer than one-third were college-educated. Twenty-one were white; 9 black; 2, Hispanic. Nursing was the occupation of 26 respondents, with social work, hospital administration, and medical technology following in descending order. One-third of the respondents chose not to disclose race and occupation.

Favorite Talk Show and Frequency of Viewing

Oprah was the overwhelming favorite: 40 votes. *Ricki Lake* received 20; *Jerry Springer*, 17; *Montel Williams*, 10; *Donahue*, 6; and *Jenny Jones*, *Sally*, *Gordon Elliott*, and *Geraldo*, 5 or fewer.

The reasons given for liking a particular show made apparent a difference between the two generations of talk shows. *Oprah* and *Donahue*

fans used the following descriptions: "informative" (the most common response); "class"; "consumer awareness"; "political"; "compassionate;" "intellectual"; "less trashy"; "balance between serious issues and entertainment"; "role models"; "treats guests with dignity"; "does not provoke"; "does not exploit"; "less freaks"; "a little more sane"; "helps people"; "uplift message"; "high road"; "down to earth"; and "sincere."

Contrastingly, fans of the newer generation (for example, *Ricki Lake* and *Jerry Springer*) cited these reasons: "many fights and arguments"; "sleazy"; "lively"; "culturally diverse"; "topics other hosts don't address"; "they be buggin out, fighting, hey it's entertainment"; "wild and crazy topics"; "confrontational topics"; "mindless viewing, entertaining"; "good way to relax after work"; "because Oprah has become so stuck up"; "'real life' circumstances"; "audience"; "show are the edge"; and "funny." The descriptor "compassionate" was applied to *Jerry Springer* and *Montel Williams* 4 times, and to *Oprah* 6 times. As whole, the responses marked the two generations of shows along a series of binary oppositions: edifying/fun, serious/fun, tasteful/sleazy, intellectual/mindless, ethical/edgy, political/entertaining.

Frequent viewers of talk shows (four or more times a week) tended to watch *Ricki* (16 respondents), *Montel Williams* (13), and *Jerry Springer* (13). Nine respondents watched *Gordon Elliott* or *Oprah* four or more times a week. It is a solid pattern of greater regular viewing of post-1990 shows.

There is a much different pattern, however, for viewers who watch once a week: identity politics shows are more popular. *Oprah* is the overall favorite (34 respondents), with *Donahue* (28), *Geraldo* (22), *Ricki Lake* (20), and *Sally* (17) runner-ups.

To a degree, this pattern can be accounted to name recognition. Frequent watchers are better acquainted with the newer and more numerous shows and accordingly list them more often. The shows that premiered in the 1980s are easily recognized and remembered. However, when age and education/professional level are coordinated, one sees that, indeed, the infrequent viewer of the identity politics programs tends to be older and more educated. Additionally, the working-class respondents (particularly those on the night shift at the hospitals) had greater access to daytime programming than the nine-to-five white-collar workers, although a number told us they used late-night rebroadcasts to unwind.

The Community of Talk Show Viewers

The majority (95 percent) of the sample watches talk shows at home. The minority watch at exercise clubs, bars, or at work in a fragmentary way ("unofficially") all day long in patients' rooms. Although the shows

are ever present for most people in a hospital, three-fourths of the respondents talked primarily to their friends about the shows and mostly (97.6 percent) at home. Just over half talk to coworkers and/or their families about the programs. Almost 15 percent talk to children about talk shows.

Only 15 respondents watch talk shows in a concentrated manner; viewing is combined with other activities. The majority of the respondents tended to do household chores, such as cleaning and laundry (28), or to cook and eat (28). Interestingly, 13 said that they alternate between reading and watching. Other respondents mentioned that they: exercise (7); talk on the telephone (5); work (5); do homework (4); babysit (4); and sew or knit (3).

Several interpretations of this way of TV viewing are possible. First, dual-activity viewing supports the argument that talk shows do not draw the usual "fan" behavior of fixed concentration on the nuanced details of a linear narrative characteristic of much prime time TV. Second, dual-activity viewing suggests that daytime TV has a specific characteristic that permits divided attention; indeed, research on soap opera viewers reveals the same behavior.[5] Third, David Morley suggests in *Family Television* that this style of viewing may be due to gender differences. Women see TV as fundamentally a "social activity": it involves "ongoing conversation, and usually the performance of at least one other activity (ironing, etc.) at the same time," whereas men tend to watch TV in a fixed, uninterrupted manner.[6] And last, talk show features—short segments, strong aural cues, and quick conflicts—accommodate the fragmented watching suited to daytime home schedules.

The Social/Personal Role of Talk Shows in Viewers' Lives

The questionnaire had only three questions that asked for subjective responses, which, it was hoped, would afford a broad sense of how the talk shows fit into the respondents' personal and social lives. The answers appear as written.

The first open-ended question, "Would you describe one of the most memorable episodes of your favorite talk shows?" was answered by 75 people. *Oprah* overwhelmingly evoked the most descriptions (26), followed by *Ricki Lake* (13), *Jerry Springer* (10), *Montel Williams* (7), *Jenny Jones* (5), and four other programs each evoked 3 or fewer descriptions. Moral uplift programs vied equally with programs of staged interpersonal confrontations for the strongest memories. Of the positive programs, family reunion and fashion makeover were the most-cited categories. Single programs with an uplift message were about "random acts of kindness," "Oprah's 40th Birthday," "saving kids," and "giving kids their wishes." Two

people liked the *Jerry Springer* "final thought" because "he teaches."

Of the confrontational category, programs with sexual conflict were the most memorable (13 descriptions); for example, respondents wrote of programs where "virgins confronted the people they wanted to be their first"; "'Look at me now and you will never be able to have me *again*'"; "women who 'dog' their men"; "a girl who wanted to warn her ex-boyfriend his new girlfriend was a 'dog'"; "I'm sleeping with Your Man and I can Do It *Again*"; "This guy was cheating on his wife with her aunt and her niece"; and "I have two girls pregnant at the same time." Interestingly, *Geraldo* and *Jerry Springer* were singled out for memorable physical confrontations (4 descriptions), particularly the famous "chair incident" on *Geraldo* in 1987, spoken of by two respondents.

Significantly, those who remembered interpersonal themes were balanced by 31 respondents who remembered programs that they described in the language of social or even public sphere issues. Five wrote of programs involving the "KKK," "skinheads," or "racism"; 5 of "AIDS" or "homophobia" programs; and 3 of "sexual abuse," "date rape," or "domestic violence" programs. Typical of stated topics were: "affirmative action"; "anorexic females"; "adult children of alcoholics"; "teen gangs"; "religious fanatics"; and "obesity." The fact that the survey was made in research hospitals most likely skewed answers toward health care and social issues.

The second question that entailed a subjective response was "Have any particular talk shows affected your personal life? Please describe the episode." Most respondents (82.1 percent) answered in the negative; seventeen believed a particular program had significantly affected them. One cohort among the seventeen comprises respondents who had an experience similar to the program topic. Three examples:

- "A program on family sexual abuse. It brought back an episode that happened to me."

- "A episode of a facially disfigured person. I have a son with this problem. The show was full of advice, gave telephone #s of drs. and support people."

- "Women who find out their husbands were gay. I had a similar experience."

Some gave one-word answers—"depression," "child safety," "relationships"—from which one can infer an issue had relevance to the respondent's life.

A cohort comprised viewers prodded into action by a program. Four examples:

- "Oprah really made my husband and I think about saving money verses spending. We already have IRAs, 401K, etc. . . . but we can do better!"

- "Once on Sally they had a show on adoption and. . . [illegible]. So I want to find out who my birth mother was."

- "The show changed my decision on Donating organs."

- "The acts of kindness show described earlier—it just brought to the forefront of my mind how important it is to try to touch people—even strangers in a positive way. Also I realized how much I admire Oprah."

Other answers involved general statements about how a particular program had made a respondent think about the possibility of something happening, such as date rape or a child's injury in the absence of safety precautions. Two replies were that a program had made them feel better about their lives in comparison to those of the program's guests.

The third question requested a subjective response accompanied by its reasoning: "The media often state that talk shows are primarily for women. Do you agree?" To my surprise, 66 people (nearly 65 percent of the respondents) disagreed. Most of those of that opinion believed the shows' topics had relevance for both sexes. The second most common reason supplied was that there were equal numbers of topics for men and women. The third most common was that the respondent knew men who watched the shows and discussed program content. Two other common responses were each offered by four persons: men are at home more these days, and men watch but do not admit it.

Of the 30 who argued with the statement that talk shows are primarily for women, 15 based their stances on program content; 5 described the shows as involving "women's issues"; 4 said that the gender bias was due to the dominance of women guests; 3 suggested that women "enjoy" different subjects than men do (for example, "feelings of the heart"; "gossipy" issues); and 3 male respondents held that the shows are primarily for women because they ridicule men. A totally different group of 11 respondents believed that the shows are for women because women are at home when the shows are aired.

The Angry and Ironic Responses

In general, the respondents—all people who had told Beechner and me they liked talk shows—had responded in all earnestness. But we want to address here fifteen responses and an undercurrent in the language that indicated readings of the shows not based on the industry's openly stated or its preferred meaning of intimacy, compassion, and serious discussion. Rather, there was a series of oppositional readings that took two forms. First, although not common, four respondents watch talk shows because they are drawn to how disgusting the programs are. A female viewer deemed them as being for the "very low class." A male viewer of *Montel Williams, Gordon Elliot,* and *Ricki Lake* declared, "I watch them to see how low the american intellect is sinking and to get a good laugh." A woman who marked that she watches more than ten shows a week wrote, "I truly believe all the hours of air time used for talk shows are wasted on unnecessary topics." One man crossed out the audience participation programs and wrote *"Rush Limbaugh Show"* into every answer, and complained about the bias of the shows and the questionnaire. However, a classic example of this angry attitude was expressed by a man: "I enjoy watching Geraldo because his biased, contorted & occasional hate-mongering inspires me to really think about the *real* issues behind his sensationalism." But as dismissive as these responses are, we need to question whether the shows actually "invite" this kind of reading, given the move in the 1990s to a more campy style. The preferred reading has possibly been shifting across the twenty years of the genre.

· This last reading could also be interpreted as ironic—a more common and related oppositional reading. This kind of viewer watches talk shows in order to laugh at the people involved. The difference in the ironic viewer is that she or he does not take the shows seriously; respondents representatitive of such a viewer tended to be *Ricki Lake, Jerry Springer,* and *Jenny Jones* fans. For them, the shows are entertaining, not socially meaningful. In their reasons for liking the shows (see above section on favorite talk shows), one sees a pattern of socially negative terms expressed positively: "sleazy," "on the edge," "confrontational." Additionally, many of these respondents used quotation marks, underlining, or ellipsis points to reveal their self-consciousness about their pleasure. Typical is the man who wrote about his most memorable program: the former boyfriend was dating a "dog" (his quotation marks). A woman chose to underline "again" three times when she wrote about her most memorable episode, "I'm sleeping with your man and I can do it *again*." Four respondents put quotation marks around "real life" or "new ideas" when discussing why they

liked *Ricki Lake*. As one man wrote, "'I do it for the laughs'." Three-fourths of the ironic readers were men, and all tended to be college-educated professionals (if one can even trust the "truth" of their other answers). Ien Ang points to a similar ironic reading of *Dallas*, arguing that "ironizing viewers therefore do not take the text as it presents itself, but invert its preferred meaning through their ironic commentary."[7] Yet in the case of the newer talk shows, this ironic reading may be the preferred meaning, in that the form has become so self-conscious that it overwhelms the pretensions to realism (see chapter 6).

A Qualitative Discussion of the Questionnaire Results

Based on this sample, there is a clear generational split in viewer age and interest between talk shows premiering before and after 1991. *Oprah* and *Donahue* viewers (66 percent) tended to be more than thirty-one years old, watched less frequently, and sought less confrontational and more edifying topics. The majority of viewers for *Ricki Lake*–style shows were under thirty-one and viewed more frequently. They enjoyed the confrontation and sexual topics, but many were often aware of the shows' antisocial or ironic potential.

I am aware that this summary does not do justice to the complexity of the content of answers and the diverse ways in which the respondents expressed their experience of talk shows in writing and abbreviated conversations. Here, I want to address Allen's question about the levels of the reading process available to empirical investigation and methods appropriate to such study. My discussion of these viewers results from tabulating instances of similar content in their responses, a procedure that forces their expressed ideas into preconceived categories—ones determined by culturally current discourses such as generational split, irony, and gendered readings. This is not to say that the tabulations have no value; they offer a bare-bones analysis of cultural patterns. In his study of the audience of the *Cosby Show*, Justin Lewis cautions: "While we cannot reduce notions like 'popular' or 'dominant ideology' to a precise numerical formula, we cannot disregard the proportion of people involved."[8] Even so, the method cannot get at the intricacy of cultural context. For example, the fact that the majority of respondents believe that talk shows as a genre are not directed to women in particular goes against the grain of this book's argument. The majority wrote that the shows' topics are either gender neutral or directed equally to each sex. Interestingly, this finding ran counter to the fact that the overwhelming interest in participating in the survey was expressed by the females among the hospital workers interviewed about TV viewing habits; three-fourths of the sample was women.

Several built-in biases in the study eventuated in women being the more numerous respondent cohort. First, the survey took place at hospitals, where the lion's share of staffing is female. Second, the fact that the two researchers (Sarah Beechner and Jane Shattuc) were women most likely affected who was comfortable about addressing us and our survey. It might also have affected the racial mix; we are both white. Historical context also needs to be taken into consideration. The 1995 survey took place after *Ricki Lake* (premiered in 1993) had substantially shifted the demographic pull of talk shows toward youth and men; gender divisions had started to blur. In fact, in the survey, *Oprah* viewers answered twice as often that talk shows are directed to women than *Ricki Lake* fans, who saw the shows as gender neutral.

Another important issue in this quantitative research: the pool of respondents is more educated and sophisticated than the average projected by the TV industry. According to the Boston demographics provided by the local ABC affiliate, the average talk show viewer has less than two years of higher education and a majority have not graduated from high school. As stated earlier the pragmatic choice of hospital cafeterias as the research sites created this bias. However, our sample of educated respondents was biased toward a part of the middle class who have lower-level degrees, such as a bachelor of arts and of science degrees, and professional master's degrees, such as in nursing, social work, and hospital administration. Many of them represent a middlebrow cultural class, which Bourdieu asserts embraces a "popular aesthetic" that is "based on the affirmation of the continuity between life and art, which implies the subordination of form to function, or one might say, on a refusal of the refusal which is the starting point of the high aesthetic, i.e., the clear cut separation of ordinary dispositions from the specifically aesthetic disposition."[9] In other words, we located a sample of viewers attracted to the way talk shows relate culture to everyday life. In particular, many of our respondents spoke of the shows' therapeutic value—social theory is given a practical, albeit sensationalistic, application.

What the survey of middle-class viewers does undercut is the cultural assumption that talk shows attract only an uneducated and unemployed viewership: the lower class. In fact, the respondents reveal that viewers watch the shows either as a serious form of edification or as a form of entertainment, often with an ironic understanding. And many of these "educated" people watch the shows quite often.

The most important issue that the quantitative results elide is the social dynamics of conducting the survey. In the process of carrying out our survey, we received two types of reactions from nonparticipants. The first

type came primarily from doctors who were openly annoyed that we would ask if they watched talk shows. The annoyance was especially strong from male physicians at Brigham and Women's Hospital—one of the world's top research hospitals. In the process of thirty hours of seeking participants, our question was met repeatedly with the rejoinder "Not if I can help it." Often we were dismissed with a shake of the head or a grimace. Talk shows appeared to be some plague they preferred to avoid. In fact, the few who did speak to us said they listened only to classical music at home. Given our interest in talk shows, two physicians seemed to assume that such music was beyond our ken and identified Mozart, Chopin, and Mahler for us.

We have never felt the cultural divide between popular and elite tastes was so great as we did at Brigham and Women's Hospital. One does not expect a universal similarity, but the refusal even to enter into a dialogue is representative of how the elite classes maintain their power through naturalized or unquestioned notions of taste. As Bourdieu argues:

> The definition of cultural nobility is the stake in a struggle which has gone on unceasingly, from the seventeenth century to the present day, between groups differing in their ideas of culture and of the legitimate relation to culture and to works of art, and therefore differing in the conditions of acquisition of which these dispositions are the product.[10]

Perhaps, some unconscious need to test these four-hundred-year-old cultural divisions had led us to carry out our research on talk shows where we did. Although popular entertainment has broken many of the cultural divisions, the system is still clearly maintained between high and low culture and the upper and lower classes.

We discovered yet another category of nonparticipants by surveying in hospital cafeterias: the nonliterate worker. It was not the site but rather the medium of the written survey that warded off many potential participants. Cafeteria and maintenance workers at first greeted us with a shy respect that later turned into outright friendliness. More than twenty people told us that English was their second language and they were not up to participating. A number of people began to answer the questions and then gave up. But every one of them mentioned watching "Ricki" or "Oprah." Often they would laugh and say, for example, "Oh, that Ricki. . . . !!!" or mention "those crazy people."

The problem of literacy brings us to our final point about the limits of quantitative research. If talk shows are popular culture and hence appeal to

people in the lower class (a class many shows seek to empower), such people are not the ones who are typically studied by researchers; there are not only literacy and language problems but cultural problems. More than forty individuals fell into this category in our research; we offered to sit down and talk to many at work or to visit them at home. Each offer met with resistance. Research was not something with which they were comfortable.

Here, we return to Robert Allen's last two questions: What is the role of the investigator vis-à-vis both the text he or she wishes to study and the reader who consumes the text? And, what is the epistemological status of articulated responses of readers in understanding the relationships between reader, text, and institutions? From our conversations with these informally educated, nonliterate workers, we ascertained that their methods of engaging with talk shows are not what researchers typically value. They do not follow the shows in their entirety because of language limitations and domestic lifestyle, but because of the shows' broad presentation and universal content they find the shows attractive. They can follow such programming better than much of prime-time programming. Their watching is also fragmented in light of child-care responsibilities, cooking, and "work" at home. They spoke of the guests in rather coarse or "impolite" stereotypes ("bitch," "ho," "nigger"), which somewhat discomfited us middle-class liberal-minded academics. We felt the cultural divide again, caught in the prison of not only class but language differences. We searched for a way to follow Rosaldo's dictum "to understand other forms of life in their own terms." We recognize that the differences are not as great as anthropologists find in tribal societies, but even with television viewers, it is easier said than done to understand the viewing experience of others "in their terms."

The Ethnographic Study:
A Discussion Group on Talk Shows

The survey was initially conceived with the central hope of constructing discussion groups around watching a talk show. Each questionnaire ended with the question: "Would you be willing to participate in a one-time discussion group to talk about television talk shows?" Twenty-eight women and fourteen men were willing.

Ethnographic studies, or participant observation, are usually how academics have overcome the epistemological problem of different ways of experiencing culture. Recognizing the problems of distance and objectivity in research, the researcher enters the viewer's experience to form an alliance to talk about the program together. Often academics write about

viewer communities of which they are a part, such as gay and women's fan groups such as Gayllactica and soap opera viewers. One of the strongest advocates of participatory research, Henry Jenkins, argues against the all-encompassing method: "[E]ach vantage point brings with it both advantages and limitations, facilitating some types of understanding while blinding us to others." However, he champions the sophistication of ethnography: "The result is a shift away from totalizing accounts of social and cultural processes toward partial, particularized, and contingent accounts of specific encounters within and between cultures."[11]

Of the 42 respondents who wished to be contacted, nine agreed to come to a scheduled discussion. Of those who agreed to particular time and place, only four actually came. Although we could have been more aggressive (and intrusive) about securing fuller participation, the attrition reveals a very different notion of community among talk show viewers than among soap opera, science fiction and Madonna fans. Not only do talk show viewers not pursue public venues for discussions (conventions, fanzines, or clubs), they primarily experience the shows alone—at best within the family. The image we see of sororal solidarity in the studio audience is played out in a much more abstract way at home, closer to the concept of the individual's right to speak out than the collective activity of a community. However, this is a powerful political change for the woman viewer, who sees as a right talking back to the TV set. The following analysis of women who "spoke out" to us is in line with Allen's query about "the epistemological status of articulated responses of readers in understanding the relationships between reader, text, and institutions" of group discussions for talk show research.

The "Quality" Discussion

Our first of two discussions involved all white women in the middle or professional class on April 29, 1995: Pat, a social worker in her thirties; Lorene, a research scientist in her thirties; Pat's daughter, Jennifer, a junior high school teenager; Sara, a graduate student and researcher in her mid-twenties; and Jane, a professor and researcher in her thirties—all live in the Boston area. Given the women's socio-economic similarity, they "hit it off" and talked non-stop for three hours. Here is an abbreviated account of the most salient moments.

Pat and Jennifer immediately revealed a humorous familial split as Jennifer announced her devotion to *Ricki Lake* and her pleasure in the "fights on stage." She thought the show "real funny." Pat declared that she "absolutely did not" watch that kind of show. She watched *Oprah* regularly "to be informed," but slowly admitted watching the more

"sensational" shows sometimes for "voyeuristic" reasons.

While Pat was cooking and watching *Oprah*, Jennifer used the time to watch *Ricki Lake* and bond with her father, who also watched the show. She said that she and her father would talk about it together. She mimicked her father in a theatrical male voice: "The only reason I watch talk shows is these people are so stupid."

Contrastingly, Lorene, who is single, watches her favorite, *Sally*, alone. She had a girlfriend she used to talk to about the show, but more often she tells her lab coworkers. Lorene acknowledged that *Sally* is "sensational" but argued the host is "sincere." "When it comes right down to it, a [talk show] is just about human interest stories which are about human behavior . . . about people. It's not a high intellectual level, but it is just about everyday lives." She said that she often "connects" or "identifies" with issues presented, and compared talk shows to "group therapy sessions" and "anthropological study." Remembering a program on "normal people who married dwarves," she laughed and admitted that she liked the mixture of sensationalism and information. For her, "people are too fast to trash them because that's the cool way to deal with them."

Both Pat and Lorene were conscious of the social contradictions in their liking talk shows, and discussed their rebellious awareness that they should be "embarrassed" to admit to it. Lorene: "I know what they are probably thinking and I know what opinion they are forming immediately. I really don't care. They are too closed-minded." Pat said she was "not at all embarrassed," likening the experience to those who say they do not read the *National Enquirer*: "Everyone reads the *Enquirer*, even if they buy it or not. But who will admit that they read it or buy it? Admitting that you enjoy it to people [reveals] that you are not very bright." What differs here with the usual middle-class discussions of enjoying popular culture is that the women did not feel that need to apologize or distance themselves from their enjoyment through ironizing the experience. Even Jennifer described how her friends just "get into it"—"laughing" and "talking" on the telephone about *Ricki Lake*. She felt the show itself encourages her joking relationship. Ien Ang found similar defensive strategies among *Dallas* viewers who sought to legitimize their viewing, and who also revealed a consciousness of the ideology of mass culture that sought to denigrate them.[12] But each set of fans has a difficult time negotiating "love" of a program and an awareness of cultural criticism of such fannish behavior. For Pat, a talk show viewer, such a contradictory position emanates from the difference between the public person who is forced to denounce the shows and the private person who desires the pleasures to be derived therefrom.

A discussion of Winfrey's success revealed belief in the talk show as "truth." The three respondents agreed about the genuineness and trust Winfrey evokes, characterizing her as "herself," "down to earth," and "a regular person" who "did not boost her ratings" by doing inauthentic programs. Even so, Lorene applauded her "skill." The program on Prozac (see chapter 5), convinced them that Winfrey is the most trustworthy on the pros and cons of taking Prozac ("certainly not the psychologists," announced Pat). In comparison, Joan Lunden of *Good Morning America* is a "distant" host. Geraldo is considered "arrogant." Pat commented that if Morton Downey Jr. were in the room, she would run out. Here it is Winfrey's projection of closeness, humility, and sincerity that allows the women to trust the values promoted by her show.

Interestingly, the two women and the teenager were more critical of the authenticity of the guests. Pat's criterion for judging the authenticity of someone on a talk show is "secondary gain." If she senses an ulterior motive, her trust in them dissipates. Guests who are flown to the big city and are provided hotel accommodations have something to gain other than an opportunity to tell their stories. On the whole, guests are suspect; *Ricki Lake*'s guests are beyond the pale.

The studio audience stands up better than guests in terms of believability. Lorene ventured that the audience was there to provide "a variety of opinions," ultimately, it "is supposed to be us." The women in the audience on the Prozac program were seen as completely "genuine" because they spoke their feelings directly. Lorene adds an important criterion: complexity of the life story, "the good with the bad." It gives the account wider applicability: "What happened to me could happen to you." The three women were astounded when I disclosed that *Oprah* monitored questions during the segment breaks; they felt tricked, their trust had been broken.

The discussion provided a much more complex and thoughtful sense of how viewers use talk shows than did the survey results. None of the women (not even the teenager) were uncritical of talk shows' motives. Only in the case of a singular belief in the authenticity of Winfrey and her motives did I sense any "belief" in the ideology of a show. Rather, they negotiated the move from certainty that the shows offer information and help to an awareness of their use of manipulative sensationalism. Additionally, the women had a conceptual understanding of the studio audience as a substitute for the home audience, as well as anger at the control the shows attempt to exert over the viewer through through the negative cultural categories of sensationalism and trash.

The "Problematic" Discussion

The above discussion was admittedly as ideal as it was troublesome. It involved four white, well-educated adult women and one similar teenager speaking about their lives, using the language and assumptions of their middle class existence. Interwoven in the conversation were ideas about personal expression, social responsibility, symbolic representation, and women's rights—all ideas associated with the rights and rituals of the American middle class. In fact, the women were rather color blind in that they argued that Winfrey's reception has nothing to do with her race.

In fact, I argue that the majority of people who did not show up as promised for the discussion groups were unmotivated to participate partly because of class differences. I offered no monetary incentive. The idea of being "immortalized" in an academic book was not attractive. (We tried this tactic on the telephone.) Nor was the noble act of contributing to knowledge important. Talk show viewers do not have the power of community as subcultural outsiders or afficionados of complex narratives that bring science fiction and soap opera fans together. Rather, they are caught in the tension between bourgeois notions of the social good (therapy, identity politics, and muckraking) and the subcultural unofficial culture (sensationalism, bad taste, and outlaw behavior). Neither part coalesces into a confirmed comfortable following.

Even more frustrating is the fact that when cultural studies does ethnographic studies of complex readings by fans and viewers, the subjects tend to be from the educated bourgeoisie. Henry Jenkins readily admits that the sophisticated fans described in his book come out of his participatory community, which happens to be white and educated.[13] Although soap opera fan studies often involve viewers who cut across class, the issues of how class and race determine who speaks and how they speak are not addressed. There are ethnographic studies that factor in race and class with varying degrees of success.[14] Researchers who openly acknowledge race and class split along lines of those who come from the community they research and those who believe they can overcome the differences. How can research cut across cultural divides to create a notion of social community yet retain a concept of social difference?

To complete this point I would like to chronicle the pitfalls of our second group or a problematic discussion with a single, working-class participant. Sari, a white woman in her thirties, an assistant clerk in one of the hospitals, was the only one to arrive for her group. She had written in the questionnaire that a *Sally* program had motivated her to look for her birth mother. So I chose to "create" a discussion with her alone. The difficulty

with the interview was that she did not speak the middle-class language of talk shows that has been central to this book's argument. Whether she was additionally discomfited by a discussion with the two researchers or by being in a college conference room in the wealthy Back Bay of Boston, I cannot prove.

Sari gave short abbreviated answers and laughed nervously throughout the discussion. We learned that she watched talk shows alone and sometimes called a friend to discuss them. When asked why she enjoyed talk shows, she answered "feedback." When I asked what kind of feedback, she looked more nervous. I tried to help: "Feedback from the audience?" Her yes came quickly. When I asked if she used talk shows in her life, she said no and made no attempt to say more. She offered some potentially interesting comments about talk shows being like soap operas, women fantasizing because of talk shows, and audiences overdoing "it a bit" in reacting to programs. But whenever I asked her expand on the comments, she would not speak or would not stick to an idea. The interview slowly became my trying to get her to speak my language about the "social good," "Oprah's role as a black," or what the host "represents." It came back simply, "Oprah is everybody."

I am not making a case that this is somehow "typical" of a discussion about the media between a working class person and a middle-class academic. Rather, I want to point out my difficulty as a researcher in accepting her ideas "in their own terms." Some might argue that she just had an understanding more simplistic than mine. But as an anthropological researcher, I needed to capture her world in her language. I could not. I had my own discursive academic agenda full of symbolism, social divisions, and political values. Even with the more educated women, I felt the barrier as I drew blanks when I asked about the symbolic role of the audience or the "construction" of the host.

Ellen Seiter speaks of a similar problem with a "troubling interview" in which a lower-middle-class man gave negative responses about soap operas, guided more by what he thought academics wanted to hear than by his own experiences. She sees the problem as based in "antagonistic differences based on hierarchically arranged cultural differences" and concludes:

> We must pay more attention to methodology in empirical audience studies, and at the very least describe these methods more fully. But the problems will not disappear by adopting a more "correct" method of interviewing. The social identities of academic researchers and the social identities of our TV viewing subjects are not only different, they are differently valued.[15]

Although I think that the gulf is often quite large between academics and the public, I do share some fundamental similarities in my understanding of TV with other viewers. Here we need to recast the image of the talk show viewer as sensation-seeking social misfit whether it be in the *New York Times* or in the language of the Empower America campaign. Rather, we should examine the class antagonisms and a battle to define culture. That language seeks to divide the classes according to a self-aggrandizing hierarchy of tastes and behavior. Academics need to reveal that cultural divisions in viewing talk shows are not so rigid and also not clearly divided along simple binaries such as moral and amoral or intelligent and stupid understandings.

Talk Show Bulletin Boards on America Online: Viewers on Their Own Terms

One of the few places that talk show viewers congregate as a potential community is in the "virtual reality" of Internet bulletin boards—areas where viewers can write to and about the program. They often serve as sites for viewer discussions about the programs. Computer-mediated communication is the new frontier of audience and community research.[16] In 1995, America Online (AOL) was host to three commercial bulletin boards for viewer messages about talk shows: *Ricki Lake, Geraldo*, and *Oprah*. Because of the shows' propensity to copycat topics, the online discussions allow us to compare the differences in viewer responses to a social issue between the older and newer shows. Computer communication has allowed a noticeably different viewer attitude toward the shows to surface. In the absence of the control exerted by the shows, these viewers are not only more critical of the topics but often discuss them in more overt social-sphere terms. And most important, women can often dominate these discussions because of the conventions women carry over from the shows.

I want to isolate an online viewer discussion about teenage pregnancies that went on in 1995 when *Geraldo* aired the program "Teenage Baby Factories" (April 27, 1995) and *Ricki Lake* aired "Kids Having Babies" (August 8, 1995). Both online discussions were driven by teenage mothers. The *Ricki Lake* discussants spoke in the present tense about the deep immediacy of the experience; the *Geraldo* discussants, who had been teenage mothers, drew on their adult distance from the earlier experience and offered "informed" and world-weary advice. The exchanges revealed how social debates are rewritten when the personal becomes political and the "victims" have the tools to speak publicly.

Bulletin boards are part of larger talk show sites on America Online that serve as advertisements for the shows. Much like the *Geraldo* site, the *Ricki Lake* site allows the viewer to pick: "Suggest a Topic"; "Upcoming Topic"; "Be on the Show"; "About the Show"; "Press"; "Order Tickets"; and "Message Board." *Oprah Online* distinguishes itself by being self-help and even more commercially oriented; users/viewers can pick from these additional features: "Our Family"; "Polls and Contests"; "Remember When . . ." (updates on old guests); "About the Show"; "Helpline" (social agencies for help); "The Book Nook" (self-help and celebrity books); "The Oprah Boutique" (show merchandise for sale); and "Share Your Thoughts" (a chat room devoted to the program of the day). All the sites enable a sense of user interaction because of the activities available, and often appear to allow the viewer a "voice" in the making of the show. However, the majority function as places to post messages that, at best, other users read.

Because AOL is a subscription service, most users access it through their own telephone lines, which necessitates a relatively sophisticated computer with a hard drive and a modem and the ability to pay the hourly online rate. The specialized knowledge of how to use a computer and go on the Internet creates social division in access to online talk show discussion groups. According to a 1995 AOL publication, 79 percent of AOL users were men, and their average age was forty. Fifty-six percent of AOL subscribers earned more than $50,000 annually; 88 percent had attended college; 65 percent had a college or professional degree.[17] The online-service demographics stood in stark contrast to the demographics of the lower-class homebound women who watch talk shows.

Nevertheless, given the American propensity for consumerism and hands-on use of technology, online users were not limited to the highly educated and wealthy. (I had been participating in the online talk show discussions for over a year.) Online service began for *Geraldo* in October 1993 and *Ricki Lake* in July 1995, and in my more than one year of participating I have seen a range of socio-economic positions professed, from being on welfare or unemployed to being a lawyer or doctor. There was also a range in written literacy that revealed great differences in education levels. Much of the discussion was replete with illiteracy and angry discontent. But use of the board still assumed a primarily written literacy-based culture as opposed to the orally and visually based cultures of those who are attracted to talk shows. Because of the anonymity of bulletin board use, it was difficult to gauge whether the dominance of women as the viewers of talk shows affected the boards' gender ratio.

Discussants for *Geraldo* announced their race and sexual orientation more than do those for *Ricki Lake*, but such announcements were

infrequent. Yet as a whole, *Geraldo*'s viewers were more conscious of their social positioning than *Ricki Lake*'s viewers in that the former address related issues more openly. The talk show discussion groups were attractive to nonformally educated people because of accessibility on a broadcast medium, the generic ritual of audience feedback, lack of written literacy demands in posting a message, and the anonymity of posting. Online, one could hide one's socio-economic status but be totally open about politics without fear of personal recriminations.

By January 1, 1996, the *Ricki Lake* general board had an aggregate of 803 messages; *Geraldo*'s, 1033; *Oprah Online*'s, 6,804; the numbers could be read and/or reviewed at any time. Online users were not as formally controlled in their discussions as the TV studio audience. One could post whatever one wants, even to the point of racial slurs or highly sexually explicit dialogues (see "Vaginal Piercing" folder, *Geraldo* online). Nevertheless, the participants were generally guided by the conventions of the talk show genre and the belief that the show producers and host read the postings. The participatory ethos of talk shows was combined with the tendency to "flame" (the aggressive style of anonymous online writers). The messages tended to be highly critical of the host, producers, and ratings driven logic of the shows. These users were not meek, passive consumers; they created the files (the subject headings) and chose whether to enter into discussion. Typical of folders from *Geraldo* online were "Geraldo, the 'low life'"; "Ricki Lake vs. Geraldo"; or "Show ideas."

Based on a comparison of 250 messages for each show, the difference between the *Ricki Lake* and *Geraldo* discussions is that Rivera is addressed as a journalist and Lake is perceived as an actress. Rivera is taken seriously by his message board participants because of his association with identity politics; when he is derided, the comments concern social identity, such as racist comments about his Jewish and/or Hispanic background. The Lake postings are much more critical of her and the program because of her association with fictional representations. Geraldo's intertext is his CNBC talk show *Rivera Live* and Lake's intertext is primarily her films for John Waters.

Both shows are regularly criticized for their male bashing, their portrayal of gays, and their sensationalism. *Ricki Lake* receives three times more criticism than *Geraldo*, generally for its inflammatory stereotypes and ethnic representations. The postings tend not to be interactive; discussions rarely occur between users, as in list-served groups. Show producers never enter into the discussion; in fact, I have been told by producers that the shows rarely use the suggested topics or take up the offers to be a guest, let alone read the postings.

The folders of "Kids Having Babies" (*Ricki Lake*, 23 postings) and "Babies Having Babies" (*Geraldo*, 15 postings) are remarkable for their highly interactive discussions, uncensored debates among women who bore children as teenagers. The discussions include fathers and other people who do not nominate themselves as a particular gender. In contrast to the lack of openly political responses on talk shows, the majority of conversants position themselves within the traditional public sphere notion of politics as a citizen arena. Most often, discussions surround the welfare or abortion debate. Typical are these postings on *Geraldo Online*. Discussant #1: "I'm a very liberal democrat, too!! I believe in letting everyone do what they they will; but this is horrifying!!!" (April 27, 1995). The second posting by Discussant #2: "First of all I am Hispanic and also I had my first when I had just turned 14." She concludes: "They [the teen mothers] better get their act together because the the way I see it, they will be welfare babies having more welfare babies. Just my opinion" (April 28, 1995). In the *Ricki Lake* discussion online, the members politicize the debate in a way it had not been on the TV program. Discussant #1: "I can't believe that not one person [on the program] brought up to these girls that the welfare they are using to raise these kids comes from the pockets of everyone in this country" (August 3, 1995). Discussant #3: "You are TOTALLY wrong!! I'm almost 16 and have a 1 yr. old son Tyler. I am NOT ON any type of welfare" (August 3, 1995). The concept of the social good of the country looms in the background of almost every message.

There is a subtle two-class system manifest in the messages. Participants who did not become teenage parents also speak and tend to invoke the social good more openly out of frustration with the young women who did. Their speech is more grammatical and their subjects more abstract. They represent the removed middle class and its social authority. Participant #6 in the *Geraldo* discussion, a biological determinist:

> If we realized that the urge to reproduce is used by nature the same way in EVERY society, that is to say that New York is no different than Timbuktu, perhaps we might start taking sex and its necessities into consideration we talk so loosely about "morality" and "family values." (May 18, 1995)

Participant #5 in the *Ricki Lake* discussion: "By the way, who watches your baby while you attend classes??? A government sponsored (i.e. taxpayers) program???? You are truly naive" (August 10, 1995). The participant clarifies later that she or he is not a parent. An important dichotomy surfaces slowly between those who have directly experienced parenthood and

those for whom the debate is based on social principles.

The second group is present and former teen mothers who tend to express their position through narratives similar to the "life stories" discussed in chapter 4. The stories are full of grammatical and spelling errors, and rely on the conventions of melodrama for the particulars of the predicament. Charlotte Linde has written that "the notion of a 'life story' itself is not universal, but is the product of a particular culture."[18] Consider how these women connect their experience with society through stories:

> Participant #3 (*Geraldo*): Let me tell you . . . Tammy's story. Tammy as born to a teenage mother. Never knew father, (runaway dad) and grew up wanting to be loved and cared for. Grew up miss trusting people, had no self confidence, always thought she was less a person than others. Tammy never finished her education and married 3 times before the age of 23yrs, because she lacked all of the above. (April 30, 1995)

Slowly, it comes out that the writer is narrativizing her own life. She mimics the language and conventions of talk shows to give her story the power that comes from a talk show, narrating it as a representation of a social issue. Later a teen mother tells her story:

> Participant #6 (*Geraldo*): Hi I am a teen mother who's so upset with the fact that these young girls want babies! They just don't realize how hard it is and what a big responsibility it is. First, I should start with the fact that I was only 17 when I got pregnant. I did not know what was really happening to me or my body. I thought it was cool. Everyone was having a baby. I then gave birth at 18. What a shock! I couldn't believe that was what was inside me! Then 1 month late my mother took custody of my daughter. I was to young and irresponsible to take care of her. Now at 19 I'm still working to get her back! (August 15, 1995)

The *Ricki Lake* entries tend to be shorter and more antagonistic. Nevertheless, the power of experience and the ability to weave a good narrative still have a greater social authority:

> Participant #7 (*Ricki Lake*): I'm 19. My husband is 23. I Had my first child when I was 16 and a half. I was also married at that age. I am not on welfare never have been. I take that back. When

I lived at home with my mom I did. Since I have have been on my own I have never need help from no one. I don't even have to work my husband does that. I stay home and take care of the kids. By choice I live a better life than most adults do. My husband and I are what they call middle class. (August 15, 1995)

Her triumph is entry into the middle class. It clearly signals her distance from the travails of teenage motherhood. So much of what emerges in both discussions is the interplay between the distant, more principled statements of those removed from the life experience of teenage motherhood and the more story-oriented and more practical sensibilities of those who are the subject of the debate.

Consider how the women who are closer to the experience take the offensive in the *Ricki Lake* discussion.

Participant #8 (mother of 7-month-old): Look [Participant #5] she made a mistake get over it. At least she's doing her best. That's more than a lot of teen girls do. I agree that teens shouldn't get pregnant and that they are just not ready for the type of commitment but don't bash them. (November 9, 1995)

Participant #9: [Participant #5], I agree with you that teens should not be having babies, but, it does happen, and you have no right to say anything about there having children do to the fact that you have no children yourself. . . . Even now as we speak my cousin, who is 16, is pregnant. (December 4, 1995)

Here, we have a public sphere debate: Does the citizen have a right to state financial support for the consequences of personal behavior? Is the citizen responsible for conducting herself or himself in such a way that state resources are not called upon? However, the debate does not take place in those rational and distance terms.

In the absence of the talk show host, expert, or even an academic to guide the discussion, there is no attempt to conclude with the definitive statement put "powerfully" in symbolic or bureaucratic terms. Rather, the language is personal and imperfect, but the debate is inherently political. It is about personal daily experiences of teenage mothers and also about the role of the state and teenagers' responsibilities as citizens and mothers. Here, the debate is being carried on by those who experience or "are" the problem. They mix life stories, emotion, and social values and reject the

symbolic knowingness of middle-class authority. The commercial discussion program has disappeared. This community of viewers is founded on the shared sense of injustices and the projection of personal responsibility onto society.

The Utopian Search for a Participatory Community

Let us not forget that it was the conservative think tank Empower America that led the backlash against daytime talk shows. Why was William Bennett so concerned about a loss of "human dignity" due to daytime talk shows? Because the people onstage enact uncomfortable stereotypes? No, he worried for the audience and, by extension, for his vision of the American people. However, the majority of these viewers happened to be in the lower classes—a group that the middle class has traditionally sought to regulate. But as this book has revealed, that audience and its reactions are not so easy to reach or to categorize cleanly as "antisocial," "perverse," or "progressive." The book is a call for those in the bourgeois public sphere to rethink their own class- and gender-based assumptions about what constitutes civil discussion.

To return to Robert Allen's questions about to what degree the text determines, talk shows provide a broad frame for constructing the topic and interpreting the meaning. As parts of large media conglomerates, they are guided by profit and therefore by the search for the largest audience share. Their programming enacts a disingenuous game of appealing to the rebellious spirit of disenfranchised citizens through appeals to sensationalism, free speech, and empowerment but closing down that appeal by ending their programs within the conservative confines of middle-class reformism and spiritual transcendence.

But talk shows as sensational as *Ricki Lake* are also capable of bringing average women into conversations about how their personal experiences intertwine with politics on issues such as abortion and welfare. Are online discussion groups, then, the utopian community where women viewers of the shows meet freely to discuss political issues? The online discussions mentioned above do provide evidence that in the absence of the spectacle of commercial TV, women viewers see the personal in political terms. Online discussion differs from studio audience participation. It does not operate with the commercial logic on which studio-audience participation depends. There are no pressures to entertain, to telegraph messages through broad stereotypes, or to stage visceral confrontations in the hopes of attracting the consumer's attention. The topics are unrestricted. The

method of communicating—written messages and postings that occur between long intervals—allows for a more meditative and less inflammatory exchange. On one level, the boards provide a platform whereby women discuss the issues "in their own terms."

Nevertheless, the talk show is a structuring, although absent, presence in online debate in important ways. It provides the topic or catalyst. It also establishes the ritual of participation. More important, it enables a form of participation dominated by women; in the heavily male world of online communication, we still see women speaking out and controlling discussion groups. These online discussions are far from utopian; even though individual women break through economic and class barriers to use them, computers and the Internet are not egalitarian. The online discussion I illustrate here is not the norm. The bulletin boards are marked by individualism, not community. Their short postings reflect one-way communication in that users identify themselves not as part of a social group, but as individuals asking for advice or a response from the all-powerful shows. Most criticisms of the shows are nothing more than quick, smart jabs at the shows, and their content is a less than thoughtful analysis of program content. And as a whole, the users do not reflect the diverse show audience.

What, then, unites the community of talk show viewers? This community is broadly based on the social situation of women as daytime viewers. But as the history of feminism has taught us, the designation of "women" as a group does not automatically entail a unified body of shared beliefs. The women of the talk show audience are not held together by subcultural practices that subvert the dominant commercial norms of femininity. They tend not to "poach" the text by remaking it to fit their experiences. They willingly participate in the rituals of personal narratives, performance, and audience interaction dictated by the talk show. Nor are they a submissive group held together by allegiance to the ideologies of self-help and commercial consumerism on talk shows. As a whole, they are too aware of the manipulations of talk shows to become simple consuming subjects. Researching this book has taught me that the responses of women to talk shows are too diverse and complex to position along on the lines of ideological subjects or even resisting women. There is not one community of talk show viewers; there are various communities. These fragmented communities undercut simple categorization, but they often belie the necessary cohesion to unite in class or gender interests to exact political change.

Nevertheless, talk shows have hailed a broad section of viewers as active participants in social debates that entail their experiences. And by

nominating their everyday experience as socially or even commercially relevant, the genre has shifted the debate about politics, self-worth, and social change. It now involves women who never thought their experiences had political consequence. Slowly, across twenty-five years, talk shows have created a community of women who believe in their right to speak about their experiences as part of the body politic.

I sense that community whenever talk shows come up in conversation at the grocery store, at my hairdresser's, or even in the radiology waiting room at my HMO. In fact, without my help, those women at my HMO in the opening lines of this chapter began an angry conversation about the male image of the female body ten minutes after I had fallen silent. I learned that my leadership was neither necessary nor welcome; I was a participant. Such women's conversation is not always dignified or organized around a clear notion of the "public good," nor is it always progressive. Rather than the bourgeois public sphere, it is the uncomfortable public sphere of people learning how to articulate their potential power.

The Talking Cure has been a call for understanding various kinds of viewers "on their own terms." But the book also asks that we rethink our hesitance about talk shows. As Renaldo Rosaldo suggests, these various communities and our "own," supposedly transparent cultural selves are borderlands. For Rosaldo these borderlands "should be regarded not as analytically empty transitional zones, but sites of creative cultural production that require investigation."[19] Talk shows were one of these borderlands where lower- and middle-class women conversed often angrily and wildly, but also constructively and creatively.

Nevertheless, *Richard Bey* stopped airing in Boston in December 1995. In January 1996 *Gabrielle* and *Richard Perez* were canceled.[20] That same month Phil Donahue announced that he would quit; his last program aired in September 1996. There was talk of Donahue running for the U.S. Senate. In January 1996 Rivera announced that he would like to be a network anchorman. He changed the title of *Geraldo* to the *Geraldo Rivera Show* and explained that it would feature more hard news. The program even published a "bill of rights," or a list of proposed changes to upgrade program content. William Bennett deemed the decision as "responsible programming."

With programs like "Advice to Oprah Letter Writers" (December 1, 1995) and "Tipping and Gift Anxiety" (November 29, 1995) Winfrey began a "spiritual quest of moral uplift"—a return to the values associated with the bourgeois tradition of feminine advice. The guests are standard-bearers, no longer average women in conflict. There is even a suggestion that talk shows are going to return the *Mike Douglas* style of the 1960s: the

light entertainment of celebrity talk. We have come full circle; talk is returning to the banter of an apolitical America.[21]

There is now less bad taste and incivility on TV. But who or what was Bill Bennett protecting? The disenfranchised, from exploitative convoluted images of themselves? Or the middle class, from dealing with the impolite and impolitic behavior of its lower class? What is sadly lost is an important venue for average people to debate social issues that affect their everyday lives. Those debates may not have taken place in total freedom, as in the idealized public sphere of Jürgen Habermas, nor did they follow the language and habits of civil debate. Often, the discussion hinged on uncomfortable stereotypes. Nevertheless, the shows "empowered" an alienated class of women to speak. In the end, we need to consider how our notions of "good taste" both mask power and stop debate.

APPENDIX

❖

Talk Show Content (February 21–25, 1995)

FEBRUARY 21, 1994

PROGRAM	TOPIC	EXPERT/TITLE	EXPERT'S BOOK/ PRODUCT/SERVICE	GUESTS: NAMES & TITLES/CAPTIONS	AUDIENCE MEMBERS: CAPTIONS
GERALDO	Repeat "Encore presentation of LaToya Jackson"				
SALLY JESSY RAPHAËL Ericka held up as example of redemption through public apology"; Denise tried to commit suicide in 9th grade	"Bullies and Victims of Bullies" (female only)	Marilee Goldberg, Ph.D., specializes in women and self-esteem; says bullies create problems for themselves and those they bully	Family therapist	Patti: says childhood ruined by a bully, Jennifer; Patty says Jennifer's bullying ruined her life; Theresa: says being a bully makes her feel powerful (breaks down and cries over family problems); Ericka & Michelle—Ericka wants to apologize for bullying Michelle; Denise: says she is still emotionally scarred from being bullied	Cynthia and Lila: used to be enemies and are now friends
PHIL DONAHUE	Married couples with unusual sexual negotiations; "Open Marriages"	Andrew Elmore, Ph.D., relationship expert; says if no coercion then o.k.	Private-practice counselor	Lisa and Rob: not jealous of husband sleeping with other women; Brenda: sleeps with Rob; Alice: when husband sleeps with other women it makes marriage stronger; Deborah & Harry: married couple who don't sleep together	

PROGRAM	TOPIC	EXPERT/TITLE	EXPERT'S BOOK/ PRODUCT/SERVICE	GUESTS: NAMES & TITLES/CAPTIONS	AUDIENCE MEMBERS: CAPTIONS
THE OPRAH WINFREY SHOW (Inspiration for show came from a previous show, on which Oprah convinced man to take off toupée)	Addictions to disguises such as wigs, makeup, etc.; hiding your true self	Mary Ann Mayo says it is a matter of motivation; wig or makeup not going to solve problem underneath; says value comes from inside	(book) *Looking Good but Feeling Bad* says you are lovable no matter how you look; it's an internal validation that has to happen	Bill Allen: beard for 20 years; Virginia Elmore: wigs for 26 years; Ed: combs hair over bald spot; Felicia Shaw: wears makeup 24 hours a day	Experiment: putting fake scars on 5 women's faces to see if treated differently, but when scars taken off women still perceived people looking at them
GERALDO Big differences between experts' and guest couples' articulations of problems	"In search of The Big O": enhancing marital pleasure. In an unusual dynamic combining the clinical and the voyeuristic; Royale says, "Play, create, explore."	Dr. Cynthia Watson; Sandra Scantling, Ph.D.; Charles Muir; Lonnie Barbach; Candida Royale	(book) *Love Potions* plus video of the same name; (book) *Ordinary Women, Extraordinary Sex: Every Woman's Guide to Pleasure and Beyond*; (book) *Tantra: The Art of Conscious Loving*; (book) *Going the Distance: Secrets to Lifelong Love*; sex videos by former porn star	Sherry and Butch, Ginny and Mark, Sara and Jeff: couples with sex problems	
SALLY JESSY RAPHAËL Sally asks therapist if Dale should be encouraged to forgive mom or hug her; audience answers, "No."	People who feel rejected by parents who put them up for adoption; people separated from their birth mothers	Ginger Grancagnolo, Ph.D., family therapist, says anger is first step towards healing; says Michelle and Dale want information	Therapist [about the best I've seen]	Michelle: angry at mom, who gave her up; Dale: angry at mom, who gave him up (both have same mother); Martha: says she was forced to give up her kids; Frank: Michelle's husband; Michelle #2: angry at mom, who gave her up; Diana: Michelle #2's mom	

PROGRAM	TOPIC	EXPERT/TITLE	EXPERT'S BOOK/PRODUCT/SERVICE	GUESTS: NAMES & TITLES/CAPTIONS	AUDIENCE MEMBERS: CAPTIONS
PHIL DONAHUE	The men whom women can't seem to resist (group of four men from a show 2 years ago plus new studs)		2 guys from NYC; 1 guy from Queens, super-confident guys, conservatively dressed	Rick: says he's God's gift to women; Flash: says he's a stud; Jamie: Charles: expert at seduction; Alisha: Jamie's girl	
THE OPRAH WINFREY SHOW Oprah says we are all responsible for actions. She is open-minded about impact of talk shows—positive and negative. Says her role is to bring issues to light	"Do talk shows and self-help movements provide excuses?" Is this too much reliance on the "abuse excuse"?	Lenora Walker, psychologist; Alan M. Dershowitz says "abuse excuse" sends wrong message to victims—it should be "get out"	Charles Sykes, (book) A Nation of Victims: The Decay of the American Character, says we trivialize real problems; Wendy Kaminer, (book) I'm Dysfunctional—You're Dysfunctional	Merrily VanderBur: former Miss America, abused by father; Michael David: attorney, defends abuse as an excuse; Jean and Gibson: Sturtridge prosecutor who calls abuse defense rubbish; Wendy Kaminer: critic of abuse excuse "blames talk shows for glorifying victims"; Debbie: Lorena Bobbitt juror; Judy and Joyce: 2 women who killed abusive husbands; Randy: abuse victim who then beat pregnant wife	

FEBRUARY 23, 1994

PROGRAM	TOPIC	EXPERT/TITLE	EXPERT'S BOOK/PRODUCT/SERVICE	GUESTS: NAMES & TITLES/CAPTIONS	AUDIENCE MEMBERS: CAPTIONS
GERALDO	"Mothers and Daughters at War"	Randy Rolfe, family therapist, says mothers want appreciation, daughters want love and support	(book) *You Can Postpone Anything But Love*	Tara & Lisa (sisters)—Lisa: says her mother is an alcoholic who is ruining her life; Tara: says her mother tried to prostitute her for drugs; Jane: Lisa's mother; Leonard: Jane's boyfriend; five other guests	Billie: says her daughter (Jane) is a bad mother (by phone); Mike: Amy's fiancé
SALLY JESSY RAPHAËL Statistics: 50% of married women cheat (Joyce Brothers), 75% according to Shere Hite	"Women Who Cheat on Their Husbands" (Marital Affairs)	Dr. Gilda Carle, Ph.D., says people don't realize how much they hurt their partners by cheating; Reggie Montgomery gives lie-detector tests	Relationship expert Kelly says her husband must love her to come on show and tell about his affair.	Ann: says she cheats to get more sex; Laura: says she cheats for the thrill of it; Patty & Kenny, married couple: Kenny says he cheated to get Patty's friend pregnant; Kelly & David: couple	Darlene (phone), Patty's friend: says she didn't cheat to get pregnant; Dottie: David's cousin (couple who has survived an affair); Kenny took lie-detector test & passed
PHIL DONAHUE	"Wedding Day Mishaps" involving police			Bill & Dottie Bork: arrested at own wedding reception; Kim & Shawn Smith: groom was shot and guest killed at wedding; another couple who had shootings at wedding (husband was shot in leg, friend killed)	Michael McGann: attorney for Bill Bork; Michael Charella: attorney for Dottie Bork

PROGRAM	TOPIC	EXPERT/TITLE	EXPERT'S BOOK/PRODUCT/SERVICE	GUESTS: NAMES & TITLES/CAPTIONS	AUDIENCE MEMBERS: CAPTIONS
THE OPRAH WINFREY SHOW	Family Budgeting	Neale Godfrey: says we need to be more open when communicating about money	(Book) Money Doesn't Grow on Trees: Parents' Guide to Raising Financially Responsible Children	Couples all participated in budget experiment: Janie and Steve, Steve and Patti, Joseph and Peggy	
GERALDO Displays anger at Sally for sticking with convicted molester	"When Parents Don't Believe Their Children Are Abused" (Stepparents' Sexual Abuse)	Randy Rolfe, family therapist, says kids don't make up lies about molestations. Says Sally shouldn't trust Steve		Dawn: molested and impregnated by her stepfather; Bonnie: husband molested and impregnated her daughter; James: Dawn's natural father; Steve: molested his stepdaughter; Sally: Steve molested their daughter; Julie & Carol: molested by their stepfather—mother doesn't believe them	Steve (phone) says his sister, Julie, molested him; Mary: abused by stepfather for 13 years; Sandra: raped by stepfather
SALLY JESSY RAPHAËL Points out that when men say they are "users," we don't get so hysterical	"Women Who Use Men and Then Dump Them"	Ann-Renee Testa, psychotherapist, says it's difficult for these women to find really intimate love; says they reject men before they let them in; "Find your own value first"	Build your own self-esteem	Kelly, Maria, and Dena: say they use men and dump them; Robb: says he was used and dumped by Dena; Tammy: says she used men for sex	Kathleen: Maria's sister; Kathy: Maria's mom says Maria thinks she is God's gift to men; Angel: says she uses men and wants to stop

PROGRAM	TOPIC	EXPERT/TITLE	EXPERT'S BOOK/PRODUCT/SERVICE	GUESTS: NAMES & TITLES/CAPTIONS	AUDIENCE MEMBERS: CAPTIONS
PHIL DONAHUE	"Women in the 90s"	Guest expert hates that women think they are victims of society	Laura Schlessinger. Ph.D., says quality of life is what you bring to it; (book) Ten Stupid Things Women do to Mess Up Their Lives; (radio talk show)KFI–Los Angeles	Patty: confrontational, reacting	
THE OPRAH WINFREY SHOW No conclusions about efficacy of personal ads. Very little shown after initial meetings took place	"Personal Ads: Do They Work?" Ads were shown in the context of "dating in the 90s," accepted as a valid way to pursue relationships	Larry Glanz: (book) How to Start a Romantic Encounter: Where to Go to Find Love and What to Say When You Find It; Bonnie Weil, Ph.D., therapist; Gail Prince: singles counselor; Nancy Fredder: personals editor, New York Magazine		Numerous people who placed personals trotted out to see if they matched their descriptions. Kevin: responded to Sue's personal ad; Melissa: tried personal ad; Brent Greenberg, M.D.: tried personal ad; Victoria Peterson: responded to Brent's ad	Dino: Chicago D.J.

FEBRUARY 25, 1994

PROGRAM	TOPIC	EXPERT/TITLE	EXPERT'S BOOK/PRODUCT/SERVICE	GUESTS: NAMES & TITLES/CAPTIONS	AUDIENCE MEMBERS: CAPTIONS
GERALDO Presents himself as square and out of touch yet superior	"Klub Kidz 94: Creatures of the New York Night"	Rachel Fisk, model, tells kids they have to work hard, not just play hard.		Richie Rich "Club Kid"; "Michael Alley: "Club Kid"; Anna: "Club Kid"; Princess Botanikle: "Club Kid"	Numerous "club kids"; Jack: mild-mannered computer programmer turned "club kid"

PROGRAM	TOPIC	EXPERT/TITLE	EXPERT'S BOOK/PRODUCT/SERVICE	GUESTS: NAMES & TITLES/CAPTIONS	AUDIENCE MEMBERS: CAPTIONS
SALLY JESSY RAPHAËL (interrupted by special report on Hebron massacre)	Viewers confront former Sally guests		OTHER GUESTS ; Bob Bould: attorney; Dorothy: doesn't agree with former Sally guest; Hank: believes in racial separation; Michael: former audience guest	Kevin: says women are attracted to gay men; Tiny: 15-year-old transsexual; Debra: viewer angry at former Sally guest; Vinny: former Sally guest; Melody: viewer angry at former Sally guest; Kirk: separatist, unreconstructed Southerner; Barbara: viewer; Ruth Peters: clinical psychologist	Desiree: Tiny's sister, also transsexual; Tiny's mom: says she loves Tiny and Desiree
PHIL DONAHUE (interrupted by special reports on Nancy Kerrigan)	"Compelling Stories of Cuban Defectors"		(book) Wings of the Morning; Andy Martin, political activist, says immigration policy in U.S. is problem. Criticizes Clinton	Anestes Lorenzo: landed plane on Cuban highway to rescue wife and children (had previously defected with MIG airplane); Vickie Lorenzo: wife; Lester Moreno: windsurfed to U.S. 4 years ago; Eugenia: windsurfed to US	
THE OPRAH WINFREY SHOW	"Life in the Year 2000" (virtual reality, etc.)	Various virtual-reality experts with products to sell; Concept House by GE; Michael Dickens, manager, advanced design/development, GE Plastics	Faith Popcorn, trend tracker, (book) The Popcorn Report, says we will be living and working mostly at home	Paul Hoffman: editor, Discover Magazine; various demonstrators; Jack Telmack: Ford product designer	

NOTES

❖

Chapter 1

1. "*The Oprah Winfrey Show*'s Ability to Attract Female Viewers," *Oprah Winfrey Show* press packet, September 1994, 1–5.

2. There are some other exceptions to the Aristotelian division between active stage and passive audience, such as World Wrestling Federation wrestling, the carnival, and Brechtian theater. But these forms integrate limited audience participation. Most often audience actions are highly prescribed and are used to comment on the spectacle's construction.

3. Robert Allen, "Audience-Oriented Criticism and Television," in *Channels of Discourse, Reassembled* (Chapel Hill: University of North Carolina Press, 1992), 118.

4. Ibid., 122–124.

5. *Commonweal*, 14 February 1992, 18.

6. Allen, "Audience-Oriented Criticism," 123.

7. Ibid., 124.

8. *Strike It Rich* (1951–1958) and *Turn to a Friend* (1953) were similar half-hour game shows: people in want stated certain needs and the studio audience determined who won. *Strike It Rich* had a segment called "Heartline," on which viewers could call in to offer forms of aid to the contestants.

9. Patricia Joyner Priest, *Public Intimacies: Talk Show Participants and Tell-All TV* (Cresskill, NJ: Hampton, 1995).

10. According to a 1995 poll, 30 percent of the talk radio audience define themselves as "conservative to ultra conservative"; only 18 percent define themselves as "liberal to ultraliberal." "The Talk Radio Audience," *Talkers*, October 1995, 7.

11. Henry Jenkins, *Textual Poachers* (New York: Routledge, 1992), 185–222; Ellen Seiter, Hans Borchers, Gabrielle Kreutzner, and Eva-Maria Warth, "'Don't Treat Us Like We're So Stupid and Naive': Towards an Ethnology of Soap Opera Viewers," in *Remote Control: Television, Audiences and Cultural Power*, ed. Seiter, Borchers, Kreutzner, and Warth (New York: Routledge, 1989), 223–247; and John Fiske, "British Cultural Studies," in *Channels of Discourse, Reassembled*, ed. Robert Allen (Chapel Hill: University of North Carolina Press, 1992), 284–326.

12. See Raymond Williams, *Culture and Society* (London: Chatto & Windus, 1958), *The Long Revolution* (London: Chatto & Windus, 1961), and

Marxism and Literature (Oxford: Oxford University Press, 1977).

13. See Stuart Hall, "The Problem of Ideology—Marxism without Guarantees," in *Marx 100 Years On*, ed. B. Matthews (London: Lawrence & Wishart, 1983).

14. See Michel Foucault, *The Archaeology of Knowledge*, trans. Alan Sheridan (New York: Pantheon, 1972), and *Madness and Civilization: A History of Insanity in the Age of Reason*, trans. Richard Howard (New York: Random House, 1965).

15. Jana Sawicki, *Disciplining Foucault: Feminism, Power, and the Body* (New York: Routledge, 1991), 95.

16. Renato Rosaldo, *Culture and Truth: The Remaking of Social Analysis* (Boston: Beacon Press, 1989) and James Clifford, "On Ethnographic Authority," *Representations* 1 (1983), 118–46.

Chapter 2

1. Fredric Jameson, *Postmodernism or, The Logic of Late Capitalism* (Durham: Duke University Press), 2.

2. Robert C. Allen, *Speaking of Soap Operas* (Chapel Hill: University of North Carolina Press, 1985), 8.

3. See Ben Bagdikan's and Mitchell Stephens's comments on the relation of tabloid culture to history in Albert Scardino, "A Debate Heats Up: Is It News or Entertainment?" *New York Times*, 15 January 1989, sec. 2, 29. Stephens argues that the notion of low culture in news can be traced back to the 1840s, when preachers organized boycotts against the *New York Herald* for printing such impolite words as *undershirt*.

4. Ibid., sec. 1., 29.

5. Brian Lowery, "Shockjocks, Trash TV Take Beating; Scares Sponsors, Lawyers, NAB Told," *Variety*, 3–9 May 1989, 54.

6. Lisa Robinson, "People Are Talking . . . about TV," *Vogue*, May 1988, 101.

7. Quoted in Scardino, "A Debate Heats Up," sec. 1, 29.

8. Ibid.

9. The role of tabloid television was debated at the convention of the Society of Newspaper Editors on 13 April 1989, and televised as part of Columbia University Seminars on Media and Culture, with Fred Friendly as moderator. Donahue accused the journalists of "unbecoming elitism." Tom Shales, TV critic for the *Washington Post*, argued that it was a matter of good taste and "television is now overrun by bad taste." Rivera defended his work as "democratizing" the news. Donald Hewitt, executive producer of *60 Minutes*, declared, "It's about ratings. It's about money. This 'democratizing America' is

baloney." See Alex S. Jones, "'Trash TV' Debated at Editors' Convention," *New York Times*, 13 April 1989, C36.

10. Elizabeth Bird, *For Enquiring Minds: A Cultural Study of Supermarket Tabloids* (Knoxville: University of Tennessee Press, 1992), 8.

11. Mary Alice Kellogg, "We're Tabloid and I'm Happy to Wear That Label," *TV Guide*, 27 June 1992, 9.

12. Bird, *For Enquiring Minds*, 25.

13. Janet Steele, *The Sun Shines for All: Journalism and Ideology in the Life of Charles A. Dana* (Syracuse: Syracuse University Press, 1993), xi.

14. Ibid., 138.

15. Michael Schudsen, *Discovering the News: A Social History of American Newspapers* (New York: Basic Books, 1978), 97.

16. Steele, *The Sun Shines for All,* 139.

17. Ibid.

18. Bird, *For Enquiring Minds*, 24.

19. George Juergens, *Joseph Pulitzer and the New York World* (Princeton: Princeton University Press, 1966), 67–69. These headlines appeared on page 1, upper right corner.

20. Ibid., 47.

21. *Webster's New Universal Dictionary* (New York: Simon & Schuster, 1983), 1652.

22. *World*, 17 May 1884, in Steele, *Sun Shines for All*, 138.

23. Robert C. McMath, Jr., *American Populism: A Social History, 1877–1898* (New York: Hill & Wang, 1993), 161–162.

24. Jim McGuigan, *Cultural Populism* (London: Routledge, 1992), 14.

25. Stuart Hall, *The Hard Road to Renewal* (London: Verso, 1988).

26. McGuigan, *Cultural Populism*, 181.

27. John Dempsey, "Downey's Down But Not Out, Says Talkshow Will Remain On the Air at Least through Jan.," *Variety*, 21-27 June 1989, 40; and David Blum, "Loud Mouth," *New York*, 18 January 1988, 37–41.

28. McGuigan, *Cultural Populism*, 38.

29. Charles Leerhsen, "Sex, Death, Drugs and Geraldo," *Newsweek*, 14 November 1988, 76.

30. Phyllis Leslie Abramson, *Sob Sister Journalism* (New York: Greenwood Press, 1990), 108.

31. Arthur M. Schlesinger lists other books: Mrs. John Sherwood of *Harper's Bazaar* wrote *Amenities of Home* (1881), *Manners and Social Usages* (1884), and *The Art of Entertaining* (1892). By the 1920s etiquette and good behavior were distilled into several "bibles": Lillian Eichler's *Book of Etiquette* (1921) and Emily Post's *The Blue Book of Social Usage* (1922), both selling more than a million copies in its first years. See *Learning How to Behave: A Historical Study of American Etiquette Books* (New York: Cooper Square, 1968), 33–51.

32. Ibid., 34. For a similar argument, see John F. Kasson, *Rudeness and Civility: Manners in Nineteenth Century Urban America* (New York: Noonday, 1991).

33. Schlesinger, *Learning How to Behave*, 32.

34. Juergens, *Pulitzer*, 147.

35. Ibid., 152.

36. Schlesinger, *Learning How to Behave*, 32.

37. Harnett T. Kane, *Dear Dorothy Dix: The Story of Compassionate Woman* (New York: Doubleday, 1952), 62.

38. Barbara Ehrenreich and Deirdre English, *For Her Own Good: 150 Years of the Experts' Advice to Women* (Garden City, NY: Doubleday, 1978), 89–239.

39. Wayne Munson, *All Talk: The Talkshow in Media Culture* (Philadelphia: Temple University Press, 1993), 27.

40. Janet Walker, *Couching Resistance: Women, Film, Psychoanalytic Psychiatry* (Minneapolis: University of Minnesota Press, 1993), 1–22.

41. Margaret Mead, "What Is a Lady?" *Redbook Magazine*, April 1963, 22.

42. Munson, *All Talk*, 49.

43. "Brothers, Joyce," *Current Biography* (New York: H. W. Wilson, 1971), 66.

44. Brothers's success did not immediately result in other similar counseling programs. Only in the 1980s, with deregulation and cable, did a generic group of sexually explicit counseling programs form. In 1982 the talk show *Couples* asked couples to examine their intimate problems openly with Dr. W. Brackelman. *Good Sex! With Dr. Ruth Westheimer* or *Dr. Ruth* (Lifetime Channel, 1984–1989) involved the diminutive therapist giving sexual advice to actors as patients. Later programs of the show featured call-ins and interviews with physicans.

45. "Brothers, Joyce," 66–67.

46. "TV Talk Shows as Therapeutic Discourse: The Ideological Labor of the Televised Talking Cure," *Communication Theory* 5.1 (February 1995): 65.

47. Eric Barnouw, *Tube of Plenty: The Evolution of American Television* (Oxford: Oxford University Press, 1981), 76.

48. Daniel C. Hallin, *We Keep America on Top of the World: Television Journalism and the Public Sphere* (New York: Routledge, 1994), 177.

49. Ibid., 173.

50. Here we need to separate the perception of objectivity of TV news reporting from the actual reporting in the 1950s and 1960s. For example, Murrow is famed for his open hostility toward U.S. Senator Joseph McCarthy in the mid-1950s. Additionally, he narrated the TV documentary *Harvest of Shame* for *CBS Reports* in November 1960, which was so openly critical of the treatment of migrant farmers that many viewers doubted its veracity. See Erik Barnouw, *Tube of Plenty*, 284.

51. Hallin, *We Keep America on Top of the World*, 177.

52. Ibid., 178.

53. Paul Lenti, "Not 'Sleaze TV' But 'Me TV,' Argues Fox Net Producer," *Variety*, 18–24 January 1989, p. 48.

54. Scardino, "A Debate Heats Up," 29.

55. A good example of this move toward syndication is the *Merv Griffin Show*. One of the longest-running daytime celebrity talk shows, it was on NBC from 1962 to 1963. After a brief period as a nighttime CBS alternative to the *Tonight Show*, it ran as a syndicated daytime show from 1972 to 1982.

56. Muriel Davidson, "Darling, Your Claws Are Showing," *TV Guide*, 30 July 1966, 7–9.

57. Morrie Gelman, "Everybody's Talking about Talkshows," *Variety*, 13 February 1980, 119.

58. Phil Donahue & Co., *My Own Story Donahue* (New York: Simon & Schuster, 1979), 100.

59. Ibid., 198–199.

60. Ibid., 203.

61. Harry F. Waters, "The Talk of Television," *Newsweek*, 29 October 1979, 76.

62. Ibid., 77.

63. Sally Jessy Raphael and Pam Proctor, *Sally: Unconventional Success* (New York: Morrow, 1990), 133.

64. Ibid., 166.

65. Deborah Lupton, "Talking about Sex: Sexology, Sexual Difference, and Confessional Talk Shows, *Genders* 20 (1994): 45–65.

66. Richard Dyer, *The Matter of Images: Essays on Representations* (London: Routledge, 1993), 12.

67. Richard Dyer, *Stars* (London: British Film Institute, 1979), 13.

68. Michel Foucault, *The History of Sexuality, Volume I: An Introduction*, trans. Robert Hurley. (New York: Pantheon, 1977), 51–73.

69. Juergens, *Pulitzer*, 54.

Chapter 3

1. Interview with Laurie Fried, publicist, *Jerry Springer Show*, 8 September 1994.

2. Karen Buzzard, *Electronic Media Ratings: Turning Audiences into Dollars and Sense* (Boston: Focal Press, 1992), 90.

3. Ien Ang, *Desperately Seeking the Audience* (New York: Routledge, 1991), 3.

4. James S. Ettema and Charles D. Whitney, eds., *Audiencemaking: How the Media Create the Audience* (Thousand Oaks CA: Sage, 1994), 5.

5. Ang, *Desperately Seeking the Audience*, 3–4.

6. Julie D'Acci, *Defining Women: Television and the Case of Cagney and Lacey* (Chapel Hill: University of North Carolina Press, 1994), 2.

7. Ibid., 3.

8. See Mary Ellen Brown, *Soap Opera and Women's Talk* (Thousand Oaks CA: Sage, 1994); John Fiske, *Television Culture* (New York: Methuen, 1987); and Ann E. Kaplan, "Feminist Criticism and Television," in *Channels of Discourse, Reassembled*, ed. Robert C. Allen, 2d ed. (Chapel Hill: University of North Carolina Press, 1992), 247–283.

9. D'Acci, *Defining Women*, 1–9.

10. Here, I return to Louis Althusser's concept of the base/superstructure model of ideology to suggest how the economic structure of the commercial media attempts to control audience ideas, tastes, and buying habits. According to Althusser, "'Ideology in general' reconciled subjects to their conditions of existence and 'state ideological apparatuses,' including communications and cultural institutions, pumped them full of 'nationalism, chauvinism, liberalism, moralism, etc.'" See "Ideology and Ideological State Apparatuses," in *Essays on Ideology* (London: Verso, 1976), 28.

11. For examples, see Paul Sweezy, *Theory of Capitalist Development* (New York: Monthly Review Press, 1942), 293; and Anthony Cutler, Barry Hindress, et al., *Marx's Capital and Capitalism Today*, vol. 1 (London: Routledge & Kegan Paul, 1977), 3.

12. Bert Dubrow, personal interview, 10 March 1994.

13. Todd Gitlin, *Inside Prime Time* (New York: Pantheon, 1985), 14.

14. Ernest Mandel, *Late Capitalism* (London: Verso, 1972), 377.

15. Ibid., 401.

16. Srully Blotnick writes: "Note the crucial difference: The success of a genuine talk show depends critically on the producer's ability to keep finding guests who are either 1) newsworthy—preferably people who are currently in the news—or 2) who deserve to be, because each has distinquished himself and perhaps has some worthwhile advice to offer." "We Just Want to Help You," *Forbes*, 28 April 1986, 339.

17. Robert C. Allen, *Speaking of Soap Operas* (Chapel Hill: University of North Carolina Press, 1985), 45.

18. CRF (Code of Federal Regulations). Annual. *Title 47: Telecommunications*, 5 vols. (Washington, DC; GPO), 765.

19. See Multimedia, Inc., *Annual Report 1993*; 10–11. Also see Steve McClellan, "Multimedia: More Than Just Talk," *Broadcasting*, 30 March 1992, 19, 22.

20. See Tribune, *New Ideas in Information and Entertainment*, 1993 Annual Report, 24–25.

21. *Inside King World, Annual Report 1993*, 4.

22. Steve Brennan, "Some Chinks in 'Oprah' Armor," *Hollywood Reporter*, 23 June 1994, 6.

23. Steve McClellan, "Oprah + King World: Not a Done Deal," *Broadcasting and Cable*, 14 March 1994, 7.

24. *Inside King World, Annual Report 1993*, 6.

25. *Hollywood Reporter,* 21 March 1994, 58.

26. During my visits to the shows in the spring of 1994, only *Geraldo* had a representative of the syndication company; a Tribune executive sat in on the tapings.

27. Liz Cheng, personal interview, 26 August 1994.

28. Verne Gay, "Sponsors Shun Sleaze Shows; Many Programs on List," *Variety*, 1–7 February 1989, 76.

29. Richard Caves, *American Industry: Structure, Conduct, Performance*, 4th ed. (Englewood Cliffs, NJ: Prentice-Hall, 1977), 19–20.

30. Sara Welles, "Talk Show Boom: What's New Copycat?" *Television Quarterly* 3 (1993): 51.

31. Robert A. Brady, quoted in Richard Dyer, *Stars* (London: British Film Institute, 1979), 11.

32. Sally Jessy Raphaël and Pam Proctor, *Sally: Unconventional Success* (New York: Morrow, 1990); and Phil Donahue & Co., *Donahue: My Own Story*, (New York: Simon & Schuster, 1979). Winfrey wrote an autobiography, *Oprah*, for Knopf in 1993 but abruptly withdrew it before publication. Rivera's biography is the only one to break from the first-name title: *Exposing Myself* (New York: Bantam, 1991).

33. "In Full Stride," *People*, 12 September 1994, 85–90. This came also after the production company's veil of control had been lifted to reveal the internal weaknesses of the show in a cover story in *TV Guide*, 14 June 1994.

34. Marcia Ann Gillespie, "On Air or Off, Oprah Makes Money Talk," *Ms.*, November 1988, 54.

35. Bill Carter, "Talk Is Cheap, but Profitable on TV," *New York Times*, 22 June 1992, D1.

36. Ibid.

37. *New York Times*, 6 September 1987, sec. 2, 21.

38. *National Enquirer* Special Edition, *"Oprah! This Is Your Life,"* ed. Mike Nevard, fall 1994, 2.

39. Nellie Bly, *Oprah! Up Close and Down Home* (New York: Kensington, 1993).

40. Myrna Blyth, "Sally Jessy Raphaël: My Toughest Year," *Ladies Home Journal*, February 1993, 119–120, 176, 178–179. One might compare the trope of Raphaël's struggle in Doug Hill, "Sally Jessy Raphaël Driven? You'd Be Too—If You Were Fired 18 Times and Lived on Food Stamps," *TV Guide*, 8 July 1989, 17–19.

41. Raphaël and Proctor, *Sally.*

42. Paul DeCamera, personal interview, 26 August 1994.

43. Carter, "Talk Is Cheap."

44. Bert Dubrow, personal interview, 10 March 1994.

45. Multimedia attempted to replicate the ABC affiliates/*Oprah* relationship by offering a group of NBC affiliates a package of *Donahue*, *Sally*, and *Jerry Springer* in 1992. In 1994, with *Donahue* and *Sally* lagging in the ratings and their audience demographics "aging," the group did not renew the agreements. "Multimedia vs. NBC O&Os," *Variety*, 14–20 February 1994, 68. According to *Variety*, talk shows as a genre are not a good lead into the news because their audiences are dominated by women under fifty, the opposite of the traditonal demographics for news. "News Lead-ins," *Variety*, 12–18 July 1989, 42.

46. Margaret Morse, "Talk, Talk, Talk," *Screen* 26 (1985): 14.

47. Bert Dubrow, personal interview, 10 March 1994.

48. Interview in "Pushing the Limits of Talk Shows," *Channels*, May 1988, 95.

49. Cecilia Capuzzi, John Flinn, and Neal Koch, "Pushing the Limits of Talk-Show TV," *Channels*, May 1988, 95.

50. Sidney Head, Christopher H. Sterling, and Lemuel Schofield, *Broadcasting in America*, 7th ed. (Boston: Houghton Mifflin, 1994), 384.

51. Adrienne Lotoski, personal interview, 29 August 1994.

52. "King World: A Portfolio of Our Shows," *Inside King World, Annual Report 1993*, 45.

53. Marilyn J Matelski, *Daytime Television Programming* (Boston: Focal Press, 1991), 13.

54. Paul DeCamera, personal interview, 26 August 1995.

55. Adrienne Lotoski, personal interview, 29 August 1995.

56. Debra Hackenberry, personal interview, 11 March 1994.

57. *Public Pulse* (Roper Starch Worldwide) 8.5 (1994): 3.

58. Debra Hackenberry, personal interview, 11 March, 1994.

59. Adrienne Lotoski, personal interview, 29 August 1995.

60. Debra Hackenberry, personal interview, 11 March, 1994.

61. David Bordwell, Janet Staiger, and Kristin Thompson, *The Classical Hollywood Cinema: Film Style and Mode of Production to 1960* (New York: Columbia University Press, 1985), xiv.

62. Bert Dubrow, personal interview, 10 March 1994.

63. Rose Mary Henri, personal interview, 10 March 1994.

64. J. Max Robins, "Talkshow Producers Find Dial-a-Dilemma," *Variety*, 11–17 April 1994, 46.

65. A number of shots of the audience are taped after the show that are cut in to fill in for insufficient footage for the hourlong program and to be part of promotions for it.

66. Bordwell, Staiger, and Thompson, *The Classical Hollywood Cinema*, 138.

67. Robert C. Allen, *Speaking of Soap Operas* (Chapel Hill: University of

North Carolina Press, 1985), 51–54.

68. David Thorburn, "Television Melodrama," in *Television: The Critical View*, ed. Horace Newcomb, 3d. ed. (Oxford: Oxford University Press, 1982), 532.

69. See Christine Gledhill, "A Melodramatic Field: An Investigation," in *Home Is Where the Heart Is: Studies in Melodrama and the Women's Film*, ed. Gledhill (London: British Film Institute, 1987), 5–42; and Jackie Byars, *All That Hollywood Allows: Rereading Gender in 1950s Melodrama* (Chapel Hill: University of North Carolina Press, 1991), 8–13.

70. See Ken Dancyger and Jeff Rush, *Alternative Scriptwriting* (Boston: Focal Press, 1991), 59–61; and Doug Heil, "Dramatic and Melodramatic Beat Structure," *Creative Scriptwriting*, Spring 1994, 45–46.

71. Jane Feuer, "Genre Study and Television," in *Channels of Discourse, Reassembled*, ed. Robert C. Allen (Chapel Hill: University of North Carolina Press, 1992), 144.

72. Stuart Hall, "The Narrative Constuction of Reality," *Southern Review* 17.1 (1984): 6.

73. David Bordwell and Kristin Thompson, *Film Art*, latest ed. (New York: McGraw-Hill, 1993), 64.

74. John Hartley, *Tele-ology: Studies in Television* (London: Routledge, 1992), 81–82.

75. Vladimir Propp, *Morphology of Folktales* (Austin: University of Texas Press, 1970), 19–20.

76. Peter Brooks, *The Melodramatic Imagination: Balzac, Henry James, Melodrama and the Mode of Excess* (New Haven: Yale University Press, 1976), 29.

77. Christine Gledhill, introduction to *Home Is Where the Heart Is*, 21.

78. Ibid., 34.

79. Ibid.

80. Annette Kuhn, "Women's Genres: Melodrama, Soap Opera, and Theory," in *Home Is Where the Heart Is: Studies in Melodrama and the Women's Film*, ed. Christine Gledhill (London: British Film Institute, 1987), 339.

81. Martha Vicinus, "Helpless and Unfriended: Nineteenth Century Domestic Melodrama," *New Literary History* 13.1 (Autumn 1981): 135–136.

Chapter 4

1. Jürgen Habermas, "The Public Sphere: An Encyclopedia Article," *New German Critique*, Autumn 1984, 49.

2. Barbara Lippert, "The Talk Show Report," *Ladies Home Journal*, April 1994, 154–156, 210.

3. John Corry, "A New Age of Television Tastelessness?" *New York Times*,

29 May 1988, 1; and John J. O'Connor, "Defining What's Civilized and What's Not," *New York Times*, 25 April 1989, C18.

4. P. Carpignano, R. Andersen, S. Aronowitz, and W. Difazio, "Chatter in the Age of Electronic Reproduction: Talk Television and the 'Public Mind,'" *Sociotext* 25/26 (1990): 33–55.

5. Gloria-Jean Masciarotte, "C'mon Girl: Oprah Winfrey and the Discourse of Feminine Talk," *Genders* 11 (Fall 1991): 81–110.

6. *Webster's New World Unabridged Dictionary*, 2d ed. (New York: Simon & Schuster, 1983), 1392.

7. Ron Rosenbaum, "Staring into the Heart of Darkness," *New York Times Magazine*, 4 June 1995, 41.

8. On 6 March 1995, a Michigan man, Scott Amedure, surprised a male friend, Jon Schmitz, by admitting that he had a crush on Schmitz during a taping of a *Jenny Jones* program on secret admirers. The next day Schmitz murdered Amedure, declaring that he had been "humiliated" by the exposure on national TV. *Jenny Jones* and talk shows in general were blamed in the press for being irresponsible in misleading guests. See the cover story: Michelle Green, "Fatal Attraction," *People*, 27 March 1995, 40–44.

9. Winfrey, host of *Oprah*, "confessed" her use of cocaine in front of a live audience during the taping of a program in late January 1995. The statement was reported on the evening news as well as in the printed press. For the tabloid coverage, see cover stories: Jim Nelson, "Oprah and Cocaine: The Shocking Story She Didn't Tell You on TV," *National Enquirer*, 31 January 1995, 5; and Ken Harrell, "Oprah: 'How a Man Made Me Slave to Cocaine,'" *Globe*, 31 January 1995, 37.

10. For examples, see Nicholas Garnham, *Capitalism and Communication: Global Culture and the Economics of Information* (London: Sage, 1990), 1–19; and David Sholle, "Resistance and Pinning Down a Wandering Concept in Cultural Studies," *Journal of Urban and Cultural Studies* 1.1 (1990): 87–105.

11. Jürgen Habermas, *The Structural Transformation of the Public Sphere*, trans. Thomas Burger (Cambridge: MIT Press, 1989), 164.

12. Carpignano et al., "Chatter in the Age of Electronic Reproduction," 40.

13. For a discussion of how the established press maintains these distinctions between high and low news, see John Hartley, *Tele-ology: Studies in Television* (London: Routledge, 1992).

14. Janet Maslin, "In Dirty Laundryland," *New York Times*, 10 October 1993, sec. 9, 7.

15. John J. O'Connor, "Defining What's Civilized and What's Not," *New York Times*, 25 April 1989, C18.

16. John Corry, "A New Age of Television Tastelessness?" *New York Times*, 29 May 1988, sec. 2,1.

17. Consider how a series of binary oppositions surface in these discus-

sions of the liberal news tradition and the exploitive talk show genre: democratic versus bias; independent versus profit-oriented; serious versus trivial; educated versus uneducated; and masculine versus feminine.

18. For an example, see Eric Sherman, "Who's the Best? Donahue? Oprah? Someone Else?" *TV Guide*, 26 March 1986, 26. *Newsweek*, 29 October 1979, describes him as "America's most trusted tour guide across today's constantly shifting social and cultural terrain."

19. Michael Schudsen, "Was There Ever a Public Sphere? If So, When? Reflections on the American Case," in *Habermas and the Public Sphere*, ed. Craig Calhoun (Cambridge: MIT Press, 1992).

20. Richard Rorty, "Two Cheers for Elitism," *New Yorker*, 30 January 1995, 86.

21. See Nancy Fraser, *Unruly Practices: Power, Discourse and Gender in Contemporary Social Theory* (Minneapolis: University of Minnesota Press, 1989), 113–143; Masciarotte, "C'mon Girl"; and Patricia Mellencamp, *High Anxiety: Catastrophe, Scandal, Age, and Comedy* (Bloomington: Indiana University Press, 1990), 194–229.

22. Fraser, *Unruly Practices*, 124.

23. Walter Goodman, "As TV Sows Outrage, Guess What It Reaps," *New York Times*, 28 March 1995, C14.

24. L. A. Kauffman, "The Anti-Politics of Identity," *Socialist Review* 20.1 (1990): 69.

25. Kate Millett, *Sexual Politics* (New York: Doubleday, 1970), 124.

26. Sara Evan, *Personal Politics: The Roots of Women's Liberation in the Civil Rights Movement and the New Left* (New York: Knopf, 1979), 82.

27. Fraser, *Unruly Practices*, 26.

28. Masciarotte, "C'mon Girl," 82.

29. Elizabeth Jensen, "Tales Are Oft Told as TV Talk Shows Fill Up Air Time," *Wall Street Journal*, 25 May 1993, 1.

30. Carpignano et al., "Chatter in the Age of Electronic Reproduction," 52.

31. Ibid.

32. Ibid., 53.

33. Ibid., 51.

34. Masciarotte, "C'mon Girl," 83.

35. Ibid., 90.

36. Ibid., 92.

37. Lisa McLaughlin, "Chastity Criminals in the Age of Electronic Reproduction: Reviewing Talk Television and the Public Sphere," *Journal of Communication Inquiry* 17.1 (winter 1993): 51.

38. Ibid., 52.

39. Masciarotte, "C'mon Girl," 90.

40. Mary Louise Adams, "There's No Place Like Home: On the Place of

Identity in Feminist Politics," *Feminist Review* 31 (spring 1989): 22–33; and Linda Briskin, "Identity Politics and the Hierarchy of Oppression: A Comment," *Feminist Review* 35 (1990): 102–108.

41. Wendy Kaminer, *I'm Dysfunctional, You're Functional: The Recovery Movement and Other Self-Help Fashions* (New York: Vintage, 1993), 38.

42. Janice Peck, "Talk About Racism: Framing a Popular Discourse of Race on *Oprah Winfrey*," *Cultural Critique* (Spring 1994), 94.

43. Ibid., 118.

44. J. B. Thompson, *Ideology and Modern Culture: Critical Social Theory* (Cambridge: Polity Press, 1990), 112.

45. Peck, "Talk About Racism," 103–104.

46. McLaughlin, "Chastity Criminals in the Age of Electronic Reproduction," 52.

47. Paul Willemen, "Review of John Hill's 'Sex, Class and Realism—British Cinema, 1956–1963,'" in *The Media Reader*, eds. M. Alvarado and J. Thompson (London: British Film Institute, 1990), 105.

48. Cornel West, *Keeping Faith: Philosophy and Race in America* (New York: Routledge, 1993), 67.

49. Ibid., 71.

50. bell hooks and Cornel West, *Breaking Bread: Insurgent Black Intellectual Life* (Boston: South End Press, 1991), 13.

51. West, *Keeping Faith*, 74–83.

52. Antonio Gramsci, *Selections from the Prision Notebooks*, trans. and ed. Quintin Hoare and Geoffery Nowell Smith (New York: International Publishers, 1971), 5.

53. Ibid., 9.

54. Maria Koundoura, "Multinationalism: Redrawing the Map of the Intellectual Labor in the Age of Postcoloniality" (Ph.D. diss., Stanford University, 1993), 26.

55. Gramsci, *Selections from the Prison Notebooks*, 10.

Chapter 5

1. Mimi White, *Tele-vising: Therapeutic Discourse in American Television* (Chapel Hill: University of North Carolina Press, 1992), 8.

2. Charles Guignon, paper presented as part of the Humanities Seminars at the University of Vermont, Burlington, VT, October 27, 1994, 3.

3. *The History of Sexuality, Volume I: An Introduction*, trans. Robert Hurley (New York: Pantheon, 1977), 61–62.

4. For examples see Jana Sawicki, *Disciplining Foucault: Feminism, Power, and the Body* (New York: Routledge, 1991) and Isaac D. Balbus, "Disciplining

Women: Michel Foucault and the Power of Feminist Discourse," in *After Foucault: Humanistic Knowledge, Postmodern Challenges*, ed. Jonathan Arac (New Brunswick, NJ: Rutgers University Press, 1988), 138–160.

5. Barnaby B. Barratt, *Psychoanalysis and the Postmodern Impulse: Knowing and Being Since Freud's Psychology* (Baltimore: Johns Hopkins University, 1993), 190.

6. E. H. Erikson, "Ego Development and Historical Change," *The Psychoanalytic Study of the Child*, vol. 2. (New York: International Universities Press, 1946) and T. C. Kroeber, "The Coping Functions of the Ego-Mechanisms," in *The Study of Lives*, ed. R. W. White (New York: Atherton Press, 1964).

7. Heinz Hartmann, *Essays on Ego Psychology* (New York: International Universities, 1964), 158–159.

8. Steven Starker, *Oracle at the Supermarket: The American Preoccupation with Self-Help Books* (New Brunswick: Transaction, 1989), 112.

9. George C. Miller, "Psychology as a Means of Protecting Human Welfare," *American Psychologist* 24 (1969), 1074.

10. Hare-Mustin, Rachel T., "An Appraisal of the Relationship between Women and Psychotherapy," *American Psychologist* 38 (May 1983), 593.

11. Starker, 113.

12. "In Dirty Laundryland," *New York Times*, 10 October 1993, 9.1.

13. "The Human Condition," *New York Times*, 2 May 1991, A25.

14. Albert Ellis, *Humanistic Psychotherapy: The Rational-Emotive Approach* (New York: Julian Press, 1973), 3.

15. Christopher Lasch, *The Culture of Narcissism* (New York: Norton, 1978), 10.

16. Phillip Rieff, *The Triumph of the Therapeutic: Uses of Faith After Freud* (Chicago: University of Chicago Press, 1987), 65.

17. Wendy Kaminer, *I'm Dysfunctional, You're Functional: The Recovery Movement and Other Self-help Fashions* (New York: Vintage, 1993), 38.

18. See Janice Peck's two essays for sophisticated discussion of this individualist ideology: "TV Talk Shows as Therapeutic Discourse: The Ideological Labor of the Televised Talking Cure," *Communication Theory* 5.1 (February 1995), 58–81, and "Talk About Racism: Framing a Popular Discourse of Race on *Oprah Winfrey*," *Cultural Critique* (Spring 1994), 89–126.

19. Wendy Simmonds, *Women and Self-Help Culture: Reading Between the Lines* (New Brunswick, NJ: Rutgers University Press, 1992), 226.

20. Phillip Cushion, "Why the Self Is Empty: Toward a Historically Situated Psychology," *American Psychologist* 45 (May 1990): 599–611.

21. Jana Sawicki, *Disciplining Foucault: Feminism, Power, and the Body* (New York: Routledge, 1991), 106.

22. Susan Sturdivant, *Therapy with Women: A Feminist Philosophy of Treatment* (New York: Springer, 1980), 52.

23. *American Psychologist* (1975).

24. Sturdivant, 87.

25. The feminism of talk shows is a complicated matter. Their audience for these shows is primarily made up of women, so it becomes easy for the hosts to espouse support of women. I base my assertion of their collective feminism on the way they connect politics and women's rights. *See* Phil Donahue's "The Faint-hearted Feminist," in his autobiography, *My Own Story: Donahue* (New York: Simon and Schuster, 1979), 231. Sally Jessy Raphaël says that she "wouldn't mind a bit if she is in part responsible for this new female assertativeness" that is part of the feminism in Myrna Blyth's "Sally Jessy Raphaël—My Toughest Year," in the *Ladies' Home Journal* (February 1993), 179. Oprah Winfrey continually states that her show is about women's self-improvement and rights. *See* Marcia Ann Gillespie's "On Air or Off, Oprah Makes Money Talk," *Ms.* (November 1988), 54. Geraldo Rivera is the least openly feminist of the hosts. His support of women results from his self-proclaimed role as a man of the "people" and therefore he champions the rights of the "unemployed women" who make up his viewers. *See* Doug Hill, "Is Geraldo Running out of Control?" *TV Guide*, 28 January 1989, 28.

26. "Feminist Criticism and Television," in *Channels of Discourse, Reassembled*, ed. Robert Allen (Chapel Hill: University of North Carolina, 1992), 251.

27. Patricia Allen and Sandra Harmon, *Getting to "I Do"* (New York: William Morrow and Co., 1994).

28. Warren Berger, "Childhood Trauma Healed While-U-Wait," *New York Times*, 8 January 1995, 33.

29. Patricia Mellencamp, *High Anxiety: Catastrophe, Scandal, Age, and Comedy* (Bloomington, IN: Indiana University Press, 1990), 218.

30. Gloria-Jean Masciarotte, "C'mon Girl: Oprah Winfrey and the Discourse of Feminine Talk," *Genders* 11 (Fall 1991): 91.

31. Judith Worell and Pam Remer, *Feminist Perspectives in Therapy: An Empowerment Model for Women* (Chichester, UK: John Wiley, 1992), 101.

32. Two examples are Janice Peck's attack on Winfrey's repeated use of her program in her article "Talk About Racism: Framing a Popular Discourse of Race on *Oprah Winfrey*," in *Cultural Critique* (Spring 1994): 89. Also Vicki Abt, a sociology professor at Pennsylvania State University, has been quoted in the *New York Times* as saying: "If you watch the talk show doctors, their advice is always a cliché, something about self-esteem." *See* Warren Berger, "Childhood Trauma Healed While-U-Wait," *New York Times*, 8 January 1995, 33.

33. Sawicki 106.

34. Kravitz, D., "Consciousness-raising and Self Help," in *Women and Psychotherapy: An Assessment of Research and Practice*, eds. A. M. Brodsky and R. T. Hare-Mustin. (New York: Guilford, 1980), 268.

35. Phil Donahue and Co., *My Own Story: Donahue* (New York: Simon and

Schuster, 1979), 109.

36. *See* Janice Peck, "Selling Goods and Selling God: Advertising, Televangelism and the Commodity Form," *Communication Inquiry* 17:1 (Winter 1993): 5–24.

37. Walter Elwell, ed., *Evangelical Dictionary of Theology* (Grand Rapids, MI: Baker Book House, 1984), 1175.

38. Nancy Hardesty, *Women Called to Witness: Evangelical Feminism in the 19th Century* (Nashville: Abington Press, 1984) and Barbara Epstein, *The Politics of Domesticity: Women, Evangelism, and Temperance in Nineteenth Century America* (Middletown, CN: Wesleyan University Press, 1981).

39. Masciarotte, 86.

40. Charlotte Linde, *Life Stories: The Creation of Coherence* (NY: Oxford University Press, 1993), 11.

41. "Twelve-Step Teleology: Narratives of Recovery/Recovery as Narrative" in *Getting a Life: Everyday Uses of Autobiography in Postmodern America*, eds. S. Smith and J. Watson (Minneapolis: University of Minnesota Press, 1995).

42. Ruth A. Peters, *Who's in Charge? A Positive Parenting Approach to Disciplining Children* (Clearwater, FL: Lindsay Press, 1990).

43. Peters, vii–viii.

44. Mellencamp, 215.

Chapter 6

1. Other talk shows in 1995 are *Danny!*, *Gabrielle*, *Charles Perez*, *Marilu*, *Shirley*, and *Mark*. Shows that were launched in the early 1990s: *Bertice Berry*, *Vicki!*, *Les Brown*, *Jane Whitney*, *Leeza*, *Dennis Prager*, and *Rolonda*.

2. Perhaps, daytime soap operas have received quantitatively more attention, given that they have been on twice as long as issue-oriented talk shows, but they have never earned the anger that talk shows have. See Robert Allen, *Speaking of Soap Operas* (Chapel Hill: University of North Carolina Press, 1985), 30–60.

3. Jane Feuer, "Genre and Television Studies," *Channels of Discourse, Reassembled* (Chapel Hill: University of North Carolina, 1992), 156.

4. William Bennett, "Statement Announcing a Public Campaign Against Select Daytime Television Talk Shows," Empower America press release, 26 October 1995.

5. Ken Auletta, "The $64,000 Question," *New Yorker*, 16 Spetember 1994, 46.

6. Ellen Goodman, "Trash TV Trickery," *Boston Globe*, 3 March 1995, 13.

7. Walter Goodman, "As TV Sows Outrage, Guess What It Reaps," *New York Times*, 28 March 1995, 22.

8. Meredith Berkman, "Liars Send in Clowns for Sicko Circuses,"*New York*

Post, 4 December 1995:8.

9. Stephen Schiff, "Geek Shows" *New Yorker*, 6 November 1995, 9.

10. Ibid., 10.

11. Jill Nelson, "Talk Is Cheap," *Nation*, 5 June 1995, 801.

12. Jeanne Albronda Heaton and Nora Leigh Wilson, "Tuning into Trouble," *Ms.*, September/October 1995, 47.

13. Ibid., 46.

14. Nelson, "Talk is Cheap," 802.

15. Ibid., 801.

16. See Siegfried Kracauer, *From Caligari to Hitler: A Psychological History of German Film* (Princeton: Princeton University Press, 1947); and Julien Petley, *Capital and Culture: German Cinema, 1933–1945* (London: British Film Institute, 1979).

17. "Statement of Senator Joe Lieberman, Talk Show News Campaign," Empower America press release, 26 October 1995, 3.

18. "Empower America Mission Statement," www.townhall.com: 1.

19. "Speeches and Lecture Series," Empower America, www.townhall.com.

20. William J. Bennett, ed., *The Book of Virtues: A Treasury of Great Moral Stories* (New York: Simon & Schuster, 1993).

21. See Richard S. Randall, *Censorship of the Movies: The Social and Political Control of a Mass Medium* (Madison: University of Wisconsin Press, 1970), 179–224.

22. William Bennett, "Statement Announcing a Public Campaign Against Select Day-time Television Talk Shows," Empower America press release, 26 October 1995, 2.

23. Ibid.

24. News release, Press Office, U.S. Senator Joseph Lieberman, 26 October 1995, 1.

25. Ibid., 2.

26. Sample letter, press kit, 8 November 1995.

27. "Talk Show Content," press release from Empower America, 26 October 1995, 1–3.

28. Traci Grant, "Ricki Lake's TV Talk-Show Formula," *Boston Globe*, 18 December 1994, B5.

29. Ricki Lake, interview, "Star Talker: The Next Generation," *Broadcasting and Cable*, 12 December 1994, 57.

30. Traci Grant, "Ricki Lake's TV Talk-Show Formula," *Boston Globe*, 18 December 1994, B5.

31. Ibid.

32. Ibid., B13.

33. Harry F. Waters, "Girls' Afternoon Out," *Newsweek*, 23 September 1991, 56.

34. David Tobenkin, "Bumper Crop of Talk Shows Hopes to Tap 'Ricki's' Success," *Broadcasting and Cable*, 12 December 1994, 48.

35. See A. J. Jacobs, "Ricki Wannabes," *Entertainment Weekly*, 25 March 1995, 52; and Jefferson Graham, "Early Word on New Talk Shows," *USA Today*, 3 October 1995, 3D.

36. Tobenkin, "Bumper Crop of Talk Shows Hopes to Tap 'Ricki's' Success," 47.

37. Sony Annual Report, 1995, 27.

38. Jim Benson, "Talkshows Reaching Saturation Point," *Variety*, 11 October 1993, 27, 36.

39. Jim Benson, "Stations Face Torrents of Talk," *Variety*, 26 July 1993, 17.

40. Bert Dubrow, personal interview, 10 March 1994.

41. Feuer, "Genre and Television Studies," *Channels of Discourse, Reassembled*, 158.

42. Riki Lake interview, "Star Talker," 57.

43. Graham, "Early Word on New Talk Shows," 3D.

44. Oprah Winfrey, "Truth, Trash, and TV," *TV Guide*, 11–17 November 1995, 15–16.

45. Winfrey, 18.

46. As evidence of the change to "uplift" programming a week's program titles in October–November 1995: "Oprah's Child Alert: Children and Guns, Part I"; "Are You Still Haunted by Your First Love?"; "Caroline Kennedy on Privacy"; "Loni Anderson"; and "What Your House Says about You."

47. Grant, "Ricki Lake's Talk-Show Formula," B6.

48. Bradley S. Greenberg and Sandi Smith, "The Content of Television Talk Shows: Topics, Guest and Interactions" (report prepared for the Kaiser Family Foundation, Michigan State University, November 1995), 1–7.

49. The competitive pressure for new and more revelatory conflict has led to a series of ongoing confessions by former producers of talk shows. For example, Joni Cohen-Zlotowitz (former *Charles Perez* producer) states: "We were told by the corporate people we had to put conflict into every segment. . . . And the conflict had to be 'wild.' Get a fight going the first segment or you're going to lose [the audience]. Those are the guidelines." She also recalls producing the program "I Have a Surprise I Want to Tell You," in which a young woman told her father that she worked as a stripper. She said that she refused when she was told to have the woman perform in front of her dad. The supervising producer was screaming at me: 'That's what makes this show.'" Chuck Sennett (lawyer for the *Charles Perez* show) acknowledged conflict is a key element in the show, noting that it "is a part of every talk show from 'Charles Perez' to 'The McLaughlin Group.'" Berkman, "Liars Send in Clowns for Sicko Circuses," *New York Post*, 4 December, 1995, 8.

50. "The World of Wrestling," in *A Barthes Reader*, ed. Susan Sontag (New

York: Wang & Hill, 1982), 23.

51. Grant, "Ricki Lake's TV Talk-Show Formula," B5.

52. Berkman, "Daytime Talk Shows: Fake Guests Common in Battle for Ratings," *New York Post*, 4 December 1995.

53. Grant, "Ricki Lake's Talk-Show Formula," B5.

54. Berkman, "Liars Send in Clowns for Sicko Circuses," *New York Post*, 4 December, 1995, 8.

55. Thomas Hess, quoted in Andrew Ross, *No Respect: Intellectuals and Popular Culture* (New York: Routledge, 1989), 145.

56. Interview with Martin Berman, New York City, 6 March 1994.

57. Richard Dyer, "It's Being So Camp As Keeps Us Going," in *Only Entertainment* (London: Routledge, 1992), 138.

58. Jack Babuscio, "Camp and the Gay Sensibility," in *Gays and Film*, ed. Richard Dyer (New York: Zoetrope Books, 1984), 40.

59. Scott, Moore, "New Show Spoofs Daytime Trash Talkies," *San Francisco Chronicle*, 30 December 1995, C4.

60. Susan Bright, *Susie Bright's Sexual Reality: A Virtual Sex World Reader* (Pittsburgh: Cleis Press, 1992), 140–149.

61. Mark Booth, *Camp* (New York: Quartet, 1983), 18.

62. Susan Sontag, "Notes on Camp," *Against Interpretation* (New York, Octagon Books, 1978).

63. Babuscio, Camp and the Gay Sensibility," 42.

64. bell hooks, *Outlaw Culture: Resisting Representation* (New York: Routledge, 1994), 118.

65. Henry Louis Gates, "Thirteen Ways of Looking at a Black Man," *New Yorker*, 23 October 1995, 60.

66. Babuscio, "Camp and Gay Sensibility," 41.

67. Mikhail Bakhtin, *Rabelais and His World* (Cambridge: MIT Press, 1968), 10.

68. Umberto Eco, "The Frame of Comic 'Freedom,'" in *Carnival*, ed. Thomas A. Seboek (Berlin: Mouton, 1985), 6.

Chapter 7

1. Renato Rosaldo, *Culture and Truth: The Remaking of Social Analysis* (Boston: Beacon Press, 1989), 26.

2. Robert Allen, *Speaking of Soap Operas* (Chapel Hill: University of North Carolina Press, 1985), 185.

3. Henry Jenkins, *Textual Poachers: Television Fans and Participatory Culture* (New York: Routledge, 1992); Lisa Lewis, ed., *The Adoring Audience: Fan*

Culture and Popular Media (New York: Routledge, 1993); and C. Lee Harrington and Denise D. Bielvy, *Soap Fans: Pursuing Pleasure and Making Meaning in Everyday Life* (Philadelphia: Temple University Press, 1995).

4. Pierre Bourdieu, *Distinction: A Social Critique of the Judgment of Taste*, trans. Richard Nice (Cambridge: Harvard University Press, 1984), 54–55.

5. Ellen Seiter, Hans Borchers, Gabrielle Kreutzner, and Eva-Maria Warth, "Don't Treat Us Like We're So Stupid and Naive," in *Remote Control: Television, Audiences, and Cultural Power* (New York: Routledge, 1989), 228–231.

6. David Morley, *Family Television* (London: Routledge, 1986), 146–150.

7. Ien Ang, *Watching Dallas: Soap Opera and the Melodramtic Imagination* (London: Methuen, 1982), 98.

8. Justin Lewis, *The Ideological Octopus: An Exploration of Television and Its Audience* (New York: Routledge, 1991), 75–76.

9. Bourdieu, *Distinction*, 32.

10. Ibid., 2.

11. Jenkins, *Textual Poachers*, 4.

12. Ang, *Watching Dallas*, 110.

13. Jenkins, *Textual Poachers*, 287.

14. See Morley, *Family Television*; Preis, "Class, Gender and Female Viewer," in *Television and Women's Culture*, ed. Mary Ellen Brown (London: Sage, 1990); and Bobo, *Black Women as Cultural Readers* (New York: Columbia University Press, 1995).

15. Ellen Seiter, "Making Distinctions in Audience Research: Case Study of a Troubling Interview," in *Television: The Critical View*, ed. Horace Newcomb (Oxford: Oxford University Press, 1994), 387–410.

16. See Steven G. Jones, ed., *CyberSociety: Computer-Mediated Communication and Community* (Thousand Oaks, CA: Sage, 1995).

17. "America Online Demographic Profile," America Online press release, 8 June 1995, 1.

18. Charlotte Linde, *Life Stories: The Creation of Coherence* (New York: Oxford University Press, 1993), 11.

19. Rosaldo, *Culture and Truth*, 208.

20. Frederic Biddle, "TV's New Shocker: The Talk Turns Tame," *The Boston Globe*, 5 January 1996, 1.

21. Ibid.

BIBLIOGRAPHY

❖

Books and Articles

Abramson, Phyllis Leslie. *Sob Sister Journalism*. New York: Greenwood Press, 1990.

Adams, Mary Louise. "There's No Place Like Home: On the Place of Identity in Feminist Politics." *Feminist Review* 31 (Spring 1989): 22–33.

Allen, Robert C. *Speaking of Soap Operas*. Chapel Hill: University of North Carolina Press, 1985.

———, ed. *Channels of Discourse, Reassembled*. Chapel Hill: University of North Carolina Press, 1992.

Althusser, Louis. "Ideology and Ideological State Apparatuses." In *Essays on Ideology*. London: Verso, 1976.

Ang, Ien. *Desperately Seeking the Audience*. New York: Routledge, 1991.

———. *Watching Dallas: Soap Opera and the Melodramtic Imagination*. London: Methuen, 1982.

Bakhtin, Mikhail. *Rabelais and His World*. Cambridge: MIT Press, 1968.

Balbus, Isaac D. "Disciplining Women: Michel Foucault and the Power of Feminist Discourse." In *After Foucault: Humanistic Knowledge, Postmodern Challenges*. New Brunswick: Rutgers University Press, 1988.

Baran, Paul A., and Paul M. Sweezy. *Monopoly Capital: An Essay on the American Economic and Social Order*. New York: Modern Reader, 1966.

Barratt, Barnaby B. *Psychoanalysis and the Postmodern Impulse: Knowing and Being Since Freud's Psychology*. Baltimore: Johns Hopkins University Press, 1993.

Bessie, Simon Michael. *Jazz Journalism: The Story of the Tabloid Newspapers*. New York: Russell & Russell, 1938.

Bird, Elizabeth. *For Enquiring Minds: A Cultural Study of Supermarket Tabloids*. Knoxville: University of Knoxville Press, 1992.

Bly, Nellie. *Oprah! Up Close and Down Home*. New York: Kensington, 1993.

Bone, Ian, Allen Pullen, and Tim Scargill, eds. *Class War: A Decade of Disorders*. London: Verso, 1991.

Bordwell, David, Janet Staiger, and Kristin Thompson. *The Classical Hollywood Cinema: Film Style and Mode of Production to 1960*. New York: Columbia University Press, 1985.

Bourdieu, Pierre. *On Distinction: A Critique of the Judgment of Taste*. Trans. Richard Nice. Cambridge: Harvard University Press, 1984.

Brady, Robert, A. "The Problem of Monopoly." In *The Motion Picture Industry, Annals of the American Academy of Political and Social* Sciences (ed. Gordon S. Watkins), 254 (November 1947): 125–136.

Braverman, Harry. *Labor and Monopoly Capital: The Degradation of Work in the Twentieth Century*. New York: Monthly Review Press, 1974.

Bright, Susie. *Susie Bright's Sexual Reality: A Virtual Sex World Reader*. Pittsburgh: Cleis Press, 1992.

Briskin, Linda. "Identity Politics and the Hierarchy of Oppression: A Comment." *Feminist Review* 35 (1990): 102–108.

Brodsky, Annette, and Rachel Hare-Mustin. *Women and Psychotherapy*. New York: Guilford, 1980.

Brooks, Peter. *The Melodramatic Imagination: Balzac, Henry James, Melodrama and the Mode of Excess*. New Haven: Yale University Press 1976.

Brothers, Joyce, and E. P. F. Egan. *Ten Days to a Successful Memory*. New York: Prentice-Hall, 1957.

Brown, Mary Ellen. *Soap Opera and Women's Talk*. Thousand Oaks, CA: Sage, 1994.

Buzzard, Karen. *Electronic Media Ratings: Turning Audiences into Dollars and Sense*. Boston: Focal Press, 1992.

Byars, Jackie. *All That Hollywood Allows: Rereading Gender in 1950s Melodrama*. Chapel Hill: University of North Carolina Press, 1991.

Calhoun, Craig, ed. *Habermas and the Public Sphere*. Cambridge: MIT Press, 1992.

Carbaugh, Donald. *Talking American: Cultural Discourses on DONAHUE*. Norwood, NJ: Ablex, 1988.

Carpignano, P., R. Andersen, S. Aronowitz, and W. Difazio, "Chatter in the Age of Electronic Reproduction: Talk Television and the 'Public Mind.'" *Sociotext* 25/26 (1990): 33–55.

Carter, Bill. *The Late Shift: Letterman, Leno, and the Battle for the Night*. New York: Hyperion, 1994.

Caves, Richard. *American Industry: Structure, Conduct, Performance*. 4th ed. Englewood Cliffs, NJ: Prentice-Hall, 1977.

Clifford, James. "On Ethnographic Authority." *Representations* 1 (1983): 118–146.

Crawford, M., and J. Marecek. "Psychology Reconstructs the Female, 1968–1988." *Psychology of Women Quarterly* 13 (1989): 147–167.

CRF (Code of Federal Regulations). Annual. *Title 47: Telecommunications*, 5 vols. Washington, DC, GPO.

Cushion, Philip. "Why the Self Is Empty: Toward a Historically Situated Psychology." *American Psychologist* 45 (May 1990): 599–611.

Cutler, Anthony, et al. *Marx's Capital and Capitalism Today*. Vol. 1. London: Routledge and Kegan Paul, 1977.

D'Acci, Julie. *Defining Women: Television and the Case of Cagney and Lacey.* Chapel Hill: University of North Carolina Press, 1994.

Dancyger, Ken, and Jeff Rush. *Alternative Scriptwriting.* Boston: Focal Press, 1991.

Donahue, Phil, & Co. *My Own Story: Donahue.* New York: Simon & Schuster, 1979.

Dryden, Edward, ed. *The Essential Albert Ellis.* New York: Springer Press, 1990.

Dyer, Richard. *The Matter of Images: Essays on Representations.* London: Routledge, 1993.

————. *Only Entertainment.* London: Routledge, 1992.

————. *Stars.* London: British Film Institute, 1979.

————. ed. *Gays and Film.* New York: Zoetrope, 1984.

Eco, Umberto. "The Frame of Comic 'Freedom,'" In *Carnival.* Edited by Thomas A. Sebeok. Berlin: Mouton, 1985.

Ehrenreich, Barbara, and Deirdre English. *For Her Own Good: 150 Years of the Experts' Advice to Women.* Garden City, NY: Doubleday, 1978.

Ellis, Albert. *Humanistic Psychotherapy: The Rational-Emotive Approach.* New York: Julian Press, 1973.

————. and Russell M. Grieger, *Handbook of Rational Emotive Therapy.* New York: Springer Publishing Co., 1977.

Ellis, John. *Visible Fictions: Cinema, Television, Video.* London: Routledge, 1984.

Elwell, Walter, ed. *Evangelical Dictionary of Theology.* Grand Rapids, MI: Baker Book House, 1984.

Epstein, Barbara. *The Politics of Domesticity: Women, Evangelism, and Temperance in Nineteenth Century America.* Middletown, CT: Wesleyan University Press, 1981.

Erikson, E. H. "Ego Development and Historical Change." In *The Psychoanalytic Study of the Child.* Vol. 2. New York: International Universities Press, 1946.

Ettema, James S., and D. Charles Whitney, eds. *Audiencemaking: How the Media Create the Audience.* Thousand Oaks, CA: Sage, 1994.

Evan, Sara. *Personal Politics: The Roots of Women's Liberation in the Civil Rights Movement and the New Left.* New York: Knopf, 1979.

Ewen, Stuart, and Elizabeth Stuart. *Channels of Desires: Mass Images and the Shaping of American Consciousness.* New York: McGraw-Hill, 1982.

Feuer, Jane, Paul Kerr, and Vahimagi Tise. *MTM 'Quality' Television.* London: British Film Institute, 1984.

Fiske, John. *Television Culture.* New York: Methuen, 1987.

Foucault, Michel. *The Archaeology of Knowledge.* Translated by Alan Sheridan. New York: Pantheon, 1972.

————. *Discipline and Punish: The Birth of the Prison*. Translated by Alan Sheridan. New York: Pantheon, 1977.

————. *The History of Sexuality. Vol. 1, An Introduction*. Translated by Robert Hurley. New York: Pantheon, 1977.

————. *Madness and Civilization: A History of Insanity in the Age of Reason*. Translated by Richard Howard. New York: Random House, 1965.

Fraser, Nancy. *Unruly Practices: Power, Discourse and Gender in Contemporary Social Theory*. Minneapolis: University of Minnesota Press, 1989.

Freud, Sigmund. *Dora: An Analysis of a Case of Hysteria*. New York: Collier, 1963.

Garnham, Nicholas. *Capitalism and Communication: Global Culture and the Economics of Information*. London: Sage, 1990.

Gergen, K. J. "The Social Constructionist Movement in Modern Psychology," *American Psychologist* 40 (1985): 266–275

Gitlin, Todd. *Inside Prime Time*. New York: Pantheon, 1985.

Glaser, K. "Women's Self Help Groups as an Alternative to Therapy." *Psychotherapy: Theory, Research and Practice* 13 (1976): 77–81.

Gledhill, Christine, ed. *Home Is Where the Heart Is: Studies in Melodrama and the Women's Film*. Christine Gledhill. London: British Film Institute, 1987.

Glynn, Todd. "Tabloid Television's Transgressive Aesthetic: *A Current Affair* and the 'Shows That Taste Forgot.'" *Wide Angle* 12.2 (April 1990): 22–44.

Gramsci, Antonio. *Selections from the Prision Notebooks*. Translated and edited by Quintin Hoare and Geoffrey Nowell Smith. New York: International Publishers, 1971.

Guignon, Charles. Paper presented at the Humanities Seminars, University of Vermont, Burlington, 27 October 1994.

Habermas, Jürgen. *The Legitimation Crisis*. Cambridge: Polity Press, 1988.

————. "The Public Sphere: An Encyclopedia Article." *New German Critique*, Autumn 1984, 49–55.

————. *The Structural Transformation of the Public Sphere: An Inquiry into a Category of Bourgeois Society*. Translated by Thomas Burger. Cambridge: MIT Press, 1989.

————. *Theory and Practice*. Translated by John Viertel. Boston: Beacon Press, 1973.

Haag, Laurie L. "Oprah Winfrey: The Construction of Intimacy in Talk Show Settings." *Journal of Popular Culture* 26:4 (spring 1993): 115–121.

Hall, Stuart. *The Hard Road to Renewal*. London: Verso, 1988.

————. "The Narrative Constuction of Reality." *Southern Review* 17:1 (1984): 3–17.

————. "The Problem of Ideology—Marxism without Guarentees." In *Marx 100 Years On*. Edited by B. Matthews. London: Lawrence & Wishart, 1983.

Hallin, Daniel C. *We Keep America on Top of the World: Television Journalism and*

the Public Sphere. New York: Routledge, 1994.

Hardesty, Nancy. *Women Called to Witness: Evangelical Feminism in the 19th Century*. Nashville: Abington Press, 1984.

Hare-Mustin, Rachel T. "An Appraisal of the Relationship between Women and Psychotherapy." *American Psychologist* 38 (May 1983): 593–600.

———. "The Meaning of Difference: Gender, Theory, Postmodernism, and Psychology." *American Psychologist* 43 (1988): 455–464.

Harrington, C. Lee, and Denise D. Bielby. *Soap Fans: Pursuing Pleasure and Making Meaning in Everyday Life*. Philadelphia: Temple University Press, 1995.

Harris, Suzanne Iva. "The Talk Show Campaign of 1992: An Examination of the Changes in Political Strategies and Political Reporting Surrounding the Recent Proliferation of Talk Show Appearances by Presidential Candidates." Bachelor's Thesis, Harvard University, 1994.

Hartley, John. *Tele-ology: Studies in Television*. London: Routledge, 1992.

Hartmann, H. *Essays on Ego Psychology*. New York: International Universities, 1964.

Head, Sidney, Christopher H. Sterling, and Lemuel B. Schofield. *Broadcasting in America*. 7th ed. Boston: Houghton Mifflin, 1994.

Heil, Douglas. "Dramatic and Melodramatic Beat Structure." *Creative Screenwriting* (Spring 1994), 44–80.

hooks, bell, and Cornel West. *Breaking Bread: Insurgent Black Intellectual Life*. Boston: South End Press, 1991.

Howard, D., ed. *The Dynamics of Feminist Therapy*. New York: Haworth, 1986.

Israel, Lee. *Kilgallen*. New York: Delacorte, 1979.

Jameson, Fredric. *Postmodernism, or the Logic of Late Capitalism*. Durham: Duke University Press, 1992.

Jenkins, Henry. *Textual Poachers: Television Fans and Participatory Culture*. New York: Routledge, 1992.

Jones, Steven G., ed. *CyberSociety: Computer-Mediated Communication and Community*. Thousand Oaks CA: Sage, 1995.

Juergens, George. *Joseph Pulitzer and the New York World*. Princeton: Princeton University Press, 1966.

Kaminer, Wendy. *I'm Dysfunctional, You're Functional: The Recovery Movement and Other Self-Help Fashions*. New York: Vintage, 1993.

Kane, Harnett T. *Dear Dorothy Dix: The Story of a Compassionate Woman*. New York: Doubleday, 1952.

Kaplan, E. Ann. "Feminist Criticism and Television." In *Channels of Discourse, Reassembled*. Edited by Robert C. Allen. 2d ed. Chapel Hill: University of North Carolina Press, 1992.

———. *Rocking Around the Clock: Music Television, Postmodernism, and Consumer Culture*. New York: Routledge, 1987.

Kasson, John F. *Rudeness and Civility: Manners in the Nineteenth Century Urban America.* New York: Noonday, 1991.

Katz, Alfred. *Self-Help in America: A Social Movement Perspective.* New York: Twayne, 1993.

Kauffman, L. A. "The Anti-Politics of Identity." *Socialist Review* 20.1 (1990): 67–80.

Kimmel, E. "The Experience of Feminism." *Psychology of Women Quarterly* 13 (1989): 133–146.

Koundoura, Maria. "Multinationalism: Rearranging the Map of the Intellectual Labor in the Age of Postcoloniallity." Ph.D. diss., Stanford University, 1993.

Kracauer, Siegfried. *From Caligari to Hitler: A Psychological History of German Film.* Princeton: Princeton University Press, 1947.

Kravetz, D. "Consciousness-raising and Self Help." In *Women and Psychotherapy: An Assessment of Research and Practice.* Edited by A. M. Brodsky and R. T. Hare-Mustin. New York: Guilford, 1980.

Kroeber, T. C. "The Coping Functions of the Ego-Mechanisms." In *The Study of Lives.* Edited by R. W. White. New York: Atherton Press, 1964.

Kuhn, Annette. "Women's Genres: Melodrama, Soap Opera, and Theory." In *Home Is Where the Heart Is: Studies in Melodrama and the Women's Film.* Edited by Christine Gledhill. London: British Film Institute, 1987.

Lasch, Christopher. *The Culture of Narcissism.* New York: Norton, 1978.

Laufer, Peter. *Inside Talk Radio: America's Voice or Just Hot Air?* Secaucus, NJ: Carol, 1995.

Lerman, Hannah. *A Mote in Freud's Eye: From Psychoanalysis to the Psychology of Women.* New York: Springer, 1986.

Lewis, Lisa, ed. *The Adoring Audience: Fan Culture and Popular Media.* New York: Routledge, 1992.

Linde, Charlotte. *Life Stories: The Creation of Coherence.* New York: Oxford University Press, 1993.

Livingstone, Sonia, and Peter Lunt. *Talk on Television: Audience Participation and Public Debate.* London: Routledge, 1994.

Lupton, Deborah. "Talking about Sex: Sexology, Sexual Difference, and Confessional Talk Shows." *Genders* 20 (1994): 45–65.

MacCabe, Colin. "Realism and Cinema: Notes on Brechtian Theses." In *Popular Television and Film.* Edited by T. Bennett, S. Boyd-Bowman, C. Mercer, and J. Woollcott. London: British Film Institute, 1980.

Mandel, Ernest. *Late Capitalism.* London: Verso, 1972.

Manning, Fiora. *Inside Hollywood: Adventures of an Australian Tabloid Journalist.* Sydney: Allen & Unwin, 1989.

Marzolf, Marion. *Up from the Footnote: A History of Women Journalists.* New York: Hastings House, 1997.

Masciarotte, Gloria-Jean. "C'mon Girl: Oprah Winfrey and the Discourse of Feminine Talk." *Genders* 11 (fall 1991): 81–110.

Matelski, Marilyn J. *Daytime Television Programming*. Boston: Focal Press, 1991.

McGuigan, Jim. *Cultural Populism*. London: Routledge, 1992.

McLaughlin, Lisa. "Chastity Criminals in the Age of Electronic Reproduction: Reviewing Talk Television and the Public Sphere." *Journal of Communication Inquiry* 17.1 (winter 1993): 45–55.

McMath, Robert C., Jr. *American Populism: A Social History 1877–1898*. New York: Hill & Wang, 1993.

Meehan, Eileen. "Why We Don't Count: The Commodity Audience." In *Logics of Television*. Edited by Patricia Mellencamp. Bloomington: Indiana University Press, 1990.

Mellencamp, Patricia. *High Anxiety: Catastrophe, Scandal, Age, and Comedy*. Bloomington: Indiana University Press, 1990.

Miller, Bill. *You're on Open Mike!: Inside the Wacky World of Late-Night Talk Radio*. Brattleboro, VT: S. Greene, 1978.

Miller, George C.. "Psychology as a Means of Protecting Human Welfare." *American Psychologist* 24 (1969): 1063–1075.

Millett, Kate. *Sexual Politics*. New York: Doubleday, 1970.

Mincer, Richard, and Deanne Mincer. *The Talk Show Book: An Engaging Primer on How to Talk Your Way to Success*. New York: Facts on File, 1982.

Morley, David. *Family Television*. London: Routledge, 1986.

Morse, Margaret. "Talk, Talk, Talk." *Screen* 26 (1985): 2–15.

Munson, Wayne. *All Talk: The Talk Show in Media Culture*. Philadelphia: Temple University Press, 1993.

Nelson, E. D., and E. W. Robinson. "'Reality Talk' or 'Telling Tales'? The Social Construction of Sexual and Gender Deviance on a Television Talk Show." *Journal of Contemporary Ethnography* 23:1 (April 1994): 51–78.

Newton, Sarah E. *Learning to Behave: A Guide to American Conduct Books Before 1990*. Westport, CT: Greenwood Press, 1994.

Peck, Janice. "Selling Goods and Selling God: Advertising, Televangelism and the Commodity Form." *Communication Inquiry* 17.1 (Winter 1993): 5–24.

————. "Talk About Racism: Framing a Popular Discourse of Race on *Oprah Winfrey*." *Cultural Critique* (Spring 1994), 89–126.

————. "TV Talk Shows as Therapeutic Discourse: The Ideological Labor of the Televised Talking Cure." *Communication Theory* 5.1 (February 1995): 58–81.

Petley, Julien. *Capital and Culture: German Cinema, 1933–1945*. London: British Film Institute, 1979.

Phelan, Shane. *Identity Politics: Lesbian Feminism and the Limits of Community*. Philadelphia: Temple University Press, 1989.

Priest, Patricia Joyner. *Public Intimacies: Talk Show Participants and Tell-All TV.* Cresskill, NJ: Hampton, 1995.

Propp, Vladimir. *Morphology of Folktales.* Austin: University of Texas Press, 1970.

"Report of the Task Force on Sex Bias and Sex Role Stereotyping in Psychotherapeutic Practice." *American Psychologist* 30.12 (1975): 1169–1175.

Rice, J. K., and D. Rice. "Implications of the Women's Liberation Movement for Psychotherapy." *American Journal for Psychiatry* 130 (1973): 191–196.

Rieff, Philip. *The Triumph of the Therapeutic: Uses of Faith After Freud.* Chicago: University of Chicago Press, 1987.

Rosaldo, Renato. *Culture and Truth: The Remaking of Social Analysis.* Boston: Beacon Press, 1989.

Ross, Ishbel. *Ladies of the Press: The Story of Women in Journalism by an Insider, Ishbel Ross.* New York: Harper, 1936.

Sawicki, Jana. *Disciplining Foucault: Feminism, Power, and the Body.* New York: Routledge, 1991.

Schlesinger, Arthur M. *Learning How to Behave: A Historical Study of American Etiquette Books.* New York: Cooper Square, 1946.

Schudsen, Michael. *Discovering the News: A Social History of the American Newspapers.* New York: Basic Books, 1978.

———. "The New Validation of Popular Culture: Sense and Sentimentality in Academia." *Critical Studies in Mass Communication* 4 (1987): 51–68.

———. "Was There Ever a Public Sphere? If So, When? Reflections on the American Case." In *Habermas and the Public Sphere.* Edited by Craig Calhoun. Cambridge: MIT Press, 1992.

Seiter, Ellen, Hans Borchers, Gabrielle Kreutzner, and Eva-Maria Warth, eds. *Remote Control: Television, Audiences, and Cultural Power.* New York: Routledge, 1989.

Sholle, David. "Resistance and Pinning Down a Wandering Concept in Cultural Studies." *Journal of Urban and Cultural Studies* 1.1 (1990): 87–105.

Simmonds, Wendy. *Women and Self-Help Culture: Reading Between the Lines.* New Brunswick: Rutgers University Press, 1992.

Starker, Steven. "Do It Yourself: The Prescription of Self-Help by Psychologists." *Psychotherapy* 25 (1988): 142–146.

———. *Oracle at the Supermarket: The American Preoccupation with Self-Help Books.* New Brunswick, NJ: Transaction, 1989.

Steele, Janet. "The 19th Century *World* versus the *Sun*: Promoting Consumption (Rather Than the Working Man)." *Journalism Quarterly* 67.3 (1990): 592–600.

———. *The Sun Shines for All: Journalism and Ideology in the Life of Charles A. Dana.* Syracuse, NY: Sycracuse University Press, 1993.

Sturdivant, Susan. *Therapy with Women: A Feminist Philosophy of Treatment.*

New York: Springer, 1980.

Sweezy, Paul. *Theory of Capitalist Development*. New York: Monthly Review Press, 1942.

Taylor, S. J. *Shock! Horror! The Tabloids in Action*. London: Bantam, 1991.

Thorburn, David. "Television Melodrama." In *Television: The Critical View*. Edited by Horace Newcomb. 3d. ed. Oxford: Oxford University Press, 1982.

Timberg, Bernard. "The Unspoken Rules of Talk Television." In *Television: The Critical View*. Edited by Horace Newcomb. New York: Oxford University Press, 1994.

Vicinus, Martha. "Helpless and Unfriended: Nineteenth Century Domestic Melodrama." *New Literary History* 13.1 (Autumn 1981).

Walker, Janet. *Couching Resistance: Women, Film, and Psychoanalytic Psychiatry*. Minneapolis: University of Minnesota Press, 1993.

Warhol, Robyn, and Helena Michie. "Twelve-Step Teleology: Narratives of Recovery/Recovery as Narrative." In *Getting a Life: Everyday Uses of Autobiography in Postmodern America*. Edited by S. Smith and J. Watson. Minneapolis: University of Minnesota Press, 1995.

West, Cornel. *Keeping Faith: Philosophy and Race in America*. New York: Routledge, 1993.

———. *Race Matters*. New York: Vintage, 1993.

White, Mimi. *Tele-advising: Therapeutic Discourse in American Television*. Chapel Hill: University of North Carolina Press, 1992.

Willemen, Paul. "Review of John Hill's 'Sex, Class and Realism—British Cinema, 1956–1963.'" In *The Media Reader*. Edited by M. Alvarado and J. Thompson. London: British Film Institute, 1990.

Williams, Raymond. *Culture and Society*. London: Chatto & Windus, 1958.

———. *The Long Revolution*. London: Chatto & Windus, 1961.

———. *Marxism and Literature*. Oxford: Oxford University Press, 1977.

Worell, Judith, and Pam Remer, *Feminist Perspectives in Therapy: An Empowerment Model for Women*. Chichester, Eng.: Wiley, 1992.

Primary Sources
Popular Journals, Magazines, and Newspapers

Boston Globe

Broadcasting

Broadcasting and Cable

Channels

Columbia Journalism Review

Commonweal

Detroit Free Press

Entertainment Weekly

Ebony

Emmy Magazine

Forbes

Globe

Hollywood Reporter

Ladies' Home Journal

Ms.
Nation
National Enquirer
New Republic
Newsweek
New York
New York Herald
New York Post
New York Times
New York World
New Yorker
Progressive

Public Pulse
People
Psychology Today
Redbook Magazine
Star
Talker's Magazine
Television Quarterly
TV Guide
USA Today
Variety (1975–1995)
Vogue
The Wall St. Journal

Corporate Reports

America Online Annual Report 1994
King World Annual Report 1993
Multimedia Inc. Annual Reports 1992 and 1993
Sony Annual Report 1995
Tribune Annual Report 1993

Archives

Museum of Broadcasting, New York
Schlesinger Library, Harvard University

INDEX